D0782326

# The Cultures of His Kingdom

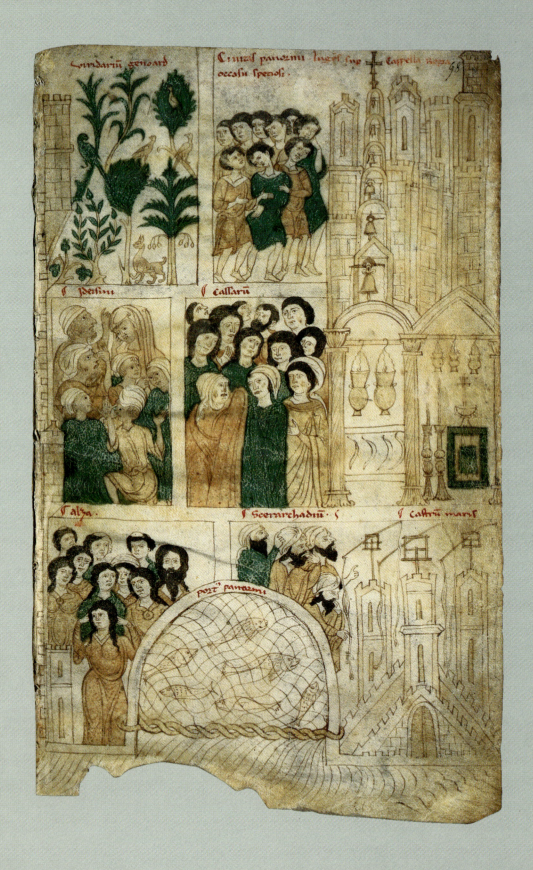

# The Cultures of His Kingdom

ROGER II AND THE CAPPELLA
PALATINA IN PALERMO

*William Tronzo*

PRINCETON UNIVERSITY PRESS
PRINCETON, NEW JERSEY

Copyright © 1997 by Princeton University Press
Published by Princeton University Press, 41 William Street,
Princeton, New Jersey 08540
In the United Kingdom: Princeton University Press, Chichester, West Sussex

All Rights Reserved

*Library of Congress Cataloging-in-Publication Data*
Tronzo, William.
The cultures of his kingdom : Roger II and the Cappella Palatina in Palermo / William Tronzo.
p.    cm.
Includes bibliographical references and index.
ISBN 0–691–02580–0 (cl : alk. paper)
1. Cappella Palatina di Palermo.   2. Church architecture—Italy—Palermo.   3. Architecture,
Norman—Italy—Palermo.   4. Church decoration and ornament—Italy—Palermo.   5. Roger II,
King of Sicily, d. 1154—Art patronage.   6. Palermo (Italy)—Buildings, structures, etc.   I. Title.
NA5621.P3T76   1997
726′.4—dc20          96-13777
CIP

Publication of this book has been aided by the Getty Grant Program
and the Millard Meiss Publication Fund of the College Art Association of America

This book has been composed in Baskerville
by The Composing Room of Michigan, Inc.

Princeton University Press books are printed on acid-free paper and meet the
guidelines for permanence and durability of the Committee on Production Guidelines
for Book Longevity of the Council on Library Resources

Printed in the United States of America by Princeton Academic Press,
Lawrenceville, New Jersey

10   9   8   7   6   5   4   3   2   1

DESIGNED BY CAROL S. CATES

# Contents

*For Gail and Phoebe*

# List of Illustrations

# Abbreviations

Alexander of Telese

Alexander of Telese, *De Rebus Gestis Rogerii Siciliae Regis Libri IV*, ed. G. del Re, *Cronisti e scrittori sincroni napoletani editi e inediti*, vol. l, *Normanni*, Aalen, 1975 (repr. of Naples, 1845)

Boglino, *Real Cappella*

Luigi Boglino, *Storia della Real Cappella di S. Pietro della Reggia di Palermo*, Palermo, 1894

Buscemi, *Notizie*

Nicola Buscemi, *Notizie della Basilica di San Pietro detta la Cappella Regia*, Palermo, 1840

Chalandon, *La domination normande*

Ferdinand Chalandon, *Histoire de la domination normande en Italie et en Sicile*, 2 vols., Paris, 1907

De Cer.

Constantine VII Porphyrogennetos, *Le livre des cérémonies*, 2 vols., ed. and trans. Albert Vogt, Paris, 1935

Deér, *Porphyry Tombs*

Josef Deér, *The Dynastic Porphyry Tombs of the Norman Period in Sicily*, Cambridge, Mass., 1959

Demus, *Norman Mosaics*

Otto Demus, *The Mosaics of Norman Sicily*, New York, 1950

*L'età normanna*

*L'età normanna e sveva in Sicilia. Mostra storico-documentaria e bibliografica*, Palazzo dei Normanni, Palermo, 1994

Garofalo, *Tabularium*

Aloysius Garofalo, *Tabularium Regiae ac Imperialis Capellae Collegiatae Divi Petri in Regio Panormitano Palatio*, Palermo, 1835

Kitzinger, *I mosaici*, fasc. 1/2

Ernst Kitzinger, *I mosaici del periodo normanno in Sicilia*, fasc. 1, *La Cappella Palatina di Palermo, I mosaici del Presbiterio*, Palermo, 1992; fasc. 2, *La Cappella Palatina di Palermo, I mosaici delle Navate*, Palermo, 1993

Monneret de Villard, *Soffitto*

Ugo Monneret de Villard, *Le Pitture musulmane al soffitto della Cappella Palatina in Palermo*, Rome, 1950

Pasca, *Descrizione*

Cesare Pasca, *Descrizione della Imperiale e Regale Cappella Palatina di Palermo*, Palermo, 1841

Philagathos, "Sermon 27"

Filagato da Cerami, *Omelie per i vangeli domenicali e le feste di tutto l'anno*, ed. Giuseppe Rossi Taibbi, vol. 1, *Omelie per le feste fisse*, Palermo, 1969, 174–82, "Homily on the Feast of Sts. Peter and Paul"

Pseudo-Kodinos

Pseudo-Codinos, *Le traité des offices*, ed. Jean Verpeaux, Paris, 1966

Riolo, *Notizie dei restauratori*

Gaetano Riolo, *Notizie dei restauratori delle pitture a musaico della R. Cappella Palatina*, Palermo, 1870

Rocco, "Cappella Palatina, parte prima/seconda"

Benedetto Rocco, "La Cappella Palatina di Palermo: lettura teologica," *B.C.A., Bollettino d'informazione per la divulgazione dell'attività degli organi dell'Amministrazione dei Beni culturali e ambientali della Regione Siciliana* 4, 1983 (1985), 21–74; 5, 1984 (1987), 31–100. These articles have been reprinted in a single volume in anastatic form by the Accademia Nazionale di Scienze, Lettere e Arti, Palermo, 1993

Romuald of Salerno
    Romuald of Salerno, *Chronicon*, ed. C. A. Garufi, *Rerum Italicarum Scriptores*, VII, pt. 1, Città di
    Castello, 1928
Trizzino, "*La Palatina*"
    Lucio Trizzino, "*La Palatina*" *di Palermo. Dalle opere funzionali al restauro, dal ripristino alla tutela*,
    Palermo, 1983
Valenti, "Palazzo Reale"
    Francesco Valenti, "Il Palazzo Reale di Palermo," *Bollettino d'Arte* 11, 1925, 512–28

# Preface

The beginning of this book can be traced back to a very pleasant trip to Sicily that I took with Ernst Kitzinger in the fall of 1987. Our goal was to visit Norman sites in Palermo, Monreale and Cefalù, which we accomplished, and which inspired a long and intense conversation between us. At that time Kitzinger was finishing his book on St. Mary's of the Admiral, and so a certain amount of our attention was directed toward the problem of Norman mosaics as historical documents. The mosaics are our most direct witness to the look and touch of the twelfth century in this land, but they have been restored, in some places as early as the later Middle Ages. Disentangling original from later restoration *in situ* proved to be absorbing. However, some questions on the use of art in the Middle Ages raised in an essay on St. Peter's that I had written two years earlier were also very much on my mind. And I remember one day in the Cappella Palatina, as we stood there, Ernst Kitzinger and I, discussing the mosaics, I could not help but feel my attention stray from the lofty walls to the floor of the building where I finally took in for the first time something the likes of which I had not encountered anywhere else: beautiful revetments, pavements and furnishings filling every inch of chapel space and looking much to be medieval in date—everything, in short, that would enable a functional history of a medieval building of the kind that I had hoped someday to write.

At first I thought this study would be an article devoted to the major components of the mise-en-scène of the chapel. But the more I scrutinized these components, the more I realized that my original formulation of the problem was inadequate to the task at hand. For one thing, change was apparent everywhere in the Cappella Palatina, and change not only in terms of later, postmedieval restorations, but also in terms of the twelfth century itself. The idea of change was unsettling, not so much because it was never broached, let alone resolved, in the scholarly literature, but because it seemed to undermine the image of the chapel as a coherent work of art. The narrowness of my formulation also chafed in another way. Not far along in my research I discovered that the furnishings and decorations that I considered most important were not comprehensible outside of the context of the elements that I ranked as secondary, and those outside of the context of elements ranked as tertiary, and so on: the scope of the endeavor thus continually widened. At the same time, I knew that what I could accomplish would not be a monograph in the strict sense of the term. There were too many unknowns; too many facts would remain unknown until a full-scale architectural and archeological survey of the building and its larger context was undertaken. Necessary, but at this point impossible.

As I stand now at the end of this book, I see more clearly the areas where such a survey would inevitably shed light: on the nave ceiling, for example, whose central section of stars and cavetto molding are almost entirely covered with postmedieval painting; on the crypt, and particularly on its date and its relationship to the main

body of the chapel; on the corridor to the north of the north aisle and northern transept arm; and on the Norman Palace as a whole, and the way in which the Cappella Palatina was originally meant to fit into it. In fact, plans are now being formulated by others to study the nave ceiling and the crypt more closely. Thus I regard much of what I say here as working hypotheses.

Since 1987, I have returned to Palermo many times, and the opportunities to revisit a great building of the past and to see it in different seasons and under different conditions I consider one of the distinct pleasures of having undertaken this research. Only the first of my visits was with Ernst Kitzinger, but his interest in the project continued, much to my benefit. I would like to thank him from the bottom of my heart for taking the time to listen to my ideas, however farfetched, with good-humored patience and when he felt that they might be useful to pursue, for offering the help that enabled me to do so. Kitzinger generously read my entire text, and his comments greatly improved it. Irving Lavin also read my manuscript, and made valuable comments on it with characteristic verve and style. His generosity and friendship have meant a great deal to me—much more in fact than I can put in words.

Access to the Cappella Palatina, and especially to the spaces behind the locked doors of the aisles and above the north aisle, critical to the completion of this study, would not have been possible without the permission of Monsignor Benedetto Rocco, who offered it to me freely. I would like to thank him for his interest in my work, and for the kind hospitality that he extended to me during my visits to the Norman Palace. The assistance of the gentle couple who are the custodians of the chapel, Signor and Signora Magrì, was also much appreciated. Maria Andaloro recommended me to Padre Rocco, followed my progress in Palermo, and read my manuscript. I have benefited greatly from her knowledge of medieval Italian and Byzantine art. Marina Falla Castelfranchi, a devoted friend, made my research visits to Rome all the more enjoyable with the hospitality of her home and family.

The questions that I asked about the Cappella Palatina often led me into unknown territory, for which I sought expert guides. One of them was Renata Holod, who offered me, over the course of several long conversations, many insights into Islamic art and architecture. Jeremy Johns sent me a copy of an unpublished paper of his own with an important new argument about the Cappella Palatina. I have also profited from the views and advice of Beat Brenk, Caroline Bruzelius, Caecilia Davis-Weyer, Mary-Lyon Dolezal, Vera von Falkenhausen, Oleg Grabar, Richard Krautheimer, Marilyn Aronberg Lavin, Henry Maguire, Henry A. Millon, and Priscilla P. Soucek. Yasser Tabbaa solved a problem with a Kufic inscription, and Irfan Shahid offered assistance with a passage of Ibn Jubayr. Katherine A. Holbrow and Richard Tollo helped me by identifying certain materials used in the chapel. Jonathan Bloom and Carolyn L. Connor were instrumental in obtaining photographs. In this regard Serena Romano is especially to be thanked for an effort she made on my behalf that has already entered the realm of legend.

Apart from the Cappella Palatina, my research in Palermo was conducted in the Biblioteca Nazionale, the Biblioteca Comunale, the Galleria Nazionale at the Palazzo Abatellis and the Soprintendenza, whose staffs offered me every assistance. I was able

to begin writing my text at the Institute for Advanced Study in Princeton in the fall of 1990; a term at the Bibliotheca Hertziana in Rome in the spring of 1991 and at the Center for Advanced Study in the Visual Arts of the National Gallery of Art in fall 1991–spring 1992 enabled me to make substantial progress toward finishing it. My visits to Palermo were funded in part by the American Philosophical Society and the American Council of Learned Societies. Duke University supported the making of drawings for this book with a grant from the Arts and Sciences Research Council. The Byzantine Library and Photograph Collection at Dumbarton Oaks proved a valuable resource close at hand.

This book would have been considerably diminished without the beautiful new photographs of Chester Brummel, who had to work at times under difficult conditions in and around the Cappella Palatina, and in other places in Palermo. Ju Tan translated verbal and visual models into ten drawings with equally beautiful results. I would like to thank both of them for their assistance and their good humor, and Patricia Waddy as well for some useful leads. The production of the book was ably guided by my editors at Princeton University Press, Elizabeth Powers, Elizabeth Johnson and Timothy Wardell. I would like to express my gratitude to the Millard Meiss Publication Fund of the College Art Association and to the Getty Grant Program for their support of the publication of this book.

It almost goes without saying that none of the aforementioned bear any responsibility for the errors that I have committed in this book. I should only add that the mistakes would have been greater without Gail and Phoebe, to whom this book is dedicated, who helped me see things more clearly. They have brightened my life.

The Cultures of His Kingdom

# 1

# The Ensemble: " . . . et ornamentis variis ditavit . . . "

It is ironic that the history of medieval architecture should be written today essentially from an ecclesiastical point of view—with the churches, monasteries and mosques (and their vestiges) that still crowd the lands of Greek and Latin Christianity and of Islam—when so much of the era belonged to princes and kings: Constantine and Heraclius, Charlemagne and St. Louis, al-Walid and Saladin. "The Fierce," "the Just," "the True," "the Bad": to conjure up their epithets is to call to mind the forms—dramatic, highly individualized and princely—in which the ebb and flow of medieval events is cast in our imagination. Yet we know so little about the palaces in which these rulers lived and worked, and thus, in a certain sense, lack a most relevant *material* frame of reference for understanding them.[1] There is hardly stone still standing upon stone in what were the noblest of the edifices of princes—the Great Palace of the Byzantine Emperors in Constantinople, the Imperial Palace of Charlemagne at Aachen, or the Fatimid Palaces in Cairo—not to mention the countless other residences whose names alone are known.[2]

[1] The emblems and insignias of kingship, or "Herrschaftszeichen," constitute another important material frame of reference that will give shape to our discussion later. On this subject, see Percy Ernst Schramm, *Herrschaftszeichen und Staatssymbolik: Beiträge zu ihrer Geschichte vom dritten bis zum sechzehnten Jahrhundert*, Stuttgart, 1954–56; Schramm and Florentine Mütherich, *Denkmale der deutschen Könige und Kaiser: Ein Beitrag zur Herrschergeschichte von Karl dem Grossen bis Friedrich II, 768–1250*, Munich, 1962; Schramm, *Kaiser, Könige und Päpste: Gesammelte Aufsätze zur Geschichte des Mittelalters*, Stuttgart, 1968–71, vol. 1, 30ff.; and the discussion of J. M. Bak, "Medieval Symbology of the State: Percy E. Schramm's Contribution," *Viator* 4, 1973, 33ff. See also the work of Josef Deér, *Der Kaiserornat Friedrichs II*, Bern, 1952, and, *Porphyry Tombs*, a study of special importance in the present context.

[2] On medieval palaces, see Karl M. Swoboda, "The Problem of the Iconography of Late Antique and Early Medieval Palaces," *JSAH*, 20, 1961, 78–89; R. Allen Brown, H. M. Colvin and A. J. Taylor, *The History of the King's Works: The Middle Ages* (ed. Howard Montagu Colvin), London, 1963; Hermann Heimpel, Wilhelm Berges and Walter Schlesinger, *Deutsche Königspfalzen. Beiträge zu ihrer historischen und archäologischen Erforschung*, 3 vols., Göttingen, 1963–79; W. Metz, "Betrachtungen zur Pfalzenforschung," *Historisches Jahrbuch* 87, 1967, 91ff.; Paolo Verzone, "La distruzione dei palazzi imperiali di Roma e di Ravenna e la ristrutturazione del Palazzo Lateranense nel IX secolo nei rapporti con quello di Constantinopoli," *Roma e l'età carolingia*, Rome, 1976, 39ff.; Jacques Gardelles, "Le palais dans l'Europe occidentale chrétienne du Xe au XIIe siècle," *Cahiers de la civilisation médiévale* 19, 1976, 115–34; Bryan Ward-Perkins, *From Classical Antiquity to the Middle Ages: Urban Public Building in*

By and large medieval palaces, unlike medieval churches or mosques, are perceptible to us today only through the veils of written sources, whose information, judiciously interpreted, may sometimes be pieced together with a surviving building to form a picture of development and use. But of the significance of these structures—not only as repositories of precious objects and settings for court ritual, but also as vehicles for self-representation—there can be no doubt. Perhaps the cultivated Cassiodorus put it best in his instruction to court architects (*formula curae palatii*) now preserved in the collection of his official correspondence (Var. VII, 5.1–11):

> Palaces are the delight of our power, the fine face of our rule, and the honored witness of our kingship. Admiring ambassadors are shown the palace, and from their view of it they form their first impressions of the king. A thoughtful king therefore greatly enjoys a beautiful palace and relaxes his mind, tired out by public cares, in the pleasure of the building.[3]

That such a sentiment was voiced by one of the most cogent and articulate statesmen of the early Middle Ages is no surprise. Cassiodorus lived in the sixth-century world of Rome, Ravenna and Milan, a world deeply steeped in the practices and beliefs of the classical Roman imperium, in which the symbolism and meaning of the visual arts, including architecture, played an important role.[4]

This book is about a part of a palace distant from Cassiodorus's time by some seven hundred years, but it has been guided and shaped by two concerns, one of which may best be expressed in the form of a question, or rather a set of questions, prompted by his words: by what means—images or words or associations between the two—did the house of the ruler convey its significance to contemporary viewers in the Middle Ages? Where did this meaning fit into the larger world of which these viewers were a part, a world that embraced not only other domains, such as the ecclesiastical, but also other rulers, and their realms? And how did it change in the course of time, from antiquity

---

*Northern and Central Italy, AD 300–850*, Oxford, 1984, 157ff.; Gottfried Kerscher, "Privatraum und Zeremoniell im spätmittelalterlichen Papst- und Königspalast," *Römisches Jahrbuch der Bibliotheca Hertziana* 26, 1990, 87ff.

For the Imperial Palace in Constantinople, see Jean Ebersolt, *Le grand palais de Constantinople et le livre de cérémonies*, Paris, 1910; Cyril Mango, *The Brazen House: A Study of the Vestibule of the Imperial Palace of Constantinople*, Copenhagen, 1959; Paul Magdalino, "Manuel Komnenos and the Great Palace," *Byzantine and Modern Greek Studies* 4, 1978, 101ff.; Lucy Ann Hunt, "Comnenian Aristocratic Palace Decorations: Descriptions and Islamic Connections," *The Byzantine Aristocracy, IXth to XIIth Centuries*, ed. M. Angold, Oxford, 1984, 139ff.

For the Imperial Palace at Aachen, see H. Fichtenau, "Byzanz und die Pfalz zu Aachen," *Mitteilungen des Instituts für österreichische Geschichtsforschung* 59, 1951, 25ff.; *Karl der Grosse: Werk und Wirkung (Aachen, 26 Juni bis zum 19. September 1965)*,

Aachen, 1965, 389ff., 395ff., no. 567; Ludwig Falkenstein, *Der 'Lateran' der karolingischen Pfalz zu Aachen* (=*Kölner historische Abhandlungen*, 13), Cologne, 1966.

For the Fatimid Palaces in Cairo, see Edmond Pauty, *Les palais et les maisons d'époque musulmane, au Caire*, Cairo, 1932, 31ff.; K.A.C. Creswell, *The Muslim Architecture of Egypt*, vol. 1, *Ikhshids and Fatimids, A.D. 939–1171*, Oxford, 1952, 33ff.; Robert Hillenbrand, *Islamic Architecture: Form, Function and Meaning*, New York, 1994, 434ff.

[3] *Magni Aurelii Cassiodori Senatoris Opera, Pars I* (=*Corpus Christianorum, Series Latina* 96), Turnhout, 1973, 264; Bryan Ward-Perkins, trans., *From Classical Antiquity*, 159.

[4] A locus classicus of the discussion is Karl Lehmann, "The Dome of Heaven," *Art Bulletin* 27, 1945, 1ff. See also E. Baldwin Smith, *Architectural Symbolism of Imperial Rome and the Middle Ages*, Princeton, 1956; William MacDonald, *The Architecture of the Roman Empire*, 2 vols., New Haven, 1982–86.

to the Renaissance, in the trajectory of the ruler's art of which Cassiodorus's formulation was a part?

Another concern that was much on my mind in the writing of this book stemmed from a set of circumstances that I have described elsewhere as follows.[5] Much of what we now know as medieval art was originally designed for liturgical rites, ceremonies and other functions. Thus individual objects were almost always created, not as autonomous works, but as parts of larger ensembles, with specific uses in mind: ritual objects that were meant to be brought together and used together in ritual spaces. But it is precisely these ensembles (how the objects went together) and these rituals (how they were intended to be used) that are so unclear. More often than not what we have been bequeathed is simply flotsam and jetsam both physically and conceptually—decontextualized fragments of once complex and interrelated environments, keyed to certain patterns of movement and action. One question that arises—how might we gain insight into the medieval method of combining and using objects, without either accepting these fragments at face value or assimilating them to more familiar art forms or traditions—brought me to twelfth-century Palermo, the Norman Palace and the Cappella Palatina.

✢ ✢ ✢

The city of Palermo, where the Normans built their royal palace and the Cappella Palatina, was the centerpiece of the richest, and newest, royal realm of the twelfth century, that of the Sicilian Norman kings (fig. 1).[6] The Normans were upstarts, adventurers from the North, "ultramontani," who had entered Italy in the early eleventh century in small bands closely linked by family ties.[7] They quickly established

---

[5] Tronzo, "The Medieval Object-Enigma, and the Problem of the Cappella Palatina in Palermo," *Word & Image* 9, 1993, 197ff.

[6] See the description of Palermo by Ibn Jubayr:

It is the metropolis of these islands, combining the benefits of wealth and splendour, and having all that you could wish of beauty, real or apparent, and all the needs of subsistence, mature and fresh. It is an ancient and elegant city, magnificent and gracious, and seductive to look upon. Proudly set between its open spaces and plains filled with gardens, with broad roads and avenues, built in the Cordova style, entirely from cut stone known as kadhan (a soft limestone). A river splits the town, and four springs gush in its suburbs. The King, to whom it is his world, has embellished it to perfection and taken it as the capital of his Frankish Kingdom—may God destroy it (Ibn Jubayr, *The Travels of Ibn Jubayr*, trans. R.J.C. Broadhurst, London, 1952, 348).

On the medieval development of Palermo, see Cesare De Seta and Leonardo Di Mauro, *Palermo*, Bari, 1981, 15ff.; see also Luigi Genuardi, *Palermo*, Rome, 1929; Rosario La Duca, *La città perduta: Cronache palermitane di ieri e di oggi*, Naples, 1977; ed. Henri Bresc and Geneviève Bresc-Bautier, *Palerme 1070–1492. Mosaïque de peuples, nation rebelle: la naissance violente de l'identité sicilienne*, Paris, 1993.

[7] Erich Caspar, *Roger II. (1101–1154) und die Grundung der normannisch-sizilischen Monarchie*, Innsbruck, 1904, 1ff.; Chalandon, *La domination normande*, 1ff.; Robert S. Lopez, "The Norman Conquest of Sicily," in *A History of the Crusades*, ed. Kenneth M. Setton, vol. 1, *The First Hundred Years*, Philadelphia, 1955, 54ff.; Léon-Robert Ménager, "Inventaire des familles normandes et franques emigrées en Italie méridionale et en Sicile (XIe–XIIe siècles)," *Roberto il Guiscardo e il suo tempo, Relazioni e communicazioni nelle Prime Giornate normanno-sveve (Bari, maggio 1973)*, Rome, 1975, 261ff.; Eugenio Dupré-Theseider, "Lo stanziamento dei normanni nel mezzogiorno," *L'art dans l'Italie méridionale. Aggiornamento dell'opera di Emile Bertaux sotto la direzione di Adriano Prandi*, Rome, 1978, vol. 4, 67ff.; Paolo Delogu, *I Normanni in Italia. Cronache della conquista e del regno*, Naples, 1984, 31ff. The Norman con-

themselves in the service of the pope under whom they laid claim to titles and territory in southern Italy and Sicily. By the late eleventh century, under two brothers, Count Roger and Robert Guiscard, they reached the limit of these lands, which they then consolidated under Count Roger's son, Roger II. In 1130, Roger II assumed for himself the title of king.[8] It was a bold move, a decisive break with the past, and soon bitterly disputed by the emperors of both East and West and the pope: Roger II needed every weapon in his arsenal to defend his new office. The choice of Palermo as his capital city, "Qui etiam adebant, quod Regni ipsius principium, et caput Panormus Siciliae metropolis fieri deceret,"[9] may be thought of as part of his program. In the twelfth century, it was by no means the norm to have a fixed capital city—witness the peripatetic life of most of the German rulers.[10] But Roger chose a city of ancient pedigree—in the words of his chronicler, Alexander of Telese, a city that had been the capital of the island in days of old—and thus capable of lending to the new regime the patina of prestige.[11]

It was Roger II who also endowed his capital with a new royal residence on its highest point, a rise to the west where it is believed that an Arab fortress once stood

quest of and dominion in the South has also been the subject of two recent exhibitions of art, documents and material culture: *I normanni. Popolo d'Europa 1030–1200*, ed. Mario D'Onofrio, Venice, 1994, and *L'età normanna*, Palermo, 1994. Regarding the political situation that the Normans encountered when they entered southern Italy, see most recently Barbara M. Kreutz, *Before the Normans: Southern Italy in the Ninth and Tenth Centuries*, Philadelphia, 1991, esp. 150ff.

[8] Caspar, *Roger II*, 96f., 237ff.; Chalandon, *La domination normande*, 2:1ff.; Léon-Robert Ménager, "L'institution monarchique dans les Etats normands d'Italie. Contribution à l'étude du pouvoir royal dans les principautés occidentales, aux XIe–XIIe siècles," *Cahiers de civilisation médiévale* 2, 1959, 303ff. (repr. as *Hommes et institutions de l'Italie normande*, London, 1981, no. II); Helene Wieruszowski, "Roger II of Sicily, *Rex-Tyrannus*, in Twelfth-Century Political Thought," *Speculum* 38, 1963, 46ff.; Reinhard Elze, "Zum Königtum Rogers II. von Sizilien," *Festschrift Percy Ernst Schramm*, Wiesbaden, 1964, 102ff. (repr. as *Päpste-Kaiser-Könige und die mittelalterliche Herrschaftssymbolik*, London, 1982, no. IX).

[9] Alexander of Telese, 101.

[10] Carlrichard Brühl, "Remarques sur les notions de 'capitale' et de 'residence' pendant le haut moyen age," *Journal des Savants*, Oct.–Dec. 1967, 193ff.

[11] "Qui etiam addebant, quod Regni ipsius principium, et caput Panormus Siciliae metropolis fieri deceret, quae olim sub priscis temporibus, super hanc ipsam provinciam Reges nonnullus habuisse traditur, quae postea, pluribus evolutis annis, occulto Dei disponente judicio nunc usque sine

Regibus mansit"; "Nam si regni solium in eademquondam civitate, ad regendum tantum Siciliam certum est exstitisse, et nunc ad ipsum per longum tempus defecisse videtur, valde dignum, et justum est, ut in capite Rogerii diademate posito, regnum ipsum non solum ibi modo restituatur, sed in caeteras etiam regiones, quibus jam dominari cernitur, dilatari debeat": Alexander of Telese, 101f. See also Michele Fuiano, "La fondazione del *Regnum Siciliae* nella versione di Alessandro di Telese," *Papers of the British School at Rome* 24, 1956, 65ff., esp. 75ff. The Arab geographer at the court of Palermo, Idrisi, also wrote of Palermo that it was "the seat of kings in ancient and modern times"; "L'Italia descritta nel 'Libro del re Ruggero' compilato da Edrisi," text and trans. Michele Amari and C. Schiaparelli, *Atti della Reale Accademia dei Lincei*, 274, 1876–77(1883), 25f. For the Arabic text see now al-Idrisi, *Opus geographicum*, Naples, 1970–84, and the translation of Umberto Rizzitano, *Il libro di Ruggero*, Palermo, 1994, 30. See also the remarks of Antonio Marongiu, "Lo spirito della monarchia normanna di Sicilia nell'allocuzione di Ruggero II ai suoi grandi," *Archivio Storico Siciliano*, ser. III, 4, 1950–51, 430; Wieruszowski, "*Rex-Tyrannus*," 51ff., particularly with regard to the privilege of Pope Innocent II issued at Mignano; Maria Andaloro, "Altavilla," *Enciclopedia dell'arte medievale*, vol. 1, Rome, 1990, 451.

The extent and nature of the pre-Norman city is difficult to grasp; see, for example, the studies of Giuseppe Bellafiore, "Edifici dell'età islamica e normanna presso la cattedrale di Palermo," *Bollettino d'arte* 52, 1967, 178ff., and *La cattedrale di Palermo*, Palermo, 1976, 13f.

(fig. 2).[12] It has been claimed that Roger's palace was not the first Norman habitation on the site, and that it incorporated parts of the preexisting Arab structure, but these propositions only highlight a tremendous archeological problem that may never be resolved.[13] The ancient Norman Palace is now the seat of the Sicilian Parliament, and its rich renaissance and baroque look attests to its almost constant use since the twelfth century, as well as to the succession of cultures—German, French and Spanish—that occupied the island. But intertwined here and there in the tangle of later additions, rebuildings and rearrangements are the medieval structures, which emerge now all the more clearly thanks to the restorations that took place in the 1920s and '30s under the Ingegnere Francesco Valenti.[14] Even today some of these medieval structures are too fragmentary to be fully comprehensible—a piece of wall here, an arch there. But many are also more or less intact, and they help us to visualize the palace and environs depicted in the illustrations of Petrus de Ebulo's epic poem on Henry VI (frontispiece),[15] or described by such visitors as the Spaniard, Ibn Jubayr:

> After the morning prayers, we bent our way to al-Madinah [Palermo]. On arrival we made to enter, but were stopped and directed to a gate near the palace of the Frankish king— may God relieve the Muslims of his dominance. We were then conducted to his Commissioner that he might question us as to our intentions, as they do in the case of all strangers. Over esplanades, through doors, and across royal courts they led us, gazing at the towering

---

[12] Pasca, *Descrizione*, 9. Modern historical research on the Norman Palace begins with Adolph Goldschmidt's study, "Die normannischen Königspaläste in Palermo," *Zeitschrift für Bauwesen* 48, 1898, 541ff. However, there is still no adequate survey of the structure in any of the published accounts, including those of Francesco Valenti (see below, n. 14). For the palace, see Antonino Cutrera, "Il palazzo degli emiri di Sicilia in Palermo," *Bollettino d'arte* 25, 1931, 198ff.; Mario Guiotto, ed., *Palazzo ex reale di Palermo. Recenti restauri e ritrovamenti*, Palermo, 1947; Gioacchino Lanza Tomasi, *Il Palazzo dei normanni*, Turin, 1966 (popular text but several good illustrations); R. Delogu and V. Scuderi, *La Reggia dei normanni e la Cappella Palatina*, Florence, 1969; Maria Grazia Paolini, "Considerazioni su edifici civili di età normanna a Palermo," *Atti dell'Accademia di Scienze, Lettere e Arti di Palermo* 33, 1973–74, 299ff.; Guido di Stefano, *Monumenti della Sicilia normanna*, 2nd ed., annotated by Wolfgang Krönig, Palermo, 1979, 68ff.; Giulia Davi, "Il Castello di Giuliana e il Palazzo Reale di Palermo," *Atti della terza settimana di studi di storia dell'arte medievale dell'Università di Roma, 15–20 Maggio 1978*, Rome, 1980, 147ff.; Trizzino, "*La Palatina*", passim; Roberto Calandra, Alessandro La Manna et al., *Palazzo dei Normanni*, Palermo, 1991; Ferdinando Maurici, *Castelli medievali in Sicilia dai bizantini ai normanni*, Palermo, 1992, esp. 55ff., 339f.; Hans-Rudolf Meier, *Die normannischen Königspaläste in Palermo: Studien zur hochmittelalterlichen Residenzbaukunst*, Worms, 1994, 37ff.

[13] Tommaso Fazello, *De rebus siculis Decades duae*, Palermo, 1560, bk. VII, c. 1, 444ff.; Mariano Valguarnera, *Discorso dell'origine ed antichità di Palermo*, Palermo, 1614, 491f.; Buscemi, *Notizie*, 5; Gioacchino di Marzo, *Delle belle arti in Sicilia dai normanni fino alle fine del secolo XIV*, Palermo, 1858–70, vol. 1, Palermo, 1858, 148; Demus, *Norman Mosaics*, 25.

[14] Valenti's findings have been published only in part in several short studies; in addition to "Palazzo Reale," see "L'Arte nell'era normanna," in *Il Regno Normanno: Conferenze tenute in Palermo, per l'VIII Centenario dell'incoronazione di Ruggero a Re di Sicilia*, Messina, 1932, 220ff., and "L'Arte arabonormanna," *Ospitalità Italiana*, Palermo, 1934, 19ff. There is considerably more information about the palace to be gained from Valenti's notes, of which there is a substantial holding in the Biblioteca Comunale of Palermo (especially important for the Cappella Palatina are Fondi 5 Qq E 146 and E 188).

[15] *Petri Ansolini de Ebulo, De rebus siculis carmen*, ed. Ettore Rota (=*Rerum Italicarum Scriptores*, 31, pt. 1), Città di Castello, 1904, 10, 15, 26; *Liber ad honorem augusti di Pietro da Eboli secondo il codice 120 della Biblioteca Civica di Berna*, ed. G. B. Siragusa, Rome, 1906, pls. III, IV and VII; *Liber ad honorem augusti sive de rebus Siculis, Codex 120 II der Burgerbibliothek Bern. Eine Bilderchronik der Stauferzeit*, ed. Gereon Becht-Joerdens, Theo Koelzer and Marlis Staehli, Sigmaringen, 1994, 42f.

palaces, well-set piazzas and gardens, and the ante-chambers given to officials. All this amazed our eyes and dazzled our minds, and we remembered the words of Almighty and Glorious God: "But that mankind would become one people (i.e. infidels), we would have given those who denied merciful God silver roofs for their houses, and stairways to mount them" (Koran XLIII, 33, gold and silver having no value in the sight of God). Amongst the things that we observed was a hall set in a large court enclosed by a garden and flanked by colonnades. The hall occupied the whole length of that court, and we marvelled at its length and the height of its belvederes. We understood that it was the dining-hall of the King and his companions, and that the colonnades and the ante-chambers are where his magistrates, his officials, and his stewards sit in presence.[16]

The facade that the Norman Palace now presents to the city, dour and irregular (fig. 3), belies the sense of wonder with which the text is filled (although such a response to works of art, not to mention places and events, seems to have been more typical of the medieval Muslim beholder than of the Westerner or Byzantine). At least the irregularity is explicable in purely practical terms: it reflects the basic disposition of the palace around two unequal courtyards—one to the north, the sixteenth-century Cortile della Fontana, the other to the south, the seventeenth-century Cortile Maqueda (fig. 4). Although in architectural form neither of these courtyards today is medieval, the arrangement may well represent the medieval plan, with entrances into the palace from both east and west, as today (fig. 5).[17]

On the north side of the palace stands the great bulk of the Torre Pisana (fig. 5, no. 7), its vast hall spotted here and there with the remains of mid-twelfth-century mosaics (put up in the reign of William I, Roger's son).[18] It is followed (as one moves southward along the eastern, city-side flank of the palace) by a wing that has been identified as the Joharia (and which contains the famous "Norman Stanza," also prob-

[16] Ibn Jubayr, *Travels*, 346f. In reference to the hall the author describes, two terms are used: مجلس , "majlis," or "place where people sit," and موضع غذاء الملك "mawdu' ghada' al-malik," or "place where the king eats." I would like to thank Irfan Shahid for discussing the text with me. On the author, see Umberto Rizzitano, *Storia e cultura nella sicilia saracena*, Palermo, 1975, 305ff. See also the remarks of Benjamin of Tudela, *The Itinerary of Benjamin of Tudela*, intro. Michael A. Signer, Marcus Nathan Adler, and A. Asher, Malibu, Calif., 1983, 137; Sandra Benjamin, *The World of Benjamin of Tudela: A Medieval Mediterranean Travelogue*, Madison, Wisc., Teaneck, N.J., London, 1995, 279ff.

[17] With regard to an entrance into the palace from the north side, see also Ibn Jubayr: "On leaving the castle (i.e., the Norman palace), we had gone through a long and covered portico down which we walked a long way until we came to a great church (the Cathedral of Palermo). We learnt that this portico was the King's way to the church"; Ibn

Jubayr, *Travels*, 347. Since the Cathedral was to the northeast of the palace, it is possible, but not capable of proof, that the "King's way to the church" extended from the north side of the palace. Filippo Pottino has suggested that the "Via coperta" terminated in the crypt of the Cappella Palatina; see Pottino, *La cripta della Cappella Palatina di Palermo: Storia e leggende, arte e culto*, Palermo, 1966, 8f.; Bellafiore, *La cattedrale di Palermo*, 336 n. 414. In the "Epistola ad petrum panormitane ecclesie thesaurarium," attributed to Hugo Falcandus, mention is made of a covered passage from the Torre Pisana to the archepiscopal palace—"a turre Pisana per viam Coopertam ad domum archiepiscopi, iuxta maiorem ecclesiam"; see *La Historia o Liber de regno sicilie e la Epistola ad petrum panormitane ecclesie thesaurium di Ugo Falcando*, ed. G. B. Siragusa, Rome, 1897, 181f.

[18] Ernst Kitzinger, "The Mosaic Fragments in the Torre Pisana of the Royal Palace in Palermo: A Preliminary Study," *Mosaïque: Recueil d'hommages à Henri Stern*, Paris, 1983, 239ff.

ably decorated under William I), and another which may be the Chirimbi, built by Roger's grandson, William II (fig. 5, no. 8).[19] To the south, the original Norman structures are much less visible. They consist mainly in foundations and substructures: the so-called Prigioni politiche, a block of rooms that rounds the corner of the palace to the southwest, and the Torre Greca, whose foundations lie to the southeast (fig. 5, nos. 4 and 6).[20] Scattered though they are, these structures nonetheless give some points of reference regarding the basic shape of the palace. It appears to have been roughly oval along a main axis north to south.[21] All the more striking then is the situation of the palace chapel, the Cappella Palatina: in the center of the complex athwart this axis, east to west (fig. 5, no. 1, and fig. 6).

The Cappella Palatina is usually reached by the visitor of today from the Cortile Maqueda, via a monumental stair to the west that was inserted into the palace complex in the eighteenth century (fig. 5, no. 5).[22] The entrance to the chapel proper lies on what one might call the *piano nobile* of the palace. The chapel is oriented, that is, its apse lies to the east, and on all sides it abuts other palatine structures: to the west, the early nineteenth-century Sala d'Ercole (formerly the Salone del Parlamento); to the north, a narrow filament of corridors and passageways, mostly modern, and the Cortile della Fontana (fig. 5, no. 3); to the east, the palace facade (fifteenth–seventeenth century); and to the south, a colonnade that lies along the north side of the Cortile Maqueda (fig. 5, no. 2). *In situ*, and without help from the kind of a diagram that might be found on the page of a book (such as fig. 6), the chapel is thus difficult to discern from the outside.

Once inside, however, there is no difficulty in seeing. In fact, the opposite is the case. There are so many vigorously competing points of interest that the process of selection is a strain. One enters the chapel today from a door at the southwest—either from the narthex or directly from the north flank of the Cortile colonnade—and then, from the south aisle, one proceeds into the lighter and loftier space of the nave (figs. 7, 8, and 9). One's gaze is drawn almost immediately to the nave ceiling—a magnificent wooden construction with a distinctly Islamic look (fig. 8). It is carved into a multitude of compartments with faceted sides, and gilded and painted with inscriptions, figures and scenes. To one's near left (as one faces north) looms the great throne platform of the nave, presided over by an enormous, somber figure of Christ flanked by Peter and Paul (fig. 9); to the right, in the distance (and often filled with the softer, brighter light that streams in from the eight windows in its high dome), stands the chapel sanctuary, like a Greek church partly surrounded by a high wall, and raised above the level of the nave by four steps; all around, on the walls of the nave, are the decorations in mosaic, with brilliantly colored depictions of narrative scenes and figures on a gold ground. A wainscoting of marble and porphyry, and a floor in an intricate pattern of colored stones complete the mise-en-scène. Together with the liturgical furnishings, these decorations ornament, articulate and make meaningful every bit of space.

---

[19] On the "Norman Stanza," see Demus, *Norman Mosaics*, 180ff.

[20] Valenti, "Palazzo Reale," 515ff.

[21] Ibid.

[22] Calandra and La Manna, *Palazzo*, 42, fig. I.26.

On closer examination the rationale of the parts comes into sharper focus. To the east stands the sanctuary composed of a choir surmounted by a dome on squinches (fig. 10; plate I), and flanked by transept arms (as these lateral bays have often been designated and will be so indicated here, even though their barrel vaults run parallel to the line of the aisles, rather than at right angles to them, and thus are not transept arms in the true sense of the term). The three spaces, the choir and the two transept arms, terminate in apses to the east, all of which contain altars. These spaces are also outfitted with a mosaic program in the form of a hierarchy of single figures—angels, prophets, evangelists, and saints—and scenes from the life of Christ descending from an image of the Pantokrator in the central dome. This decoration clearly derives from the Classical System of the Middle Byzantine church (fig. 11), and as such is appropriately embellished with *tituli* mostly in Greek.

The nave, on the other hand, is a longitudinal space formed by two colonnades that support highly stilted arches (five on each side) and a narrow clerestory; it is flanked by aisles to the north and south. The outer walls of the aisles are also pierced by windows (six on each side). Both of these spaces are decorated with narrative cycles—the nave, with scenes from the Old Testament, and the aisles, with scenes from the lives of the apostles Peter and Paul—themes that were well represented in the West, particularly in the basilicas of central and southern Italy. Almost all of these scenes are accompanied by Latin texts. In addition, there are other "sets" of single figures—busts of saints in the soffits of the arches, busts and figures in the apses, bishops in the spandrels of the nave colonnades, and holy women in the aisles—that are divided between sanctuary and nave essentially into Greek and Latin.

Unlike the sanctuary, which has masonry vaults, the nave and aisles are covered with wooden ceilings. The most spectacular is the ceiling of the nave, with its central compartment of twenty star-shaped panels and wide frame executed in the muqarnas, or stalactite, technique. The term *muqarnas* refers to the design of the numerous small compartments cantilevered out into space that had been invented in the Muslim world only a century or so earlier. The aisles are covered with much simpler channeled ceilings that slope downward from the nave to the outer walls of the chapel. All three ceilings are decorated with paintings of figures—drinkers, dancers, musicians and so on—and inscriptions in Arabic in Kufic script that proclaim what has been described as a string of royal epithets. They are actually more like a set of royal "conditions" announced to the viewer—"Victory," "Power," "Magnificence," "Good Fortune."

The chapel is made a functional space by the parapet walls that surround the altars and the choir, and the pulpit and paschal candelabrum at the east end of the south aisle, not to mention the great throne platform of the nave. Doors into the aisles and transept arms from the south, west and north give access to the chapel, and at the eastern end of the aisles are stairs that descend into a lower space, consisting of a chamber beneath the choir, another one beneath the nave and a set of corridors linking the two.

There is an important observation that the visitor to the Norman Palace is in a better position to make than is any reader of modern scholarship. The Cappella Palatina in Palermo is not just a building or a decoration (i.e., a mosaic program). It is an

*ensemble* of architecture and the arts created for this place in the twelfth century.[23] In fact it is one of the best preserved interior ensembles—not only of the medieval Norman Palace, but of any other structure from the Middle Ages that we know. To prove the point it is sufficient to recall an interior from any of the other churches of the Middle Ages, from the Lateran, Hagia Sophia and Notre Dame, to the parish and monastic churches of Rome, Constantinople and Paris, or indeed any of the other medieval palaces, houses or public buildings that still stand, and how thoroughly transformed they have been; how rare it is to encounter an original piece of medieval furniture, liturgical or otherwise—an altar, pulpit, icon screen or throne—*in situ*, let alone several pieces together; and how often these singular medieval elements have been overlaid with material traces of subsequent use.[24]

To understand the significance of this observation, however, one must also realize that much of what we now consider to be "medieval art" was created for just this purpose. Many if not most of the medieval objects now extant—the altarpieces and liturgical vessels, the sculptures and the paintings—are the *disiecta membra* of ensembles just like the Cappella Palatina, where they were intended to fit into a larger context that was also defined by the architecture and monumental decoration of the space. These ensembles, moreover, were also conceived of as sets of images to be conjured up in different configurations depending on one's position in the physical space of the church and place in time in the liturgical year, as a mise-en-scène for an ever-changing series of liturgical rites, ceremonies and other activities.

To grasp this point, therefore, is to begin to appreciate the unique opportunity offered by the Cappella Palatina to experience a space in much the same way that it was perceived and used in the twelfth century. It is also to appreciate the opportunity offered to historians specifically to address questions about historical use and meaning. Where else could one examine a medieval building that has been conserved to such a degree, embracing not only the decoration of ceilings, floors and walls, but also the various furnishings that made it a functioning whole? Where else, to study such a range of arts and objects in one place—each carefully conceived and skillfully executed—and to ponder the way in which these parts were related to one another, and the significance that this arrangement might have held? And where, finally, to investigate how the inside of a medieval building fit its outside within the larger context of a royal palace—a palace that was one of the most ambitious in its own day in terms of the time, attention and money that was lavished on it?

✛    ✛    ✛

[23] See the remarks of Demus, *Norman Mosaics*, 27: "Even now after much spoliation and restoration, its interior is one of the most perfect creations of the Middle Ages, only ceding first rank to the Sainte Chapelle in Paris."

[24] Graphic illustration of the point is provided for the early Christian churches of Rome in Richard Krautheimer, *Corpus basilicarum christianarum Romae*, 5 vols., Vatican City, 1937–77. In the Sicilian context, one might also note the Cathedral of Monreale, whose elaborate medieval liturgical furnishings painstakingly detailed in a late sixteenth-century description of the church have now been almost entirely stripped away; see Wolfgang Krönig, *Il duomo di Monreale e l'architettura normanna in Sicilia*, Palermo, 1965, 54ff.

In neither the general literature on Norman art nor studies on the Cappella Palatina have these issues been a point to which much attention has been paid. To be sure, there are many monographs on the chapel that purport to cover all of its major components—those of Buscemi (1840), Pasca (1841) and Boglino (1894) come readily to mind—but these tend to be older and mainly descriptive.[25] Modern studies, broadly speaking, tend to be more analytical, but they are also more narrowly focused in their approach—concentrating on the mosaics, the nave ceiling or the throne platform, for instance—even if they pay lip service to the ensemblistic character of the whole.[26] Yet it is precisely the ensemblistic character of the Cappella Palatina that makes it a critical component in the Norman Palace, and a pivotal element in our picture of the complex. The fact that this issue has not been fully explored is surprising, and one wonders why it has been so.

Part of the answer may lie in the nature of the historical record. One of the main problems with the Cappella Palatina as a medieval ensemble is that it has been restored, at times heavily.[27] Like the rest of the Norman Palace, the Cappella Palatina has remained in almost continuous use from the twelfth century, and it has been repaired, even updated with modern features as the need arose. Some of these post-medieval features were removed by Valenti, or by his predecessors in the nineteenth century who, in the wake of the romantic movement and imbued with sentiments of Sicilian nationalism, sought to reclaim an indigenous medieval past. Some of these restorations are still in place, and are recognizable because they have been "signed"— often with the coats of arms of the rulers under whom they were done (e.g., fig. 12). But other restorations are less obvious, and the problem here has been to uncover them—to determine precisely where (and often why) they occurred. Identifying original features and those that were added or changed has involved a rather painstaking effort and a variety of analytical techniques—material and stylistic. But these efforts have been only partial in the sense that they have taken on only selected aspects of the chapel (such as individual mosaics), and for the time being at least, especially given the modern role of the chapel in the city of Palermo and its place at the heart of the Regional Parliament building, one point is clear: nothing more comprehensive will be attempted or allowed. Thus in the absence of a comprehensive "archeology," doubt may well have arisen over the true nature of the Cappella Palatina as a "comprehensive" whole, and this doubt may have caused some of the most interesting questions

[25] Buscemi, *Notizie*; Pasca, *Descrizione*; Boglino, *Real Cappella*.

[26] The broadly framed studies of Ingamaj Beck, "The First Mosaics of the Cappella Palatina in Palermo," *Byzantion* 40, 1970, 119ff., and Nora Nercessian, "The Cappella Palatina of Roger II: The Relationship of Its Imagery to Its Political Function," Ph.D. diss., University of California at Los Angeles, 1981, Ann Arbor, Mich., UMI, are compromised by lack of attention to matters of chronology. See also Slobodan Ćurčić, "Some Palatine Aspects of the Cappella Palatina in Palermo," *Dumbarton Oaks Papers* 41, 1987, 125ff. and Beat

Brenk, "La parete occidentale della Cappella Palatina a Palermo," *Arte medievale*, ser. 2, 4, 1990, 135ff.

[27] With regard to the mosaics, see Demus, *Norman Mosaics*, 29ff.; Kitzinger, *I mosaici*, fasc. 1, 15ff.; fasc. 2, 15ff.; and Valentino Pace, "La pittura medievale in Sicilia," *La pittura in Italia. L'Altomedioevo*, Milan, 1994, 304ff. Essential information on the restorations is provided by Riolo, *Notizie dei restauratori*, and is contained in ms. 102 of the Archivio Capitolare of the Cappella Palatina. On the latter, see Kitzinger, *I mosaici*, fasc. 1, 17 n. 26.

about the chapel to be neglected. Suffice now to say simply this: from the point of view of the work that has been done on the chapel in individual studies of the past, particularly on the mosaics, we can frequently see how sharply delineated, clearly recognizable and often faithful to original medieval intentions the later restorations were, and when they diverged from these intentions, how, in both stylistic and structural terms, it has been possible to tell.[28]

To my mind, however, the more important problem lies in our historical point of view. The issue is complex and one to which it will be necessary to return, but first consider the words of one of the most influential modern historians on the Norman period in Sicily, Charles Homer Haskins:

> The art of the Sicilian kingdom, like its learning and its government, was the product of many diverse elements, developing on the mainland into a variety of local and provincial types, but in Sicily combined and harmonized under the guiding will of the royal court. Traces of direct Norman influence occur, as in the towers and exterior decoration of the cathedral of Cefalù or in the plan of that great resort of Norman pilgrims, the church of St. Nicholas at Bari; but in the main the Normans, in Bertaux's phrase, contributed little more than the cement which bound together the artistic materials furnished by others. These materials were abundant and various, the Roman basilica and the Greek cupola, the bronze doors and the brilliant mosaics of Byzantine craftsmen, the domes, the graceful arches and ceilings, and the intricate arabesques of Saracen art; yet in the churches and palaces of Sicily they were fused into a beautiful and harmonious whole which still dazzles us with its splendour.[29]

In one sense Haskins's assessment of the situation is undoubtedly correct. The visual culture of Norman Sicily was forthrightly synthetic in the way in which it drew upon and brought together in new combinations art forms, even artists, from different traditions with different cultural roots and affiliations, as has been demonstrated in individual studies of Norman Sicilian monuments since Haskins's day, time and again.[30] The term often used in the literature to describe the phenomenon is *hybrid* (or *mongrel*), which, although not a happy choice, is not an entirely inaccurate one. This is not to say that there are not important distinctions to be made, both in terms of Norman Sicily and of the larger Mediterranean world in the later Middle Ages, in a chronological and a conceptual sense; to a large extent the following study will be taken up with them. But to ignore the "hybrid" nature of Norman art is to miss the point.

On the other hand, we must take issue with Haskins's assessment of the role of the

[28] Kitzinger, *I mosaici*, fasc. 1, 15ff. Two studies of Ernst Kitzinger's, both concerning heavily restored portions of the mosaic surface in the chapel, well illustrate the point: "The Descent of the Dove: Observations on the Mosaic of the Annunciation in the Cappella Palatina in Palermo," *Byzanz und der Westen: Studien zur Kunst des europäischen Mittelalters*, ed. Irmgard Hutter, Vienna, 1984, 99ff., and, regarding the figure of David, "The Son of David: A Note on a Mosaic in the Cappella Palatina in Palermo," *ΕΥΦΡΟΣΥΝΟΝ. ΑΦΙΕΡΩΜΑ ΣΤΟΝ ΜΑΝΟΛΗ ΧΑΤΖΗΔΑΚΗ*, Athens, 1991, 239ff.

[29] Charles Homer Haskins, *The Normans in European History*, New York, 1915, 240f. Haskins's theme has its roots in nineteenth-century Sicilian art history; see, for example, Di Marzo, *Delle belle arti*, vol. 1, 153; Boglino, *Real Cappella*, 19.

[30] See, for example, Wolfgang Krönig, *Il duomo di Monreale*, 170; C. G. Canale, "Spazio interno nell'architettura religiosa del periodo normanno: mosaici e sculture," *Storia della Sicilia*, Naples, 1981, 127ff.

Norman patron. To argue that the Normans were simply the cement that held these different artistic strands together is to impute an essentially passive or negative role to the patrons for whom these works were made, which is also an implication often carried by the use of the term *hybrid*. Norman art is a hybrid, we infer from the literature, because Norman society itself was hybrid, and art reflects society. Such terminology begs the question—it does not explain—*why* the various elements were put together in any given situation, or what bearing they might have had on one another in the context of the whole. To call the Cappella Palatina a hybrid *tout court* is to give precedence to its "sources" at the expense of the "structure" that holds them together. To put the matter another way, it is to divide the chapel into parts—an Islamic ceiling in the nave with figures of oriental dancers, Greek inscriptions in the sanctuary, and the Roman "twins," Peter and Paul, above the great throne—to align these parts with traditions that are better known, if not more comprehensible to us from elsewhere, to the detriment of our picture of the whole. What is involved here is not only the process of selection that a historian might engage in—of one set of objects, as opposed to another, as the proper subject of study out of a more densely populated field—but also of the framing of parts, the isolation of one facet of a protean and differentiated work as the bearer of significance to the neglect of whatever else might therein be contained.

As it pertains to the medieval world, this process has often been undertaken with a mind to assimilating medieval objects to the categories and types of later art forms that are more familiar to us—icon to panel painting, for instance—with attendant distortions and falsifications. In the case of the Cappella Palatina, it has had primarily three implications: it has meant the isolation of individual images in the decoration, which have been extracted and framed as if they were works of art in their own right, rather than elements in a spatially more complex ensemble; it has meant the isolation of the various art forms and styles from one another, which have been picked apart by the specializations into which art history has come to be divided (Byzantine, Islamic, Western), absorbed into these individual streams, and virtually ignored as elements that might have bearing on one another in the construction of the whole; and it has meant the isolation of the inside of the chapel from its outside, to the extent to which it has been virtually forgotten that the Cappella Palatina does not have an outside in the normal sense of the term. It was not a freestanding and integral edifice, but an element embedded in a larger context—a room, or rather a set of rooms, not a self-sufficient building.

To visit the chapel today mindful of the scholarly literature is to be struck by how artificial these divisions and categories of analysis have been. The predominant impression is one of the overwhelming richness, even the cacophony, of forms, so that the question that most naturally arises is whether this was all intended to go together at a single blow (the *communis opinio* is that it was). The physical process of entering and exiting the chapel—in, around, up and down—although clearly only a counterfeit of the medieval experience, also drives home the fact that the edifice was not simply an isolated and elemental structure, but part of a very complicated whole.

✣   ✣   ✣

The few facts that we possess about the building history of the Cappella Palatina are well known.[31] In 1132, Archbishop Peter of Palermo conferred the parochial dignity on the chapel, "cappellam vestram in honorem b. petri apostolorum principis intra castellum superius panormitanum fundatum," thus rendering Roger's "capella privata" a "capella publica."[32] Eight years later, on 28 April 1140, the king issued a charter of foundation for the chapel (ecclesia), "intra n(ost)r(u)m regale palatiu(m), quod est in urbe Panormi," dedicated to St. Peter ("titulo beati Petri ap(osto)lor(um) principis").[33] The charter, which made the chapel the direct responsibility of the king, also endowed it with eight prebends. The next point of reference is the famous inscription at the base of the dome of the sanctuary—"ΑΛΛΟΥϹ ΜΕΝ ΑΛΛΟΙ ΤΩΝ ΠΑΛΑΙ ΒΑϹΙΛΕΩΝ . . . ," which, although fragmentary, bears a date of 1143.[34] There then follows the sermon of Philagathos, the famous homilist of the Norman court, for the feast of Sts. Peter and Paul, whose proemium contains a description of the chapel resplendent on all sides—walls, floors and ceiling—and filled with people.[35] This is one of the few extended architectural descriptions from the Middle Ages that we possess. The text was written most likely in the late 1140s or early 1150s.[36] Finally, there is a reference in the chronicle of Romuald of Salerno to mosaics and other decorations that were added to the chapel by William I, who ruled the Norman kingdom between 1154 and 1166.[37]

A plausible, if sketchy, scenario based on the foregoing data is thus possible. Roger may have had the right to build a new palace chapel in 1132, but the fact that he issued a foundation charter only in 1140 suggests that construction did not begin or was subject to some delay. Perhaps an earlier structure continued to serve the religious needs of the court (in this context Demus has cited the passage in Fazello referring to a chapel built in the palace precinct by Roger's father).[38] Perhaps the time was propitious only after Roger had resolved his quarrel with Innocent II in 1139.[39] In any

[31] For example, Guido Di Stefano, *Monumenti della Sicilia normanna*, Palermo, 1979, 37ff.; Ćurčić, "Some Palatine Aspects," 125; Kitzinger, *I mosaici*, fasc. 1, 11f.; fasc. 2, 13f.

[32] Garofalo, *Tabularium*, 7; *L'età normanna*, 36f. On the distinction between "capella privata" and "capella publica," see below, n. 76.

[33] Garofalo, *Tabularium*, 7; Carlrichard Brühl, *Rogerii II: Regis diplomata Latina* (=*Codex diplomaticus Regni Siciliae*, ser. 1, 2/1, ed. C. Brühl), Cologne and Vienna, 1987, 133ff.; *L'età normanna*, 44ff. See also C. Brühl, *Urkunden und Kanzlei König Rogers II. von Sizilien* (=*Studien zur normannisch-staufischen Herrscherurkunden Siziliens* 2), Cologne-Vienna, 1978, 89f. According to legend, Peter visited Sicily and founded the Sicilian church before he arrived in Rome; see Antonino Mongitore, *Discorso apologetico di Filalete Oreteo intorno all'origine, e fondazione della chiesa palermitana dal principe degli apostoli S. Pietro*, Palermo, 1733, esp. 22, 51ff. See also below, chapter 2, p. 65.

[34] Kitzinger, *I mosaici*, fasc. 1, 11; Guglielmo Cavallo and Francesco Magistrale, "Mezzogiorno normanno e scritture esposte," *Epigrafia medievale greca e latina. Ideologia e funzione, Atti del seminario di Erice (12–18 settembre 1991)*, ed. Guglielmo Cavallo and Cyril Mango, Spoleto, 1995, 295ff.

[35] Philagathos, "Sermon 27."

[36] Ernst Kitzinger, "The Date of Philagathos' Homily for the Feast of Sts. Peter and Paul," *Byzantino-sicula II: Miscellanea di scritti in memoria di Giuseppe Rossi Taibbi*, Palermo, 1975, 301ff.

[37] Romuald of Salerno, 254 (1166); see below, chapter 3, pp. 125ff.

[38] Demus, *Norman Mosaics*, 25. Vladimir Zorić is planning a study of the crypt of the Cappella Palatina, which he believes preexisted the main body of the present church, and may thus represent the older sanctuary called "Hierusalem."

[39] Caspar, *Roger II*, 227ff.; Chalandon, *La domination normande*, 2:88ff.

case, in 1143 construction must have been advanced enough that the mosaic decoration of the sanctuary dome was completed to the level of the inscription. By the time of Philagathos's sermon, the interior must have been finished to the point where it could be presented to the public. Specific information from Philagathos's sermon will figure in the discussion that is to follow; suffice to mention here the one feature that the author so unmistakably describes: the ceiling of the nave. He writes of it as adorned with carvings in the form of little baskets (καλαθίσκος), gleaming with gold, and imitating heaven with its "choir of stars."[40] There can be no doubt that this ceiling, which covered the nave of the chapel by the early 1150s at the latest—barring the rather clumsy restorations that it has undergone since then—is precisely the one now in place.[41]

Much of what can be seen today, including the architectural form of the chapel and major elements of its decoration, must have been executed in a single campaign under Roger II. But not all. To judge from Romuald's remarks, other decorations were added to the chapel under William I, and although the author does not specify what these might have been, his words have often been taken to refer to the mosaics of the nave and aisles.[42] The matter of these additional elements, which forms the core of chapter 2, will be taken up at a later point.

<center>✢   ✢   ✢</center>

The Cappella Palatina is a church, which means that it was built to serve the holy liturgy. From the very first document associated with it, the foundation charter of 1140, we learn that Roger II provided for the support of eight canons whose purview, among other things, must have been the performance of the liturgy in the chapel.[43] The king, furthermore, conferred the responsibility of celebrating the major feasts of the liturgical year on the abbot of the nearby monastery of S. Giovanni degli Eremiti, thus rendering him master of the chapel who was also "ex officio concillor, familiar, chaplain, and father-confessor of the King."[44] S. Giovanni was a Benedictine establishment of Roger's, and if the nature of the institution with which the celebrant was associated is an indication, these special feast celebrations were conducted in Latin, as a fragmentary twelfth-century missal now in Palermo Cathedral might also suggest.[45]

---

[40] Philagathos, "Sermon 27," 175.

[41] Trizzino, *"La Palatina"*, dissents, but unconvincingly.

[42] Kitzinger, *I mosaici*, fasc. 2, 13f.

[43] Above, n. 33.

[44] Lynn White Jr., *Latin Monasticism in Norman Sicily*, Cambridge, Mass., 1938, 128.

[45] *Missale antiquum s. panormitanae ecclesiae (Pa ASD 2: Palermo, Archivio Storico Diocesano, Cod. 2)*, ed. Francesco Terrizzi, Rome, 1970, 27ff. on the date. On the palatine liturgy, see Johannis de Johanne, *Tractatus de divinis siculorum officiis*, Palermo, 1736, 88ff. Giuseppe Maria Carafa, *De Capella regis utriusque Siciliae et aliorum principum*, Rome, 1749, 195ff. Cesare Pasca, "Miscellanea," Palermo, Biblioteca Nazionale, XII.G.2, fol. 453r ff., "Notizie sulla liturgia della chiesa palatina"; Pasca, "Intorno alla sagra liturgia della Cappella Palatina," Palermo, Biblioteca Nazionale, XIII.F.11.; Ernst Kantorowicz, *Laudes Regiae: A Study in Liturgical Acclamations and Mediaeval Ruler Worship*, Berkeley, 1946, 157ff. See also the study of Benedetto Rocco, "Il tabulario della Cappella Palatina di Palermo e il martirologio di epoca ruggeriana," *Ho Theologos*, 14, 1977, 131ff.

The possibility that the Greek liturgy was also celebrated in the chapel cannot be excluded.[46]

But the Cappella Palatina was also built to serve the king, and I could not help wondering, especially after having visited the edifice, about this royal role: surely the customary celebration of the liturgy represented only one aspect of the functional rationale of the edifice. There must have been other activities that took place here that were to account for some of the more unusual features of the chapel, particularly those that have seemed so puzzling in the past. The features that struck me at first were two. One was the grandiose throne platform in marble and mosaic placed against the west wall of the nave, by which the nave was also entirely spanned (fig. 9), and the other, the spectacular painted and gilded wooden nave ceiling of star-shaped panels and a muqarnas frame (fig. 8). There is no true parallel for either form as such—throne platform or ceiling—in the ecclesiastical architecture of Byzantium or the medieval West, and each, though in a different way, seemed at first glance to be unfathomably odd.

Given its size and imagery, especially the overlarge fastigium with the figure of Christ directly above it, there can be little doubt that the throne platform was designed to be used by the king. A problem arises only when one begins to imagine how: its twelfth-century occupant either seated or standing could hardly have been able to see the main altar of the chapel, and hence the liturgy performed there, since the barrier across the front of the chancel was once much higher than it is now; nor, on the other hand, could he have been readily seen, since to face him any visitor would have had to turn his own back to the sanctuary, which might have been felt to be a breach of etiquette in a building that was considered simply a church.[47] With regard to the ceiling, I know of no other medieval chapel or church (except one which was at least arguably constructed under the influence of the Cappella Palatina) that was covered with a ceiling so blatantly secular, I daresay pagan, in its form and decoration.[48] That this ceiling, with its drinking, music-making and dancing figures dressed in the costumes of oriental courtiers, furthermore, surmounts—directly—an entire cycle of scenes from the Old Testament rendered in the time-honored Christian medium of mosaic makes it only doubly bizarre. What functional considerations played a role in the design of these elements?

The question, of course, is not new to the discussion of the Cappella Palatina. In his study of 1949 of the sanctuary mosaics, Ernst Kitzinger suggested that the throne platform in the nave might have served for the public appearance of the king in the chapel, as opposed to his private participation in the liturgy effected through a balcony which Kitzinger reconstructed on the upper north wall of the northern transept arm.[49] Taking up this distinction, Slobodan Ćurčić then stressed the reverse focus of

---

[46] Kitzinger, "The Mosaics of the Cappella Palatina," 274 n. 29.

[47] Ćurčić, "Some Palatine Aspects," 140.

[48] The beams of the wooden ceiling in the nave of the Cathedral at Cefalù display imagery that is closely related to that on the nave ceiling in the

Cappella Palatina; see Mirjam Gelfer-Jørgensen, *Medieval Islamic Symbolism and the Paintings in the Cefalù Cathedral*, Leiden, 1986, and below, chapter 2, p. 62.

[49] Kitzinger, "The Mosaics of the Cappella Palatina," 284.

the nave away from the sanctuary—its "occidentation" toward the throne platform as opposed to its orientation toward the altar of the chapel, which made it seem more like a reception hall in the tradition of secular palace architecture than like the nave of a church.[50] Most recently, Beat Brenk has pushed the distinction even further, arguing that two places reserved for the king in the chapel—in the sanctuary and in the nave—must be seen in light of the coronation ceremony and its yearly "commemoration," or "Festkrönung," employed by the Norman kings in imitation of the German emperors. In this ceremony both the consecration of the ruler and his acclamation by the court took place in the cathedral, though in different locations.[51]

It was my impression from the beginning that all of these suggestions, and more—I have not attempted to give a full review of the literature on this point—had merit, though none of them could be proven, and none accounted for all features of the nave, especially its ceiling. A large part of the problem here has to do quite simply with the lack of documentary evidence pertaining to the use of the chapel. Although in certain sources, such as the chronicle of Alexander of Telese, we have tantalizing references to the elaborate rituals of the Norman court, Norman rulers—unlike, most notably, their Byzantine counterparts—never had these rituals set down in writing, or at least none of these records have come down to us today. Thus the precise role of a palace chapel in the life of the Norman court remains an open question. In addition, very little is known about the liturgy in Norman Sicily generally.[52] Finally, references to the chapel in contemporary literature are few and far between, so that apart from some scattered insights no coherent picture of the use of the building emerges.[53]

The more I studied the chapel, however, the more that I felt that it contained in its very fabric evidence that might serve to counter this situation, and this evidence was precisely in its extraordinary state of preservation. The Cappella Palatina has remained in almost continuous use from the time of its creation under Roger II until today, and it has been much repaired and restored. But its nave retains its medieval form to a remarkable degree; in fact, it is the best preserved ecclesiastical ensemble to have survived from the Middle Ages, encompassing the decoration of floors, walls and ceiling, the liturgical furnishings including a chancel barrier, pulpit and paschal candelabrum, and the throne platform. Furthermore, the chapel as a whole is embedded in a larger complex, the palace of the Norman kings, which, though considerably augmented and rearranged since the twelfth century, still provides more of an immediate context than we have for nearly any other medieval chapel or church. It struck me that the various features of the nave had often been studied individually or in groups, but they had never been investigated as a whole and in relationship to the sanctuary and to the palace complex, in other words, as a functional arrangement in its totality, which was precisely where I felt a rationale for the edifice might be most clearly revealed.

---

[50] Ćurčić, "Some Palatine Aspects," 140ff.

[51] Brenk, "La parete," 135ff. See also the related study by the same author: "Zur Bedeutung des Mosaiks an der westwand der Cappella Palatina in Palermo," *Studien zur byzantinischen Kunstgeschichte.*

*Festschrift für Hörst Hallensleben zum 65. Geburtstag,* ed. Birgitt Borkopp et al., Amsterdam, 1995, 185ff.

[52] Above, nn. 43–46.

[53] Below, chap. 2, passim.

But my attempt to look at the nave of the chapel as an ensemble only highlighted a problem that one had to face in examining any aspect of it, namely, chronology. Thanks largely to the work of Demus and Kitzinger, who were responsible for defining the scope of the question and suggesting much of the solution, the chronological problems of the mosaics of the chapel have become well known. But almost every other element of the chapel—the throne platform in the nave, the pulpit and paschal candelabrum, the chancel barrier, not to mention doors and windows, floors and ceiling, and the narthex—has also been disputed in one way or another, claimed alternately as an original work of the founder of chapel, King Roger II, or a later addition by his son or grandson, or even later still. The problem of chronology, of course, is a very serious one for an understanding of an individual form, particularly as the example of a type that had a tradition and development outside of the chapel itself (e.g., the paschal candelabrum). Even more so, it has a critical importance for an understanding of the functioning of the whole. To consider the pulpit later rather than earlier, for instance, at least potentially changes the set of relationships in the chapel at a given moment, and it is precisely upon these relationships that our understanding of the use of the structure must be based.

One solution to the problem is to assume that even if its constituent elements were executed over years or even decades, the chapel nonetheless was planned as a whole from the very beginning under Roger II. In fact, with few exceptions this has been the prevailing view; recently, it has been emphatically restated in two studies that have been concerned with the "program" of the chapel—Brenk's article mentioned above and Eve Borsook's monograph on Norman mosaics.[54] But it will not be the view held here, primarily because of the discrepancies in the structure that will be discussed.

To adduce a principle of discrepancy, or a lack of coherence or fit within the context of the Cappella Palatina, requires some explanation. The chapel is perhaps best known in the scholarly literature as a "hybrid." Architectural historians, for example, have often spoken of the building as the union of a centrally planned sanctuary based on the form of a Middle Byzantine church and a basilican nave of Western derivation.[55] The decorations of sanctuary and nave, moreover, seem to reinforce this distinction: the sanctuary, with its central image of the Pantokrator and descending hierarchy of angels, saints and narrative scenes, being more "Eastern," and the nave, with its narrative cycles from the Old and New Testaments, being more "Western." Add to this an Islamic component in the ceiling of the nave, and Greek, Latin and Arabic inscriptions, and the result is a heterogenous mix indeed. In a certain sense, it is thus possible to think of the Cappella Palatina as a concatenation of "discrepancies."

What I mean by *hybrid*, however, is much more mundane: it is essentially a lack of fit of a different sort—an actual physical incongruity—that reveals, as I shall argue here, a change of plan that took place in the twelfth century. That such changes occurred in

[54] Brenk, "La parete"; Eve Borsook, *Messages in Mosaic: The Royal Programmes of Norman Sicily 1130–1187*, Oxford, 1990, 17ff. and Borsook, "Messaggi in mosaico nella Cappella Palatina di Palermo," *Arte*

*medievale*, ser. 2, 5, 1991, 31ff.

[55] Krönig, *Il duomo di Monreale*, 169ff.; Ćurčić, "Some Palatine Aspects," 126.

the chapel in more recent times has already been demonstrated by Kitzinger for the sanctuary.

One of Kitzinger's main achievements in his study of 1949 was to demonstrate the dual nature of the mosaic program of the sanctuary of the chapel in the degree to which it both adhered to and diverged from the Byzantine prototype. The mosaics of the sanctuary are Byzantine-derived primarily in their overall composition and choice of subjects—in the placement of an image of the Pantokrator in the apex of the central dome, in the descending rows of angels, prophets, evangelists and saints, and in the narrative scenes of Christ's life (figs. 10 and 11). The program diverges from Byzantine precedent most dramatically, however, in the crowding of the christological scenes on the south wall of the southern transept arm (fig. 13) which, together with other elements such as the group of warrior saints on the north side of the northern arch separating the chancel from the northern transept arm, suggested, as Kitzinger argued, a privileged point of view from the north. But from where and of whom?

To answer these questions Kitzinger then turned to evidence concerning the state of the north wall of the northern transept arm. Until the late 1820s this wall had been covered by a massive and purportedly extremely unattractive double wooden tribune made for the Spanish viceroys (upper part, built 1621–1665) and the Bourbon court (lower part, built 1798–1799) respectively ("due palchi di disgustosa apparenza").[56] When the tribune was removed in 1838, an opening 11 palmi wide and 10 palmi high (2.46m × 2.23m) was discovered behind it in the present window zone of the north wall—an opening, according to the report of Cesare Pasca, that was a medieval (i.e., original) Norman feature of the chapel.[57] This opening, in turn, gave onto a space that must have communicated with the wing of the palace to the north, or, in other

[56] Pasca, *Descrizione*, 100, as quoted below, n. 57. One of the few visual records of this structure is to be found in Paris, Bibliothèque Nationale, Cabinet des Estampes, U6236, L. Dufourny, vol. VI, "Notes rapportées d'un voyage à Sicile," folder labeled "Edifices di Palerme XIIe siècle"; Kitzinger, *I mosaici*, fasc. 1, fig. E. See also Trizzino, "*La Palatina*", fig. 3, where the structure is partly visible in a not altogether accurate view of the chapel dated to 1823.

[57] Pasca, *Descrizione*, 100:

Furono inoltre rimossi dall'interno della regia cappella per ridurla alla sua primitiva semplicità, due palchi di disgustosa apparenza, uno più piccolo nella metà superiore del muro della Cappella del Sacramento, che servia per gli antichi vicerè, e inferiormente un altro più grande per uso della regal corte. Quest'ultimo era tutto di legno ricoperto di velluto rosso con frange d'oro, era attaccato alla parete ove sono rappresentate le figure di alcuni santi della chiesa, e protraevasi fino al muro, che forma spalliera agli stalli del coro. *Nel palchetto superiore ch'era tutto di legno fu ritrovato un arco acuto murato, era*

*largo undici palmi, ed alto dieci; essendo stato riconosciuto quest'arco di epoca primitiva per alcuni segni non fallaci, si congettura che potea essere un arco d'ingresso al palchetto da servire alla regal corte normanna, quando volea intervenire alle sacre funzioni del tempio, tanto più che non troviamo alcun luogo in esso che ci possa far credere d'essere stato adatto a tal uso. Fu ordinato da S.M. d'ingrandirsi quest'arco per servir come palco per la regal corte. Al lato sinistro dell'arco medesimo è stato poco fa portato a compimento un quadro a musaico, che rappresenta la predicazione di S. Giovanni nel deserto esequito sopra il cartone del sig. Rosario Riolo; forma continuazione al rimanente del musaico del lato opposto fatto ai tempi del Cardini, ove vedesi una boscaglia col bastone di S. Giovanni con lo scritto ecce Agnus Dei. Si pretese dagli artisti con somma imperizia di rappresentare in questo musaico il deserto, e vi fecero appartenere un'antica figura di S. Giovanni, che per caso ritrovavasi nel muro vicino; ma quella figura non è in nessuna maniera adatta per quella rappresentazione* [italics mine].

words, with the zone that included the private living quarters of the king (figs. 14 and 15).[58] These facts of the physical environment, taken together with the evidence of the mosaics of the sanctuary suggested to Kitzinger one explanation above all: that the north wall of the northern transept arm originally contained a balcony from which the king himself could view the liturgy and around which the entire mosaic decoration of the sanctuary was contrived. It is a compelling argument, and although it has not found unanimous acceptance, no decisive evidence to the contrary has ever come to light.[59]

Kitzinger's study offered two main points of assistance to the present endeavor. It demonstrated, in a clear and cogent way, the value of a close examination of the physical condition of the chapel, always with an eye to possible changes and re-

---

[58] Antonino Mongitore, "Dell'istoria sacra di tutte le chiese, conventi, monasteri . . . ," Biblioteca Comunale, Qq E4, 21: "In fronte all'altare maggiore, a piè della chiesa vi ha il solio reale, ove assistevano i Re di Sicilia ai divini uffici, oggi da Vicerè usato, da musaico, porfidi, serpentine rarissime e pietre preziose composto. Costumavan pure assistere i Re privatamente, senza discendere nella Chiesa, da un balcone che si vede in essa chiesa, che ha communicazione con le camere reali." See also Aloysius Garofalo, Palermo, Biblioteca Nazionale, XII.G.1, fol. 144v. Valenti, "Palazzo Reale," 516ff., and esp. 519 on the king's access to the Cappella Palatina from the north. Kitzinger, "The Mosaics of the Cappella Palatina," 284 and n. 87.

That the Torre Pisana in particular functioned as a keep is clearly indicated by the reference in the Chronicle of Romuald of Salerno to the events of 9 March 1163, when the royal palace was invaded and sacked by rebels who made the king and his family prisoners in the Torre Pisana, from a window of which they called for help: "Rex autem huius rei nescius et ignarus et de tam repentino casu attonitus, ad fenestram turris Pisane venit, et quosque transeuntes cepit ad suum auxilim conuocare"; Romuald of Salerno, 246.

The clearest picture of the function of the palace, albeit from the later twelfth century, is presented in the "Epistola ad petrum panormitane ecclesie thesaurarium," attributed to Hugo Falcandus, in which mention is made of the treasury in the Torre Pisana and the Joharia as a place of royal relaxation and the residence of women, children and eunuchs; see La Historia o Liber de regno sicilie, ed. G. B. Siragusa, Rome, 1897, 177ff.

[59] Trizzino, "La Palatina", 35, dissents, adducing the report of Valenti regarding the discovery of fragments of two window frames embedded in the upper zone of the north wall, essentially corresponding in size to the two windows in the same zone on the wall opposite (south wall of the south-

ern transept arm). In the opinion of the architect, these frames exclude the possibility of a royal loge on the north wall in Norman times because they were broken into by the larger opening in between them. For the Valenti report, see Palermo, Biblioteca Comunale. 5 Qq E146, nos. 36 (18 October, 1928), 44l' (and l"), and 5Qq E146, no. 28, photo no. 10 ("muro nord del presbiterio con le finestre antiche vandalicamente deturbate ed ostrutto con fabbriche moderne").

The upper portions of the two window frames are still visible on the exterior of the north wall of the northern transept arm, the surface of which, however, has been entirely restored. Both Valenti and Trizzino appear to be unaware of Pasca's report cited in n. 57 and of the fact that the present opening on the north wall was created in 1838. This opening, as rendered on the measured drawing of Terzi, is 3.04 m wide and 1.95 m high. The opening that Pasca described, however, was considerably narrower, since 11 palmi = 2.46 m. As such it would have been fully compatible with the two windows of Norman date. In any case, such frames in and of themselves could never be taken as proof of Trizzino's conclusion; see, for example, Maria Andaloro et al., I mosaici di Monreale: restauri e scoperte (1965–1982). XIII Catalogo di opere d'arte restaurate, Palermo, 1986, esp. 47ff., regarding changes in the windows of the cathedral between the time the walls were constructed and the mosaic decoration was put up. The reconstruction of fig. 15 in the present study represents the attempt to render the Norman opening in the wall according to the measurements given by Pasca, together with the documents of Valenti in the Biblioteca Comunale cited above, which record the position of the two windows flanking the present opening in the upper story of the wall. See also the discussion of Ingamaj Beck, "The First Mosaics of the Cappella Palatina in Palermo," Byzantion 40, 1970, 127ff.

arrangements that the chapel might have undergone, and it showed precisely how such changes might be perceived and understood. Given the supreme importance of the Cappella Palatina, not only as a historical monument but also as a functioning church and one of the most popular matrimonial chapels in Palermo, an archeological investigation disrupting daily services in order to settle problems of structure and date seems now unfortunately to be out of the question. What can be done, however, is precisely what Kitzinger accomplished: to read what is available to the eye closely, to coordinate this reading with the information contained in earlier descriptions of the Cappella Palatina and in restoration documents and reports, most notably those of Valenti, and to attempt to place the picture that emerges from these sources within the context of the decoration of the chapel as a whole. This method, the archeology of the standing building, will also be employed in this work.

But Kitzinger also demonstrated most clearly something that nearly everyone who has taken a close look at the chapel has sensed, namely, the degree to which the sanctuary of the Cappella Palatina is separate from the nave. This separation was not simply a result of different architectural or pictorial "sources"; it must have been due to functional divide which we may now express in the following terms: the primary functional axis of the nave must have lain along the primary visual axis, which was also the primary longitudinal axis of the chapel, that is, the east-west axis; however, the primary functional axis of the sanctuary was north-south, that is, the royal axis that included the view of the king. In other words, sanctuary and nave were set at right angles to one another functionally speaking, which, in turn, presumes separate rather than unified activities. It is this separation that provides one basis for a close examination of the nave, in which, of course, a relationship with the sanctuary will figure.

✠   ✠   ✠

It might be useful to situate, at least in a preliminary way, Roger's chapel—the "ecclesia . . . intra nostrum palatium regale" (Foundation Charter)[60]—in the long line of the palatine chapels of the Middle Ages to which it so clearly belongs. Unfortunately, no attempt has ever been made to take up the more general questions of the history and development of the palatine chapel as a form, or even to determine whether such questions are appropriate, and so on a certain level our picture must remain rather sketchy.[61] Certain scholars claim that the tradition began in late antiquity, perhaps with Constantine himself, as witness the so-called Golden Octagon, the great church of Antioch, which may have been part of the imperial palace (though this is also in dispute).[62] The Christian ruler's palace chapel may have been adumbrated in the pre-Christian ruler's cult shrine or temple, such as the temple of Apollo on the Palatine

[60] Garofalo, *Tabularium*, 7; Brühl, *Urkunden*, 89.

[61] André Grabar, *Martyrium. Recherches sur le culte des reliques et l'art chrétien antique*, Paris, 1946, 1:559ff.

[62] A. Grabar, *Martyrium*, 1:560; Richard Krautheimer, *Early Christian and Byzantine Architecture*, 4th ed., New Haven, 1986, 75ff. and esp. nn. 19 and 22.

See also, Alfonso Bartoli, "Scoperto dell'oratorio e del monastero di S. Cesario sul Palatino," *Nuovo Bollettino di Archeologia Cristiana*, 13, 1907, 191ff.; Josef Deér, "Die Vorrechte des Kaisers in Rome, 172–800," *Schweizer Beiträge zur allgemeinen Geschichte*, 15, 1957, 24f.

Hill in Rome next to the House of Augustus, where rituals were performed for the benefit of the ruler.[63] Such functions, it is interesting to observe, are to be associated with the palace chapel—though obviously in a Christian sense—from the very first unambiguous mention of the structure in the early Middle Ages by Paul the Deacon, with regard to the Pavian palace of the Lombard king Liutprand (712–44): "Inside his palace he built a chapel of S. Salvatore, and installed priests and clerks to sing the holy office for him daily, which at that time no other kings had."[64]

From the mid-eighth century onward, palace chapels became widely diffused in both Western and Eastern realms, in a variety of forms, and in different palatine contexts.[65] One example is the chapel of ca. 800, which now stands almost in its entirety in Aachen, that was built by Charlemagne as a component of his palace, part of which he called the Lateran (fig. 140).[66] The edifice itself is centrally planned (it is also an octagon), with a gallery where the ruler's throne was located and an altar dedicated to Christ; on the ground floor there was an altar dedicated to the Virgin. After Aachen, the double story arrangement was taken up in other places, and especially in Germany and France.[67] The question as to whether the Byzantine emperor had a palace chapel like the Western ones at Aachen or Palermo, for instance, remains open.[68] The church of H. Sergios and Bakchos has been described as the palace chapel of the Hormisdas Palace, and the Virgin of the Pharos (St. Mary's of the Lighthouse), the main chapel of the Great Palace of the Byzantine emperors in Constantinople.[69] According to the sources, however, there were other churches in the precinct of the Great Palace as well. Many of the crusaders' castles were outfitted with

[63] Paul Zanker, *Augustus und die Macht der Bilder*, Munich, 1987, 73ff., 90ff.

[64] Ward-Perkins, *From Classical Antiquity*, 168. See also Günter Bandmann, "Die Vorbilder der Aachener Pfalzkapelle," *Karl der Grosse*, vol. 3, *Karolingische Kunst*, Düsseldorf, 1965, 424ff.

[65] Inge Hacker-Sück, "La Sainte-Chapelle de Paris et les chapelles palatines du moyen age en France," *Cahiers Archéolgiques* 13, 1962, 217ff.; Josef Fleckenstein, *Die Hofkapelle der deutschen Könige, II: Die Hofkapelle im Rahmen der ottonisch-salischen Reichskirche* (=*Schriften der Monumenta Germaniae Historica*, 16, II), Stuttgart, 1966; Hans Belting, "Studien zum beneventanischen Hof im 8. Jahrhundert," *Dumbarton Oaks Papers* 16, 1962, 141ff., esp. 175ff. (St. Sophia, Benevento); Percy Ernst Schramm, "Hofkapelle und Pfalzen," in *Beiträge zur allgemeinen Geschichte: Dritter Teil, Vom 10. bis zum 13. Jahrhundert*, Stuttgart, 1969, 135ff.; Meier, *Die normannischen Königspaläste*, 97ff.

[66] Wolfgang Schöne, "Die kunstlerische und liturgische Gestalt der Pfalzkapelle Karls des Grossen in Aachen," *Zeitschrift für Kunstwissenschaft* 15, 1961, 97ff.; Felix Kreusch, "Kirche, Atrium und Portikus der Aachener Pfalz," *Karl der Grosse*, vol. III, *Karolingische Kunst*, Dusseldorf, 1965, 463ff.; Schramm,

*Kaiser, Könige und Papste*, 206ff. Falkenstein, 'Lateran'.

[67] See below, n. 76. O. Schürer, "Romanische Doppelkapellen," *Marburger Jahrbuch für Kunstwissenschaft* 5, 1929, 99ff. Grabar, *Martyrium*, 1, 577. Hacker-Sück, "Sainte-Chapelle," 222ff. The Palatine Chapel at Aachen was also a model to be emulated, as, for example, in the late-eleventh-century chapel of Robert of Lorraine in the episcopal palace at Hereford: "ecclesiam tereti edificavit scemate, Aquensem [Aachen] basilicam pro modo imitatus suo" (Otto Lehmann-Brockhaus, *Lateinische Schriftquellen zur Kunst in England, Wales und Schottland von Jahre 901 bis zum Jahre 1307*, vol. 1, Munich, 546 n. 2047); see *Royal Commission on Historical Monuments, Herfordshire*, I, London, 1931, 115ff.

[68] Cyril Mango, *Byzantine Architecture*, New York, 1976, 89f.

[69] Grabar, *Martyrium*, 1:563 (Virgin of the Pharos). One indication of the eminence of the Pharos church is the collection of icons and relics that it had in its possession; see Jean Ebersolt, *Sanctuaires de Byzance*, Paris, 1921, 23ff. On Sergios and Bakchos, see Krautheimer, *Early Christian and Byzantine Architecture*, 224 n. 22, with discussion of the literature.

chapels, and as time went on, chapels became customary in noble houses or in those of wealthy men (e.g., Arena Chapel, Padua).[70] The palaces of ecclesiastical officials also had chapels (Ravenna), as did the pope himself in his various ancillary residences (Viterbo), and in the Lateran in Rome (the Cappella S. Lorenzo, or the Sancta Sanctorum).[71] There is thus considerable diversity to the palace chapel when viewed in extended hindsight, but in three respects the Cappella Palatina may well have been unusual, if not unique.

First is siting. There seems to have been no fixed principle regarding the location of a chapel within a palace complex. A chapel could be situated along one of the sides of a palace building, or above an entrance or in the middle of a court.[72] On the other hand, the Norman palace in Palermo seems to be the only case prior to the mid-twelfth century in which the chapel is located in the center of the palace, indeed in which it formed the palace center in a most decisive way: as the element linking two ancillary groups of buildings or courtyards to the north and south. That the northern section of the palace served as the private living quarters of the king may be inferred from the sources.[73]

Second is access. It was not common before the Cappella Palatina to have the main public entrance to the chapel at a corner of the nave or on the long side of the edifice. The question of access is one to which we shall return. Suffice to say here that the present entry pattern only distantly resembles the one that originally pertained. The narthex of the chapel as a vaulted space was probably added only under William II (1166–89), as Valenti has argued. Valenti has reconstructed a monumental stair at the northwestern corner of the south cortile, which is generally considered to have been the main public portion of the edifice (fig. 16).[74] This entrance would have been for visitors to the chapel other than the king, who would have ascended the stair and proceeded into the chapel through the large door at the western end of the south aisle, or through the two doors from the narthex flanking the great throne platform of the nave. There is no physical evidence to prove that Valenti's stair once existed, but it is plausible. Palatine chapels elsewhere, on the other hand, as well as other chapels and churches, were usually entered on axis, at least as far as the main public entrance was concerned.[75]

Third is position. Finally there is the question of the raised position of the chapel. Palatine chapels, particularly in the period after Charlemagne's palace at Aachen, could be equipped with either a gallery or a full second story, and this arrangement

[70] *Giotto and the Arena Chapel Frescoes*, ed. James Stubblebine, New York, 1969; Robert H. Rough, "Enrico Scrovegni, the *Cavalieri Gaudenti*, and the Arena Chapel in Padua," *Art Bulletin* 62, 1980, 24–35. See also Karl Heinz Clasen, "Burgkapelle," *Reallexikon zur deutschen Kunstgeschichte*, vol. 3, Stuttgart, 1954, 221ff.

[71] For Ravenna, see Friedrich Wilhelm Deichmann, *Ravenna: Hauptstadt des spätantiken Abendlandes*, vol. 1, *Geschichte und Monumente*, Wiesbaden, 1969, 201ff.; vol. 2, *Kommentar, 1. Teil*, Wiesbaden, 1974, 198ff. For the Lateran, see Ph. Lauer, *Le*

*palais de Latran: Etude historique et archéologique*, Paris, 1911, passim. See also Charles Seymour, Jr., *Notre Dame of Noyon in the Twelfth Century*, New Haven, 1936, 63 (episcopal chapel dated 1183), and below, chap. 4, n. 34 (archepiscopal chapel, Schwarzrheindorf, mid-twelfth century).

[72] Gardelles, "Le palais" (above, n. 2), 125ff.

[73] See above, n. 58.

[74] Valenti, "Palazzo Reale," 519ff., and 520 with reference to a passage in the "Epistola ad petrum panormitane ecclesie thesaurarium," 180.

[75] But see also below, chapter 2, n. 146.

could have both a symbolic and functional rationale.[76] But there were also many cases of single-story chapels in the Middle Ages, or chapels that were simply rooms of buildings that were otherwise devoted to other purposes. But the Cappella Palatina in Palermo does not fit any of these models. The main body of the chapel is raised above the ground by a substructure that does not constitute a lower story in the true sense of the term (fig. 17). Its internal space—a small apsed chamber of three bays under the sanctuary, to which was added later (probably under William I) another small chamber under the nave—is neither coincident with the main body of the chapel in extent nor a functioning part of the main chapel space.[77] In other words, it does not relate to the "upper story" as a "lower story" would in other palatine cases. It is now accessible from the main body of the chapel only through two narrow stairs at the eastern ends of both aisles as if it were a crypt. It is articulated architecturally like a crypt, with low vaults, and so perhaps may be thought of as a raised crypt, brought above ground to elevate the main chapel space.[78]

However, one observation makes the problem more complicated, and potentially more interesting. It has recently been suggested that the cryptlike substructure of the Cappella Palatina does not belong to the same period as the main body of the chapel but predates it, as a piece of the palace that preexisted the building of Roger II.[79] Although it remains to be seen whether this view is borne out in the further archeological examination necessary to resolve the issue, it is interesting to observe that the parapet wall around the north aisle stair (and perhaps even the north aisle stair itself) was not an original feature of the Rogerian building, but a later interpolation.[80] This is opposed to the south aisle parapet and by implication the south aisle stair, which, to every indication, are Rogerian in date. Thus it would appear that the symmetry now apparent in the chapel in this regard is a fiction, at least as far as the Rogerian building is concerned: access to the lower space from the main body of the chapel may well have been gained originally not through both aisles equally, but (mainly?) through the south stair in the south aisle. While this asymmetry may not have a direct bearing on the date of the cryptlike substructure of the chapel, it does not contradict a view of this substructure as the relic of a previous architectural mise-en-scène of the palace, as has been proposed.

If these aspects of the Cappella Palatina thus distinguish the chapel from ecclesiastical structures in other palatine contexts, they also bring it into an association with a different genre of palatine architecture, namely, the monumental or great hall with which so many medieval palaces were endowed.[81] The great hall was often used as a throne room or audience chamber, but it was semi-independent in form.[82] In this case

---

[76] Günter Bandmann, "Doppelkapelle, -kirche," *Reallexikon zur deutschen Kunstgeschichte*, vol. 4, Stuttgart, 1958, 196ff., esp. 204ff., regarding distinction between "capella privata" and "capella publica."

[77] Cf. Ćurčić, "Some Palatine Aspects," 126ff.

[78] See also the discussion below, p. 152.

[79] See above, n. 38.

[80] See chapter 2, n. 38.

[81] Gardelles, "Le palais" (above, n. 2), 124ff.;

Tancred Borenius, "The Cycle of Images in the Palaces and Castles of Henry III," *Journal of the Warburg and Courtauld Institutes* 6, 1943, 40ff.

[82] *The History of the King's Works*, vol. 1, 42ff., esp. fig. 9 ("Comparative Plans of Great Halls in England and on the Continent"); Randolph Starn and Loren Partridge, *Arts of Power: Three Halls of State in Italy, 1300–1600*, Berkeley, 1992, 1ff.

too, however, there has been no historical synthesis of the material, and so only certain general observations are possible: like chapels, great halls can trace their lineage to antiquity; they were widely diffused in the Middle Ages; and they took on a variety of forms. The halls at Viterbo, in the papal palace, and Westminster, in the royal palace, evoke the range of the structures involved.[83]

In the context of the Cappella Palatina, there are certain characteristics of at least a subgrouping of these halls that are particularly worthy of note: that they are centrally located within the palace complex; that they are raised above ground level on a sub-structure that does not constitute in any real sense a lower story; and that they are entered on the long side, via a monumental staircase, at either end. Like the nave of the Cappella Palatina, too, these structures were often roofed in wood. The extent to which this is a valid connection in historical terms—that these strands were recognized as such and were consciously brought together by the architects of Roger's chapel—remains to be determined.

✛  ✛  ✛

It is appropriate to conclude these introductory remarks by expressing one of the intentions of this study to which I have already alluded: to argue that the Cappella Palatina was actually furnished in two very different ways in the twelfth century—one of them under Roger II when the chapel was first built, and the other under Roger's successors William I and William II; that these two solutions served different functions and had different meanings; and that investigating each in turn will add a new dimension to our understanding of the edifice as a whole.[84] The point of the following investigation will be to establish these differences and to explain their significance. It will thus be divided into two parts: the first will treat the evidence of the building itself in order to reveal the presumptive change, and the other will interpret the results in terms of sources that are to a great extent outside of the Cappella Palatina.

In addition to reassembling the pieces of the Cappella Palatina that have traditionally been thought of in separate terms, the other methodological goal of this endeavor will be to investigate the chapel as a specific case in the following sense. There has been much work done recently on the social and political framework of medieval art, and on the forces of society and the state that shaped this art. Our picture of "context" has thus been sharpened, and there has been a considerable gain in our understanding of the social framework of art production and consumption, of the implications for art of political structures and ideological change, of art patronage and function, even of the role of gender in the making and using of art. But such insights have tended to take the form of generalizations, and to be expressed in terms of movements and forces that are larger than any individual, monument or site. What has not emerged as clearly is the quality of the specific historical moment in time and

[83] Gary Radke, *The Palazzo dei Papi in Viterbo: Profile of a Thirteenth-Century Papal Palace*, Ph.D. diss., New York University, 1980.

[84] Both Demus, *Norman Mosaics*, 58, and Beck,

"The First Mosaics," 125, stress changes in the "program" of the Cappella Palatina, but only with regard to the mosaic decoration.

place. It is precisely this quality that this study seeks to define. Thus I have concentrated my attention on a single edifice, and have sought to give equal weight to both the building itself as a material form and to the life that it may have been intended to serve, which brings me to my final point. Wherein lie the traces of this life? It is to be detected most clearly, I shall contend, in the humblest parts of the building, and the most often overlooked, in its floors, and in the arrangement of its doors, in its furnishings and in the revetments of its walls. These are the "various ornaments" that Romuald of Salerno referred to when he spoke about the features of the chapel owed to Roger II: "Interea rex Rogerius, qui tempore pacis et belli otiosus esse nescivit, regni sui pace et tranquillitate potitus, Panormi palatium satis pulcrum iussit edificari, in quo fecit capellam miro lapide tabulatum, quam etiam deaurata testudine cooperuit, *et ornamentis variis ditavit pariter et ornavit.*"[85] In them, I shall argue, we have the most important clue as to the actual form of the chapel as it was first constructed under King Roger, and to its meaning and use.

[85] Romuald of Salerno, 232.

# 2

# New Dates and Contexts for the
# Decorations and Furnishings
# of the Chapel

In order to trace the development and use of the Cappella Palatina in the twelfth century (which is the goal of chapter 3) it will be necessary first to identify the main constituent elements of its decoration and furnishing: this chapter will thus be a series of case studies, divided into two parts. The first will treat the features of the chapel that are argued to have belonged to the time of Roger II, and the second, the elements that were added after his death, in the later twelfth century. The results shall then be used to map, insofar as it is possible, a chronology for the outfitting of the chapel from its origins under Roger II through the reign of William II. In this regard, three considerations will prove crucial: the structure itself, and how the various pieces fit together; the form of the different elements—their style, their iconography, and the methods or techniques by which they were made—and their relationship to other relevant objects elsewhere (although regarding liturgical furnishings of the twelfth century it should be emphasized at the outset that there are still a great many unknowns); and finally, contemporary descriptions of the chapel as in the Chronicle of Romuald of Salerno, the "Epistola ad petrum panormitane ecclesie thesaurium" attributed to Hugo Falcandus, and in the proemium of Philagathos's sermon on the feast of Sts. Peter and Paul.[1] The latter is especially important because of its detailed nature, and although it was written as a homily, its factuality with regard to the chapel can hardly be doubted.

Two significant points of chronology have already been discussed, though perhaps they should be reiterated here. One concerns the building itself. To all appearances the construction of the Cappella Palatina was not a protracted affair; on the contrary,

---

[1] Romuald of Salerno, 232, 254. *La Historia o Liber de regno sicilie*, ed. G. B. Siragusa, 180. Philagathos, "Sermon 27," on the date of which see Ernst Kitzinger, "The Date of Philagathos' Homily for the Feast of Sts. Peter and Paul," *Byzantino-Sicula II:* *Miscellanea di Scritti in Memoria di Giuseppe Rossi Taibbi*, Palermo, 1975, 301ff. See also Bruno Lavagnini, *Profilo di Filagato da Cerami con traduzione della Omelia XXVII pronunziata dal pulpito della Cappella Palatina in Palermo*, Palermo, 1992.

it seems to have been handled with dispatch, beginning probably in the late 1130s, and apart from the few, though important, changes that will be described more fully at the appropriate time, the building's structure (i.e., its columns, floors, ceilings and walls) stands today much the way it was built under Roger II (the functional and decorative apparatus is a different story, as we shall see). The other point concerns the mosaics of the sanctuary. Again, apart from the few changes that will be noted (and that have already been observed by others), there is no reason to depart from the chronology that has been proposed: that work on the sanctuary mosaics began in the early 1140s in the apex of the dome, as indicated by the inscription at the dome base, which yields a date of 1143, and then progressed downward and outward, to reach at least the outer limit of the sanctuary by the mid-1150s, or around the time of Roger's death in 1154.

## ORIGINAL FEATURES

*The Pavement*

Curiously enough, the pavement of the Cappella Palatina has never been the subject of a detailed examination nor has it ever been fully published, even though it constitutes one of the best preserved twelfth-century floors known.[2] It belongs quite clearly to the regional subset of the opus sectile genre of southern Italy and Sicily. The opus sectile floors of this region, however, have not been scrutinized with the same care as those of Rome and Latium, and so the following remarks can only be considered a preliminary formulation of the problem with the goal of establishing one main point: that the pavement of the Cappella Palatina through sanctuary, transept arms, nave and aisles is a single, coherent entity that was laid at one time when the chapel was first built.

The pavement is rendered almost entirely in opus sectile, that is, in a variety of colored stones cut in circular, triangular and square shapes fitted together to form the geometric designs that were ubiquitous in the liturgical arts in Italy in the later Middle Ages. In this case, the overall design consists of a series of panels—a single large panel under the dome of the choir (fig. 18), two in each of the transept arms (fig. 19), four in

[2] The pavement of the Cappella Palatina has never been reproduced photographically in its entirety. For a rendering of the design, see Domenico lo Faso Pietrasanta duca di Serradifalco, *Del duomo di Monreale e di altre chiese siculo normanne ragionamenti tre*, Palermo, 1838, p. xv (cited hereafter as Serradifalco). This rendering also appears in Theodor Kutschmann, *Meisterwerke saracenisch-normannischer Kunst in Sicilien und Unteritalien*, Berlin, 1900, fig. 8; Max Zimmermann, *Sizilien II: Palermo*, Leipzig, 1905, fig. 36; and Hiltrud Kier, *Der mittelalterliche Schmuckfussboden*, Düsseldorf, 1970, fig. 337. Individual panels of the pavement are illustrated in Andrea Terzi, *La Cappella di S. Pietro nella Reggia di Palermo*, Palermo, 1889, pls. XXIV and XXV. The pavement is discussed by Demus, *Norman Mosaics*, 28f.; Dorothy Glass, "Studies on Cosmatesque Pavements," Ph.D. diss., Johns Hopkins University, 1968, 101ff. and idem, *Studies on Cosmatesque Pavements* (=*British Archaeological Reports, International Series* 82), Oxford, 1980, 4; and Lorenza Cochetti Pratesi, "In margine ad alcuni recenti studi sulla scultura medievale nell'Italia meridionale: II. Sui rapporti tra la scultura campana e quella siciliana, III," *Commentari* 21, 1970, 264ff.

each of the aisles (fig. 20; plate II) and three in the nave (fig. 21)—separated from one another by bands of white marble and narrow opus sectile strips. Within the panels themselves the dominant motif is a group of disks in porphyry or serpentine breccia, surrounded by interlace patterns that divide into two types: with curved or angled strips. Curvilinear patterns predominate in the sanctuary and the south aisle; rectilinear, in the transept arms, the north aisle and the nave. The interlace, in turn, is "filled in" with colored stones in a variety of arrangements—what we might call the "micropatterns" of the pavement. In addition, narrow rectangular panels, approximately the width of the bases of the columns, span the intercolumnar spaces of the nave colonnade; these also contain curvilinear and rectilinear patterns as well as smaller panels of variously colored stones (fig. 21). With this orientation in mind, two closely interrelated issues should now be discussed: the authenticity of the pavement and the nature of its design.

The pavement of the chapel is first mentioned by King Roger's court homilist, Philagathos, who speaks, in the proemium of his sermon of June 28, of the temple floor, "adorned with pieces of marble colored like flowers, truly like a spring meadow except for the fact that flowers wither and die, and this is a meadow that will never wither but will last forever, preserving in itself an eternal spring."[3] The meadow metaphor, of course, was a medieval topos, but it befits the present floor perfectly, and it is impossible to believe that it could have referred to another pavement in the chapel of which there is now no trace.[4] Of all the structural elements, however, the floor must have been subject to the greatest wear in a much used building since the mid-twelfth century, and the question arises as to whether there were any restorations that may have significantly changed, over the course of years, the way the medieval pavement looked.

To answer this question we must turn first to the other end of the chronological spectrum and Francesco Valenti, who was responsible for the most extensive restoration of the chapel in the twentieth century. One document in the Valenti archive in the Biblioteca Comunale of Palermo refers to such work on the pavement. Dated 1932, the "Perizia preventiva dei lavori di restauro urgenti ai musaici geometrici in pietre dure dei pavimenti . . . " specifies the replacement of worn stones in the pavement, at the entrance ("pavimento in corrispondenza della porta d'ingresso"), the north and south aisles, the presbytery and the presbytery steps, and the nave.[5] Although the document also calls for the work to be done with pieces of stone of like material and the same size ("con tessere uguali a quelle antiche, seguendo la tecnica antica . . . ") an extreme skeptic might wonder whether any more serious interventions were attempted at this time.[6] For three main reasons, however, the authenticity

[3] Philagathos, "Sermon 27," 175.

[4] The metaphor was employed by Leo of Ostia in describing the pavement of the basilica at Monte Cassino; see *Chronica monasterii casinensis*, ed. Hartmut Hoffmann (=*MGH, SS,* 24), Hannover, 1980, 396 (III, 27).

[5] Palermo, Biblioteca Comunale 5Qq E146, no.

39, dated 1932.

[6] A photgraph in the Valenti Archive in the Biblioteca Comunale of Palermo records the original design in the setting bed: "presbiterio (lato nord), sottostante del pavimento a mosaico col disegno antico di distribuzione"; see 5 Qq E146, no. 59a, photo no. 32.

*authenticity*

of the pavement as a medieval work of art should not be questioned: the close relationship between the present pavement and the design recorded in the nineteenth century; the internal consistency of the pavement; and the stylistic relationship between the pavement and other eleventh- and twelfth-century floors.

Long before Valenti intervened in the Cappella Palatina a record was made of the chapel pavement in a drawing engraved by F. S. Cavallari (fig. 22). It was published several times in the nineteenth and twentieth centuries, beginning with the monograph of Serradifalco in 1838.[7] The drawing allows us to dismiss the possibility that Valenti seriously altered the design of the pavement or any portion thereof; it matches the present floor to a remarkable degree. What the drawing does not enable us to conclude, however, is that there were no changes in the pavement before the early nineteenth century (and after the twelfth). To make this point, it is necessary to consider the internal evidence of the pavement, beginning with its consistency as a work of art.

By internal consistency, I do not mean an absolute and unbending regularity, but a norm that is detectable both throughout the pavement and in two important respects, namely, in materials and in the micropatterns that complete the interlace designs. With regard to materials, a survey of the pavement has revealed that it is constructed almost entirely in five different kinds of stone: porphyry (dark red), serpentine breccia (dark green with light green flecks), cipollino (white with gray streaks), giallo antico (ranging from a pale yellow to dark orange), and a fine-grained white limestone.[8] Cipollino is used for the bands that separate the panels of ornamental motifs. The exceptions to this rule occur in the western panel of the southern transept arm, where there are disks of pink and green marble with gray globules (a breccia?), and in the two narrow bands in the third intercolumniation of the nave from the west, on both the north and south sides, where there are three rectangular panels of a pink marble with purple veining (south), and a gray-white marble (north). The same five-stone system also applies to the risers of the steps that form the throne platform at the west end of the nave (fig. 23), as well as the corresponding steps to the choir (fig. 24), with the addition here of one further material, red glass.[9] The exceptions to the five-stone system, therefore, are quite rare throughout the entire paved area of the chapel.[10]

---

[7] Above, n. 2.

[8] I would like to thank Dr. Richard Tollo, Professor of Geology at George Washington University, and Katherine A. Holbrow, Mellon Fellow in the Object Conservation Department of the National Gallery of Art, Washington, D.C., for help in identifying these stones.

[9] Red glass is used together with porphyry, serpentine breccia, and white marble in a twelfth-century plaque now in the Zisa; see below, n. 16.

[10] The colored stones available to the workshop that constructed the Cappella Palatina must have been more varied, as witness the spoliate columns of nave and sanctuary. The columns of the nave are divided into two types, a red- and black-flecked granite and a black-and-white marble, paired across

the nave and alternating from west to east, granite-marble-granite-marble-granite-marble. The last pair of marble columns stands together with a pair of porphyry columns at the conjunction of nave and choir. The four corner columns in the main apse are also porphyry. The larger columns flanking the apse opening and supporting the southern and northern arches of the choir are red granite. The corner columns in the side apses are a red-brown and white marble. The capitals of the columns, many of which are gilded, likewise are a mixed set, partly ancient, partly medieval and partly modern; see, for instance, Trizzino, "*La Palatina*", 13, regarding a restoration; Benedetto Rocco, "Il candelabro pasquale nella Cappella Palatina di Palermo," *B.C.A. Bollettino d'informazione trimestrale per la di-*

Nor is there a concentration of one type of material in one part of the pavement. The five stones are applied throughout in the same even proportions, with no predominant coloristic variations. The only major accents occur in the disks of various sizes that form the centerpieces of the decorative patterns in the panels, of which there are a rather large number: in the nave and aisles, 33 in porphyry and 37 in serpentine breccia; in the choir, 7 porphyry and 3 serpentine breccia; and in the transept arms, 3 porphyry and 1 serpentine breccia.[11] These change from panel to panel, from porphyry to serpentine breccia, but not systematically, or with an emphasis on one area, such as the nave as opposed to the aisles. Nor is there a significant variation in the size or shape of the stones. The largest disks are in the choir and nave, but the surrounding elements, cut in shapes of triangles and squares, are essentially the same size across the floor. Thus it is no surprise that these pieces are composed throughout the pavement in essentially the same way. It would be difficult and in the end pointless in the present context to describe all of these arrangements; suffice to mention a few of the more prevalent types: triangles set tip to tip; hexagons linked to one another by rectangles; eight-pointed stars framed by rectangles; a checkerboard with alternating in-fill of triangles; six-pointed stars composed of triangles; parallel bands of triangles; and circles formed of four oval shapes set tip to tip enclosing triangles.[12] These micropatterns occur without any discernible rhythm throughout the floor.

The evident consistency in the pavement with regard to materials and micropatterns contrasts sharply with the walls and ceiling of the chapel, as we shall see, and its importance is only underscored by the fact that the floor of the chapel clearly received the majority of wear and tear. Porphyry and serpentine breccia are extremely durable. But this is not to say that the chapel pavement bears no traces of use. One important indication is in the differing conditions of the north and south aisles. The pavement in the south aisle is bowed and bent with wear, the most heavily worn area of the chapel, whereas the north aisle pavement by contrast is virtually pristine. If such a difference is not the result of a restoration—as I believe—then it must be a sign of the function of the chapel, about which there is more to be said.[13]

A second important consideration is the relationship between the chapel pavement and other medieval floors. Closest to the Cappella Palatina pavement, in both materials and micropatterns, is the floor in the nearby church of St. Mary's of the Admiral

---

*vulgazione dell'attività degli organi dell'Amministrazione per i Beni culturali e ambientali della Regione Siciliana*, VI–VIII, 1985–87, pl. XVIII.

[11] The disks range in size from 89 cm to 6.4 cm.

[12] Many of these patterns are of ancient or late antique origin; see, for example, the pavement from the Cathedral at Trier of ca. 400 (Kier, *Schmuckfussboden*, 135f., figs. 1 and 2), the pavement from the third level (552–751) of the so-called Palace of Theodoric in Ravenna (Kier, *Schmuckfussboden*, fig. 300), and a series of pavements from Antioch

(Doro Levi, *Antioch Mosaic Pavements*, 2 vols., Princeton, 1947), and Ostia (Giovanni Becatti, *Mosaici e pavimenti marmorei* [=*Scavi di Ostia*, 4], Rome, 1961; idem, *Edificio con 'opus sectile' fuori Porta Marina* [=*Scavi di Ostia*, 6], Rome, 1969). See also Asher Ovadiah, *Geometric and Floral Patterns in Ancient Mosaics*, Rome, 1980, and Catherine Balmelle, Michèle Blanchard-Lemée et al., *Le décor géométrique de la mosaïque romaine*, Paris, 1985.

[13] See below, chapter 3, pp. 122ff.

(fig. 25).[14] The same five-stone system that was applied to the chapel also occurs here, with the sole distinction that there are fewer porphyry disks and they are smaller. Similarly, there is a close relationship in the micropatterns of the pavement, though not a complete overlap. St. Mary's of the Admiral contains a greater number of curvilinear micropatterns, especially rosettes and interlaced circles, than the Cappella Palatina. It also makes use of figural motifs in the form of frogs, birds and so on that are entirely lacking in the Cappella Palatina. Nonetheless, the resemblance of the two pavements is strong.

St. Mary's of the Admiral was built and decorated in the late 1140s, and it is possible that the same *marmorarii* who laid the chapel pavement also made the floor here.[15] Unfortunately no other mid-twelfth-century pavements have survived from Palermo or its environs, and so it is impossible to determine to what extent these two cases are indicative of a regional practice.[16] Moving outward from Palermo, however, we may make two further observations that have some bearing on the issue of authenticity. One is that a number of the micropatterns noted here occur with frequency in other contexts. One such context is Rome, where the art of opus sectile decoration flourished in the twelfth century. Dorothy Glass has attempted a catalogue of these patterns for the Roman pavements, on the basis of which a number of correspondences may be noted.[17] In this connection, it is interesting to observe that patterns (or close variations upon them) associated by Glass with "The Paulus Group," of the first half of the twelfth century—nos. 15, 19 and 20—are particularly well represented in the Cappella Palatina pavement.[18]

Another point concerns a motif, or rather a set of motifs, which we have not yet discussed. In the pavement of the main apse of the Cappella Palatina snakes are depicted, one to either side of the main altar (fig. 26). These figures, both approximately

[14] For a diagram of the pavement design, see Serradifalco, pl. XXIII; Kutschmann, *Meisterwerke*, fig. 7; Zimmermann, *Sizilien*, fig. 32. Views of the pavement are to be found in Giuseppe Bellafiore, *La cattedrale di Palermo*, Palermo, 1976, fig. 186; Ernst Kitzinger, *I mosaici di Santa Maria dell'Ammiraglio a Palermo*, Bologna, 1990, figs. A12, 1 and 2. The pavement has never been properly published, and my remarks here are based on my own examination of the work. See also Cochetti Pratesi, "In margine," 266.

[15] On the date of the church, see Kitzinger, *Santa Maria dell'Ammiraglio*, 15ff.

[16] I have not been able to the study the floor of San Cataldo, probably built by Maione da Bari between 1154 and 1160, nor have I had access to photographs of the pavement; for the edifice, see Di Stefano, *Monumenti*, 59ff. ("Manca un vero e proprio saggio monografico"), and for a diagram of the pavement, see Serradifalco, pl. XXV; Kutschmann, *Meisterwerke*, fig. 6; Zimmermann, *Sizilien*, fig. 29. See also Cochetti Pratesi, "In margine," 266. In this

context one might also consider other types of objects, such as the mid-twelfth-century marble plaque with quadrilingual epitaph, with opus sectile decoration in porphyry, serpentine breccia, white marble, and red and gold glass; Michele Amari, *Le epigrafi arabiche in Sicilia trascritte, tradotte e illustrate*, ed. Francesco Gabrieli, Palermo, 1971, pl. IX, fig. 2, 201ff.; *L'età normanna*, 146f. The piece is now on exhibition in the Zisa in Palermo.

[17] Glass, *Cosmatesque Pavements*, 140ff., from which I note the following correspondences with the Cappella Palatina pavement: 141, nos. 1, 2, 4; 142, nos. 6–8; 143, no. 11; 144, nos. 13–16; 145, no. 19; 147, no. 24.

[18] Glass, *Cosmatesque Pavements*, 144f. At the same time, the differences between the chapel pavement and the pavements of Rome should also be stressed. As Glass has observed, two of the mainstays of Roman floor design, the patterned rectangle and the alignment of disks along the main axis of the nave, are not to be found in the chapel, or anywhere else in twelfth-century Sicily; see *Cosmatesque Pavements*, 4.

one meter in length, follow the same pattern in porphyry and serpentine breccia, giallo antico and limestone. In addition, at the nave entrance to the choir, there is a small panel containing addorsed lions on either side of a schematized tree (fig. 27). The lions are rendered predominantly in mosaic, in giallo antico and serpentine breccia. The placement of the three motifs, the two in proximity to the altar and the one at the entrance to the choir, the space of the sanctuary immediately preceding the altar area, may be compared to a similar usage in the Desiderian Basilica at Monte Cassino (1066–71).[19] There, in the pavement before the altar, stand two facing beasts identified as dogs. Bloch has interpreted these figures as the guardians of the altar as well as the tomb of Benedict beneath it; a similar apotropaic meaning may well underlie the choice of the snake motifs in the Cappella Palatina. The lions too may have functioned in the same way, although, as symbolic elements, they may also be associated with the king, and thus may well carry the additional implication that the entrance to the choir denoted entry into a royal space. The fact that such apotropaic devices appear earlier in Byzantine pavements supports the conclusion that the practice was Eastern in origin, lending weight to Bloch's intrepretation of the basilican pavement at Monte Cassino as a Byzantine-derived scheme. One example is from the eleventh-century monastery church at Sagmata in Greece, where a panel in front of the bema contains the figure of a snake.[20]

These comparisons, suggestive though they are, do little to clarify the immediate source of the chapel pavement. In fact, they seem to point in different directions— Rome, southern Italy and Byzantium—which to my mind only highlights the lack of precision inherent in an analysis that concentrates exclusively on individual forms and isolated motifs.[21] To gain further insight into the chapel pavement it will be necessary to take a closer look at the composition of its panels and its overall design. In this regard, we may return to an observation made at the beginning of this section concerning the two types of interlace—curvilinear and rectilinear—present in the pavement. It was precisely to this distinction that Emile Bertaux first drew attention in his study of southern Italian art of the later Middle Ages, and in it he was followed by Otto Demus, though with a different implication.[22] For Bertaux, the difference signified different cultural affiliations and sources, namely, Byzantine (curvilinear) as opposed to Islamic (rectilinear); for Demus, it also signified a difference in date, with the "Byzantine" patterns of the sanctuary being earlier than the "Islamic" patterns of the nave. Demus's point we have good reason to believe now was not the case: in all likeli-

[19] Angelo Pantoni, *Le vicende della basilica di Montecassino attraverso la documentazione archeologica*, Montecassino, 1973, 105ff. Herbert Bloch, *Monte Cassino in the Middle Ages*, 3 vols., Cambridge, Mass., 1986, 1:47, 3:fig. 5.

[20] Kier, *Schmuckfussboden*, figs. 319, 321. The snake motif, though not placed in relationship to the altar, also occurs in the church of S. Adriano in S. Demetrio Corone in Calabria (1088–1106); see Paolo Orsi, *Le chiese basiliane della Calabria*, Florence, 1929, 172f., figs. 100, 119 and 120; Kier, *Schmuckfussboden*, 30, fig. 341.

[21] The complexity of these interrelationships in themselves is illustrated by the discussion of Glass, *Cosmatesque Pavements*, 25ff., on the connections between pavements in Monte Cassino, Rome and Byzantium.

[22] Emile Bertaux, *L'art dans l'Italie méridionale*, Paris, 1903, 496ff, esp. 498 and 500; see also, idem, "Les arts de l'orient musulman dans l'Italie méridionale," *Mélanges d'archéologie et d'histoire de l'Ecole française de Rome* 15, 1895, 419ff., esp. 441ff. Demus, *Norman Mosaics*, 28f.

hood the pavement was laid in a single campaign.[23] Bertaux's cultural distinction, on the other hand, deserves a closer look.

Bertaux is undoubtedly correct that the curvilinear patterns in the pavement derive ultimately from Byzantium, though a more immediate source in the Byzantine-influenced region of southern Italy cannot be excluded.[24] It is possible that the southern Italian tradition originated with the patronage of Monte Cassino (as has also been argued by Herbert Bloch), whose floor, in fact, must have borne some resemblance to the pavement in the Cappella Palatina (fig. 28).[25] One possible parallelism lies in the use of animal motifs near the altar, aforementioned; there are also similarities in the ornamental patterns employed to make up the designs. Additional support for a south Italian derivation comes from other sources, such as the late eleventh-/early twelfth-century church of S. Mennas in S. Agata dei Goti, whose pavement contains two types of panels, one with rows of interlocked disks *en série* and the other with a central disk surrounded by a looped circular frame.[26] These types are almost identical to panels in the Cappella Palatina, but are not attested elsewhere before the late twelfth century.

Similarly, the rectilinear patterns in the chapel pavement have a distinctly Islamic look, as Bertaux also observed. They have no true precedents in the Italian or Byzantine floors predating the Cappella Palatina, nor do they occur in Islamic pavements, of which in any case there are no comparable examples in opus sectile.[27] But similar patterns are commonly found in Islamic architecture, where they appear with some frequency as decorative elements in panels or friezes sculpted in relief.[28] They also turn up quite often on the numerous objects of the decorative and monumental arts bearing the unmistakable stamp of Islamic craftsmanship that were either made on the island of Sicily or imported into it, such as the wooden doors and other architectural elements that decorated the Norman Palace in Palermo as well as other Norman buildings (fig. 29).[29]

Notwithstanding these differences, there are also important points of similarity between the two types of interlace. Both curvilinear and rectilinear patterns are to a large extent organized along the same lines in the sense of a structure or a matrix, which is to say a configuration of five disks—a large one in the center and four smaller ones around the sides—or the quincunx, which was one of the staples of Italian floor

[23] Demus's conclusion was reiterated by Cochetti Pratesi, "In margine," 264, and as with Demus, only on the basis of the evidence of the patterns of the pavement. Cochetti Pratesi's assertion that an "Islamic taste" came to the fore in the chapel in the later 1150s is contradicted by the evidence of the nave ceiling, which Philagathos described in the late 1140s/early 1150s.

[24] See the discussion of Glass, *Cosmatesque Pavements*, 25ff.

[25] See the fuller discussion of Bloch, *Monte Cassino*, 1:44ff., 3:figs. 4–5. Bernardo D'Onofrio, *L'abbazia di Montecassino: Storia, Religione, Arte*, Rome, 1986, figs. 59 and 61 (color photographs).

[26] Bloch, *Monte Cassino*, 1:49, 3:figs. 9–11; Kier,

*Schmuckfussboden*, 30, fig. 343.

[27] Glass, "Studies," 116 n. 11.

[28] Derek Hill and Lucien Golvin, *Islamic Architecture in North Africa: A Photographic Survey*, London, 1976, figs. 299 (Fez, al-Qarawiyyan mosque, minbar), 304–5 (Fez, al-Qarawiyyan mosque, door panel), and 310 (Fez, Andulusians' mosque, minbar); Derek Hill and Oleg Grabar, *Islamic Architecture and Its Decoration*, London, 1964, 49, 81, figs. 5, 6 and 8 (Maghak-i Attari mosque, facade); John D. Hoag, *Islamic Architecture*, New York, 1977, 237f. (Ghazna, Minaret of Mas'ud II), 261 (Maragha, Gunbad-i-Kabud).

[29] *Il Regno Normanno*, fig. 154.

design. (There are no quincunxes in Islamic art, so to call the rectilinear patterns in the chapel pavement simply "Saracenic" as Demus does is a mistake.) Furthermore, as we have already seen, the micropatterns of the pavement, the patterns of superimposed triangles, interlaced hexagons, stars, etc., which are used to fill the interlace strips and the interstices between them are the same throughout the design. Finally, the various panels of the transept arms and aisles are all roughly the same size, and the same proportion to one another and to the (larger) panels in the nave and sanctuary, and all of these are related to the bay system of the architecture of the chapel. In other words, the same basic composition for the floor is employed throughout. All of these elements of consistency, in turn, imply some form of individual control in designing the pavement.

If anything, it is the composition of the pavement as a whole that is perhaps the most revealing in this regard. Generally speaking, in Byzantium considerable attention was paid to the coordination of pavement and architecture in the sense that each portion of the building defined architecturally, each bay and subdivision, was reflected in the composition of the floor. A particularly well-preserved example from the twelfth century is the floor in the Pantokrator monastery in Constantinople, where not only the central space but also the ancillary areas and even the soffits of the arches are reflected in the design (fig. 30).[30] Western pavements, and especially Italian ones, on the other hand, tend to be much looser in this respect. Examples include the pavements in the Roman churches of S. Clemente, S. Lorenzo flm and S. Maria in Cosmedin, where the panel system is only partly in accord with the symmetry and regularity of the nave colonnade.[31] Much the same could also be said about the other pavements in southern Italy, as in St. Mennas in S. Agata dei Goti or the Calabrian church of S. Adriano in S. Demetrio Corone (also late eleventh/early twelfth century).[32] The only major exception to this rule in the period under consideration here is the basilican pavement at Monte Cassino. The elaborate panel system of the pavement was clearly constructed with the architecture of the church in mind. Isolated as it is from the more general Italian practice as it may be discerned in this respect, the Monte Cassino pavement clearly attaches to the Byzantine approach, which lends further support to an interpretation of the Desiderian pavement as a Byzantine-derived scheme.

It is to the former, or Byzantine, approach that the pavement in the Cappella Palatina also bears a clear affinity.[33] The individual panels of transept arms and aisles fit neatly into the spaces defined by the intercolumniations of the colonnade; in the sanctuary, a symmetry is also preserved with the form of the dome; and the large panels of the nave, offset a bit by the throne platform to the west and the chancel steps to the east, nonetheless match the intercolumniations in number and are uniform in length

[30] Arthur H. S. Megaw, "Recent Work of the Byzantine Institute in Istanbul," *Dumbarton Oaks Papers* 17, 1963, 335ff., figs. 1ff. See also Semavi Eyice, "Two Mosaic Pavements from Bithynia," *Dumbarton Oaks Papers* 17, 1963, 373ff.; Kier, *Schmuckfussboden*, figs. 313–321; Theodore Macridy, "The Monastery of Lips (Fenari Isa Camii) at Istanbul (translated by Cyril Mango)," *Dumbarton Oaks Papers* 18, 1964, figs. 52–55; Glass, *Cosmatesque Pavements*, pls. 56–64.

[31] Glass, *Cosmatesque Pavements*, pls. 17, 28–30 and 34–7, and 25ff. on the essential differences between Byzantine and Roman pavements.

[32] See above, nn. 20 and 26.

[33] See also Kier, *Schmuckfussboden*, 29.

and width. These characteristics are so striking, and distinguish the chapel pavement so decisively from other Italian floors, that only one conclusion seems possible: the designer of the pavement was either an Easterner or Byzantine-trained, that is to say, steeped in Byzantine practice and approach. But how is this conclusion to be reconciled with Bertaux's observations on sources?

One point about these sources merits reiteration: that they are employed more or less separately in different sections of the floor. The curvilinear patterns dominate the sanctuary and the south aisle; the rectilinear, the transept arms, the north aisle and the nave. This separation could hardly have been the result of mere circumstances, such as the employment of craftsmen with diverse backgrounds in the execution of the design (nor even so clearly the result of a chronological development that moved from east to west in the chapel, as Demus supposed). The more reasonable explanation is that it was planned. Any further speculation about the nature of this plan, however, would be premature until more of the nave has been examined. For now the conclusion must be that the guiding spirit behind the Cappella Palatina pavement was Byzantine, and that it was executed with Byzantine and Islamic motifs that were combined in an apparently purposeful way.

Thus the differences that Bertaux and Demus perceived do not compromise a view of the Cappella Palatina pavement as the result of a single effort and a unified plan, for which one further observation will provide support. Besides the Cappella Palatina and St. Mary's of the Admiral, there is one other twelfth-century opus sectile pavement in Sicily, though considerably later than mid-century, in the choir of the Cathedral of Monreale (fig. 31).[34] When this work is set beside the two earlier pavements, an interesting pattern emerges. The two earlier examples show a close adherence to the individual panel format or to the quincunx composition that is characteristic of medieval floor decoration in general. In the later pavement of Monreale, however, this etiquette has broken down. The entire floor is covered with a free-ranging rectilinear interlace dotted with porphyry and marble disks that only distantly recall a composition like that of the quincunx. It is as if the earlier format had been subjected to a process of blending and unification, which, *mutatis mutandis*, is also evident in other aspects of the design of the Cathedral.

Thus there is much that speaks in favor of the integrity of the pavement in the Cappella Palatina and the fact that it was laid when the chapel was first built—and so it will be assumed in the following discussion. The foregoing analysis has stressed the regularity of the chapel pavement; but one important anomaly deserves mention here, although it has no chronological implications and will figure in our discussion only at a later point. The pavements in the two aisles are essentially symmetrical in design, with the exception of the south aisle to the west. There, instead of the typical rectangle with a variation on the quincunx, we encounter a panel that is composed of a smaller interior field and two wide flanking bands. The form occurs twice, marking the first two bays of the aisle, and nowhere else in the chapel (figs. 22 and 32).[35]

[34] Cochetti Pratesi, "In margine," 266.

[35] A similar asymmetry occurs in the pavement of the basilica at Monte Cassino as recorded in Gat- tola's engraving, although here the area in question lies in the north, not south aisle; see Bloch, *Monte Cassino*, 3:fig. 4.

*The Wainscoting, the Altars and the Door Frames*

The term *wainscoting* is intended to mean the wall decoration extending from the floor of the chapel up to and including the upper border of the band of ornament that Bertaux has called the "lotus lancéolé" (figs. 33 and 34; plates II and III). This motif runs along the side walls of the chapel, including the transept arms from the juncture with the east or altar wall on both sides, down the walls of the aisles, and onto the west wall, except for the fastigium of the throne platform at the western end of the nave. The wainscoting (but here not the lotus ornament) also extends across the three apses to the east, whose altars abut the apse walls and thus will be included in the following discussion. Discussion of the wainscoting will also include the door frames in the aisles and transept arms, because these too are an integral part of the wainscoting design. It must be admitted at the outset of this discussion, however, that short of taking the marble revetment off the wall, there are certain problems concerning the wainscoting of the chapel that cannot be solved.

Clearly the most distinctive feature of the wainscoting is the decoration of its borders and panels, with their ornamental patterns in opus sectile. The number of patterns, in fact, is large: my count reveals over two dozen separate motifs in the wainscoting area of the entire chapel, including the fastigium of the throne platform (figs. 36 and 37). But it is also clear, even from a cursory glance, that the wainscoting has been tampered with much more than the pavement, with repairs and restorations, as variations in material and color immediately reveal.[36] The question is, where, if anyplace, in the present wainscoting, is the medieval system to be seen? In the absence of external documentation, an answer can come only from an internal examination of the wainscoting as it currently stands.

Let me begin by attempting to characterize at least one phase of modern restoration, of which two incontrovertible cases may be discussed. One exists in the altars themselves (fig. 38). There are presently three altars in the chapel, one in each apse. That this was the original configuration of Roger's chapel there can be little doubt, for two reasons (in addition to the fact that the apse is a conventional location for the altar in the medieval church): the relics recorded as having been uncovered in each of the altars that were replaced by the ones now standing in the chapel correspond essentially to the saints depicted in the twelfth-century mosaics in the apses above, and, as we have already seen, there is no apparent disruption to the pavement at the eastern end of the chapel, which suggests a place where one or more of the altars alternately might have been located. The present altars date to the late eighteenth and early nineteenth centuries; in fact they can be dated with precision by the inscribed plaques accompanying each one: 1797, main altar; 1813, north altar; 1817, south altar.[37] With

[36] On a restoration of the wainscoting, see Trizzino, "*La Palatina*", 9 (1754).

[37] The inscribed plaque to the right of the main altar reads: "Anno MDCCXCVII / Pervigilio Nativitatis / Christi Diem / Consecrationis Altaris / Ab Illmo Et Rmo / Huius S:R:Palat:Cap: / Cantore Simone Iudica / Ep Teleptense Peractae / Hic Recolentes XL: / Dierum Indulgentiam / Quotannis Lu-

crantur." To the left of the north altar: "Anno 1813 / Quintodecimo Kalendas Septembris / Peractae Consecrationis Die Recurrente / 40 Dierum Indulgentia Tribuitur." To the right of the south altar: "Anno 1817 / Sexto Idus Aprilis Peractae / Consecrationis Die Recurrente 40 / Dierum Indulgentia Tribuitur." See also Buscemi, *Notizie*, 20f.(text), 25f.(notes); Trizzino, "*La Palatina*", 10.

the exception of the porphyry panels on the faces of the altars (which may have been taken from the earlier forms), they are new in their entirety, with new moldings, ornamental frames and tops.[38]

The second case is on the exterior wall of the south aisle, on what constitutes the main "facade" of the chapel to the present-day visitor (fig. 39). There one encounters a set of mosaics in the upper register of the wall illustrating the story of Absalom, a row of portraits of apostles and saints and a marble wainscoting.[39] The unusual subject of the mosaics, drawn from 2 Kings: 18 and 19, has been related to the politics of Ferdinand IV of Bourbon, King of Naples and Sicily 1759–1825, and there are several indications in the work itself that the entire south wall belongs to this period, or shortly thereafter.[40] The design of the wall is recorded in a drawing now preserved in the Norman Palace and signed by Santo Cardini, "Regio Direttore e Capo Mosaicista della Real Cappella," whose signature is also preserved beside the figure of Absalom at the oak.[41] At the end of the pictorial cycle, there is, in addition, the signature of Santi Cardini's assistant, Pietro Casamassima, and the year 1832.[42]

In both of these places, on the altars and on the south exterior wall of the chapel, bands of opus sectile are used to frame the marble and porphyry panels, in much the same way that occurs throughout the wainscoting in the interior of the chapel (figs. 40 and 41). Both too are similar in the way in which this opus sectile is rendered, although in this respect the rendering is often quite different from what is found elsewhere in the chapel. The pieces that make up the opus sectile bands here are smoother and more tightly fitting. They have a machine-cut regularity that creates a perfectly even surface, in contrast to the rougher and more broken effect often seen

[38] The parapet walls in front of the two side altars are also modern (perhaps of the same period as the altars themselves as indicated by the size and nature of the tesserae and the quality of the workmanship), as is the parapet at the western end of the northern transept arm that serves to give the area the semi-independent spatial quality of an ancillary chapel, and encloses as well the north aisle stairs into the crypt. All three parapets—in front of the south altar, in front of the north altar and around the north aisle stairs—have common features that link them technically and stylistically, and differentiate them from the parapet in front of the main altar, which is an original form of the Rogerian phase of the chapel. Size and nature of tesserae figure again here, as do other factors. In all three of these cases, for instance, the finials capping the uprights are integral with the body of the upright. In the main altar parapet, the finials are separate pieces, and probably modern additions. The northern parapet around the northern stair to the crypt was apparently made in imitation of the southern one (which predates the pulpit and belongs to the first, Rogerian, phase of the chapel), and remains unfinished today. That the northern parapet was not an original feature of the chapel is also indicated by the fact that it breaks into the pattern of

panels in the northern transept arm pavement. Such is not the case with the parapet wall around the stair to the south, where the pattern of the pavement in both the south aisle and southern transept arm is clearly designed to take this form into account. The parapets in front of both of the side altars are also awkward in the way in which they abut the parapet in front of the main altar. In addition, the parapet in front of the altar in the northern transept arm is unfinished.

[39] Benedetto Rocco, "Cappella Palatina, parte seconda," 84ff., figs. XXXIV–XXXVII, XL.

[40] Ibid., 85f. Riolo, *Notizie dei restauratori*, Palermo, 1870, 10ff.

[41] Rocco, "Cappella Palatina, parte seconda," fig. XXXIII. Rocco's interpretation of the drawing as the record of the early sixteenth-century decoration alluded to in the inscription on the adjacent east wall dated 1800 (see ibid., fig. XLII, and 84 n. 84) cannot be correct. Granted, the drawing shows a hunting scene and not the biblical narrative, it matches the present mosaic decoration in several important particulars. It may well represent an earlier formulation of Santo Cardini's that was rejected in favor of the present scheme.

[42] Ibid., 89.

in the chapel. They are also mostly glass, as opposed to the stone used elsewhere in the chapel, and in a wide range of colors that includes three shades of blue, three shades of green, red-brown, yellow, white, gold and black, although the dominant palette is pastel. These colors also have their analogue in the mosaics of Cardini and Casamassima. Finally, some of the patterns that are employed for these strips are unique in the chapel and unusually complex even within the context of the most complicated patterns found in the chapel.[43] On the south wall, for instance, the lower border of the wainscoting is made up of a series of circular shapes carved out of the white marble of the frame and filled in with multicolored star-shaped inserts.

It is especially by examination of materials and technique, of the multicolored, smoothly cut and evenly finished pieces of the wainscoting, that modern (that is to say, postmedieval) restorations in the chapel can be detected. The patchwork that even a cursory glance reveals is thus a true physical and chronological mix, with all of the attendant uncertainties of analysis that this conclusion implies. Nonetheless, one aspect of the wainscoting decoration could not have been affected by these restorations, however extensive and prolonged. It is a critical difference in design between the eastern and western ends of the chapel which manifests itself in one main way: in the overall arrangement of the patterns.

Let us begin by taking a closer look at the wainscoting design, starting with the sanctuary and transept arms. The remodeling of the three altars must have involved some rearrangement of the wainscoting of the apses and eastern wall of the sanctuary. The three altars all sit against the wall, which certainly would have sustained some damage when the original forms were removed and the new altars were inserted. Repairs, in fact, are visible throughout this area, particularly in the bands of ornament that frame the marble panels revetting the wall. But the system across the entire eastern wall of the chapel, not just the apses, is consistent (fig. 42). The wall is divided into two registers: a low baseboard composed of cipollino slabs without any ornamental frames between them, and an upper zone of the same material framed at intervals by narrow ornamental bands in opus sectile. These upright bands contain one of the three ornamental patterns that are used in the wainscoting of the three apses, interlaced six-pointed stars alternating large and small. The other two patterns—interlaced eight-pointed stars and diamonds, and interlaced eight-pointed stars set tip to tip—appear in the upper and lower borders respectively, framing the upper zone of the wainscoting. These ornamental bands are executed in red and black glass, porphyry and serpentine breccia, and gold glass.[44]

On the two walls flanking the apse wall, in the northern and southern transept arms, the wainscoting is also divided into a low baseboard and an upper zone of cip-

[43] See also the discussion of the throne platform, pp. 68ff.

[44] It is in precisely these ornaments, particularly in the red and black glass, that one can detect the variations—in color and surface texture, from dull and irregular to smoothly polished—that create the patchwork effect. The latter surface may be related to the glass ornament that is used both on the altars themselves and on the exterior wall on the south side of the chapel, and thus considered repairs probably executed when the new altars were inserted into the three apses in the late eighteenth and early nineteenth centuries.

ollino, with bands of ornament separating the two (figs. 36 and 37). The vertical and horizontal frames of the marble panels in the upper zone have the same ornamental patterns as in the corresponding frames of the apse wainscoting, the interlaced six-pointed and eight-pointed stars respectively, but here the similarity ends.[45] The preponderant materials on the north and south walls are porphyry and serpentine breccia, giallo antico and limestone, although red, black and gold glass are also employed. The baseboard is framed at intervals by narrow bands of ornament, and the upper horizontal frame of the upper zone contains the pattern Bertaux termed the lotus lancéolé. In addition, one new pattern is introduced into the upper frame of the upper zone (a diaper pattern), and the large marble panels of the upper zone are decorated at intervals with crosses whose outer edges are curved so that they appear almost as roundels.

The system initiated in the transept arms with the lotus motif in the upper frame of the upper zone of the wainscoting continues onto the north and south walls of the north and south aisles and across the western wall (except at the fastigium of the throne platform in the nave), together with all of the ornamental patterns heretofore noted. But even when the motifs are the same, they are often rendered differently. The diaper pattern at the top of the wainscoting, for instance, is identical to that of the transept arms but for the fact that the central X is made of serpentine breccia, and in the transept arms both porphyry and serpentine breccia are used. The ornamental repertory has also expanded enormously. On the south wall, there are four horizontal and two vertical motifs; on the north wall, five horizontal and four vertical motifs. The main panels of the upper zone are also embellished with porphyry disks framed with bands of ornament (three motifs on the south side, four on the north), or are made entirely of porphyry (three panels on each side). With regard to the ornamental patterns, it might also be said that they have reached a new level of complexity, as witness especially the borders beneath the lotus motif on both sides where the geometric motifs have been completely submerged in an intricate interlace.[46] There are also materials not attested before—turquoise and green glass and white terracotta (all probably stemming from restorations). In the transept arms, finally, the wainscoting extends to the lowermost edge of the lower range of windows, whereas in the aisles there is a small band of ornament in mosaic between the two.

Most striking about the arrangement of the aisles in contrast to that of the transept arms is the lack of symmetry north to south with regard to ornamental motifs. The two transept walls are absolutely identical in their arrangement, and although they

[45] The interlaced six-pointed star motif also appears on the fragment of a chancel barrier in the Cathedral of Cività Castellana, and the eight-pointed star motif, on the pulpit of the Cathedral at Fondi; Peter Cornelius Claussen, *Magistri Doctissimi Romani: Die römischen Marmorkunstler des Mittelalters*, Stuttgart, 1987, pl. 98, figs. 203–4, pl. 19, fig. 38.

[46] It is interesting to observe that two of these interlace patterns also appear in one of the rare examples of Muslim marble wall decoration, in the Pal-ace of Radwan Bey in Cairo; see Jacques Revault and Bernard Maury, *Palais et maisons du Cairo du XIVe au XVIIIe siècle*, 4 vols., Cairo, 1975–1983, 1:67ff, and esp. 76, pl. LII A and B. Similar patterns also occur in the Palace of As'ad Pasa al-Azm (spolia) and the Mausoleum of al-Mansur Qala'un in Cairo; see Michael Meinecke, *Die mamlukische Architektur in Agypten und Syrien*, 2 vols., Glückstadt, 1992, 1:58 a and c.

differ from the eastern wall, in the three walls together the original twelfth-century decorative system for the sanctuary can be detected: a system that created decoratively a unified space and simultaneously emphasized the wall that served as a backdrop for the altars. The ornamental motifs in the aisles, on the other hand, are almost completely different side to side (in other words, the two walls are not mirror images of one another), and even within the walls themselves the ornaments are not consistent.[47] Later restoration may account for the odd motif here or there, but it can hardly explain the whole. Here too, therefore, we must reckon with a medieval system, although one that was asymmetrical in its decorative approach.[48] Coupled with the differences in material and in patterns, these different decorative approaches become even more significant in separating the eastern from the western ends of the chapel in the twelfth century.

The difference in approach may reflect a difference in function, in executant workshop or in date, or some combination of the three. Related decorative programs with original twelfth-century material are very few and far between in Palermo and its environs, but one case proves interesting. In the Zisa, one of the Norman royal garden pavilions built just outside the city, there is some indication of the original decorative program in the main hall of the ground floor, where a step fountain is located.[49] Pieces of the original wainscoting still stand there, as well as the marble fountain and water channel, all decorated with opus sectile ornament familiar from the Cappella Palatina (fig. 43). This ornament bears a striking similarity to the chapel in two respects, namely, in its motifs, such as the eight-pointed star and several forms of complex interlace, and in its arrangement, especially in the asymmetrical disposition of patterns (which is especially dramatic when the patterns occur in close proximity). In both of these respects, the relationship to the chapel is closest, not to the sanctuary, but to the nave.[50] The Zisa was built and decorated by Roger's son, William I, as an inscription on the facade informs.[51]

Is it possible that the wainscoting of the nave was put up only later under Roger's successor, in imitation of the sanctuary wainscoting but also in response to the new taste in ornament of a later generation? Such a conclusion may find some support and also, in turn, help to explain a rather puzzling reference to the chapel in the chronicle of Romuald of Salerno. Like his father before him, William I decorated the Cappella Palatina with mosaics—as Romuald reports—which have traditionally (and in my

[47] One technical difference between south and north walls may also be mentioned here. The lotus lancéolé motif is rendered on a series of plaques of cipollino set side by side. On the south wall every fourth element or so of the motif is split down the middle and shared between two plaques of cipollino. On the north wall the motif is positioned on the plaques in such a way that it is not split.

[48] See also the discussion of the throne platform, pp. 72ff.

[49] Wolfgang Krönig, "Il palazzo reale normanno della Zisa a Palermo: Nuove osservazioni," *Commentari* 26, 1975, 229ff.; Giuseppe Caronia, *La Zisa di Palermo, Storia e restauro*, Rome, 1982, 66f., 72, figs. 73, 136, 165; Ursula Staacke, *Un palazzo normanno a Palermo: La Zisa. La cultura musulmana negli edifici dei Re*, Palermo, 1991.

[50] Complex interlace was also employed in the decoration of the Cathedral of Monreale; see, for example, the frame around the porphyry panels that form the back of the king's throne on the north side of the choir; Krönig, *Il duomo di Monreale*, fig. 53.

[51] See also the reference to the building in the Chronicle of Romuald of Salerno, 252f.

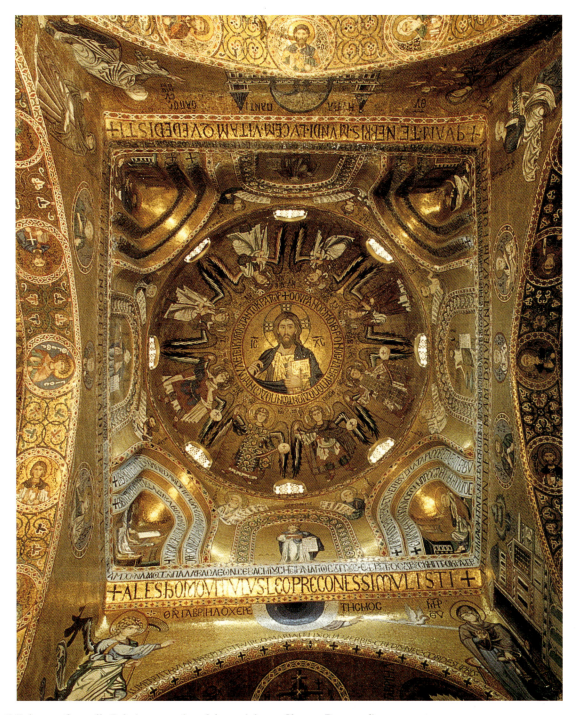

I. Palermo, Cappella Palatina, mosaics of dome (photo: Chester Brummel)

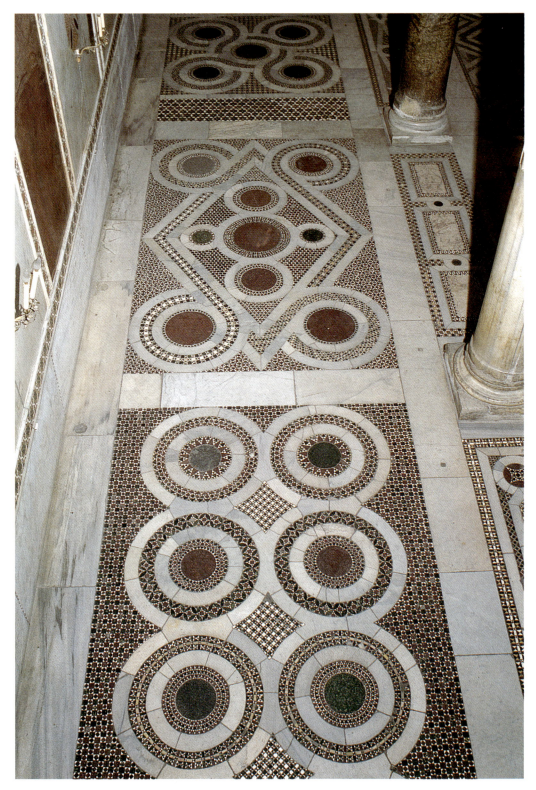

II. Palermo, Cappella Palatina, pavement of south aisle (photo: Chester Brummel)

III. Palermo, Cappella Palatina, wainscoting of south aisle (photo: Chester Brummel)

IV. Palermo, Cappella Palatina, wainscoting of south aisle, detail of lotus lancéolé (photo: author)

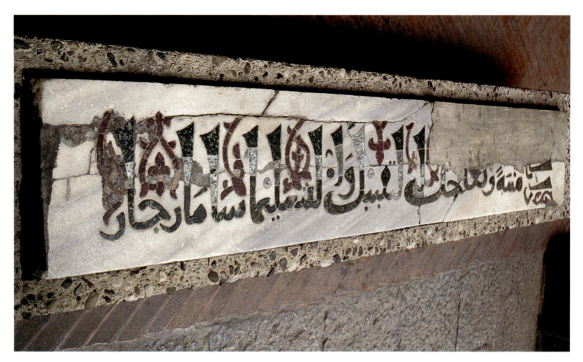

V. Palermo, Palazzo Abatellis, inscription (photo: author)

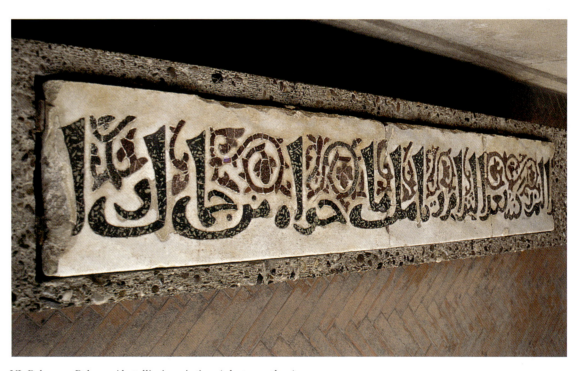

VI. Palermo, Palazzo Abatellis, inscription (photo: author)

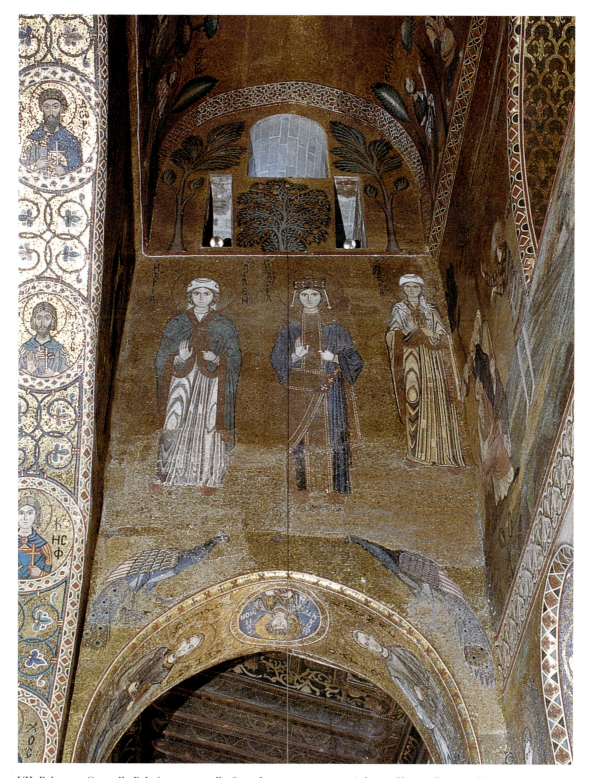

VII. Palermo, Cappella Palatina, west wall of northern transept arm (photo: Chester Brummel)

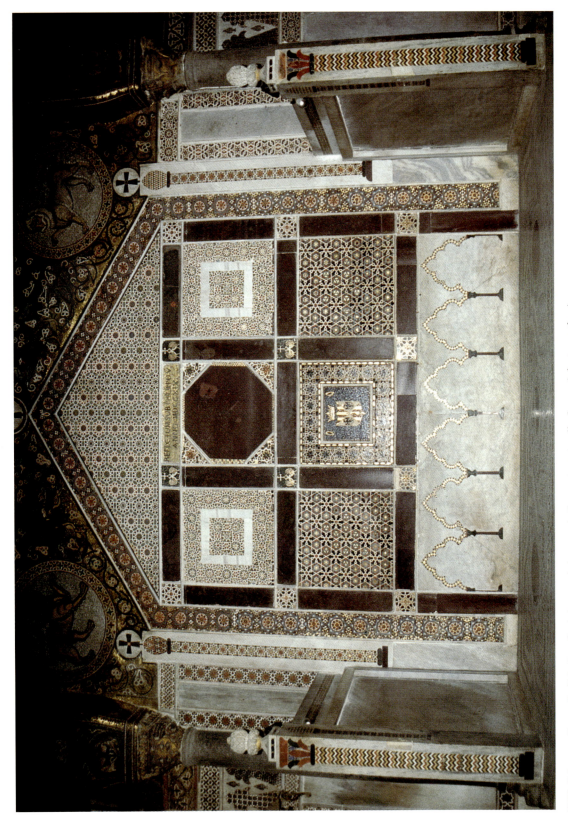

VIII. Palermo, Cappella Palatina, fastigium and throne platform at west wall of nave (photo: author)

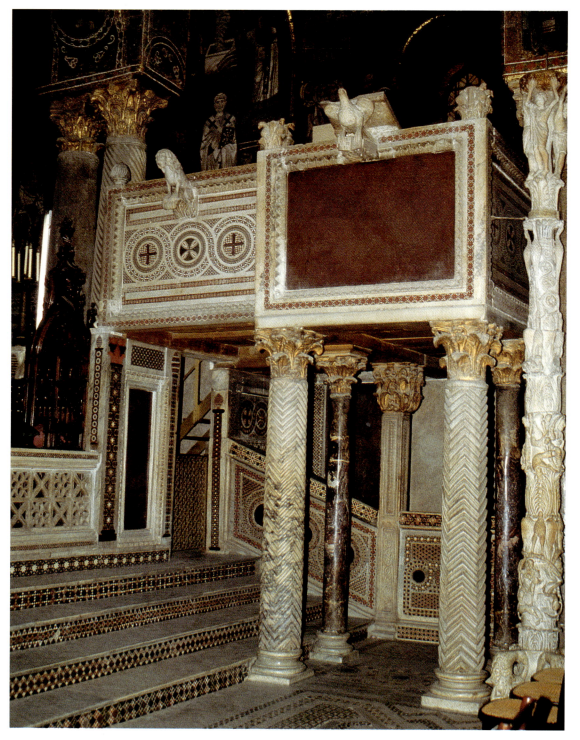

IX. Palermo, Cappella Palatina, pulpit and paschal candelabrum (photo: author)

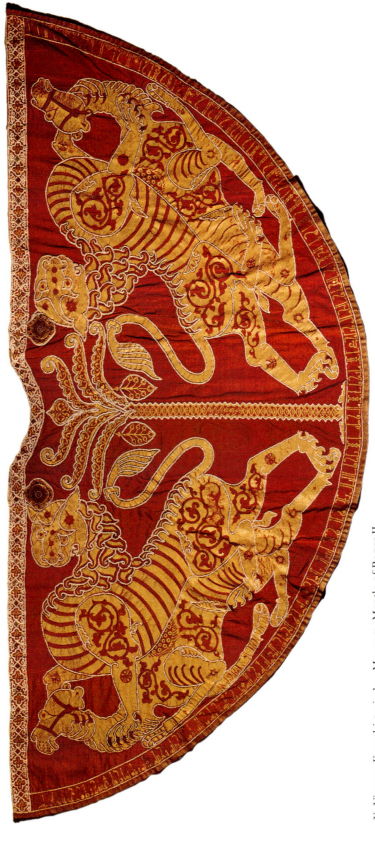

X. Vienna, Kunsthistorisches Museum, Mantle of Roger II
(photo: Erich Lessing/Art Resource, New York)

opinion correctly) been understood to have been the mosaics of the nave and aisles. Romuald then goes on to say that William additionally provided the edifice with colored marbles—"et eius parietes preciosi marmoris varietate vestivit"—which are something of a mystery. Romuald clearly refers to the interior of the building, but the marbles were certainly not those of the sanctuary, or the parapet walls of the choir, as we shall see. On the other hand, if they belonged to the nave, they would have befitted reporting, being so extensive and elaborate; and they would also imply a certain coherence to William's intervention: with both mosaics and marbles William's plan for the nave would have been comprehensive.[52] Philagathos refers to wall hangings—tapestries in many colors—that decorated the Cappella Palatina on the feast of 28 June in Roger's time, and although their precise location is uncertain, they (and not colored marbles) may well represent the original intention for the mural embellishment of the nave and aisles, at least on special occasions.

Turning now to doorways, we are aided in our investigation by an early plan of the chapel. The doors are among the most altered elements of the chapel's functional arrangement, and of all of them—the doors in the northern and southern transept arms, the north and south aisles (to the west), and the west wall flanking the throne platform—there is only one that still preserves its original, mid-twelfth-century form. This is the door in the southern transept arm. On its outer face, the doorway still bears a distinctive molding which suggests that the door opened onto the exterior in the twelfth century, as it does today (fig. 44). The door panel too is original, with its twelfth-century handle (framed with a Kufic inscription) and rows of bosses, both of which are now covered with a thick coat of green paint (figs. 45 and 46). This doorway appears in the first extant plan of the chapel drawn by Joseph Valenzuela in 1754, and now kept in the chapel archive (fig. 47).[53] The handle with its Kufic inscription was rendered in a line drawing in Terzi's monograph, but unfortunately not accurately.[54] According to Yasser Tabbaa, who was kind enough to examine the inscription at my request, the text may be construed as follows: "Encompassing grace, long life, and blessing for its owner."[55]

It is interesting to observe that a door opening is also recorded in the drawing for the northern transept arm, even though the condition of this opening today is far from satisfactory.[56] The Valenti documents suggest that the northern transept arm as well as the passageway behind it was one of the most thoroughly worked over areas in the chapel in modern times. Indeed the work must have gone back to the time when the Spanish viceroys and then the Bourbons after them built balconies and platforms here (and perhaps even earlier). It is no surprise that the door frame in the northern

---

[52] The same inference was also drawn by Pasca; see *Descrizione*, 21.

[53] Rocco, "Cappella Palatina, parte seconda," fig. XXVII; *L' età normanna*, 51, fig. 9l.

[54] Andrea Terzi, *La Cappella di S. Pietro nella Reggia di Palermo*, Palmero, 1889, vol. 1, parte II. cap. I, "Architettura normanna del continente italiano e di Sicilia," 10, and pl. LXVII.

[55] The text: نعمه شامله وبقا وبركه لصاحبه

[56] See also Aloysius Garofalo, Palermo, Biblioteca Nazionale, XII.G.1, fol 223v: "Nel muro della chiesa vi è una porta che corrisponde in riscontro di quella dell'ala sinistra per cui si sale oggi agli appartamenti reali ma nulla di antico conserva."

transept arm, as well as the door that it encloses, is modern. The ornament of the opening has the same pristine, machine-tooled regularity that was noted on the three modern altars and the exterior (south) wall of the chapel, and its exterior frame is rough-hewn. Thus the precise form that this area took in the twelfth-century is unknown; but based on the evidence that an opening existed here in the mid-eighteenth century, it may be inferred that a doorway similar to the one in the southern transept arm was the original design for the north as well.

At the western end of the north and south aisles we encounter two sets of doorways, three openings of which are represented on Valenzuela's plan. All of these openings have ornamental patterns that match one another, at least in part.[57] A door frame on the northern wall of the north aisle also matches the others with regard to ornament, but it does not appear on the plan. This door frame is now closed by a wall that is covered with marble revetment of indeterminant date. But the fact that it was once open, and indeed opened in the twelfth century, is demonstrated by the molding that surrounds the filled-in opening on its reverse (exterior) side, which is similar to the one on the exterior of the door in the southern transept arm. This door would have mirrored the one that now stands in the south wall of the south aisle, although the possibility that it was never used cannot be excluded.

Even on Valenzuela's plan it is quite clear that the door in the south wall of the south aisle is the most prominent of the six that we have reconstructed for the twelfth century (fig. 32).[58] It was the widest, and as today, it was the only opening to the outside of the chapel whose approach was defined in formal terms by another architectural form.[59] The south aisle is flanked to the south by an open colonnade supported by seven spoliate columns of gray and pink granite (fig. 4). The colonnade is now subsumed in the Cortile Maqueda, which was constructed in the seventeenth century. But Valenti, who has studied this area, has concluded that the colonnade was the replacement by William II, after an earthquake, of the original colonnade of the chapel, which constituted the main public facade of the edifice to the south (fig. 16).[60] Thus it is important that the intercolumniation directly in front of the south aisle door is considerably wider and higher than any of the others, thus signaling an approach of singular importance. On the other hand, the door that now leads into the narthex from the south by which access to the chapel is usually gained today is considerably smaller and quite minor by comparison, and clearly of lesser significance in the context of the "colonnade-facade."

The stress placed on the south aisle door in this sense was one of the factors that led the Arabist Jeremy Johns recently to make an important connection with two long

[57] Regarding Valenti's restoration of the door frames, see Palermo, Biblioteca Comunale, 5Qq E146, no. 39, sections 18–21. The opus sectile frame around the door from the north aisle into the narthex is entirely modern.

[58] Nicola Buscemi also considered it to have been the original main entrance to the chapel; see *Notizie*, 14.

[59] The southwest aisle door opening is 154.5 cm wide. By contrast, the door opening in the southern transept arm is 102.5 cm wide, and the original door opening in the north aisle (not the one presently in place) leading into the narthex was 142.5 cm wide.

[60] Valenti, "Palazzo Reale," 520. See the hypothetical reconstruction of Valenti of the entrance into the chapel from the exterior in Palermo, Biblioteca Comunale, 5Qq E146, 72a; *Il Regno Normanno*, figs. 101f.

forgotten but critical pieces of the palatine puzzle. The pieces are the fragments of two monumental Kufic inscriptions, both claimed to have been found in the chapel in the nineteenth century, although at different times, and given to the Museo Nazionale of the Palazzo Abatellis, in whose courtyard they now reside (figs. 48 and 49; plates V and VI). They are virtually identical in size, material and technique. They are carved from blocks of cipollino 31.7–32.8 cm wide, with letters approximately 20 cm in height in serpentine breccia, and decorative elements in porphyry. Nontheless it is unlikely that the two fragments once formed part of the same object. They are rendered in different meters. No. 1 in Johns's account is in kamil meter: " . . . minnatan//wa-tu 'âjilu (or yu' âjilu) al-taqbîla wa-l-taslîma. Sâmâ Rujjâru," translated by Johns as, "graciously//and you make haste to kiss and to salute him. Roger has competed with . . . " (fig. 48). No. 2 is in ramal meter: " . . . r (?) iltham rukna-hû ba' da ltizâmî (or iltizâm)//wa ta'mmal mâ hawâ-hu min jamâlî (or jamâl). Wa- . . . ," translated as, " . . . (?) kiss its corner after having embraced it//and contemplate the beautiful things that it holds" (fig. 49).[61]

That the inscriptions once had a place in the Norman Palace and indeed in the Cappella Palatina is hardly to be doubted. Besides the fact that they were both discovered in the chapel, albeit in secondary contexts, one of them mentions Roger by name, and in materials and technique they match the opus sectile decoration of the pavement and wainscoting of the chapel very closely. I know of no other case of *disiecta membra* like this having been brought to the Cappella Palatina in modern times from the outside. Where were they originally situated? Johns has argued, largely on the basis of their size and content, that they once formed part of the frames of two separate doors in the chapel. The possibility that they belonged to some other form, the trace of which is now entirely lost, cannot be exluded, of course, but in the present state of knowledge Johns's is the most plausible hypothesis.

The investigation up to this point should allow us to eliminate all of the doors on the interior of the chapel (with the exception of the northern transept arm), for which in each case there is enough extant twelfth-century revetment *in situ* to reconstruct the entire frame. Among the exterior frames, neither the transept openings nor the opening in the north wall of the north aisle have a place for marble frames. Nor are the openings from the aisles into the narthex a likely possibility, since their twelfth-century marble frames are still intact and *in situ*. There are thus two possibilities, the south door of the south aisle and the inner face of the north door of the northern transept arm. Of the two, the south door of the south aisle is the more likely home for at least one of these pieces. Although the present door frame is modern, erected in the nineteenth century, given the size and importance of the opening, it could hardly

[61] Jeremy Johns, "I re normanni e i califfi fatimiti: nuove prospettive su vecchi materiale," unpublished paper presented at the Fondazione Caetani, Rome, in May 1993. I would like to thank Dr. Johns for allowing me to read this unpublished paper. For no. 1, see B. Lagumina, "Iscrizione araba del re Ruggiero scoperta alla Cappella Palatina in Palermo," *Rendiconti della Reale Accademia dei Lincei, Classe di scienze morali, storiche e filologiche*, ser. 5, 2, 1893, 231ff.; and for no. 2, Amari, *Le epigrafi arabiche*, 1.31–2, no. V, pl. II, fig. 3. See also Adolph Goldschmidt, "Die normannischen Königspaläste in Palermo," *Zeitschrift für Bauwesen* 48, 1898, fig. 14, and for no. 2, Valenti, "Palazzo Reale," 513f.

have lacked a frame in the twelfth century.[62] Conversely, a boldly displayed Kufic inscription in itself may have been sufficient reason to remove the frame from so prominent a location in post-Norman times. Either of the two fragments would easily have fit the space, and both too would have fit the context: no. 1 because it mentions the king, and no. 2 because it refers to the building, and especially to a corner, where the south door is located, as Johns has pointed out.[63] As a matter of fact, the two inscriptions can also easily be imagined in sequence, since they both involve acts of homage, to the building and to its occupant, the king, that one wonders whether they were not placed in juxtaposition to one another, one perhaps on the south door, the other on some structure that may have preceded it, such as the stair that may have led up to the chapel. It is telling that Johns has related the inscriptions to the better preserved exterior monumental inscription in Kufic from the Rogerian palace at Messina, which also implores the visitor to admire the palace of the king, since this is precisely the context in which they would appear to make the most sense: as monumental directives offered to the visitor *before* entering the building, providing an essential key to his experience.[64] As for the other possibility in the northern transept arm, it is not a satisfactory solution: not only is the door itself somewhat obscure, it is difficult to see what would have been served by imploring a visitor at this point to pay homage to the building or to the king. To summarize: the two inscriptions may plausibly be reconstructed as parts of door frames belonging to the chapel, possibly positioned, one on the exterior face of the south aisle door (no. 1?), and the other on a stair that led up to the chapel from the south courtyard of the palace (no. 2?).

Let us return in conclusion to the ornament of the wainscoting. So much of it, particularly in the sanctuary, matches the micropatterns of the pavement that one can readily see them—both wainscoting and pavement—as having been the work of a single, coherent group of *marmorarii*. There is one pattern, however, that stands out. It is the lotus lancéolé, which a number of scholars have suggested was an Islamic creation (fig. 34).[65] But the motif, or at least something very close to it, also occurs with some frequency in the Byzantine sphere, as witness, for instance, a series of glazed terracotta tiles from Preslav (fig. 35).[66] If the lotus derived ultimately from Islamic art, these examples at least raise the possibility that Byzantine art was a carrier of the

[62] On this frame, see Luigi Boglino, *Storia della Real Cappella di S. Pietro della Reggia di Palermo*, Palermo, 1894, 39.

[63] The exterior frame of the south aisle door—39 cm wide, minus the acanthus border, part of which is twelfth-century in date—is a modern addition put up probably when the door was altered in the nineteenth century; see Trizzino, "La Palatina", 11.

[64] On the Messinese inscription, see Amari, *Le epigrafi arabiche*, 123ff.

[65] A. L. Frothingham, Jr., "Notes on Byzantine Art and Culture in Italy and Especially in Rome," *American Journal of Archaeology and of the History of the Fine Arts* 10, 1895, 206ff.; Bertaux, *L'art dans l'Italie*

*méridionale*, 502; Demus, *Norman Mosaics* 29, n. 36. See, for instance, the merlons of the mosque of Ibn Tulun (ninth century) or the Sabil Kuttab of Qait Bey (1472–4) in Cairo; Giuseppe Bellafiore, *Architettura in Sicilia nelle età islamica e normanna (827–1194)*, Palermo, 1990, fig. 16, and Hill and Golvin, *Islamic Architecture*, pl. I, figs. 6–7.

[66] Krustiu Miiatev, *Die Keramik von Preslav*, Sofia, 1936, 34ff., fig. 40 and pl. XXIV, and Zagorka Janc, *Ornaments in the Serbian and Macedonian Frescoes from the XII to the Middle of the XV Century*, exh. cat., Museum of Applied Art, Belgrad, 1961, pl. 41, nos. 260, 261, 263 for related motifs. See also the remarks of Pratesi, "In margine," 267ff.

motif—in other words, that the motif came to Sicily as one element of the ornamental repertory of the workshop that executed both pavement and wainscoting in Roger's time. The final piece of the wainscoting belongs properly to the throne platform of the nave, and it will be discussed when this feature of the chapel is examined.

## The Chancel Barrier

The chancel, which occupies the area under the dome of the chapel, is surrounded on three sides—north, south and west—by a high wall, 183 cm tall, with the exception of a section, 528 cm long on the west side, where two lower, semitransparent screening walls are now in place (fig. 50).[67] In an unpublished account of the Cappella Palatina now preserved in the Bibliotheca Comunale, Antonio Mongitore (1663–1743), scholar and canon of the Cathedral of Palermo, reports that the two parapet walls presently flanking the throne platform at the west end of the nave were moved there from the chancel barrier of the chapel in the late seventeenth century by the Spanish Viceroy DiStefano, who also at that time removed two other parapets from the same chancel and sent them to Spain (fig. 51).[68] The report, in turn, is confirmed by the records for payment for work done on the chapel in 1685 preserved in the chapel archive.[69]

It must be the lower screen on the west side of the chancel that was the replacement for the removed parapets, as indicated by the two flanking uprights whose sides were then exposed and clearly redecorated accordingly (fig. 52). The present sides of the throne platform match the remaining parapets of the chancel screen in decoration, and nearly so in height, and if placed in what is here presumed to be their original position on the west side of the barrier, would complete the perimeter, leaving approximately 198 cm for a central opening.[70]

But what then of the two pieces that were purportedly sent to Spain? These pieces have never been identified, and their location remains unknown today.[71] They pose a problem, however, in the sense that the present sides of the throne platform are more than sufficient to fill the only gap in the chancel barrier—leaving aside, of course, space for a central opening. There are three possible explanations. One is that Mongitore was mistaken, and that the plaques sent to Spain did not come from the chancel barrier of the chapel, but this seems unlikely given the reliability and accuracy of Mongitore's work. Another possibility is that the plaques came from some irregular or idiosyncratic part of the chancel barrier that has disappeared without a trace. This is perhaps more likely, but obviously cannot be pursued any further here. Finally, there

---

[67] See also Valenzuela's plan, Rocco, "Cappella Palatina, parte seconda," fig. XXVII. It should be noted, however, that the upper edge of the high chancel wall is a modern addition. The true height of the wall in the Middle Ages is unknown.

[68] Mongitore, "Dell'istoria sagra," 21. But see also below, n. 71.

[69] Archivio della Cappella Palatina, vol. XIX, 103. See also, Aloysius Garofalo, Palermo, Biblioteca Nazionale, XII.G.1, fol. 221v.

[70] The present sides of the throne platform are 191 cm high and 165 cm wide.

[71] See also the remarks of Aloysius Garofalo, Palermo, Biblioteca Nazionale, XII.G.1, fol. 120r: "Non so come asserisca il Mongitore che due tavole furon trasportate in Ispagna"; Benedetto Rocco, "I mosaici delle chiese normanne in Sicilia: Squardo teologico, biblico, liturgico," Ho Theologos 3, 1976, 132 n. 35.

is the possibility that the plaques served to complete the west side of the barrier, that is, to fill in the space that might otherwise be assumed to have been left open for a door, thus creating an opaque screen that would have completely blocked off the sanctuary from the nave. Although such an arrangement is not attested elsewhere, it is interesting to observe the degree to which Philagathos has insisted upon the impregnability of the altar area, describing it as surrounded by a marble barrier that forms an obstacle to anyone seeking to penetrate the sacred precinct by force.[72] However, this possibility too must be excluded. The panel with the flanking lions at the foot of the present entrance to the choir from the nave is as clear an indication as one could want of an opening in this spot in the twelfth century (fig. 27). The reference in the text to additional panels, therefore, still seeks an explanation.

In light of the preceding discussion of the wainscoting, it would be useful to characterize the style of the parapet walls (figs. 53 and 54). The two sides to the north and south, which constitute the largest uninterrupted stretches of the parapet, consist of three large panels of geometric motifs—roundels or rectangles of porphyry linked by an interlace—framed by four narrow uprights with schematized columns. The panels and uprights stand on a continuous low base, also decorated with a geometric ornament in opus sectile, and at the top, at the level of the capitals of the columns, are three horizontal panels of interlaced circles and rosettes (south) and a guilloche (north).[73] The large panels are framed by a simple molding. The border of acanthus leaves carved in relief at the top of the wall is modern.[74] Rounding the corner at the west, there are two panels of porphyry, one on each side of the low, open-work wall framing the choir opening, and these also stand on the same low base and are framed by the same simple molding as the panels of the north and south sides.

What is most striking about the chancel panels in the context of the wainscoting is the delicacy of their opus sectile ornament. The pieces of stone used here are considerably smaller than those employed in the wainscoting, which has allowed the craftsmen to make the individual geometric motifs—the micropatterns—more complex. These motifs also fill the entire panel from edge to edge, and within the panels crowd one another, so that very little of the white marble support in the form of edges and borders is visible. Nonetheless, these motifs find parallel without exception in the chapel pavement and wainscoting. Similarly, almost without exception the materials with which they are rendered match those of the pavement and wainscoting. The chancel barrier employs the same five-stone system of the pavement, with a few relatively well-circumscribed exceptions. Gold glass appears on the columns and capitals of the uprights, for instance, as well as in certain motifs in the main panels. Other glasses, in turquoise, red, dark and medium green, and green- and yellow-glazed terracotta, are used especially in the rosettes of the horizontal panels at the top of the south wall and at scattered points in the panels of the north wall. Given the presence

---

[72] Philagathos, "Sermon 27," 175.

[73] The rosette pattern finds a very close analogy in the pavement of the church of Hagia Sophia in Iznik (Nicea), as well as a number of the other micropatterns employed in the chancel barrier in the

chapel; see Eyice, "Two Mosaic Pavements," 373ff., figs. 3–5.

[74] For a discussion of the acanthus border, see below, 77f.

of glass, particularly red and gold, in the wainscoting of the sanctuary, however, such materials are hardly unexpected in this context, and do not detract from the conclusion that the chancel barrier was made by the same *marmorarii* who executed the pavement and the sanctuary wainscoting of the chapel.

### A Balcony in the Nave

At a certain point in his *Descrizione della Imperiale e Regale Cappella Palatina di Palermo* of 1841, Cesare Pasca turns his attention to the mosaics in the nave, and specifically to three scenes in the upper register of the north wall to the east: Lamech informing his wives of the killing of Cain, the Assumption of Enoch, and the Family of Noah fig. 55).[75] These scenes, Pasca reports, are not twelfth century in date, but are from the hand of Santi Cardini in the late eighteenth century (after 1783?),[76] and for a reason he then makes clear: "Nel luogo ove sono i menzionati musaici [i.e., the three scenes], eravi anticamente un palchetto per i vicerè, al quale aveasi ingresso dell'attuale officina de lavori a musaico."[77] The statement comes as somewhat of a surprise; there is no direct reference to a balcony, a "palchetto," in the nave of the chapel in any medieval source. Yet if the text is to be believed, it would fundamentally change our image of the nave in the early modern period, which would have implications, at least potentially, for the twelfth century as well.[78] The following section, therefore, will explore the evidence bearing on Pasca's claim in what is, in fact, one of the most troubled and enigmatic parts of the entire palatine structure.

The first thing to be said in Pasca's favor is that the three mosaics in question were undoubtedly and entirely the work of the late eighteenth century.[79] This is proven by their style, in their suave, spatially sophisticated and coloristically harmonious rendering. Scrutiny of the region *in situ* and in photographs has not disclosed one tessera of earlier work in the entire area of the three scenes, and the eighteenth-century style is clearly visible as well in the subjects flanking the group to the left and right, the Reproval of Cain for the Murder of Abel and the Building of the Ark. Now the appearance of a later style in the mosaics is by no means an extraordinary event in an edifice that has remained in continuous use since the twelfth century. However, by and large, later interventions in the other mosaics are partial in the sense that they have involved figures or parts of figures, and thus may be construed as restorations aimed at maintaining or improving the quality of the edifice. The sole exception, of course, is the upper zone of the north wall of the northern transept arm where modern mosaics now decorate the wall that once presumably held the king's balcony. What is most

---

[75] Pasca, *Descrizione*, 97ff.

[76] On the date of Santi Cardini's work, see Kitzinger, *I mosaici*, fasc. 2, 17.

[77] Pasca, *Descrizione*, 97ff., which is annotated with the phrase "ch'era altresì una cappella privata di viceré adorna di pregevolissime pitture del (illegible)," in the copy of the text bound into Palermo, Biblioteca Nazionale, XIII.F.9; see also Aloysius

Garofalo, Palermo, Biblioteca Nazionale, XII.G.1, fol 208r; Buscemi, *Notizie*, 42 n. 8; Riolo, *Notizie dei restauratori*, 43; Boglino, *Real Cappella*, 32; Kitzinger, *I mosaici*, fasc. 2, 9.

[78] See the discussion of Rocco, "Cappella Palatina, parte seconda," 44ff.

[79] Kitzinger, *I mosaici*, fasc. 2, 17; Demus, *Norman Mosaics*, 34f., 44, and 34 on Santi Cardini.

unusual about the case of the mosaics in the nave is that it involves a whole stretch of wall with three entirely new scenes.

Of course it is possible that the modern mosaicist was guided by some fragments or other indications from the twelfth century, and that he reproduced what was essentially a medieval scheme.[80] This was the case with the Reproval of Cain and the Building of the Ark, where twelfth-century mosaic work is still clearly visible. With regard to the three new scenes, however, the possibility seems less likely. The fact that speaks most decisively against it is that the three new scenes are missing from the one other pictorial program we have good grounds to believe actually copied the Cappella Palatina nave in the twelfth century, namely, the program of the Cathedral of Monreale, which was executed under William II, probably in the 1180s.[81] This omission is doubly odd since Monreale is a much larger church, offering a considerably greater area of wall to be covered with scenes. Given a relationship with the Cappella Palatina, one would expect at Monreale to find, if anything, additions to the program, to compensate for the difference in size, rather than deletions. Another reason the scenes were probably later additions has to do with the subjects themselves. They are unusual episodes, minor events in the Old Testament story, very much out of keeping with the heroic nature of the cycle as a whole, and in one case, namely the Family of Noah, not even a narrative subject at all, but a portrait. They are also rare, if not unprecedented in monumental medieval renditions of the Genesis narrative. But they have the distinct advantage of falling between the scene of God's Reproval of Cain for the Murder of Abel and the Building of the Ark, which are represented on either side of the three scenes. To a later mosaicist seeking to fill a gap in the wall between these two subjects and to maintain the narrative unity of the whole, they would have been a clear choice. The only question is why there would have been a gap: if there were no mosaics in the twelfth century, what was on the wall?

At this point it will be useful to examine the opposite side of the wall to which Pasca also makes reference, and access to the "palchetto" through the space behind it, a space Pasca calls the "officina de lavori a musaico." The date the "officina" originated as an institution is something of a mystery—work on the mosaics of the chapel, if only sporadic, is traced from the fourteenth century on—and the precise location of this workshop is also unknown.[82] One good possibility consistent with the text, however, is in the space that still exists over the north aisle of the chapel, whose south wall, in fact, is the north wall of the nave (fig. 56). The present, somewhat sterile form of this space owes much to the work of Valenti in the 1920s and '30s, and his predecessor G. Patricolo in the last years of the nineteenth century. In a series of campaigns undertaken over the course of several decades beginning around the turn of the century, the floor and ceiling now in place were laid, postmedieval structures removed, the north wall (flanking the Cortile della Fontana), consolidated and glazed, and the surface of the south and east walls, with all of the windows of the clerestory of the chapel, cleaned

[80] This is the conclusion of Rocco, "Cappella Palatina, parte seconda," 44.

[81] Ernst Kitzinger, *The Mosaics of Monreale*, Palermo, 1960, 50ff.

[82] Trizzino, *"La Palatina"*, 9f.

and regularized.[83] But this space also had an important prior history, of which now, it would seem, there are only three tangible manifestations.

One of them is in the wall paintings that were recorded in photographic form before they were removed (and destroyed?) by Valenti in 1939.[84] These paintings, attributed to Pietro Novelli, are important because they are the last remaining traces of another institution that may be associated with the space above the north aisle, the Cappella del Vicerè. Again here our chronology is dim. We do not know when the chapel was created, nor do we know how it related to the "officina": it is possible, but impossible to prove, that, after the passing of the viceregal system, the chapel itself became the site of the "officina."[85] On the other hand, we do know the precise location of at least one of its walls: the present north, clerestory wall of the nave, whose inner face contains the Old Testament mosaics including the three eighteenth-century scenes. It could hardly be coincidence that the Balcony of the Viceroys and Chapel of the Viceroys were located in such close proximity to one another, and yet be chronologically and conceptually separate. Much more likely is the possibility raised so overwhelmingly by the congruity of their names, that they were formed, if not simultaneously at least in conjunction, and that we have in them one important historical system of approach (now no longer accessible), from without to within the chapel.

A second indication comes from two drawings now preserved in the Valenti archive in the Biblioteca Comunale in Palermo (figs. 57 and 58).[86] The drawings show the area over the north aisle of the nave in which a full third of the space to the west was given over to a staircase built to make accessible the observatory that was constructed in the palace to the north of the chapel in the late eighteenth century.[87] The eastern portion of the north aisle, however, was screened off by a wall and a ceiling visible in both the plan and elevation drawings.[88] The smaller space thus delineated coincides with the width of the presumed balcony into the nave, and embraces as well the apertures in the west wall of the northern transept arm. In it may well be preserved the original shape of the Chapel of the Viceroys, or indeed of any earlier room this chapel may have superseded.

[83] The stages of the work are detailed in Palermo, Biblioteca Comunale, 5 Qq E146, nos. 29e, 29e bis, 31, 37/38, 44f, 50 (June 3, 1939), no. 55y(2) (September 7, 1940), 55y(3) (July 15, 1940), 56, 57b (March 21, 1941), 58d (May 6, 1942), 58l (September 4, 1942), 58q (November 27, 1942), no. 58r (November 30, 1942), 61a, 61e.

[84] Palermo, Biblioteca Comunale, 5 Qq E146, no. 55e' (Misura ed apprezzo dei lavori, October 13, 1939): "Modifica al ponte di servizio nell'interno della Cappella per collegamento dei mosaici ed apprestamento d'altro ponte pel distacco degli affreschi negli ambienti sulla navatina di sinistra guardando l'abside"; no. 55y(3) (Letter of Valenti to Soprintendente ai monumenti della Sicilia occidentale, Palermo, July 15, 1940): "Che per quanto riguarda lo strappo degli affreschi che decoravano la cappella del sec. XVII costituta da muri posati in falso sulle travi della navatella settentrionale io debbo dichiarare di non aver mai veduto tali affrreschi dopo il loro distacco. . . ." Earlier Valenti wrote of "lo stato di disordine della muratura sotto gli affreschi della Cappella dei Vicerè dipinta da Pietro Novelli," in Palermo, Biblioteca Comunale, 5 Qq E146, no. 44f (May 22, 1936).

[85] See above, n. 77.

[86] 5Qq E188 no. 17. The drawings are unnumbered.

[87] On the observatory, see Trizzino, "La Palatina", 9f., and, in addition, on the space over the north aisle, 11, 13f., 19ff.

[88] Traces of the holes that once held the beams supporting this ceiling are still visible on the nave wall.

That a room over the north aisle in which the Chapel of the Viceroys was situated may have gone back to the twelfth century is suggested by the third piece of evidence. The clerestory zone of the chapel throughout nave and transepts is pierced at regular intervals by windows that have one basic shape, a rectangle with a slightly pointed, curved top.[89] The one departure from this norm, therefore, is particularly worthy of note. It occurs on the west wall of the northern transept arm, to which the pendant wall in the southern transept arm may be contrasted (figs. 59, 60, and 61; plate VII). Instead of the arrangement of two windows, one positioned above and slightly to the left of the other (south), we find on the north, a configuration, in a single zone, of a smaller rectangular opening and two narrow slits. The opening has a windowlike appearance, but together with the slits, such a grouping of forms could hardly have been conceived simply to admit light: why would it have differed from any of the other windows in the chapel? The shape of the slits immediately calls to mind defensive architecture, secret and protected viewing or listening, and it is in this sense, I believe, that they should be understood: as openings that would have allowed someone to see or to hear whomever was below, but not to be seen; in other words, as functioning not from exterior to interior (like a window), but from interior to interior, which is interesting since the west wall of the northern transept arm now forms the east wall of the north aisle room.

This odd configuration, which is explicable in my opinion only in terms of a viewing/listening hypothesis, is the clearest indication we have that a space over the north aisle was enclosed in the twelfth century, and thus a true precedent to all of its subsequent uses. Together with the eighteenth-century mosaics, which also have implications for the twelfth-century wall, this evidence allows us to suggest that the "palchetto"/"Cappella" of the Viceroys was not simply a configuration entirely intrusive and new; there was a history to the forms that must be explained in twelfth-century terms. The one thing that we lack is direct witness to the precise shape of the earlier arrangement. Could it too have been a balcony with an antechamber behind it on the order of the structure about which Pasca wrote?

The meager evidence that we now possess does not permit us to answer this question with absolute certainty, but there is one factor in a balcony hypothesis that is of more than passing interest. A balcony, by its very nature, is a form that projects from the wall, and it is precisely in a projection forward that such a form too may have left some trace in the chapel. As a matter of fact, there are two features of the area immediately surrounding the eighteenth-century scenes that may be explicable in these terms. Between the muqarnas frame of the ceiling and the mosaics of the wall runs a cavetto molding around the entire nave. This molding now bears an Angevin inscription dated to the year 1478, but as I shall argue presently, the inscription was most likely the replacement for an earlier text in Arabic that was the original border of the nave ceiling. In any case, the present inscription occupies the length of the molding, except for a piece directly above the area of the eighteenth-century scenes (fig. 55).

---

[89] On the exterior form of the windows, which was much changed by Valenti, see Biblioteca Comunale, 5 Qq E146, nos. 34 (July 15, 1928), 35 (July 27, 1928). For an important earlier restoration of the windows, see Kitzinger, *I mosaici*, fasc. 2, 17f.

This molding, furthermore, contains two cuts, one about one-third of the way along the scene of Lamech and the other to the left of the head of Noah in the scene of the Ark, which, together with the change of text, suggest that the section between was a replacement piece. The other point concerns the mosaics beneath the eighteenth-century scenes. The area at the level of the lower register of the narrative cycle has remained essentially unaffected by Santi Cardini's intervention, and retains its medieval appearance.[90] It is at this level that there occurs throughout the nave a series of medallions containing busts of saints, one over the apex of each arch in the nave colonnade. These medallions typically span the full height of the space between the upper border of the nave arch and the lower border of the upper register of narrative scenes, with the exception of the medallion on axis with the window in the midst of the eighteenth-century scenes (fig. 55). In this case, the medallion, which depicts St. Alexander, occupies only about half of this space, as if it had been planned to take into account some feature which was later removed. I am reminded of the figures of John the Baptist and the female saint on the east and west walls of the northern transept arm respectively, whose eccentric placement is explained in terms of the projection of a now missing balcony.[91]

It is important to grasp these facts: both the medallion and the molding are departures from a norm that otherwise holds throughout the nave of the chapel; both occur in an area of the mosaics that was profoundly changed in the late eighteenth century; and both are substantially premodern in date. The position of the medallion reflects a situation of the twelfth century, and the cavetto molding, of the late fifteenth century (at the latest), and all of these facts bespeak the presence of some now missing element, which, given the size and shape of the space and the elevated situation, can be imagined as a balcony (fig. 62). Such a conclusion cannot be proven, but in the absence of evidence to the contrary, it will be the working conclusion of this study; as such, it deserves two further words, both concerning access.

Access into the balcony from the space behind it could have been effected through the opening in the eighteenth-century scenes that is now glazed like all of the other windows in the Cappella Palatina. At approximately 1.8 m in height, the opening is large enough to accommodate a human being.[92] How access to a room over the north

[90] But see Palermo, Biblioteca Comunale, 5 Qq E146, no. 52 (Misura ed apprezzo del lavoro . . . , July 25, 1939): "Distacco di una zona di mosaico in corrispondenza della fascia sotto le finestre della parte nord della nave centrale, allo scopo d'incastare nella sottostante muratura il corrente ed i tiranti di ferro"; and 5 Qq 146, no. 54 (Misura ed apprezzo del lavoro . . . , October 2, 1939): "Lavoro di ricollocazione di una zona verticale di musaico distaccato sopra l'arcata tra la seconda e la terza colonna a contare della tribuna dopo esequito il risanamento della lesione nella muratura sottostante il mosaico (lato nord)." That the wall ruptured in this location is particularly noteworthy. Palermo, Biblioteca Comunale, 5 Qq E146, no. 55t(3) lists mosaics

taken down, cleaned and put back up in the chapel, including "alcuni tratti" on the north wall of the nave. Palermo, Biblioteca Comunale, 5 Qq E146, no. 58n (Letter of Valenti to Soprintendente ai monumenti/Palermo) speaks of agreement to remove and reattach "grandi tratti di musaici pericolanti della zona superiore del paramento nord della nave centrale con rappresentazioni del Vecchio Testamento"; also no. 58p (15 September 1942).

[91] Kitzinger, "The Mosaics of the Cappella Palatina in Palermo," *Art Bulletin* 31, 1949, 285.

[92] See Trizzino, "*La Palatina*", fig. 39 for an illustration to scale. It is interesting to observe that the mosaic directly beneath this window differs in treat-

aisle might have been gained, on the other hand, is less apparent. The problem, which also applies to the king's balcony of the northern transept arm, concerns the area immediately flanking the chapel to the north (fig. 63). This area has undergone several major transformations since the Middle Ages, from the late fifteenth century when the Cortile della Fontana was built, whose southern flank now forms the northern wall of the narrow space immediately adjoining the chapel, to the late nineteenth-/early twentieth-century restoration efforts of Patricolo and Valenti.[93] These latter efforts were painstakingly comprehensive—they involved not only tearing down, but also building up (as in the case of the northern door frame)—and it is to this activity that we owe much of the present surface in this area. In order fully to comprehend the medieval form, it would be necessary, therefore, to remove what the restorers themselves put in place, which is a most unlikely eventuality in the present circumstances. The only other relevant point that can be adduced here is the one that has also been cited in the past, namely, that the king's residences in the Chirimbi, Joharia and Torre Pisana lay along the eastern flank of the palace to the north, and these structures must have communicated with one another and with the chapel at some point, and probably along the chapel's northern flank.[94]

### The Sanctuary Mosaics and the Ceilings of the Nave and Aisles

Grouped together in this last section of original features are the two most important decorative elements of the chapel which are also the best preserved and the best known: the mosaics of the sanctuary and the ceilings of the nave and aisles. Both features belong without a doubt to the Rogerian edifice; they have been described at length elsewhere, and the questions posed by their somewhat problematic condition in places, thoroughly documented and well discussed. I shall limit myself, therefore, to a brief, general description, with an emphasis in each case on the features of the decoration whose implications perhaps have not been brought out as fully as the others, and which will figure in the discussion to follow.

There are two main reasons to treat the mosaics of the sanctuary as if they were a distinct unit within the context of the Cappella Palatina. On the one hand they conform to a remarkable degree to the Pantokrator program devised for the Middle Byzantine church, which itself was created as an independent unit, systematic in nature and comprehensive in scope.[95] All of the essential ingredients of the Byzantine

ment from the other under-window areas in the nave of the chapel. Throughout the nave of the Cappella Palatina the small strips of wall underneath the windows are decorated with mosaics that are essentially continuations of the landscapes belonging to the flanking scenes. The strip beneath the window that lies in the middle of the three scenes in question here, however, bears a simple covering of gold mosaic, as if it had been decorated either before or after the corresponding mosaics to either side. I would like to thank Ernst Kitzinger for

the observation.

[93] See above, esp. nn. 77 and 83.

[94] The notion, often adduced, that the Cappella Palatina was once surrounded by porticoes like the one to the south on two, three or even four sides is, insofar as I have been able to determine, without any foundation of physical evidence; see Pasca, *Descrizione*, 11; Valenti, "Palazzo Reale," 526; Demus, *Norman Mosaics*, 29.

[95] Kitzinger, "Mosaic Decoration in Sicily," 147ff.

program are represented here: the Pantokrator bust surrounded by a medallion frame at the apex of the choir dome, the rings of angels and prophets below it, the evangelists in the four squinches, the christological narrative from beginning (Annunciation) to end (Pentecost) on the walls and subsidiary vaults, and the portraits of saints in full figure and bust length on the walls and soffits of the arches (figs. 10 and 11). The point of this program was to depict the Christian universe as an emanation of the divinity in a historical, hierarchical and liturgical sense. But as Kitzinger has shown, this program was also diverted in the Cappella Palatina in a most un-Byzantine way in order to accommodate the presence of the king, which is the second factor to be adduced here.

Roger II had made for himself a unique place in this space to watch the liturgy, a balcony on the north wall of the northern transept arm, and it is from this viewpoint that much of the decoration also seems to have been contrived. The presence of the king, for instance, accounts for the arrangement of holy warriors on the north face of the north arch of the choir, an otherwise most obscure location, but it was the immediate facade of his view outward; it accounts for the figure of the Hodegetria in the arch above the northern apse, a potent twelfth-century image of dominion in the Byzantine sphere, and one thus to be kept in close physical proximity to the ruler; and it also accounts for the Transfiguration and Entry into Jerusalem on the wall opposite (the south wall of the southern transept arm), images of power and triumph that were the appropriate center of the king's view, and the proper pendants to his glory, when he was viewed in his balcony by others below (figs. 13, 14, and 15). The king in the sanctuary was imagined as standing or sitting to the north, not along the main axis of the chapel; his view cut across this axis at a right angle, and thus served in the most deliberate way to separate sanctuary from nave.

The mosaics in the sanctuary are relatively well preserved, with only one major exception, in the upper zone of the north wall of the northern transept arm. The vicissitudes of this wall are well known. It is where the king's balcony has been argued to have stood in Norman times, which was then reworked in subsequent structures culminating in the great Bourbon palco, whose removal necessitated much of the redecoration presently in place (figs. 14 and 15). This decoration, above the zone of holy fathers in twelfth-century mosaic, consists of a scene of John the Baptist preaching to the left, by the mosaicist Riolo in the mid-nineteenth century, and to the right a late-eighteenth-century fragment of a landscape by Cardini.[96] According to Pasca the original opening on this wall going back to Norman times (but now no longer visible) was 11 palmi wide (2.46 m), which would have left considerable wall space to either side (essentially coincident with the mosaics of Riolo and Cardini) to be fitted into the twelfth-century decorative scheme (see fig. 15). Is there any indication of how it might have been treated?

In fact, there is one major departure in the twelfth-century program of the sanctuary, a gap so striking given the otherwise close affiliations of the program to a Byzan-

[96] Gioacchino Di Marzo, *Delle belle arti in Sicilia dai normanni fino alla fine del secolo XIV*, vol. 2, Palermo, 1859, 76 n. 1.

tine scheme, that it is difficult to believe that it could have been intentional. The christological cycle forms a coherent narrative of Christ's life illustrating the events that were celebrated in the major feasts from Annunciation to Pentecost, with the exception of two episodes, the Crucifixion and the Anastasis. These episodes, the feast scenes for Good Friday and Easter Sunday respectively, were among the most important of the christological events; it is inconceivable that they would have been omitted in any cycle that purported to be complete.[97] As Kitzinger has pointed out, however, the two scenes could easily have been accommodated in the pieces of wall that may have existed to either side of the king's balcony.[98]

One feature of the sanctuary program, however, does not seem to speak, at least directly, to either the Byzantine or the royal theme as it may be defined in terms of a balcony on the north wall of the northern transept arm. It occurs on the east wall above the south apse, in the lunette formed by the curve of the southern barrel vault and in the large panel beneath it. There we encounter a second, smaller image of the Pantokrator above an unusually richly detailed scene of the Nativity (fig. 64).[99] The two images are separated by a text whose content, however, may also be understood to link them: "Stella parit solem rosa florem forma decorem."[100] Giving pride of place to the stellar/solar metaphor, the verse echoes the theme of the Pantokrator's open book, "I am the light of the world" (John 18:1ff.), as well as the theme of the shining star in the scene of the Nativity below. These two images are neither fully integrated into the concentric composition of the sanctuary as a whole nor are they within the purview of the royal balcony in the northern transept arm.[101] They face forward into the south aisle and nave, and one wonders whether it was not at least in part in relationship to a function in the western part of the chapel that this apparently purposeful set was contrived. It should be noted that such a function can be imputed without doubt to another image of the sanctuary program. In the spandrels of the western face of the western arch of the choir are the figures of two angels (fig. 67). These figures have been drastically restored. They were removed by Valenti and set back in place after the wall behind them had been consolidated.[102] But the nearly perfect match of the two heads to the head of Gabriel in the Annunciation leaves no doubt as to their date.[103] The angels bow in homage across the arch opening, at once honoring the occupant(s) of the sanctuary and drawing to their view the attention of the visitor in the western part of the chapel.

[97] Cf. Ingamaj Beck, "The First Mosaics of the Cappella Palatina in Palermo," *Byzantion* 40, 1970, 152.

[98] Wolfgang Krönig concurs; see "Considerazioni sulla Cappella Palatina di Palermo," *Atti del convegno internazionale di studi ruggeriani (21–25 aprile 1954)*, Palermo, 1955, vol. 1, 251; idem, "Zur Transfiguration der Cappella Palatina in Palermo," *Zeitschrift für Kunstgeschichte* 19, 1956, 164f. See also Demus, *Norman Mosaics*, 217.

[99] Eve Borsook, *Messages in Mosaic: The Royal Programmes of Norman Sicily 1130–1187*, Oxford, 1990, 35ff. For further discussion of this scene, see below, pp. 112ff.

[100] Compare the verse attributed to Hildebert of Lavardin, "Solem stella parit, aurora diem, petra fontem," *PL* 171, 1383 ("De nativitate Christi"). I thank Stanko Kokole for this reference.

[101] Krönig, "Zur Transfiguration," 166f. suggests that the placement of the Nativity indicates that at the time of the creation of the scene the south wall program had not yet been formulated.

[102] Kitzinger, *I mosaici*, fasc. 2, 18, figs. 2, 154 and 155.

[103] For the head of Gabriel in the Annunciation, see Kitzinger, *I mosaici*, fasc. 1, fig. 145.

Moving from sanctuary to nave, we experience as great a contrast as exists within the scope of any single medieval building. Perhaps even more so than the mosaics, it has been the ceiling of the nave that has made the Cappella Palatina famous—or infamous—with its patently Islamic form and decoration (fig. 8).[104] This ceiling is actually a false ceiling carved from cedar, suspended from the roof of the chapel and attached to the walls of the nave.[105] Seen from below, its multifaceted surface seems almost infinitely complex, although it is clearly composed of two parts, a central panel of 20 eight-pointed stars arranged two by two, and a surrounding frame in the muqarnas technique (figs. 68 and 69). Much of the original effect, however, must have been due to the gilding and painting, the figures, ornament and Kufic inscriptions that must have covered every facet, and that, where still extant, are now tarnished and damaged with age. To judge from the only systematic close-up views of the ceiling that we now possess, the photographic survey published by Monneret de Villard in 1949, the central panel of stars has suffered the most in repainting, though photographs taken before the restoration campaign of 1948 demonstrate that portions of the muqarnas frame before this time were also in very bad shape.[106] One of the early restorations of the ceiling took place under the Angevins, whose work is recorded in the inscription of 1478 in the cavetto molding, about which more will be said presently; subsequent campaigns took place in the sixteenth and eighteenth centuries.[107] However, it would be unfair to convey the impression that there is much less here than

[104] The ceiling in the nave of the Cappella Palatina is undergoing restoration and it is hoped that a report on its condition will soon be available. For the most complete photographic survey of the ceiling to date, see the monograph of Ugo Monneret de Villard, with a discussion of muqarnas. See in addition Alexis A. Pavlovskij, *Zhivopis' Palatinskoï Kapelly v Palermo*, St. Petersburg, 1890; idem, "Décoration des plafonds de la Chapelle Palatine," *Byzantinische Zeitschrift* 2, 1893, 361ff.; idem, "Iconographie de la Chapelle Palatine," *Revue Archéologique*, ser. 3, 25, 1894, 305ff.; Richard Ettinghausen, "Painting of the Fatimid Period: A Reconstruction," *Ars Islamica* 9, 1942, 112ff.; André Grabar, "Image d'une église chrétienne parmi les peintures musulmanes de la Chapelle Palatine à Palerme," *Aus der Welt der islamischen Kunst: Festschrift für Ernst Kühnel zum 75. Geburtstag am 26.10.1957*, Berlin, 1959, 226ff.; Ettinghausen, *Arab Painting*, Lausanne, 1962, 44ff.; Dalu Jones, "The Cappella Palatina, Problems of Attribution," *Art and Archaeology Research Papers* 2, 1972, 41ff.; Annabelle Simon Cahn, "Some Cosmological Imagery in the Decoration of the Ceiling of the Palatine Chapel in Palermo," Ph.D. diss., Columbia University, 1978; Nora Nercessian, "The Cappella Palatina of Roger II: The Relationship of Its Imagery to Its Political Function," Ph.D. diss., UCLA, 1981, 152ff.; Francesco Gabrieli and Umberto Scerrato, *Gli arabi in Italia*, Milan, 1985, 359ff.; David Gramit, "The Music Paintings of the Cappella Palatina in Palermo," *Imago Musicae: International Yearbook of Musical Iconography* 2, 1985, 9ff.; Staale Sinding-Larsen, "*Plura ordinantur ad unum*: Some Perspectives regarding the 'Arab-Islamic' ceiling of the Cappella Palatina at Palermo (1132–1143)," *Acta ad archaeologiam et artium historiam pertinentia* 7, 1989, 55ff.

On the origins and development of muqarnas, see Ernst Herzfeld, "Damascus: Studies in Architecture I," *Ars Islamica*, 9, 1942, 1ff.; Lucien Golvin, *Recherches archéologiques à la Qal'a des Banu Hammad*, Paris, 1965, 124ff.; Henri Terrasse, *La mosquée al-Qaraouiyin à Fès*, Paris, 1968, 31ff.; Yasser Tabbaa, "The Muqarnas Dome: Its Origin and Meaning," *Muqarnas*, 3, 1985, 61ff.; Charles Wilkinson, *Nishapur: Some Early Islamic Buildings and Their Decoration*, New York, 1986, 242, 251ff.; Jonathan M. Bloom, "The Introduction of the Muqarnas into Egypt," *Muqarnas*, 5, 1988, 21ff.

[105] Mention should be made here of the hypothesis advanced by Trizzino that the nave ceiling was not an original feature of the chapel but a later addition, which has been reiterated by Brenk; see Trizzino, "*La Palatina*", 34; Brenk, "La parete occidentale della Cappella Palatina a Palermo," *Arte medievale*, ser. 2, 4, 1990, 148 n. 50. The hypothesis is not sustainable based on the evidence published heretofore.

[106] Trizzino, "*La Palatina*", figs. 87 and 88.

[107] Monneret de Villard, *Soffitto*, 22ff.

meets the eye: most of the architectural form and much of the painting is thoroughly visually consistent and it would be imprudent not to consider it authentic. In other words, as useful as it would be to have a modern analysis of the ceiling, documenting the original surface with a precision that we cannot now claim, lacking such an analysis does not preclude an attempt at historical contextualization. It only bids us to proceed with caution.

There is another deficiency here, however, that is more serious in its implications. "Il caso di Palermo non ha precedenti": thus Monneret de Villard summed up the art historical situation that he was able to reconstruct for the ceiling over forty years ago.[108] Even given our research and discoveries since then, we are in a very different position with the ceiling vis-à-vis tradition than we were with the mosaics in the sanctuary. Like the mosaics, the ceiling has the feel of an elemental form from another context, taken over like some elaborate quotation. But we know little about possible contexts, especially in the Muslim world. The evidence of twelfth-century Islamic monumental arts on the order of the ceiling is so scarce, in fact, that some Islamicists have used the ceiling to reconstruct the indigenous situation—whether in Iraq or Egypt or North Africa—treating it as if it were a work of pure Islamic art. But we are interested in elucidating the significance of the ceiling in the Norman palatine context, for which developments in the Islamic world in the twelfth century, independently attested, would have served as a most useful frame of reference.

I for one would not be surprised if Pavloskij, Monneret de Villard and Ettinghausen were right, and that the primary inspiration for the ceiling came from Fatimid Egypt.[109] The closest parallel to the muqarnas frame of the palatine ceiling comes from the ruins of the Bath of Abu'l-Suʿud in Fustat (fig. 70).[110] The muqarnas found there, dated to the eleventh century, is made of plaster and is now in fragments. Nonetheless, in both its form and its remarkable decoration of rinceaux, paired birds, a drinker and a dancer, and beaded borders around the edges of the compartments, it finds extraordinarily close analogy in the nave ceiling of the Cappella Palatina. Indeed it goes the farthest of any of our evidence toward explaining the context from which the design of the chapel ceiling derived. Another example comes from the other end of the Islamic world, from the al Qarawiyyan mosque in Fez (fig. 71).[111] The

[108] Monneret de Villard, *Soffitto*, 26.

[109] Pavloskij, *Zhivopis'*, 174ff.; Monneret de Villard, *Soffitto*, 48; Ettinghausen, "Fatimid Period," 113ff. See also Golvin, *Qalʿa des Banu Hammad*, 127; Heinrich Gerhard Franz, *Von Baghdad bis Cordoba: Ausbreitung und Entfaltung der islamischen Kunst, 850–1050*, Graz, 1984, 112. A number of comparisons to the chapel ceiling may be made with Fatimid ceramics and wood carving. For examples of the latter in addition to the catalogue of the Musée de l'art arabe du Caire, *La céramique égyptienne de l'époque musulmane*, Cairo, 1922, see Esin Atil, *Freer Gallery of Art Fiftieth Anniversary Exhibition III: Ceramics from the World of Islam*, Washington, D.C., 1973, 128ff., nos. 57ff; Helen Philon, *Early Islamic Ceramics, Ninth to Late Twelfth Centuries*, Westerham, Kent, 1980, passim, and the discussion of Mirjam Gelfer-Jørgensen, *Medieval Islamic Symbolism and the Paintings in the Cefalù Cathedral*, Leiden, 1986, 114ff., and figs. 58–60. See also below, chapter 3, pp. 101ff.

[110] Janine Sourdel-Thomine and Bertold Spuler, *Die Kunst des Islam* (=*Propyläen Kunstgeschichte* 4), Berlin, 1973, 262, pl. 34a and b, and Bloom, "Muqarnas," 21, fig. 4. See also Ettinghausen, "Fatimid Period," 112ff.

[111] Henri Terrasse, "La mosquée d'al-Qarawiyyin à Fès et l'art des Almoravids," *Ars Orientalis* 2, 1957, 135ff., esp. 143ff.; idem, *Mosquée*, 23ff., figs. 21ff., pls. 28ff. See also the late tenth- or eleventh-century fragments of muqarnas from Sabz Pushan

mosque is an older construction, but it underwent a phase of substantial rebuilding in the mid-twelfth century (1135–43), which included the addition of an elaborate, double bay muqarnas vault to its nave. The vault is executed in plaster with incised relief, and contains no figurative decoration, but its configuration of cusped compartments matches that of the palatine muqarnas rather closely.[112] Figural decoration is also omitted in the third example that has also been cited in this context, from the Qal'ah of the Beni Hammad in Algeria.[113] Fragments of cusp-shaped compartments, dated to the late eleventh century, have been discovered at this site, which have been plausibly reconstructed as a muqarnas vault, for which the composition of the palatine ceiling has provided a close parallel. All of these examples, of course, have a bearing on only a part of the palatine ceiling—the muqarnas frame. There are no equally close comparanda for the field of the star-shaped compartments from any of these contexts.

There is, however, the fact that the Cappella Palatina ceiling is so richly painted. This painting consists largely in single figures or small groups, dancers, drinkers and musicians, a pair of women looking out of a balcony, a group of chess players, lions, birds and some other strange-looking beasts.[114] Apart from a few misguided efforts to read some of these images in Biblical terms, it is the scholarly opinion that this is not a religious cycle, nor is it developed sequentially or linearly.[115] The pleasures depicted are distinctly earthly, even courtly, and an important clue to their meaning lies in one of these figures. The figure occurs not once but seven times in the muqarnas frame (to no discernible pattern): a seated ruler, cross-legged on a low platform, dressed in a caftan, wearing a three-pointed crown, and flanked by servants (fig. 72).[116] The stylistic presentation of the figure is clearly Islamic, but the physiognomy is not. As Johns has observed, the face, hairstyle and beard of the figure are "European," and contrast sharply with the look of many of the other figures on the ceiling (fig. 73). This ruler

---

(Wilkinson, *Nishapur*, 251ff.), or the muqarnas of the Great Mosque at Marrakesh, dated 1146–62 (Sourdel-Thomine and Spuler, 284f., fig. 228).

[112] One significant difference between the two ceilings, however, must be mentioned. The compartments of the vault at Fez are demarcated by miniature columns, which are lacking in the ceiling of the Cappella Palatina; see Terrasse, *Mosquée*, pl. 29.

[113] Golvin, *Qal'a des Banu Hammad*, 123ff., pls. XLV–XLVII.

[114] Monneret de Villard, *Soffitto*, 34ff. But see also the iconographic discussion of H. P. L'Orange, *Studies on the Iconography of Cosmic Kingship in the Ancient World*, Cambridge, Mass., 1953, 69ff., and Francesco Gabrieli and Umberto Scerrato, *Gli arabi in Italia*, Milan, 1985, 391ff.

[115] The imagery on the ceiling does not appear to have been distributed to take into account or give emphasis to any single location, or architectural feature or point of view in the chapel. For a graphic

diagram of the locations of subjects, see Gramit, "The Music Paintings," 37ff.

[116] On the iconography of the seated ruler in the Islamic world, see Ernst Herzfeld, *Die Malereien von Samarra*, Berlin, 1927, 38ff.; Ernest Kühnel, *Die islamischen Elfenbeinskulpturen VIII–XIII. Jahrhundert*, Berlin, 1971, 39ff., 70ff., nos. 32, 35 and 90 (late tenth/early eleventh, late eleventh/early twelfth centuries); Emel Esin, "Oldrug-Turug: The Hierarchy of Sedent Postures in Turkish Iconography," *Kunst des Orients* 7, 1970–71, 3ff.; Dorothy G. Shepherd, "Banquet and Hunt in Medieval Islamic Iconography," *Gatherings in Honor of Dorothy E. Miner*, ed. Ursula E. McCracken et al., Baltimore, 1973, 79ff.; R. H. Pinder-Wilson and C.N.L. Brooke, "The Reliquary of St. Petroc and the Ivories of Norman Sicily," *Archaeologia* 104, 1973, 277ff. One example attributed to the Palace of the Fatimids in Cairo is illustrated by Edmond Pauty, *Les bois sculptées jusqu'à l'époque ayyoubite: Catalogue général du Musée du Caire*, Cairo, 1931, pls. XLVI–LVIII, LX, LXI.

can be none other than King Roger himself: what other Western king in Eastern garb could Roger have tolerated seven times in his chapel on the ceiling under which he repeatedly sat or stood?

The figures have often been spoken of as if they covered the entire ceiling, but as André Grabar has pointed out, they are concentrated in the muqarnas frame, to the exclusion of the panel of stars.[117] As a compositional precedent, Grabar adduced the figure frieze of classical wall painting, like the famous Odyssey landscapes now in the Vatican Museum, often located near the top of the wall and serving as a transitional element between wall and ceiling. But the distinction is also important in the context of Philagathos's description. Philagathos, it will be recalled, spoke of the ceiling, "adorned with fine carvings variously worked in the form of little baskets, and gleaming all over with gold, it imitates the heavens when the peaceful night air shines with the choir of stars."[118] The term, "little basket" (καλαθίσκος), was also used for lamps in the Middle Ages, and although I do not want to suggest that Philagathos was being overly precise, what he was clearly focusing on here was the central compartment. In other words, I do not think that his text can be used to support an interpretation of the entire ceiling as a heavenly or astrological scheme, replete with the constellations, as has been done. Rather, in the distinction between field and frame the ceiling embraces both heavenly and earthly realms, not as entities in the abstract, but the actual heavens (in the stars) as they overarched Roger's own kingdom (in the muqarnas).

What must have been intended to bring this message home, at least to the Arabic-speaking viewer, finally, were the numerous Kufic inscriptions. These line the frames of the central stars in a non-narrative (non-sequential) litany: "health," "blessing," "good fortune," "power," "magnificence," "prosperity," "perfection."[119] They repeat themselves, like the figures in the muqarnas frame, intertwining to form a dense network of overlapping, interpenetrating and mutally supporting associations and concepts. What is lacking here is the subject—or is it? Something is "health," something "power," something "magnificence," and so on. How could this be other than the regnum of Sicily under Roger's rule, where the pleasures and perfections of life, by the very nature of the rule, were guaranteed. This is what is represented in images in

---

[117] A. Grabar, "Image," 232. The eight-pointed stars of the central field are decorated largely with later depictions of Christian saints; see Monneret de Villard, *Soffitto*, 22.

[118] Philagathos, "Sermon 27," 174. Simon Cahn has collected other examples of medieval ceilings that have been compared in contemporary sources to the heavens; Simon Cahn, "Some Cosmological Imagery," 48ff.

[119] This list contains only a selection of the surviving inscriptions, an entirely new group of which, I am informed by Monsignor Rocco, has recently been discovered in a survey to assess the condition of the ceiling. The new inscriptions match ones previously known, with the exception of two texts in the south aisle. These texts are not isolated words,

but form sentences. They have not been transcribed. Monsignor Rocco has informed me in addition that there is what appears to be a name inscribed beside the figure of a dancer, in two separate panels of the ceiling. For the published inscriptions, see Andrea Terzi, *La Cappella di S. Pietro nella Reggia di Palermo*, Palermo, 1889, vol. 1, parte IV, cap. II, "Epigrafi arabiche della R. Cappella. Soffitto della navata maggiore," paginated separately from text; Monneret de Villard, *Soffitto*, 31ff.; Michele Amari, *Le epigrafi arabiche*, 47ff.; Janine Sourdel-Thomine, "Le style des inscriptions arabo-siciliennes à l'époque des rois normands," *Etudes d'orientalisme dédiées à la mémoire de Levi-Provençal*, Paris, 1962, 307ff.; Sinding-Larsen, "Plura ordinantur," 63ff.

the muqarnas frame, the "pleasures of days and nights without cease and change," to quote the Kufic inscription from the hem of Roger's mantle. There is no true parallel in the Islamic world to such a combination of words and images (as Sinding-Larsen has observed the inscriptions here do not have their source in the Koran, and it has been something of red herring to adduce the Muslim "princely cycle"), because the theme was a Western one, and of long standing: the peace and prosperity of the kingdom, for which all should be grateful, as an emanation of the virtue of the king.[120] The ceiling was not just a hymn of praise, but a call for gratitude on the part of those who saw it. Such a sentiment, I suspect, may once have been expressed more explicitly.

The one part of the ceiling for which there is no accounting today is the cavetto molding that runs around the base of the muqarnas (figs. 8 and 55). In large part original, it must have had some decoration before it came to bear the Angevin inscription of 1478, but whatever it might have been has been blotted out. Could it have been an inscription? This would make sense for two reasons. Such moldings or bands are found quite commonly in Islamic architecture, at precisely this point, the base of the ceiling—examples from Nishapur, Algeria and Marrakesh come to mind—and there they often serve as the locus for a monumental inscription.[121] On the other hand, given the impact that such an inscription might have had on the chapel, it would be no surprise that it would have been removed in post-Norman times, when the Christian nature of the edifice was highlighted even more clearly, and hence the purpose of the Angevin text at this point might also be explained.

It is curious to observe that the ceiling bears a relationship to tradition similar to that of the mosaics of the sanctuary: like the mosaics, the ceiling clearly derives from a formal world that was the creation of another cultural context, but the forms here have been shaped to express new themes. Like the mosaics, the ceiling turns inward, although its images and words do not so much revolve around a central point as float in the air, seeming to make up the very atmosphere that one breathes. Like the mosaics, it is also systematic, although its system was of the earthly, that is to say physical, and not the heavenly or spiritual order. And like the mosaics, it was the product of craftsmen brought in from the outside to execute these forms, which is the final point that I would like to make.

That Byzantine mosaicists were primarily responsible for the laying of the tesserae in the sanctuary has been been argued on the basis of style.[122] A similar argument can

---

[120] The categories in which medieval Islamic imagery has been analyzed seem too rigidly defined in any case, and perhaps should be reconceptualized; see Oleg Grabar, "Les arts mineurs de l'orient musulman à partir du milieu du XIIe siècle," *Cahiers de civilisation médiévale* 11, 1968, 186ff. on the six types of medieval Islamic images; idem, "Imperial and Urban Art in Islam: The Subject Matter of Fatimid Art," *Colloque international sur l'histoire du Caire, 27 mars–5 avril, 1969*, Cairo, 1972, 173ff. (repr. in idem, *Studies in Medieval Islamic Art*, London, 1976,

no. VII).

[121] George Marçais, *Coupole et plafonds de la grande mosquée de Kairouan*, Paris, 1925, pls. 4ff. (ninth century); Hoag, *Islamic Architecture*, fig. 250 (Gulpayyan Mosque, early twelfth century), fig. 171 (Cairo, Mosque of al-Azhar, 1131–49). Oleg Grabar, *The Mediation of Ornament*, Princeton, 1992, 47ff., discusses some of the aesthetic and programmatic implications of these inscriptions.

[122] Ernst Kitzinger, "Two Mosaic Ateliers in Palermo in the 1140s," *Artistes, artisans et production ar-*

be made for the ceiling of the nave. The nave ceiling is a most complicated geometrical and physical construction whose closest comparisons, as we have already observed, are to be found now in Egypt and North Africa. There is nothing on the island of Sicily from either before or during Roger's reign that would suggest the existence of an indigenous architectural tradition of the requisite skill and quality. Similarly, the painting on the ceiling finds its closest parallels in works of art—albeit not in a monumental vein—from Egypt and North Africa, certain examples of which are strikingly close (fig. 74).[123] The one other case of ecclesiastical ceiling painting of this kind, from the nave of the Cathedral of Cefalù, only serves to underscore, in the awkwardness of its execution, the fact that the painters of the Cappella Palatina had the style, the imagery and hence the tradition in their blood.[124] The Cefalù paintings, which are later than the chapel decoration in date, were doubtless painted as quotations by artists who were looking at these figures from the outside—who had no intuitive grasp of the internal principles of their construction (fig. 75). It was not just that Roger's chapel brought together different art forms, therefore; it actually yoked together culturally distinct groups of people in the service of the king, reiterating in microcosm the very structure of Roger's state.

One word in conclusion about the aisles of the chapel. Their low, sloping ceilings are related to the ceiling of the nave but have, by contrast, a much simpler form, and thus serve clearly to characterize the aisles as a secondary space (fig. 76).[125] In each case, the broad rectangle of the ceiling is deeply excavated at regular intervals by oblong channels bearing ornamental and figurative decorations, both of which have been heavily restored. The figural component of the decoration appears to recapitulate at least one of the themes of the imagery of the muqarnas in its drinking and music-making figures.

## LATER ADDITIONS

### The Mosaics of the Nave and Aisles

The largest, most often reproduced, and presumably best known mosaic in the western portion of the Cappella Palatina is the panel of Christ flanked by Peter and Paul, which will be examined in the context of the throne platform (fig. 83). The mosaics adjacent to it will form the focus of the present discussion. These mosaics display two main subjects: an Old Testament cycle in two registers that run along the walls of the

*tistique au moyen âge: Colloque international, Centre National de la Recherche Scientifique, Université de Rennes II, Haute-Bretagne 2–6 Mai 1983*, ed. Xavier Barral i Altet, vol. 1, *Les hommes*, Paris, 1986, 277ff.

[123] See above, n. 109. Monneret de Villard, *Soffitto*, 49ff.; Ettinghausen, "Fatimid Period," 112ff.; Gabrieli and Scerrato, *Gli arabi*, 373ff.

[124] Cf. Gelfer-Jørgensen, *Medieval Islamic Symbol-*

*ism*, 17ff., and Gabrieli and Scerrato, *Gli arabi*, 360. On the Cefalù paintings, see also Vladimir Zorić, "Considerazioni analitiche sulla construzione della cattedrale normanna di Cefalù," *La Basilica Cattedrale di Cefalù: Materiali per la conoscenza storica e il restauro*, vol. 1, Palermo, 1989, 313ff., with bibliography.

[125] Monneret de Villard, *Soffitto*, 22ff.

nave above the colonnade, and a cycle of scenes from the lives of the apostles Peter and Paul between the windows of the aisles. In addition, there are a number of single figures arrayed in groups, holy bishops and holy women in the spandrels of the colonnade on the nave and aisle sides of the arches respectively, medallions with portraits of saints at the tops of the nave arches, busts of saints on the arch soffits, not to mention the decorated borders and other ornamental motifs.[126]

Both Demus and Kitzinger have indicated, insofar as it is possible to do so by visual analysis abetted by documents, the places where restorations, that is to say postmedieval interventions into the mosaics, have occurred, and they are quite extensive.[127] As we have already had an opportunity to observe, a most striking change took place in the upper reaches of the north wall of the nave, where three entire scenes (Lamech and his wives, the Assumption of Enoch and the Family of Noah) and parts of two others (the Reproval of Cain and the Building of the Ark) were created in the late eighteenth century. But there is little else in the ensemble that has not been touched in some way by the restorer's hand. In places, these restorations have been "signed" with a coat of arms or an inscription (figs. 12 and 77). More commonly it would seem that they were not, and it is to be hoped that close visual examination will one day be suppported by technical analyses of the mosaics.[128] As things stand now, however, visual determinations must serve as a foundation for our discussion, which will concentrate on one point, namely, the nature of the relationship between the mosaics of the nave and aisles and those of the sanctuary.

Simply on the grounds of choice and placement of subjects alone there are several good reasons to believe that the entire mosaic decoration of the Cappella Palatina through sanctuary and transept arms, aisles and nave formed a single, coherent program that was conceived when the chapel was first built under Roger II. Narrative cycles of scenes from the Old and New Testaments were among the most common subjects for church decoration in the Middle Ages, and to dispose them as here—New Testament in the sanctuary and Old Testament in the nave—would have been to follow a time-honored tradition, especially in Italy.[129] The argument has also been made that one of these scenes may have been placed in a such a way as to render it a kind of commentary on the relationship between the two parts of the Bible thus situated. The scene is the Presentation of Christ in the Temple, which decorates the western arch of the sanctuary, that is, the arch separating sanctuary and nave. Kitzinger has observed that this scene in the Cathedral of Monreale, which occupies a similar place on the western arch of the choir, may have been understood together with the scene of Christ among the Doctors placed beside it as the triumph of Christ over representatives of the Old Law.[130] Thus it may have been appropriate that it was

---

[126] The mosaics are described and fully catalogued by Kitzinger, *I mosaici*, fasc. 2.

[127] Demus, *Norman Mosaics*, 30ff.; Kitzinger, *I mosaici*, fasc. 2, 15ff.

[128] Demus's observations have been at least partly confirmed by the analyses of Maria Andaloro.

[129] Demus, *Norman Mosaics*, 195ff.; Kitzinger, *I mosaici*, fasc. 2, 9ff.; William Tronzo, "I grandi cicli

pittorici romani e la loro influenza," *La Pittura in Italia: L'altomedioevo*, ed. Carlo Bertelli, Milan, 1994, 355ff.

[130] Kitzinger, "The Mosaics of the Cappella Palatina in Palermo," 281f. and also n. 40. On the placement of the scene of the Presentation in the christological cycle, see also Alberto de Capitani d'Arzago, "Gli affreschi di S. Maria di Castelseprio," in *Santa*

placed in a position that would have enabled it to serve as a link as well as a divide between sanctuary and nave—in other words, between the realms of the New Testament narrative of the sanctuary and the Old Testament of the nave. Such a meaning, Kitzinger reasons, may well have adhered to the Presentation in the Cappella Palatina—even though putting the scene likewise on the western arch of the choir meant isolating it somewhat from the rest of the christological cycle. Since sanctuary mosaics in the chapel were completed first, the presence of the scene may imply the existence of the Old Testament program already in the mind of the designer of the chapel decoration. It was also the case that Peter and Paul were the dedicatees of the chapel, a fact that would have amply justified the inclusion of a cycle of scenes from their lives.

But there is also good reason to believe that the mosaics in the western portion of the chapel were later than those of the eastern portion in date. The locus classicus of the discussion is the passage in Romuald of Salerno's chronicle that mentions a gift of mosaics made by King William I (1154–66) to the chapel. The reference, admittedly, is not very specific—"mirabilis musidii fecit pictura depingi," without any further hint as to location or subject. Nonetheless it has often been assumed that the text refers to the mosaics of the nave and aisles—an assumption, as Demus points out, that would make very good stylistic sense.[131]

Although one cannot speak of a sharp line of demarcation or an abrupt break between the mosaics of the eastern and western portions of the chapel, there is clearly a development that may be observed in the style of motifs and figures and in the composition of scenes.[132] Demus has characterized this development in terms of certain preferences that become more accentuated as one proceeds westward in the chapel: for broader and flatter forms in general, for instance; for broken curves and tangential lines in the modelling of drapery; for placid, facial expressions; for purely decorative details, and materials like mother of pearl; and for increasingly strident colors—in other words, for the complete dilution of the organic feel and communicative power of the art of the workshop that operated in the Cappella Palatina in the 1140s (figs. 80 and 81). If this workshop that began in the chapel in the 1140s was made up essentially of Byzantine craftsmen—as Kitzinger has argued—then one possible explanation for these changes would be the one that Demus has offered: the injection into the project of different, possibly non-Byzantine or even local, personnel.

Be that as it may, the styles of nave and aisles themselves are not entirely uniform, and so it is necessary here too to think in terms of some difference, either of artists or dates or perhaps even models.[133] Demus has proposed a chronology that would place the aisle mosaics slightly later than those of the nave—in the 1160s to early 1170s as opposed to the 1150s to 1160s for the nave—for which he has sought support in the mosaics of Cefalù. The figures of Ananias in the scene of the Baptism of Paul in the Cappella Palatina and of Hosea at Cefalù, for example, are remarkably similar in their

*Maria di Castelseprio*, ed. Gian Piero Bognetti, Gino Chierici and A. de Capitani d'Arzago, Milan, 1948, 602f.

[131] Romuald of Salerno, 254; Demus, *Norman Mosaics*, 54ff., esp. n. 246. See also the review of

Demus, *Norman Mosaics*, by Ernst Kitzinger in *Speculum* 28, 1953, 147ff.

[132] Demus, *Norman Mosaics*, 51ff.

[133] Kitzinger, *I mosaici*, fasc. 2, 14f.

modelling and proportions, and have many of the same details, such as the small loop of drapery to the left above the waist (figs. 78 and 79). It is difficult to imagine that these figures were separated by many years in date. But the chronology of Cefalù itself must be established with greater certainty before it can be used as evidence. The date of 1148 recorded in the apse inscription has generally been taken as the starting point for the decoration, but how the work proceeded from there is still an open question.

On the other hand, Demus's dating cannot be excluded, and there is one more objective criterion that lends it some support. By the late 1170s a new workshop with an entirely different approach to form had arrived in Sicily to decorate the great Cathedral of Monreale. Of the new style that it practiced—spirited, emotionally engaging and coloristically sophisticated—there is not the slightest trace in the mosaics under discussion here.[134] The possibility of chronological overlap without intermingling, of course, is not out of the question. But it is more likely that the nave and aisle mosaics of the chapel had already been finished by the time the Monreale project began, which would accord with the chronology that Demus has proposed: the period of William I for the mosaics of the nave and aisles, with the possibility that the work continued into the later 1160s or even the early 1170s.

When we speak about a unified plan for the mosaics of the chapel, therefore, we are talking about a program that was executed unaltered over the course of several generations, with attendant changes of executant personnel and patron—which in itself is not out of the question. On the other hand, the programmatic observations adduced earlier are not sufficient to bear the weight of this conclusion. Indeed it is possible that the scene of the Presentation may have functioned as a kind of hinge between sanctuary and nave. But it could also have been intended at first to stand as a narrative scene in its own right: witness the church of St. Mary's of the Admiral, for instance, with Presentation on the western arch, where there were never Old Testament scenes to the west. Nor is it entirely certain when the Cappella Palatina was first dedicated to Peter and Paul. Philagathos assumes the dual dedication in the late 1140s or early 1150s—"most beautiful Temple of the Apostles" is how he refers to the chapel in the proemium of his sermon. But in the first two extant documents to speak about the chapel—the charter of foundation, which was issued in 1140, and the inscription at the base of the dome of 1143—both offered essentially as pronouncements of the king, only one dedicatee is mentioned, St. Peter.[135] A parallel depiction of the two saints in the aisles, though not excluded by the dedication of the chapel to only one of the saints, would nevertheless not have had as clear-cut a rationale.[136]

But the most serious obstacle to regarding the present mosaics of the nave and aisles as having been planned from the very beginning of the chapel lies in the remarkable way in which they are situated. In the case of the Old Testament scenes of the nave,

[134] However, see below, pp. 70ff.

[135] See above, chapter 1, p. 15, and n. 33.

[136] See the remarks of Kitzinger, *I mosaici*, fasc. 2, 10f.; also the iconographic discussion of Hélène Toubert, "Un nouveau témoin de la tradition illus-tré des actes des apôtres: Les fresques romanes découvertes à l'abbaye de Nonantola," *Cahiers des civilisations médiévales* 30, 1987, 227ff. (repr. in idem, *Un art dirigé: Réforme grégorienne et iconographie*, Paris, 1990, 403ff.).

the panels in the upper zone are fairly regular in their size and shape, thus allowing for a presentation of the scenes that is straightforward and clear. In the lower zone, however, figures are often abruptly cut off by the arches of the nave colonnade (the Three Angels in the Hospitality of Abraham, the Creator in the Sacrifice of Abraham, or Rebecca at the Well), or, so situated that they seem about to walk into a void (the animals leaving Noah's ark, Rebecca led away on a camel; figs. 80 and 81). Similarly, in the aisles, there are a number of overlaps that are quite clumsy or intersections of figures that are confusing, suggesting that the compositions of the scenes have been unduly compressed: witness the blinded Saul who stands in front of another image of himself being led away to the city of Damascus, which in any case is placed behind the figure and not facing him as his goal; or the guard in the scene of Paul's escape who, because he must turn away from the main action of the scene, appears to be participating in the episode of Paul's preaching that takes place to his immediate right.[137] In addition, figures involved in the same scene are also occasionally divided rather awkwardly, like Peter and his rescuing angel who are placed on adjoining walls.

Clearly the designer of the decoration sought to implement a scheme that had long been common for the decoration of the walls of the nave and aisles of a basilica, that is, a grid with either one or two registers into which were then placed the various narrative scenes.[138] It is equally apparent that he did not always have the proper amount or kind of space to do so. The scheme worked well enough in the clerestory zone of the nave, where the individual panels could be inserted between the windows. But the wall surface that was then left over below in the spandrels of the arches was considerably less accommodating: a series of spaces with steeply curving sides, narrow bottoms and wide tops. Nonetheless the mosaicists simply put in these spaces the same content that they had inserted into the panels above, that is, narrative scenes whose compositions had been generated for a rectilinear grid. But these compositions had to be cut to fit. In the aisles, the available wall space between the windows had a somewhat different shape. It was narrow and high, so that the problem here was not the cutting off but the compressing and lengthening of the various elements of the scenes. Hence the ungraceful and at times confusing results.

If both architecture and mosaics for the nave and aisles had been planned together in the Cappella Palatina—an assumption that is at least implied in the view that narrative scenes had been intended for the western part of the chapel from the very beginning—one could have expected more of a fit. In particular one could have expected the arches of the nave colonnade to have been less highly stilted, thus leaving a more appropriate wall surface for the implementation of a double register of narrative scenes, and the walls of the aisles to have had more accommodating panels. This was precisely the case, for instance, in the Cathedral of Monreale. The design of Monreale, though later than the Cappella Palatina and based in part on this earlier model,

[137] Demus, *Norman Mosaics*, figs. 40A and 41A.
[138] The system of decoration is discussed by Demus, *Norman Mosaics*, 200ff. On the iconography, see Ernst Kitzinger, "The Arts as Aspects of a Renaissance: Rome and Italy," in *Renaissance and Renewal in the Twelfth Century*, ed. Robert L. Benson and Giles Constable, Cambridge, Mass., 1982, 665; Kitzinger, *I mosaici*, fasc. 2, 10.

is instructive in this regard. As it has often been stressed, Monreale was the result of planning in tandem—of architecture and mosaics—and thus provides an example of the degree of integration that could be achieved in a twelfth-century Norman church. Significantly enough, nowhere in the Cathedral are the figures in the mosaics cut in half so brutally or compressed so awkwardly as they are in the nave and aisles of the Cappella Palatina (fig. 82). That a balance of media is lacking in this part of the chapel suggests that the opposite was the case: that architecture and decoration had not been planned together, and decoration entailed working around an existing framework that was not well suited to the forms that were then put into it.

There is also a hermetic quality to the decorations of both the eastern and western portions of the chapel that supports this disjunction. The position and possible meaning of the Presentation in the Temple notwithstanding, the main thrust of the decoration of sanctuary and transepts is north to south. There is precious little here—and even less from the twelfth century than now exists, as we shall soon see in our analysis of the three apses—that makes an appeal to a viewer standing in the nave. Likewise, in the nave and aisles, notwithstanding the movement implied by the two narrative cycles, a number of elements turn the ensemble in upon itself. Most of the saints on the soffits of the arches, for instance, are Roman in origin, and the soffit designs themselves—which are different from the ones used in the sanctuary—are paired laterally across the width of the nave. Roman too may have been the model for the Old Testament sequence, and the scenes from the lives of Peter and Paul.

We may conclude, therefore, that the mosaics of the nave and aisles, far from being planned for the chapel from the very beginning, were retrofitted, as it were, onto walls that had been designed to serve another purpose. As to what the original purpose might have been, unfortunately, we do not have many clues.[139] In light of the foregoing remarks on the figures in the mosaics, perhaps a purely ornamental decoration would have been more appropriate, and it is interesting to observe that Philagathos in his sermon implies that the nave of the chapel was ornamented with cloth hangings or tapestries. After orienting the listener by giving him a view of the chapel as a whole, Philagathos discusses first the sanctuary and then the nave, of which he says: "Many tapestries were also hung there. These had been made by Phoenicians, who had woven the cloth from a multi-colored silk intertwined with strands of gold, with a truly marvelous and unusual skill."[140] These hangings, of course, would have been part of

[139] Demus, *Norman Mosaics*, 47 n. 221, speculates that the nave was originally painted, adducing the discovery, reported by Pasca, of plaster painted with colored figures underneath the mosaics. The compositions of medieval mosaics, however, were often worked out in colored underpaintings. For the passage in Pasca, see *Descrizione*, 88ff.

[140] Philagathos, "Sermon 27," 175. Lavagnini suggests that the term "Phoenician" was used by Philagathos to signify Muslim manufacture (*Profilo di Filagato*, 10 n. 1). See Romuald of Salerno, 33, for contemporary usage. Could it also have been used

to signify the color purple? See G. Casson, "Phoenicians and the Purple Industry," *Antiquary*, 1913, 328ff. On medieval customs regarding the use of tapestries, see W. G. Thomson, *A History of the Tapestry from the Earliest Times Until the Present Day*, London, 1906, 44ff.; Jean Ebersolt, *Le grand palais de Constantinople et le livre de cérémonies*, Paris, 1910, 83, 87; Percy Ernst Schramm and Florentine Mütherich, *Denkmale der deutschen Könige und Kaiser: Ein Beitrag zur Herrschergeschichte von Karl dem Grossen bis Friedrich II. 768–1250*, Munich, 1962, 40ff.

the outfitting of the chapel for special occasions.[141] But of the places where it could be imagined that they were hung—such as on the nave or aisle walls or between the columns—it is difficult to believe that they would not have covered a significant part of the structure in some way, which in turn implies a decoration of lesser (i.e., ornamental) rather than greater (i.e., figural) purport, which was capable of being hidden at such an important time.

### The Throne Platform, West Wall Decoration and Two Aisle Doors

The Cappella Palatina contains two places that were made specifically for the use of the king: the balcony in the northern transept arm, discussed earlier, and the throne platform set against the western wall of the nave, which dominates, or perhaps more accurately, overwhelms the interior of the chapel (figs. 9, 83, and 84; plate VIII). This structure resembles a king's throne, but was clearly intended to serve only as a backdrop for the presence of the king. Almost everything about it, however, makes determining its origins problematic, from the mosaic of Christ flanked by Peter and Paul above the platform proper, which has been dated to a period after Roger's death, to the throne form itself, which is so obviously a restored work. Various dates, in fact, have been put forth for the structure, or parts of it, ranging from the twelfth through the eighteenth centuries (with even later alterations), leaving one question, above all, hanging in the balance: what would have been the significance of two royal places in the Cappella Palatina, with their different levels and axes of view?[142] This question, which raises an issue critical to our understanding of the function of the chapel, will be addressed in chapter 3. The goal of this section, however, is to set forth the evidence for the chronology of the throne platform and the western wall of the nave in the twelfth century.

What I refer to as the throne is composed of two elements—a low platform and the decoration on the wall behind it. The platform, constructed of the same cipollino used throughout the pavement, is 234 cm long and 697 cm wide at the farthest edge of its lowest step. It extends from the rear wall of the chapel to edge of the second pair of columns of the colonnade (counting from the west), spans the entire width of the nave, and is raised above the level of the nave floor by five steps. These steps are decorated with geometric designs executed in opus sectile, as is the floor of the platform itself (figs. 23 and 98). The opus sectile design continues onto the west wall of the

---

[141] It is interesting to note the following item recorded in the 1309 inventory of the Cappella Palatina: "Item Tappeta tria vetusta, duo magna, unum parvum"; see Garofalo, *Tabularium*, 98. See also the remarks of Alexander of Telese on the outfitting of the Norman palace for the coronation of Roger II: "Palatium quoque regium undique interius circa parietem palliatum glorifice totum rutilabat. Solarium vero ejus multicoloriis stratum tapetis terentium pedibus largifluam praestabat suavitatem"; Alexander of Telese, 103.

[142] Demus, *Norman Mosaics*, 52ff., 69 n. 201; Kitzinger, "The Mosaics of the Cappella Palatina,"

284 n. 88; Deér, *Porphyry Tombs*, 55, esp. n. 44; Slobodan Ćurčić, "Some Palatine Aspects of the Cappella Palatina in Palermo," *Dumbarton Oaks Papers* 41, 1987, 140ff.; Brenk, "La parete," 135ff.; Antonio Cadei, "*Exegi monumentum aere perennius*: Porte bronzee di età normanna in Italia meridionale e Sicilia," *Unità politica e differenze regionali nel regno di Sicilia: Atti del convegno internazionale di studio in occasione dell'VII centenario della morte di Guglielmo II, re di Sicilia (Lecce-Potenza, 19–22 aprile 1989)*, ed. Cosimo Damiano Fonseca et al., Galatina, 1992, 147; Kitzinger, *I mosaici*, fasc. 2, 16ff.

chapel, where it forms an enormous pedimented throne back, surmounted by a rinceaux with two lions in medallions executed in mosaic (fig. 84). Directly above the panel is another mosaic showing the enthroned Christ flanked by Peter and Paul—the most grandiose image in the entire chapel with the largest figures by far (fig. 83).

At first glance—and viewed head-on from a vantage point in nave—the platform and the decoration of the western wall behind it make a perfectly plausible and coherent ensemble. The platform itself is contained within, indeed its dimensions appear to have been generated from, the very architecture of the chapel and the western wall rises above it to make an obvious backdrop. None of the subdivisions of the wall or floor that create the composition, or the images, decorative motifs or frames continue onto the portions of wall adjacent to the platform on either side. Thus it is also well circumscribed. What might have been the rationale of the ensemble, too, is easily discerned. The large pedimented form is a fastigium, an honorific frame that was often used to define the place of the earthly ruler,[143] and the image above clearly delineated the sphere of the heavenly overlord. Taken together—and imagined with the king standing or seated in front of the fastigium—these two zones would have demonstrated to the viewer the degree to which the king's earthly rule was a mirror of the heavenly order.[144] Such a theme, which drew on a long tradition, would have well suited a royal chapel of the twelfth century, and thus supports the immediate impression that comes from a general view: that platform, fastigium and mosaic constituted an ensemble and a distinct unit within the chapel. But a closer examination of the physical fabric of the structure does not bear this impression out.

Let us start with the platform, since there is every reason to believe that it was planned and in place from the very beginning of the building. In fact, two unusual features of the architecture of the chapel would be inexplicable without it. One is the lack of a central door to the west, which is otherwise only rarely attested in medieval ecclesiastical architecture, and in no directly relevant precedent.[145] Nor is there an indication in the chapel that such a door was ever planned. The work of Valenti in the narthex has shown that no essential change at floor level had ever been made to the western wall of the chapel.[146] Presumably, therefore, something different was intended for this area of the chapel from the beginning. There is also no trace of a change to the nave colonnade, which has an unusual aspect as well. The first intercolumniation from the west is considerably wider by far (337 cm north; 358 cm south) than any of the other nave intercolumniations (north, proceeding east: 294 cm,

---

[143] On the symbolism of the fastigium, see Deér, *Porphyry Tombs*, 32ff., and the discussion of lions, *Porphyry Tombs*, 66ff.

[144] See also Beat Brenk, "Zur Bedetung des Mosaiks an der westwand der Cappella Palatina in Palermo," in *Studien zur byzantinischen Kunstgeschichte. Festschrift für Horst Hallensleben zum 65. Geburtstag*, ed. Brigitt Borkopp et al., Amsterdam, 1995, 192f.

[145] A central western entrance into the nave is lacking in certain Cistercian abbey churches of the twelfth century. See the abbey church of Senanque, begun ca. 1160 (Anselme Dimier and Jean Porcher,

*L'art cistercien*, Paris, 1962, 83ff. and 88 for the plan); Silvanès, begun ca. 1157 (ibid., 93ff., and 98 for the plan); and Le Thoronet, also begun ca. 1160 (ibid., 185ff., and 190 for the plan). I would like to thank Caroline Bruzelius for drawing this evidence to my attention.

[146] See also Boglino, *Storia*, 16, regarding "saggi recentemente fatti dalla parte del'antisacrestia, dietro la spalliera del soglio, ove si vorebbe fosse esistita la porta maggiore," but which turned up no physical indication of the prior existence of such a door.

303 cm, 300 cm; south, proceeding east: 300 cm, 294 cm, 293 cm), except for the easternmost, which is nonetheless narrower in its extent (335 cm north; 328 cm south).[147] It is significant, therefore, that precisely this wider intercolumniation contains the throne platform, by which, in fact, it is entirely filled. It is also interesting to observe that the westernmost columns of the colonnade, which are applied directly to the western wall and now serve to define the lateral extent of the throne platform, rest directly on bases that stand on the first step of the platform. The marble that covers the platform—as it appears now to the naked eye—runs directly beneath and behind the bases. Furthermore, the ornamental patterns used on the risers of the platform as well as the design of the central panel of the floor—consisting of three interwoven disks, two of red porphyry flanking a central one of serpentine breccia—find close parallel in the floors and steps of the sanctuary (figs. 23 and 98). In fact, if the particular piece of floor that now covers the platform had been found at nave level, there would have been no question as to its date. As it is, the resemblance it bears to the rest of the chapel pavement only underscores the point that the platform was conceived together with the architecture, as an integral and original feature of the chapel.

The same, however, could not be said about the decoration of the wall above it, which will be examined first with regard to its mosaic (fig. 83). Of all of the mosaics of the chapel, the panel on the west wall of the nave is perhaps the most difficult to approach and the most problematic: clearly heavily restored, and thus hardened and regularized by the interventions of postmedieval hands unsympathetic to the nuances of medieval style, the mosaic also, and equally clearly, bears the stamp of medieval workmanship. There are considerable areas of loss. The head of the angel in the upper left and the torso of the angel in the upper right, for instance, have been substantially reworked, as have been large areas in the figures of Peter and Paul.[148] But there are also areas where the tesserae have remained relatively undisturbed, and in these are some rather clear chronological indicators. Three of these indicators belong to the period of William I: the figures of Peter and Paul are closest to the types employed in the mosaics of the aisles, to the exclusion of the sanctuary, Cefalù and St. Mary's of the Admiral (figs. 85 and 86); in the panel beneath them, the figures of the lions find parallel in the so-called Norman Stanza, dated to the period of William I (figs. 89 and 90); and also in the Stanza occur the closest comparisons to the peculiar looping and tri-lobed leaves of the rinceaux of the west wall, which also appear in the decoration of the Torre Pisana, dated to the time of William I as well (figs. 91 and 92).[149]

What stands out in this context is a fourth indicator, for which the comparanda are considerably later. This element is the head of Christ, which, with its high forehead, almond eyes, narrow jaw and lofty crown of hair, differs markedly from the other

---

[147] As is clear to the eye, the nave arches diminish noticeably in height as one moves west to east in the chapel. This may have been an element of illusionism, making the nave seem longer to viewers at the west.

[148] See Demus, *Norman Mosaics*, 30 and 57; Kitzinger, *I mosaici*, fasc. 2, 13 and 15.

[149] Ernst Kitzinger, "The Mosaic Fragments in the Torre Pisana of the Royal Palace in Palermo: A Preliminary Study," *Mosaïque: Recueil d'hommages à Henri Stern*, Paris, 1983, 241f. Brenk, "La parete," 139, although Brenk draws a different conclusion about chronology.

images of Christ in the chapel (figs. 93, 94 and 96). Nor do any of the other Christ images at Cefalù or in St. Mary's of the Admiral, for that matter, have such narrow eyes that slant downward at the sides, or such a full head of hair (fig. 97).[150] But it is precisely these features that characterize the images of Christ at Monreale, as realized most dramatically in the head of the Pantokrator in the apse vault (fig. 95).[151] In a sense it is not surprising that they occur here. The slanting eyes and fuller hair make the head of Christ more tumultuous and expressive, which is very much in keeping with the stylistic exaggerations of Monreale in every other respect. This exaggerated style was new to Sicily with the Monreale workshop beginning in the late 1170s, although there is every indication that its roots and origins lay in Byzantium, where the source of this new Christ type too is probably to be sought.

These indicators lay to rest the Angevin dating of the mosaic proposed by Demus, prompted in part by the appearance of three Angevin coats of arms to the left of the figure of St. Peter (figs. 83 and 77).[152] Diverse though they are, the indicators point so insistently to the twelfth century to the exclusion of the fourteenth that they make some other explanation of the coats of arms a necessity: could the arms not have been made in reference to the restoration work undertaken in the narrative scene on the wall adjacent, which produced the badly mangled "medievalism" of the angels in the scene of Lot at Sodom (fig. 77)?[153] Be that as it may, the more pressing issue concerns the different directions suggested by the evidence in the mosaic, and there are two ways in which this discrepancy might be resolved. On the one hand, it might be argued that the head of Christ, or perhaps even some larger portion of the figure, was a replacement from the period of the later 1170s on, put into an earlier mosaic from the period of William I. However, even taking into consideration the restoration that the west wall has undergone, there is not the slightest trace of the kind of sutures that this act of replacement would have presumed. As a matter of fact, barring the central square of the fastigium, the entire wall forms a unified surface which must have originated in the twelfth century. It is more likely that the mixture of styles occurred naturally, within the workshop that produced the mosaics to begin with—in other words, that the Monreale style was introduced into the Cappella Palatina purposefully.

The proximity of mosaic commissions within the palace (Norman Stanza, Torre Pisana, nave and aisles of the Cappella Palatina) suggests a possible scenario: that there was mosaic workshop constituted under William I for the projects of the palace, a palatine workshop[154]; that the workshop had maintained a continuity throughout this time, and with that continuity perhaps even a "conservative" character; that it found itself working on the west wall of the chapel on the cusp of the new project of Monreale; and that it fell under the influence of this new project to such an extent that it included in its own work a version of the new image of Christ that was then being

---

[150] Demus, *Norman Mosaics*, 57.

[151] Demus, *Norman Mosaics*, fig. 61; Ernst Kitzinger, *I mosaici del periodo normanno in Sicilia*, fasc. 3, *Il Duomo di Monreale, I mosaici dell'abside, della solea e delle cappelle laterali*, Palermo, 1994, pls. 2 and 3. Cf. Brenk, "La parete," 140: "Il mosaico non si trova

sotto l'influsso di Monreale, deve essere sorto in epoca anteriore."

[152] Kitzinger, *I mosaici*, fasc. 2, 16.

[153] Kitzinger, *I mosaici*, fasc. 2, figs. 74 and 76.

[154] See the observation of Kitzinger, "Mosaic Fragments in the Torre Pisana," 243.

purveyed. Given the importance attached to the image of Christ, and implications that a change in the image might have had for Norman rulership, such an "influence" is not out of the question. In any case, as the latest in the series of chronological indicators in the mosaic thus discerned, the head of Christ must be taken as a terminus post quem, which would mean that the west wall mosaic of the Cappella Palatina was executed sometime after the late 1170s but before the end of the Monreale project in late the 1180s.

The foregoing analysis helps us to understand why the fastigium of the lower zone looks the way that it does.[155] Part of the explanation must also be restoration. A restoration is commemorated in the inscription prominently displayed above the porphyry octagon directly beneath the pediment, "Refectum sub Philippo V Anno MDCCXIX," and confirmed by the Aragonese coat of arms in the panel beneath the octagon (fig. 84). But to what extent? Brenk thought that the outer strip of opus sectile enframing the entire fastigium was original (that is to say, belonged to the period of the rest of the decoration of the west wall), and with this opinion I must agree: the pattern employed here is close to one also used in the Zisa, as Brenk observes, and the profile of this perimeter (including the medallion of the cross at the apex of the triangle) thoroughly interpenetrates the zone of the lion medallions, which is one of the least corrupted sections of mosaic on the entire wall.[156] If this profile had been inserted into the mosaic area later, in all likelihood the mosaic would have borne evidence of the change. But the upper perimeter and the mosaic make a perfect fit.

Regarding the two sections of the west wall to the right and left, between the outer perimeter of the fastigium and the westernmost columns of the nave colonnade, similar observations may be made: the ornamental patterns employed here match those also found in other portions of the nave and aisle wainscoting, on the south, west and north walls.[157] In addition the side walls of the throne platform abut these sections of the west wall awkwardly and without regard for their composition (fig. 51). The compositions, therefore, must have predated the two side walls of the throne platform, which were put up in the late seventeenth century—that is, well before the restoration of 1719.[158]

Of additional interest and importance is everything from the outer strip of the fastigium inward, including the grid of porphyry strips and their ornamental infill, the ornamental pattern within the pediment, and the panel with the miniature arches and columns that nearly spans the bottom of the fastigium (fig. 98). We find two clear

[155] See also the discussion of Nercessian, "The Cappella Palatina of Roger II," 102ff.

[156] Brenk, "La parete," 139. However, this strip also been restored, as witness the tracts of different qualities of stone and glass (dark green, dark purple and red) that it contains, and the fact that it does not extend to the same point on both sides at the bottom. Cf. the opinion of Cadei who takes a more extreme view: "Sappiamo che il trono è un assemblaggio del XV e XVIII secolo . . . ," "Porte bronzee," 147.

[157] See fig. 37. There are three patterns em-

ployed on the left (south) side: nos. 4, 5, and 15. All three occur in the wainscoting on the south wall and on the west wall of the south aisle; no. 5 also occurs on the north wall and the west wall of the north aisle. There are four patterns employed on the right (north) side: nos. 5, 6, 7, and 9. All four occur in the wainscoting on the west wall of the north aisle; three on the north wall (nos. 5, 6, and 7); and one on the south wall and the west wall of the south aisle (no. 5).

[158] See above, pp. 47ff.

indications of restoration, in five of the six smaller squares, the interstitial squares, and the pediment, that may be associated with 1719: complex geometrical patterns that are not attested in any other twelfth-century Norman context, and smooth, machine-cut pieces of glass in a wide variety of pastel colors that call to mind the opus sectile of the altars and of the south, exterior wall of the chapel.[159] As a design this area too is problematic: one might well doubt whether such a fussy checkerboard of hyper-intricate patterns would ever have been deemed a fitting backdrop for the Norman kings.

One solution that would restore to the fastigium a boldness of concept appropriate to the twelfth century, and would also help to explain why this area may have been altered in the early eighteenth, is suggested by the presence of porphyry in the grid of strips and in the octagon in the upper-central small square. As Deér has shown, por-phyry was highly esteemed by the Normans, who exploited its symbolism richly in their royal programs.[160] In the Cappella Palatina, there would have been no more fitting place to display this royal material than on the platform that displayed the king. This connection must account for the porphyry that is now *in situ*. Of course the royal significance of the stone was not forgotten in the eighteenth century, but as a material porphyry must have been much less readily available and less likely to have been used in quantity even in the Cappella Palatina. The stone was so valuable, in fact, that ever since antiquity it was mined from existing contexts and adapted to new ones, which may well have been what happened here.[161] What makes the gridded framework of the fastigium seem so peculiarly unmedieval is the complicated pastel ornament that fills in the smaller squares thus delineated and the pediment. But if one were to re-place this ornament with porphyry panels, either octagonal like the one now in place or square, filling the smaller square panels in their entirety, the composition itself would seem less disjointed and intrusive. As a geometric disposition, after all, it is intrinsically unified: the large square of the main body of the fastigium is divided into thirds lengthwise, with six smaller squares positioned above a single continuous panel at the bottom. The panel with the miniature colonnade fits so neatly into the larger composition of the wall, and its use of tesserae matches the nave and aisle wainscoting so closely, that it too must be a twelfth-century piece.[162] That porphyry panels would

[159] The upper-central smaller square with the porphyry octagon does not contain any of the patterns found in the other smaller squares. Ornamental pattern no. 5 is located at the four corners of the panel, beween the sides of the octagon and the enframing porphyry strips; it also occurs in all of the other portions of wall in the nave and aisles that contain wainscoting. The patterns in the five other smaller squares and in the pediment are complex versions of interlace based on a star motif executed in turquoise, blue, red, black, gray, gold, and white glass, porphyry and serpentine breccia. The interstitial squares contain star-shaped ornaments related to the patterns in the five smaller squares, with the exception of four interstitial squares that con-

tain figures of peacocks holding crosses, executed in the same colored glasses, against a background of serpentine breccia tesserae.

[160] Deér, *Porphyry Tombs*, passim.

[161] See Richard Delbrueck, *Antike Porphyrwerke* (=*Studien zur spätantiken Kunstgeschichte*, 6), Berlin and Leipzig, 1932.

[162] The columns of the colonnade are porphyry, the capitals and bases, serpentine breccia. The arches are composed of red, white, and gold glass, and serpentine breccia. The fact that the columns seem to hang suspended in space presumes an additional feature, perhaps the base of a throne or a temporary (wooden?) platform, on which they were to be seen as standing; Ćurčić, "Some Palatine As-

have been removed from the fastigium to be used elsewhere, perhaps even in the chapel itself (for repairs?) is not unthinkable. There is evidence that particularly valuable materials such as gold tesserae were recycled—removed from one part of the wall and put in another—by the workshops that were responsible for keeping the mosaics in other Palermitan churches in good repair.[163] In answer to the question of restoration, the following reconstruction may thus be proposed: that the fastigium was altered in the early eighteenth century by the substitution of panels of ornamental motifs for porphyry panels in the smaller squares, the interstitial squares, and in the pediment. The fastigium otherwise represents the intention of the twelfth century, at the moment in which the the mosaics of the west wall were created.

In so situating the two parts of the great throne—the platform, at the beginning of the building of the chapel, and the decoration of the west wall, after the beginning of work at Monreale—we are in a position now to appreciate the other aspect of the relationship between these two parts that becomes evident on closer inspection: their lack of coordination. To see the situation more clearly, however, it will be necessary first to disregard the set of parapet slabs that make up the two sides of the throne platform. As it will be recalled from Mongitore's description of the chapel, these slabs were taken from the chancel barrier in the late seventeenth century, when other pieces of the chancel screen were sent by Viceroy DiStefano to Spain. Mongitore's account is confirmed by the awkward way in which the two parapets now abut the back of the throne platform, while at the same time matching, both in size and type, the other parapets of the chancel barrier and fitting the portion of the perimeter of the barrier now open in front.

More important are other discrepancies. The major vertical divisions of the fastigium do not meet or, in fact, even take into account the major divisions of the floor of the platform. The uprights of the fastigium fall about two-thirds of the way along the edge of the marble border surrounding the central mosaic of the floor, and the miniature colonnade at the bottom of the wall adjoins the pavement, rigorously divided into three, in an awkward and unsyncopated way (fig. 98). Nor, on the other hand, do the major horizontal subdivisions of the throne back correspond to the subdivisions of the walls to the right and left (fig. 51). These, the latter subdivisions, were determined by the wainscoting of the sanctuary, which, it will be recalled, was an original feature of the chapel. The entire design of the west wall, disconnected from everything around it, thus seems to float free. It is difficult to believe that such inconsistencies would have occurred if the decoration of the west wall had been envisioned together with the decoration of the nave and aisles at some early point in the plan. More likely it was not—it was imposed on the situation later, for which two further observations will provide support.

On the outside of the western wall—the eastern wall of the narthex of the chapel—there is a window now entirely blocked (fig. 99).[164] This window shows every sign of having been an original feature of the wall, although, if opened to the interior of the

---

pects," 142. A miniature colonnade also forms the lowermost zone of the back of the throne platform in the Cathedral of Monreale, above which are situated two large porphyry panels.

[163] Kitzinger, *I mosaici di Santa Maria*, 119.
[164] See Gioacchino Di Marzo, *Delle belle arti*, 1: 149f.

chapel, it would cut directly across the pediment of the fastigium and the lower portion of the figure of the enthroned Christ. It is also interesting to observe that Philagathos makes no reference to a throne in the nave of the chapel, even though he describes many of the other major features of the building that were then in place. This is especially troubling considering that the throne as it now stands is an inescapable presence in the Cappella Palatina. It looms over the narrow space of the nave, overwhelming the other forms of the chapel. But perhaps this is the important point: that the throne platform as it now stands is gigantic, dramatically outsized and out of scale, with the effect of miniaturizing the already rather delicate forms that surround it.

The quality of grandiosity might be ascribed to a concept of rulership inherent in the very notion of a royal throne, but in the case of the Cappella Palatina it had a specific, visual source, which can be identified in an unusually concrete way. There are a number of formal precedents to the throne platform in the chapel; many of them have already been cited by Josef Deér, among which circus tribunes depicted on consular diptychs, aediculae on sarcophagi, papal and episcopal thrones from Rome and southern Italy, and the throne of Charles the Bald, with its "pediment" supported by a miniature "colonnade" bear some resemblance to the palatine structure.[165] The throne platform may also be compared to depictions of ancient and medieval thrones, particularly in the way the pediment overlaps the rectangular piece containing the rinceaux and the lion medallions. This kind of overlap does not seem so much architectural as pictorial, as witness the consular diptychs again, or certain painted portraits, such as the one found in the Psalter of Charles the Bald now in Paris.[166] But of all of the medieval comparanda, only one comes close to the throne platform in the Cappella Palatina as an ensemble, namely the royal throne platform in the Cathedral of Monreale (fig. 100).[167] Given the close geographical, chronological and cultural proximity of the two, such a relationship is hardly surprising, and it is only natural to think in terms of the impact of the Cappella Palatina on Monreale. But there is reason to believe that the influence actually went the other way.

The similarity to which I would like to draw attention lies in the area above the platform proper. Like the superstructure of the Cappella Palatina, the back of the platform in Monreale has three zones: a lower zone with a fastigium decorated with porphyry panels, a middle zone with a rectangular panel partly overlapped by the pediment of the fastigium and bearing an emblem of the Norman kings (here coats of arms; in the Cappella Palatina, lions), and an upper zone with a mosaic of Christ (here with the king; in the chapel, with Peter and Paul).[168] This horizontal division is especially interesting in light of the way each of these structures relates to its larger setting.

---

[165] Deér, *Porphyry Tombs*, 32ff.; Hans Gabelmann, *Antike Audienz und Tribunalszenen*, Darmstadt, 1984.

[166] For the psalter miniature, see Schramm and Mütherich, *Denkmale*, pl. 38.

[167] The left side of the throne was remade after the fire of 1811: Krönig, *Il duomo di Monreale*, 49ff.; Francesco Gandolfo, "Le tombe e gli arredi liturgici medioevali," *La cattedrale di Palermo: Studi per l'ottavo centenario della fondazione*, ed. Leonardo Urbani,

Palermo, 1993, 238ff., fig. 33. Gandolfo rightly observes that the structure in Monreale is not a throne, but the monumental receptacle for a throne, a tribune, which is precisely the function of the form in the Cappella Palatina; Gandolfo, 242. On the chronology of the mosaic above the throne, see Demus, *Norman Mosaics*, 123.

[168] For the mosaic, see Demus, *Norman Mosaics*, 118 and fig. 76A.

In the case of the throne at Monreale, and particularly for the divisions that form the horizontal zones of its back, it might be said that the architecture of the church was fundamentally determinative: that the height and position of columns and capitals, entablatures and arches has determined the horizontal membering of the interior walls—that is, the widths of the zones of revetment—and that these horizontal divisions, in turn, have determined the horizontal subdivisions of the throne. The platform at Monreale rises to a height of the baseboard of the walls, which matches that of the bases of the columns of the chancel; the fastigium matches the height of the main panels of the dado of the walls, and the height of the shafts and capitals of the columns; the middle zone of the throne continues the line of a band of ornament that is at the height of the cornice carried by the capitals of the columns; and the mosaic panel above the fastigium matches the height of the area between the cornice and the entablature at the springing of the arches of the chancel and the space before the apse. In other words, the configuration of the back of the throne in Monreale is linked in a direct and organic way to the membering of the walls, which is a direct result of the specific architectural forms used in the church.

In the Cappella Palatina, however, the opposite is the case. Although a number of discrepancies suggest that the superstructure of the throne platform was a later addition to the chapel, most striking perhaps is the one between the internal divisions of the superstructure and the walls and floor in the area surrounding it. None of these divisions carry over from one section to another. Since the horizontal subdivisions of the walls surrounding the throne platform belong to the larger context of the chapel, and indeed ultimately stem from the earliest decoration of the sanctuary, it is the superstructure of the throne platform that is the intrusive element. What these observations imply—that is, the perfect coherence of the throne back in Monreale with its larger context versus the lack of fit of the one in the Cappella Palatina—especially given the otherwise close relationship between the two, is that Monreale served as a model and source of inspiration for the Cappella Palatina with regard to the superstructure of the throne platform. This conclusion, in turn, would also fit the evidence for the date of the throne in the chapel, and its "larger-than-life" quality. If anything, it is precisely this quality that characterizes the entire project of Monreale, as well, it might also be assumed, as the new image of the king that this project embodied.

This discussion began by noting the essential unity of the throne platform, when viewed from the nave. This unity proved illusory as we moved closer and were able to acknowledge the discrepancies and discontinuities in the structure as a whole, and their attendant chronological differences. It is plausible now to speak of the existence of two separate phases of construction for the throne platform in the twelfth century: an early phase contemporary with the original building of the chapel, which included the platform itself, lodged against the western wall in the first intercolumniation, and raised above the level of the floor by five steps (fig. 101); and a later one, which embraced the decoration of the entire wall behind it. But one problem remains: what of the earlier decoration of the west wall? The only concrete indication we have is the window in the narthex, which, if opened to the nave as it originally appears to have been, would have effectively precluded the kind of large-scale figural decoration now

in place. Such a change may have had a bearing on the orientation of the viewer as well. As things stand now, with the majestic and symmetrical image of Christ flanked by Peter and Paul and the immense fastigium, there is a strong frontal pull to the throne. A window, both more modest and more abstract, would not have exerted the same pull, with the implication that lateral views of the west wall arrangement would have been, if not equally important, not as emphatically marginalized as they are now.

Two further observations on the platform. On the western side of the chancel barrier, and in place of the parapet slabs that form the present sides of the throne, now stand two open-work panels, approximately the same width as these slabs but considerably lower in height (fig. 50). It can only be assumed that these panels were put here as replacements for the removed parapets, and to all appearances they are twelfth century in date. Hence it is interesting to note the extent to which they could fit the throne better than the present parapets. They would extend essentially the same length,[169] but they would rise to only half the height, to a point on the wall where two colonnettes now seem to hang in space (116 cm from the floor). With the low sides to the platform in place, using the pavement of the platform as a guide, these colonnettes would make perfect sense: their bases would seem to rest on the upper edges of the sides. What this connection suggests, therefore, is not simply a replacement, but an actual exchange, probably in the seventeenth century, wherein the chancel slabs that were taken from barrier and put on the platform to make the sides of the throne were traded for the lower panels of the throne that were then taken to the barrier to form its new western perimeter. But one might also reasonably expect the platform to have had sides of one form or another from the very beginning, and what better candidates than these two pieces, which fit the later—not to mention the earlier—context. Assuming this to have been the case, it would then have been necessary for the decoration of the west wall to take into account such sides, and the accommodation would have been precisely in the placement of the two colonnettes.

Our final consideration must be the two sets of bronze doors in the western door frames, which have recently been adduced as meaningful elements in the larger configuration of the throne platform (figs. 102 and 103).[170] The doors, each divided into four panels, are decorated with a thick frame of acanthus leaves, acanthus bosses, and lion's head handles. Simply, even elegantly crafted, the doors have aptly been compared to the bronze doors that were commissioned by Charlemagne for the Palatine Chapel in Aachen, although precedents in Mainz, Canosa and Troia might also be cited.[171] In terms of the quality of their carving, however, they find a satisfactory

---

[169] The low walls are 194 cm (north) and 188 cm (south) in length, including the uprights which were clearly added on to the panels to frame a central door to the choir. Without the uprights the panels are both 165 cm long, which is the width of the present sides of the throne platform; see above, pp. 47ff.

[170] Brenk, "La parete," 135ff.; Ursula Mende, *Die Bronzetüren des Mittelalters 800–1200*, Munich, 1983,

53ff., 145f., pls. 54 and 55; Antonio Cadei, "La prima committenza normanna," *Le porte di bronzo dall'antichità al secolo XIII*, ed. Salvatorino Salomi, Rome, 1990, Testi, 357ff.; Tavole, pls. CCCXXVIIff.; idem, "Porte bronzee," 135ff., esp. 146ff., figs. 37f.; Brenk, "Zur Bedetung des Mosaiks," 185ff.

[171] Mende, *Die Bronzetüren*, 25ff., figs. 6 and 7 (Mainz), 47ff., figs 40 and 41 (Canosa), 48ff., figs. 50 and 51 (Troia).

context in the Cappella Palatina itself. The acanthus frames are a most telling feature (fig. 104). Carved acanthus is found in a number of different places in the Cappella Palatina, from the capitals of the columns to the frames of the parapet walls to the pulpit and paschal candelabrum, in a variety of formal configurations, but essentially two styles: crisply worked and carefully, one might even say elaborately detailed, often with numerous leaflets (fig. 105); and slurred and generalized often into a single leaf with a jagged but unified edge (fig. 106). These styles, as I shall argue in the case of the pulpit, appear to have a chronological significance as well, with the first belonging to mid-century and the second to the reign of William II.[172] It is to the latter that the acanthus on the doors comes closest, and this is one piece of evidence that may be used to assign them to the post-Rogerian period.[173] There is also the fact that they constitute, for the present door frames, clearly a secondary use. They are considerably smaller than the door openings, whose frames then had to be filled in at the top with additional panels. It was more than door frames that underwent change in this area of the chapel, however; according to Valenti, it was only in the reign of William II that the present narthex, with which the western doors communicate, was added.[174] Valenzuela's plan indicates how greatly this space might have been altered in the intervening years, with staircase and walls that Valenti removed (fig. 47). In addition, one of Valenti's photographs suggests that the space may never have been entirely finished even in its medieval manifestation. It shows the southern door outfitted with a marble frame, but lacking its opus sectile ornament (which Valenti then completed).[175] Beyond the stylistic evidence of their date, however, there is one other important factor that serves to link doors and narthex in these circumstances: that the doors were intended to function from the narthex. It was the side of the doors facing the narthex that was finished with panels and ornament, so that when viewed closed from that space, they present a dignified aspect. When viewed closed from the interior of the chapel, on the other hand, the doors have a rough-hewn and unseemly appearance.

In bringing the doors and narthex into the scope of the throne, we have touched on what was almost certainly a broader pattern of change in the Cappella Palatina. If the west wall was redecorated sometime in the late 1170s to 1180s and a narthex added to the chapel under William II, is it not logical then to associate the two, and to bring them together as well with the closing of the window of the west wall and the rearrangement and re-outfitting of the western doors? The coincidence of events in this single location is striking, and suggests the implantation of an entirely new structure into the chapel, with the implications of a new symmetry and axiality, not to say a new function.

---

[172] Krönig, *Il duomo di Monreale*, 47ff., fig. 53ff.; Gandolfo, "Le tombe," 238ff., fig. 53.

[173] It is interesting to observe that Cadei ("Porte bronzee.", 146ff.) compares the heads of the lions on the doors to the lions on the base of the paschal candelabrum in the chapel, assuming the candelabrum to be from the period of Roger II; on the latter, see the discussion below, pp. 83ff.

[174] See *Il Regno Normanno*, 221, figs. 105–7. Palermo, Biblioteca Comunale 5 Qq E146, no. 44z, refers to the replacement of the original columns and capitals of the narthex, which were found in a garden.

[175] *Il Regno Normanno*, fig. 106.

## The Pulpit

The most impressive piece of liturgical furniture in the chapel is the pulpit, which spans the south aisle at the eastern end of the colonnade (fig. 107; plate IX). It is a complicated structure, and I will examine it with regard to three closely interrelated points: its shape, its relationship to its immediate context in the chapel, and its date.[176]

As it stands today the pulpit is composed of a large L-shaped box that abuts the south wall of the chapel and rests on a mixed set of columns and piers, the rear wall of the parapet around the south aisle stairs and the southwest edge of the chancel barrier. The box is formed out of five panels of cipollino decorated with fields of opus sectile. The opus sectile is framed by an acanthus border carved in relief, and sculpted figures also embellish the top edge of the box: a lion to the northeast and an eagle to the northwest, both probably intended to serve as lecterns (although only the eagle carries the flat support for a book on its back), and finials at three corners. A large porphyry slab beneath the eagle lectern forms the front of the pulpit. The forwardmost pair of columns, in white marble streaked with purple, is richly fluted in a chevron pattern, and the capitals show traces of gilding. The columns behind them are of a reddish-brown marble with white streaks (pavonazzetto?) similar to the corner columns of the side apses. A third pair of supports, a set of thin piers embedded in the parapet wall of the south aisle stairs, is of cipollino. The pulpit projects forward from the south wall of the chapel 333 cm at its greatest depth, and is 269 cm wide at its greatest width. Access to the pulpit today is gained from the southern transept arm by means of a modern metal stair.

There are two degrees of awkwardness in the pulpit, both with important chronological implications: one in the pulpit's form, the other in the way in which the entire structure is placed in its setting. Boxlike pulpits supported on columns generally resembling the one in the Cappella Palatina were fairly common in central and southern Italy in the twelfth century, particularly in its second half, as witness examples in Troia (Cathedral, 1169), Corfinio (S. Pelino, 1168–88), Casauria (S. Clemente, 1176–82), Bominaco (S. Maria, 1180), Pianella (S. Maria Maggiore, late twelfth century) and Salerno (Cathedral, "Aiello pulpit", late twelfth century).[177] Within this group, furthermore—most of the members of which are decorated with sculpted reliefs—

---

[176] On the development of the pulpit in the Middle Ages, see Götz Adriani, *Der mittelalterliche Predigtort und seine Ausgestaltung*, Stuttgart, 1966.

[177] For S. Maria Assunta in Troia, see Horst Schäfer-Schuchardt, *Die Kanzeln des 11. bis 13. Jahrhunderts in Apulien*, Würzburg, 1972, 27ff., pls. 18ff.; Emile Bertaux, *L'art dans l'Italie méridionale*, Paris, 1903, 444. For S. Pelino in Corfinio, see Otto Lehmann-Brockhaus, "Die Kanzeln der Abruzzen im 12. und 13. Jahrhundert," *Römisches Jahrbuch für Kunstgeshichte*, 6, 1942–44, 330ff., figs. 307 and 308; Bertaux, *L'art*, 568, fig. 257. For S. Clemente in Casauria, see Lehmann-Brockhaus, "Kanzeln," 318ff.,

fig. 300; Bertaux, *L'art*, 568; *L'art dans l'Italie méridionale: Aggiornamento dell'opera di Emile Bertaux sotto la direzione di Adriano Prandi*, vol. 5, Rome, 1978, 729. For the abbey church of S. Maria in Bominaco, see Lehmann-Brockhaus, "Kanzeln," 358ff., fig. 332; Bertaux, *L'art*, 568, pl. XXV; *Aggiornamento*, vol. 5, 729; vol. 6, pl. CXXXV. For S. Maria Maggiore in Pianella, see Lehmann-Brockhaus, "Kanzeln," 336ff., figs. 314, 315; Bertaux, *L'art*, 566. For Salerno Cathedral, see Cocchetti Pratesi, "In margine, III," 255ff., figs. 1ff; Francesco Aceto, "I pulpiti di Salerno e la scultura romanica della costiera di Amalfi," *Napoli Nobilissima* 18, 1979, 169ff.

there is also a small number quite richly outfitted in panels of opus sectile (Caserta Vecchia; Salerno; Minturno).

Double lecterns on a single pulpit are considerably rarer to find, but there is one in the church of S. Maria del Lago near Moscufo dated to 1159, another in S. Maria in Valle Porclaneta, 1150, and a third in the church of S. Stefano in Cugnoli dated to 1166.[178] The most common support for the lectern in all of these cases is the eagle, with its obvious symbolic significance. I do not know of another example of a lion, with or without the lectern, in the position in which the figure is found on the Cappella Palatina pulpit, which is the first unusual feature to which attention should be drawn. The second is the form of the pulpit as a whole—the L-shape—which is also unknown from any other source.

A closer examination reveals an explanation for these anomalies: the eastern portion of the pulpit, that is, the slightly recessed rectangular section with the lion, shows every sign of having been added on to the existing structure of the western portion, which originally must have been a simple rectangular box.[179] In order to support the floor of the eastern section on its eastern side, the parapet wall, for instance, above the southern stair to the crypt had to be raised with the insertion of a new and crudely finished parapet. The two larger panels that make up the sides of the eastern section, though closely resembling the panels of the western side in style, are also much damaged, and one of them breaks into the border of the western portion of the pulpit in an awkward way (figs. 108 and 109). The other, narrower panel with a palm tree is most unusual in the context of the entire pulpit (not to mention the entire chapel), both for its subject matter and for its workmanship. The finials above the uprights on the eastern side are also not integral with the posts, as they are on the western side, and they have channeled tops rather than a decoration of acanthus leaves.

All of these factors bespeak the expansion of the pulpit with the addition of the eastern section to the western one, which may well have occurred in the late sixteenth century when Philip II installed musicians here.[180] This expansion changed the floor of the pulpit and probably added the narrow side panel with the palm tree to the two larger side panels taken over from the earlier structure. To restore the pulpit to its original appearance, therefore, these panels may be resituated on the eastern side of the western section, to form a simple box with enough space left over for an entrance stair, which may have been constructed in wood (fig. 110).

To focus on the awkward way in which the eastern portion of the pulpit is put together, however, is to distort the situation of the whole structure. The fact is that the entire pulpit, even in the state in which we have reconstructed it, is ungainly, and ill-suited to its setting. The pulpit is a mass of stone thrust against the south wall of the

[178] Lehmann-Brockhaus, "Kanzeln," 286ff., figs. 256–58; Bertaux, L'art, 561ff., pl. XXIV, fig. 256; Aggiornamento, vol. 5, 725ff.

[179] The walls of the western portion of the pulpit are 333 cm (depth) x 134 cm (width). The walls of the eastern portion of the pulpit are 248.5 cm (depth) x 135 cm (width).

[180] Trizzino, "La Palatina", 8; see Pasca, Descrizione, 23 and Palermo, Biblioteca Nazionale, XIII.F.9 (Cesare Pasca, "Storia della Basilica di S. Pietro dentro il Real Palazzo oggi detta Cappella Palatina di Palermo"), fol. 50v.

chapel and across the entire south aisle, essentially at eye level, with two main consequences for the viewer: on the one hand, the pulpit makes it virtually impossible to see the mosaics on the east wall of the southern transept arm from the aisles or nave, even though they were so obviously created for such a view; the pulpit also breaks into the mosaics (and revetment) of the south wall and blocks a large part of the first scene of Saul's request for letters to the synagogues of Damascus (fig. 111). It is clear, too, that the building of the pulpit involved some rather substantial alterations to a part of the chapel that was already in place. Around the south aisle stairs leading to the crypt there is a low wall, identical to the one around the north aisle stairs in every respect except one. In place of the low uprights that punctuate the north stair wall, the south wall has tall pilasters that also serve to support the pulpit above. But these pilasters are obviously a later interpolation. Not only are they carved from a slightly different colored marble than the rest of the wall, but they break the line of the parapet slabs, and in particular, must have caused the removal of part of their borders.

When was the pulpit built? As already indicated, the basic form of this pulpit was popular in Italy in the second half of the twelfth century. Of course, this period covers the reigns of all of the Norman kings, but we also have at least one point of reference in the chapel itself. The pulpit rests on top of the decoration of the south wall, both revetment and mosaics, which means that it was constructed after them. If the dating of this decoration is correct, then we have for the pulpit a terminus post quem. On the other hand, it is difficult to believe that the structure could have exceeded the reign of William II in date. As a matter of fact, the best comparanda for certain motifs on the pulpit are to be found at this time.

One telltale detail is the chevron pattern on the two front columns of the pulpit (fig. 107). Such a pattern, as used on the shafts of columns specifically, is unknown in Sicily before the late twelfth century, when it then occurs with some frequency. It appears, for instance, in the fountain of the cloister of Monreale, in the canopies of Roger's and Constance's tombs in Palermo Cathedral and in the now fragmentary paschal candelabrum of the Cathedral of Palermo.[181] The acanthus border framing the parapets that make up the outer perimeter of the box of the pulpit, furthermore, is very close to the version of the motif carved into the frame of the western door of the Cathedral of Monreale.[182] Also telling in this regard is the opus sectile decoration of the parapet slabs, which differs quite markedly in style from the opus sectile work of King Roger's

[181] For the cloister fountain at Monreale, see Krönig, *Il duomo di Monreale*, 59ff., 224ff., figs. 66ff. For the tombs of Roger and Constance, see Deér, *Porphyry Tombs*, figs. 99 and 127. For the paschal candelabrum in the Cathedral of Palermo, see Michael Schneider-Flagmeyer, *Der mittelalterliche Osterleuchter in Süditalien: Ein Beitrag zur Bildgeschichte des Auferstehungsglaubens*, Frankfurt aM, 1986, fig. 7. See also the paschal candelabrum in the Cathedral of Salerno, where the chevron motif is rendered in opus sectile; Aceto, "I pulpiti," fig. 2; Schneider-

Flagmeyer, *Osterleuchter*, fig. 6. H. Gally Knight describes what appears to have been a similar motif in the apses of the Cathedral of Messina; "Relation d'une excursion monumentale en Sicile et en Calabre," *Bulletin monumentale* 5, 1839, 92. The historical development of the pattern is treated by A. Borg, "The Development of Chevron Ornament," *Journal of the British Archaeological Association* 120, 1967, 122ff.

[182] See also above, p. 78.

time (fig. 112). The motif of circular patterns containing crosses on the pulpit parapets, for instance, does not otherwise occur in the chapel, or in any other work of early or mid-twelfth-century date in Sicily. But it is found in the decoration of the Cathedrals of Monreale and Palermo, which were projects of the 1170s, 80s and 90s (fig. 113).[183] Noteworthy too is the fact that considerably more of the gray-white marble support is visible in the pulpit parapets, in borders framing the micropatterns, which also seems to be a stylistic trait of Monreale and Palermo Cathedral.[184] Finally, the figure of the eagle, as well as the heads of the dogs(?) carved onto the rear, west finial, find close parallel among the sculptures of the cloister at Monreale (figs. 114, 115, and 116).

These facts, admittedly, do not enable us to establish the date of the pulpit with a great deal of precision. But they do suggest a period after William I, but before the end of the reign of William II, in other words, ca. 1170–ca. 1190, which is more than sufficient for our purposes here. In light of this chronology perhaps one critical aspect of the pulpit may now become clear. It has occasionally been claimed, or at least to my knowledge, never been explicitly doubted that the pulpit was part of the original plan for the chapel. But is this a reasonable expectation given the awkward massiveness of its form, whose construction, moreover, entailed rather substantial changes to and rearrangements of the chapel as it then existed, not to mention the fact that it now constitutes a serious obstacle to the viewing and appreciation of important parts of the decoration, and was probably inserted into the chapel almost two generations after the edifice itself was originally planned? The situation must have been quite the contrary. Like the mosaics of the nave and aisles, and the back of the throne platform, the pulpit must have been forced into place—a place that was never intended to hold such a structure to begin with. This, in turn, implies that such a structure was not part of the original concept of the chapel, or at least not in this particular form, or location.

Philagathos does not mention a pulpit in his description of the chapel. Nor does he refer to a baptismal font, although the modern literature on the chapel occasionally assumes one, and assumes as well that such an object was located under the pulpit.[185] But the font itself has never been identified, and the tradition regarding it is equivocal.[186] The earliest documented reference to a font is in the plan of 1754 by Valen-

[183] For examples of such panels from the Cathedral of Monreale, see Krönig, *Il duomo di Monreale*, fig. 33; Giuseppe Bellafiore, *La cattedrale di Palermo*, figs. 16, 168, pl. XIX.

[184] Also revealing in this regard is the pavement of the choir in the Cathedral of Monreale; see Krönig, *La cattedrale*, 215ff., figs. 158ff.; Deér, *Porphyry Tombs*, fig. 122 (Palermo Cathedral). See also Cochetti Pratesi, "In margine," 255ff., regarding the pulpits and chancel barrier in the Cathedral of Salerno, which have been ascribed to two phases of construction in the second half of the twelfth century. The fragments of a chancel barrier(?) now preserved in the cloister of the Cathedral of Amalfi, which may be dated to the late twelfth century, have the same stylistic elements; see Armando Schiavo,

*Monumenti della costa di Amalfi*, Milan/Rome, 1941, figs. 29 and 30; Claussen, *Magistri*, 154f., fig. 216.

[185] See Buscemi, *Notizie*, 22, n. 9; Rocco, "Cappella Palatina, parte seconda," 75; Trizzino, "*La Palatina*", 9; Borsook, *Messages in Mosaic*, 20.

[186] Foremost among the potential candidates, including the porphyry pedestals flanking the throne platform in the chapel, or in the Museo Nazionale (see Deér, *Porphyry Tombs*, 168, figs. 205 and 206), is a basin published in the exhibition catalogue, *L'età normanna*, no. V, 152f., with illustration. The hemispherical basin, decorated in opus sectile—to all appearances, twelfth century in date—is now located in a corridor of the Norman Palace that leads to the Sala del Presidente dell'Assemblea. On the form of the font in the Midde Ages, see E. Tyrrell-Green,

zuela, which so identifies a location in the area of the pulpit (letter G on the plan, fig. 47).[187] On the other hand, the late date of the document alone is not reason enough to reject the possibility that such a feature existed in the chapel in the twelfth century. Although there are no other examples of a baptismal font located underneath a pulpit, the pulpit of the Cathedral of Monreale housed a chapel dedicated to the Baptist.[188] This association, in turn, may have been derived from Monte Cassino, where a pulpit and an altar dedicated to the Baptist were also apparently closely associated. Thus the existence of a font in the Cappella Palatina in the twelfth century must be regarded as an open question.

## The Paschal Candelabrum

Directly to the west of the pulpit and in front of the second-to-last column from the east of the southern colonnade stands a tall paschal candelabrum, elaborately carved in gray-white marble (fig. 107).[189] Normally such objects, which constitute a liturgical art form characteristic of southern Italy, functioned in the context of a pulpit, from which the Easter vigil liturgy was pronounced and the candle itself lit.[190] This connection provides prima facie evidence of date, but before any conclusion can be reached, there is a rather complicated problem, partly iconographic and partly stylistic, to be broached.[191]

---

*Baptismal Fonts Classified and Illustrated*, London, 1928; G. Pudelko, *Romanische Taufsteine*, Berlin, 1932; Folke Nordstrom, *Medieval Baptismal Fonts: An Iconographical Study*, Stockholm, 1984; Emilia Zinzi, "La conca del Patirion (1137): Un recupero e alcune considerazioni sulla cultura figurativa dei monasteri italo-greci del sud in età normanna," *Rivista storica calabrese*, n.s. 6, 1985, 431ff.

[187] Rocco, "Cappella Palatina, parte seconda," 74, pl. XXVII.

[188] Krönig, *La cattedrale*, 55, citing the description of Lello of 1596, and 256, no. 1. In the Cathedrals of Cefalù, Monreale and Palermo, on the other hand, the baptismal font was located in the south aisle; see Bellafiore, *La cattedrale di Palermo*, 239 n. 305; Krönig, *Il duomo di Monreale*, 55. There are also cases where an altar was situated beneath a pulpit; see Arturo Carucci, *I mosaici salernitani nella storia e nell'arte*, Cava dei Tirreni, 1983, 142, regarding Salerno Cathedral where an altar dedicated to S. Giuseppe, "dicebatur extructum a domino Romoaldo Guarna," stood beneath the pulpit of Romuald until the eighteenth century, and the twelfth-century pulpit in S. Maria in Valle Porclaneta. Carucci calls such a practice "rarissimo."

[189] Pasca's assertion that the candelabrum was moved from an original position near the main altar of the chapel is without independent confirmation, and in all likelihood, incorrect; Pasca, *Descri-*

*zione*, 75, and Filippo Pottino, *La Cappella Palatina di Palermo*, Palermo, 1976, 32.

[190] The liturgy, Early Christian in origin and widely diffused by the twelfth century, was especially popular in southern Italy, where it gave rise to another distinctive liturgical art form to serve it, the Exultet Roll; among recent studies, see Guglielmo Cavallo, *Rotoli di Exultet dell'Italia meridionale*, Bari, 1973, 3ff.; Anna Rosa Calderoni Masetti, Cosimo D. Fonseca, and Guglielmo Cavallo, *L'Exultet "Beneventano" del duomo di Pisa*, Galatina, 1989.

[191] The scholarly debate on the chronology and iconography of the palatine candelabrum has been summarized by Lorenza Cochetti Pratesi, "Il candelabro della Cappella Palatina," *Scritti di storia dell'arte in onore di Mario Salmi*, Rome, 1961, 291ff.; see also Eileen Lucile Roberts, "The Paschal Candelabrum in the Cappella Palatina at Palermo: Studies in the Art, Liturgy, and Patronage of Sicily, Campania, and Rome during the Twelfth and Thirteenth Centuries," Ph.D. diss., State University of New York at Binghamton, 1984, but with caution; Rocco, "Il candelabro pasquale," 33ff. In addition, the candelabrum has been discussed by Deér, *Porphyry Tombs*, 157ff.; Hjalmar Torp, "*Monumentum resurrectionis*: Studio sulla forma e sul significato del candelabro per il cero pasquale in S. Maria della Pietà in Cori," *Acta ad archaeologiam et artium historiam pertinentia, Institutum Romanum Norvegiae* 1, 1962, 98ff.; Wolf-

The candelabrum is actually composed of three separate pieces: a low, squarish base; a middle portion in the form of a tall shaft; and a flaring top. The base is formed out of the figures of four lions, two with animals and two with human victims, wedged into the diagonals of the block, and wrapped around voids that preserve their pure circular shape (fig. 117). The base supports the shaft, which is divided into bands of different ornamental motifs: acanthus, rinceaux populated with figures, and birds (fig. 118). The main figural component occurs in the middle of the shaft at about eye level, and consists of two separate groups of figures, back to back. One side of the shaft shows the Pantokrator seated in a mandorla and surrounded by four angels, being worshipped by a kneeling cleric at his feet (fig. 119); the other, a rather more enigmatic scene of a half-standing, half-seated, partly draped figure holding a small rectangular object aloft in his left hand, and accompanied by an angel on his right (fig. 120). The shaft is surmounted by a third piece in the form of a bowl supported by four atlantids, which was intended to hold the candle (fig. 121).

It has been suggested that the three pieces of the candelabrum were carved from different marbles (though the suggestion has never been substantiated by a materials-analysis), and there is *a* something of an awkward quality to the way in which the three adjoin.[192] The transition from base to shaft is particularly abrupt, and the shaft repeats—redundantly it would seem—the flare of the top, though on a reduced scale. But there can be hardly any doubt that the two bottom pieces were carved together to form a whole that in all likelihood also included the piece at the top.[193] To begin with, they follow, if not the most common format employed for the decoration of the paschal candelabrum, at least one that is known elsewhere, in the general disposition of themes—savage motifs on the base, rinceaux and figures on the shaft, and atlantids around the top bowl. There is also a stylistic relationship among the pieces. Generally speaking, the forms on the candelabrum—the human figures, animals, birds and foliage—have the same blunt, dry look; however well articulated and expressive, they are also slightly disjointed and misshapen, with the result that the various parts of the composition tend to blend into a larger, more evenly patterned whole. The relationship of figure to ground is essentially the same throughout—the pieces are carved in rather high relief—and so too are aspects of technique. On both the base and top, for instance, the background is left rough, even though the figures themselves are highly finished. It is true that the proportions of the figures change from shaft to top, from rather stubby to long and lean, but the rendering of certain details does not. Hands

gang Krönig, "Vecchie e nuove prospettive sull'arte della Sicilia normanna," *Atti del congresso internazionale di studi sulla Sicilia normanna (Palermo, 1972)*, Palermo, 1973, 133ff.; Schneider-Flagmeyer, 221ff. There is a marble copy of the candelabrum in Michigan; see Eileen Lucille Roberts, "Replicas of Italian Medieval Sculpture at Cranbrook: A Chapter in the History of American Taste," *Source* 9, 1990, 23ff.

[192] Pasca, *Descrizione*, 74f., also thought that the top piece was added later, in the fifteenth century.

[193] That the piece would have been carved in this way is not unprecedented; see Torp, "Monumen-

*tum*," 79ff. (Cori). The results of the visual analysis of the materials of the three pieces conducted by Rosario La Duca were reported by Roberto Salvini, *Il chiostro di Monreale e la scultura romanica in Sicilia*, Palermo, 1962, 76 n. 52: "Per quanto concerne il candelabro (cero pasquale) esso è realizzato in marmo saccaroide bianco a grana fine, che con tutta probabilità, potrebbe essere marmo greco. Il fiore del candelabro, in base ad un esame sommario, potrebbe apparire eseguito in marmo diverso. In effetti pero anch'esso è in marmo bianco, ma è stato ricoperto da una doratura eseguito con mistura."

and feet have the same schematic aspect for the atlantids above as for the figures in the rinceaux below. Also similar are draperies, with their piles of soft, waxy folds, and the acanthus leaves, drily symmetrical, that form the various borders of the ornamental motifs.

Regarding the date of the candelabrum, there has been a considerable divergence of opinion, with attendant implications for the history of sculpture of the period as a whole.[194] But there are two incontrovertible facts that are decisive with regard to chronology: one has to do with the relationship between the candelabrum and sculpture at Monreale, and the other with the paschal candelabrum in S. Paolo fuori le Mura in Rome (fig. 122 and 124).

In terms of style, the closest comparisons to the Cappella Palatina candelabrum are to be found at Monreale (fig. 123).[195] It is here, among the capitals of the cloister, rendered in a multitude of styles, that one encounters the same blunt, dry version of the romanesque style that one sees in the Cappella Palatina candelabrum.[196] Given the obvious differences of form and function, parallels for compositions or larger units of decoration could hardly be expected; but there are many parallel details. The pecking birds on capitals E14, S16, and S18 are virtually identical in their form, with their scaly backs and long tail feathers, and in their attitude, with their necks extended and their heads pushed back, to the birds at the top of the shaft of the Cappella Palatina candelabrum (fig. 116).[197] Also close are the lanky, disjointed figures of capital E22 and the figure in the rinceaux on the lower zone of the candelabrum; several of the heads on N8 and the head of the Pantokrator on the candelabrum; the rosettes on E20, N16 and W20 and at the top of the shaft of the candelabrum; the acanthus on the impost of N21 and above the atlantids of the candelabrum; and the acanthus of N15, N18, S11 and S22 and on the shaft of the candelabrum (figs. 118 and 123). These correspondences prove that a close connection exists between the candelabrum and the products of the Monreale workshop—or to put the matter another way, they indicate that the making of the Cappella Palatina candelabrum must be understood, in both a stylistic and a chronological sense, within the context of the Monreale project.[198]

On the other hand, the chapel candelabrum also bears an unmistakable resemblance to the one now in the church of S. Paolo fuori le Mura in Rome, though the resemblance is not stylistic but iconographic (figs. 122 and 124).[199] The S. Paolo candelabrum is a considerably more complex form than the one in the chapel, with not

[194] Salvini, *Il chiostro di Monreale*, 13ff., 59ff.; Cocchetti Pratesi, "In margine, I/II," *Commentari* 18, 126ff.; 19, 165ff.

[195] Salvini, *Il chiostro di Monreale*, passim (references herewith to the Monreale capitals follow Salvini's numeration).

[196] See the review of Deér, *Porphyry Tombs*, by Carl D. Sheppard in *Art Bulletin* 42, 1960, 235 (dating the palatine candelabrum not before 1172).

[197] I am also struck by the resemblance of a capital in the Zisa to these works; see Salvini, *Il chiostro di Monreale*, fig. 84.

[198] See the remarks of Salvini, *Il chiostro di Mon-*

*reale*, 72ff. One might seek further comparisons in the church itself; the lions at the corners of the royal throne, for example, closely resemble those on the base of the palatine candelabrum; Josef Deér, "Die basler Löwenkamee und der süditalienische Gemmenschnitt des 12. und 13. Jahrhunderts," *Zeitschrift für schweizerische Archäologie und Kunstgeschichte* 14, 1953, 129ff., figs. 21 and 22.

[199] Rocco has also argued a connection between the two candelabra, though for the most part on different grounds; Rocco, "Il candelabro pasquale," 33ff.

one but three tiers of narrative scenes, an urnlike top and a large pyramidal base covered with figures and beasts.[200] But it has a banded structure, with rinceaux and atlantids, much like the Cappella Palatina, and a particularly striking correspondence with the palatine piece in its upper scenes. As on the candelabrum in the Cappella Palatina, the topmost scenes are two, and are set back to back: one shows the Pantokrator seated in a mandorla (fig. 122); the other, a figure with his hand raised holding a small object and a cross, though concerning his identity, there can be no doubt: the figure is Christ of the Resurrection at the moment at which he issued forth from the tomb (fig. 124, register I, no. 1).

Let us return for a moment to the so-called enigmatic scene on the chapel candelabrum (fig. 120). One of the best reasoned interpretations of this scene was offered by Josef Deér, who argued that it represented the high priest Joshua of Zacharias, 3:1–10 and 6:11–13, whose soiled garments were removed by an angel of the Lord, after which he was reclothed and proclaimed king.[201] It is the reclothing specifically that Deér saw in the enigmatic scene. But there are difficulties with this reading. It does not account for the object that the figure holds so prominently in his left hand. Deér interpreted this object as a cup—logical enough because of its shape—and the figure's gesture as a "gesto di festività." But the reading has no warrant in the text, and is rather strained. Why would the high priest have been imagined as actually toasting his new appointment? Nor does the text explain the figure's awkward half-standing, half-sitting pose. The pose could hardly have been an easy one for the sculptor to concoct, and so must have been meaningful in some way. Nor finally, does the text account for the gesture of the angel, who seems both to embrace the figure and to grasp his right hand.

All of these features find parallel in the iconography of the Resurrection of Christ. The bodily resurrection of Christ was commonly depicted in western medieval art only from the late tenth century on, and with a number of variations: with Christ posed in different ways (standing in his sarcophagus or in front of it, for instance), and holding a number of different kinds of objects.[202] Beginning in the twelfth century, however, it became popular to depict Christ standing erect in a sarcophagus and parallel to the picture plane, with one leg raised (usually his right), as if he were just about to step out of and over his tomb (fig. 125). In these depictions Christ is often shown holding a cross staff. But there are also cases where he carries other objects as well. The initial *E* that begins the Easter epistle in a late tenth-century epistolary from the cloister of S. Maria ad martyres in Trier (Berlin, Staatsbibl. Ms. theol. lat. fol. 34) is decorated with two angels beneath a figure of Christ who holds his right hand up in

[200] Torp, "*Monumentum*," 105; Karl Noehles, "Die Kunst der Cosmaten und die Idee der Renovatio Romae," *Festschrift Werner Hager*, Recklinghausen, 1966, 17ff.; Mario Petrassi, "L'artistico candelabro di San Paolo," *Capitolium* 46, 1971, 4ff.; Enrico Bassan, "Il candelabro di S. Paolo fuori le mura: note sulla scultura a Roma tra XII e XIII secolo," *Storia dell'arte* 45, 1982, 117ff.; Schneider-Flagmeyer, *Osterleuchter*, 279ff.; Claussen, *Magistri*, 28ff., fig. 26ff.

[201] Deér, *Porphyry Tombs*, 158ff.

[202] Otto Schönewolf, *Die Darstellung der Auferstehung Christi: ihre Entstehung und ihre ältesten Denkmäler*, Leipzig, 1909; Helga Möbius, *Passion und Auferstehung in Kultur und Kunst des Mittelalters*, Berlin, 1978.

prayer, and in his left a circular object that has been identified as a globe or a host.[203] In the later thirteenth-century Joinville Credo (Paris, Bibl. Nat. nouv. acq. fr. 4509–10, fol. 6v), Christ is depicted stepping over a soldier as he emerges from the tomb, with a book in his hand (fig. 126).[204] Christ is also shown holding a book in miniatures in two Byzantine psalters, the ninth-century Chludov Psalter (fol. 26v) and British Museum Pantokrator 61, an eleventh-century psalter from the Pantokrator Monastery on Mount Athos (fol. 109r).[205] Christ is also represented with attending angels, or even just the single figure of an angel, at the moment he steps out of the tomb. Most often the angels stand at his side.[206] In the illustration to Psalm 18, possibly representing the Resurrection in the ninth-century Utrecht Psalter (fol. 10v), on the other hand, they cling to him, as if to lift him up as he walks forward from the tomb (fig. 127).[207]

In light of these iconographic observations, and bearing in mind the significance of the subject of the Resurrection to the object in question, it may be proposed that the enigmatic scene on the candelabrum represents the Resurrection, with Christ poised on one leg, holding the other slightly raised as he begins to leave his tomb, embraced by an angel and brandishing a book. The only element missing is the tomb itself, but the deficiency may be attributed to the exigencies of space. The shaft of the Cappella Palatina candelabrum is so narrow and thus so sharply curved that it is difficult to see how a rectangular object like the presumed tomb could have been fitted in. There is also small piece of architecture or terrain under Christ's right foot, which may be the tomb in residual form. In certain other depictions of the Resurrection of Christ from the twelfth and thirteenth centuries, the tomb itself is quite marginal indeed.

[203] Valentin Rose, *Verzeichnis der lateinischen Handschriften der königlichen Bibliothek zu Berlin*, II/2, Berlin, 1903, 696f., no. 698. The illumination appears on fol. 18. See also the discussion of Meyer Schapiro, "Two Romanesque Drawings in Auxerre and Some Iconographic Problems," *Studies in Art and Literature for Belle da Costa Greene*, ed. Dorothy Miner, Princeton, 1954, esp. 341ff., with regard to fig. 255, and William M. Hinkle, "The Iconography of the Apsidal Fresco at Montmorillon," *Münchner Jahrbuch der bildenden Kunst* 23, 1972, 37ff.

[204] Lionel J. Friedman, *Text and Iconography for Joinville's Credo*, Cambridge, Mass., 1958, 39 (fig.), and also pl. 16 (thirteenth-century Breviary ostensibly from St. Nicaise of Rheims) where Christ of the Resurrection is depicted with a cross beside two adoring angels. For the latter see also, Charles-V. Langlois, "Observations sur un missel de Saint-Nicaise de Rheims conservé à la Bibliothèque de Leningrad," *Comptes-rendus de l'Académie des Inscriptions et Belles-Lettres*, 1928, 362ff.

[205] For the Chludov Psalter, see M. V. Shchepkina, *Miniatiury Khludovskoi psaltyri*, Moscow, 1977, fol. 26v, Psalm 30, vv. 6–7. For Pantokrator 61, see Suzy Dufrenne, *L'illustration des psautiers grecs du*

moyen-âge, Paris, 1966, pl. 16, fol. 109r.

[206] See, for example, Amiens, Bibliothèque Municipale, ms. 19. Psalter-Hymnal, twelfth century, fol. 9v. (Victor Leroquais, *Les psautiers manuscrits latins des bibliothèques publiques de France*, Mâcon, 1940–41, 1:9ff., pl. XLII); Cambrai, Bibliothèque de la Ville, 190. Epistolary, fol. 72r.; Hildesheim, Cathedral Library, 688c. Lectionary, fol. 57r.; London, British Museum, Add. 17687. Psalter, ca. 1240 (Hanns Swarzenski, *Die lateinischen illuminierten Handschriften des XIII. Jahrhunderts in den ländern an Rhein, Main und Donau*, Berlin, 1936, 1:154, pl. vol.:pl. 169b [no. 931]); London, British Museum, Harley 2895. Psalter, fol. 72r.; Messina, University Library, 346. Gradual, late-thirteenth/early-fourteenth century, p. 8 (Angela Daneu Lattanzi, *Lineamenti di storia della miniatura in Sicilia*, Florence, 1966, 194f., fig. 63); Paris, Bibliothèque Nationale, lat. 17325. Pericopes, eleventh century, fol. 30v (Philippe Lauer, *Les enluminures romanes des manuscrits de la Bibliothèque Nationale*, Paris, 1927, 138f., pl. B); Paris, Bibliothèque Nationale, N. Acq. lat. 1392. Psalter, fol. 12v.

[207] Ernest Theodore De Wald, *The Illustrations of the Utrecht Psalter*, Princeton, 1932, 11f., pl. XVI.

If this identification is correct, then of the two works, it is the S. Paolo candelabrum that seems the more complete and coherent. Not only does this sculpture contain a richer narrative than the one in the Cappella Palatina, the individual scenes are more clearly presented and more logical: taken together they form a cycle of Christ's passion. Thus if one were to posit a relationship in terms of model and copy, it would be logical to assume that S. Paolo was the model and the Cappella Palatina the copy. It is unlikely in any case that an object in a major Roman basilica would have been modeled on a related one in the Sicilian king's court. But this hypothesis raises an important chronological question. Given the close connection with the cloister sculpture of Monreale, the most likely date for the Cappella Palatina candelabrum is in the 1180s, when the Cathedral project itself was in full swing. The S. Paolo candelabrum is dated to the early 1190s. The dates are thus close, but they do not overlap. How is this apparent discrepancy to be explained?

There are two possibilities. One is that the S. Paolo candelabrum was actually carved somewhat earlier than scholars today believe. The candelabrum is a signed but not dated work of the Roman sculptor Nicolaus de Angelo, who is also known to have participated in other sculptural projects at the Cathedral of Gaeta, the Lateran and S. Bartolomeo all'Isola in Rome. The last, in fact, is dated by an inscription to 1180, attesting to the fact that the sculptor was active in the period in question. The only problem is that an earlier dating would not fit very well with the development of the artist that may be reconstructed from other sources, and with the context in S. Paolo as argued in the recent monograph of Peter Cornelius Claussen, which makes it a less attractive alternative.[208]

The other possibility is that both candelabra, in S. Paolo and in the Cappella Palatina, are themselves connected by a common model. This is more likely given the fact that the two works, though clearly related to one another in important ways, are not at all identical, and even differ in some crucial details. The scene of the Resurrection on the S. Paolo candelabrum, after all, has the tomb, cross staff and disk that do not appear in the Cappella Palatina. But what common model could it have been? Among extant paschal candelabra, there is none close enough in form to be nominated, which leaves the others that are known from the sources. The most important of these was surely the candelabrum Abbot Desiderius had made at Monte Cassino, which was apparently the first in the great series of such monuments in southern Italy and Sicily. From the brief mention in Leo of Ostia's Chronicle ("he had set up on a base of porphyry a partially gilded column six cubits high . . . "), it is difficult to imagine what the work looked like.[209] But it is interesting to observe how closely a fragment at Monte Cassino purported to have come from a paschal candelabrum there resembles the one in S. Paolo.[210]

[208] Claussen, *Magistri*, 38ff.

[209] *Chronica monasterii casinensis* III, 32, 404. See Schneider-Flagmeyer, *Osterleuchter*, 33, regarding the possibility that the candelabrum of Desiderius was depicted in an Exultet Roll from Monte Cassino.

[210] Torp, "*Monumentum*," 93. Schneider-Flagmeyer, *Osterleuchter*, 222, suggests that the palatine candelabrum had been inspired by the one at Monte Cassino. In 1143, Roger II despoiled the Monastery of Monte Cassino of its treasure and antependium. See *Annales Casinenses*, ed. G. H. Pertz (*MGH, SS*, XIX), Leipzig, 1925, 310; Bloch, *Monte Cassino*, 1:71.

It is here proposed that the paschal candelabrum of the Cappella Palatina was made in 1180s, in the ambient of the Monreale project. Thus there is no reason not to associate the candelabrum directly with the pulpit, which was also set up in the chapel at this time. The palatine candelabrum may have been related to another example of the genre (which may have served as a model for the candelabrum in S. Paolo flm in Rome as well). But its imagery was also individualized with addition of a kneeling cleric at the Pantokrator's feet (fig. 128). The discussion of imagery on the candelabrum, in fact, often begins with this figure; here, I shall close with it. Even though the figure is dressed in episcopal garb, he has been identifed as King Roger himself.[211] This identification has been based on the supposition that the garb the figure wears would have been appropriate to the office of papal legate, and that this office, first granted to Roger I in 1098 by Pope Urban I, was renewed for Roger II by Pope Eugenius III. But Deér has shown the argument to be erroneous on both counts.[212] Deér points out that the kneeling figure also wears a pallium signifying a bishop of metropolitan rank—a garment, in the author's words, that "possessed a purely sacerdotal character and could never be conferred upon a layman or be usurped by one."[213] On the other hand, there is no direct evidence that Roger II possessed the legatine office, and the indirect testimony often adduced—a letter written by the Roman people to the German emperor Conrad III in 1149 in which mention is made of episcopal (i.e., "legatine") vestments given by the pope to the king ("Papa concessit Siculo virgam et anulum, dalmaticam et mitram atque sandalia")—Deér has shown refers to the abbot of S. Giovanni degli Eremiti, who, it will be recalled, had the responsibility of celebrating the liturgy in the chapel for the major feasts of the year.[214]

Who could the bishop on the Cappella Palatina candelabrum be? Given the period argued here as being most likely for the creation of this work, one possibility is the abbot of Monreale, in whose term of office the great cathedral project planned to house the king's own tomb was initiated. With the support of the king the abbot of Monreale received the pallium after he had been given the rank of Archbishop in February 1183 by Pope Lucius III, and it was to the workshop of his cloister that the closest comparanda to the candelabrum have been found.[215] His name too was William, and he was immediate successor of the founding abbot of the monastery, Theo-

[211] Buscemi, *Notizie*, 24 nn. 14, 15; Sigfrid H. Steinberg, "I ritratti dei re normanni di Sicilia," *La Bibliofilia* 39, 1937, 46ff., fig. 7; Lynn White Jr., *Latin Monasticism in Norman Sicily*, Cambridge, Mass., 1938, 127 n. 4.

[212] Josef Deér, "Der Anspruch der Herrscher des 12. Jahrhunderts auf die apostolische Legation," *Archivium Historiae Pontificiae* 2, 1964, 117ff.; idem, *Porphyry Tombs*, 157ff. See also the discussion of Percy Ernst Schramm, *Herrschaftszeichen und Staatsymbolik: Beiträge zu ihrer Geschichte vom dritten bis zum sechzehnten Jahrhundert*, Stuttgart, 1954–56, vol. 1, 77ff., and Léon-Robert Ménager, "L'institution monarchiqe dans les Etats normands d'Italie. Contribution à l'étude du pouvoir royal dans les

principautés occidentales, aux XIe–XIIe siècles," *Cahiers de civilisations médiévale*, 2, 1959, 453 n. 284, who concur that the kneeling figure on the palatine candelabrum could not represent King Roger (80).

[213] Deér, *Porphyry Tombs*, 157.

[214] For the text of the letter, see *Ottonis et Rahewini Gesta Friderici I. Imperatoris*, ed. G. Waitz, Hannover/Leipzig, 1912, 46. Deér, *Porphyry Tombs*, 158, identified the kneeling figure as Archbishop Hugh of Palermo, but he was seeking to reconcile the identity of the figure with a date for the object in Roger's reign.

[215] White, *Latin Monasticism*, 132ff.; Deér, *Porphyry Tombs*, 159.

bald, both of whom came to Sicily from the Benedictine monastery of La Cava from which William II staffed his new establishment. His term of office extended from 1178 to 1188, covering almost the entire period that seems relevant here. Abbot William, in addition, oversaw a great extension of the power and the wealth of the monastery, much of which was orchestrated directly by the king. By contrast, the Archbishop of Palermo, the other obvious candidate in the immediate area, was not on particularly good terms with the king at this time.[216] Considering the relationship that had developed between the abbot of Monreale and the king, therefore, it may well have been appropriate for the abbot to give a gift like the candelabrum to the royal chapel, and to commemorate himself as donor on it.

*The Apse Decorations*

The final feature of the decoration to be examined is a set of mosaics which belong to the eastern end of the chapel, but which relate more directly than almost anything else in the sanctuary and transepts to the aisles and nave.[217] The images in the three eastern apses face the viewer standing in the aisles and nave (figs. 38 and 129). It might also be assumed that they bear, or at least at some point bore, a relationship to the altars housed there. But they have also been extensively rearranged and restored, and the question arises as to what they looked like when they were first made, and what changes they underwent in the course of the twelfth century.

As they stand now, the three apse compositions bear a distinct resemblance to one another. They are all divided into two parts, with full-length figures in the lower zone on the apse wall, and a bust-length figure in the upper zone in the concha: the main apse shows the Pantokrator above figures of Peter, Mary Magdalen, the Virgin enthroned, John the Baptist, and James; the south apse, Paul above Philip, Anne with the young Virgin, and Sebastian; and the north, Andrew above Barnabas, Joseph with the young Christ, and Stephen.[218] Each apse also had a window in the middle of the lower zone, which was then closed and covered with a mosaic—the Virgin enthroned in the main apse, Anne and the Virgin in the south and Joseph and Christ in the north—in the disastrously inappropriate modern style of Cardini (fig. 130).[219] By replacing these windows, the rather more rigorous symmetry of the three arrangements becomes clearer (fig. 42).

That the mosaics in the two side apses go back to the earliest phase of decoration in the chapel, and thus were meant to form a coherent group with other mosaics in the sanctuary and transepts can be demonstrated more or less clearly on the basis of style, bearing in mind the fact that all of the figures in the apses have also been restored. In

---

[216] Deér, *Porphyry Tombs*, 14ff.

[217] The only feature that relates more clearly to the aisles and naves is the decoration of the east wall of the southern transept arm—the scene of the Nativity and the bust of the Pantokrator above it—which will be discussed below, pp. 112ff.

[218] Kitzinger, *I mosaici*, fasc. 1, figs. 129–36 (main apse), figs. 117–22, 147 (south apse), figs. 93, 101–2 (north apse).

[219] The windows of the three apses were closed in the late eighteenth century, and thereafter the mosaics of Santi Cardini were put up; see Riolo, *Notizie dei restauratori*, 31; Demus, *Norman Mosaics*, 34; Trizzino, "*La Palatina*", 10.

this respect Paul and Andrew have plainly suffered most. Nevertheless there is a foundation of twelfth-century work in both of the figures that relates to relevant types. The type of Paul, for instance, is precisely the same as the one employed elsewhere in the transepts for the saint (Pentecost)—with its bulbous forehead and wisp of hair, curving nose, drooping mouth, and pointed beard—and with the same configuration of modeling lines on forehead, brow and cheeks, which give the figure such a curious intensity (figs. 131 and 132).[220] In this regard the head of the figure may also be compared to the Paul in the Cathedral of Cefalù, to which it is also closely similar—a similarity with important chronological implications.[221] Much less has survived of the original figure of Andrew, but here too, what remains connects with the depiction of the saint elsewhere in the transepts.[222]

In the standing saints from the lower walls of the apses the situation is also clear. The lower portions of Philip and Sebastian in the south apse have a disturbingly flat and regularized look; Barnabas and Stephen, on the other hand, are rendered with a bravura modeling that far exceeds twelfth-century expertise. But the face of the figure in each case clearly preserves a medieval structure and details. The head of Sebastian, for instance, is represented again on the eastern portion of the soffit of the north arch of the choir in exactly the same type—even down to certain asymmetries, such as the raised right eye (fig. 133).[223] Also striking is the resemblance of the saint to the figure of St. Eustratios on the southern portion of the soffit of the western arch of the choir (fig. 134).[224] Philip bears comparison with the heads of certain angels from the dome of the sanctuary, all of which show a similar pattern of lines for the features of the face, including thick, tautly curved eyebrows and sharp, crescent-shaped highlights on the cheeks (figs. 135 and 136).[225] The head of Stephen, though somewhat disarranged on the right side, is most like the Stephen on the eastern portion of the south arch of the choir, and the Barnabas, like the Gregory of Nyssa on the north wall of the northern transept arm, though lacking the contrasting lines of color under his eyes.[226]

The four standing figures may well have been related to the relics that were once contained in the two side altars.[227] Such a claim, of course, is ultimately not provable, since the altars were replaced and reconsecrated in the early nineteenth century and their contents lost.[228] But at the time of the replacement, the relics discovered in the

---

[220] Also close is the figure of Paul in St. Mary's of the Admiral (Kitzinger, *I mosaici di Santa Maria*, fig. 46). This type contrasts quite markedly with the type for Paul that was employed in the mosaics of the Cathedral of Monreale, with its shorter nose, more deeply curved brow and curlier hair; see Kitzinger, *The Mosaics of Monreale*, figs. 2, 6 and 11, pls. 80, 81 and 83.

[221] Demus, *Norman Mosaics*, 3ff., fig. 4B.

[222] The argument that the figure of Andrew replaced a figure of Peter in the apse when a church dedicated to Andrew was destroyed in the early sixteenth century is not convincing; see Pasca, *Descrizione*, 29 (citing Mongitore); Boglino, *Real Cap-*

*pella*, 28f. See also the discussion of Kitzinger, *I mosaici*, fasc. 1, 14f. For the figures of Andrew in the Ascension and Pentecost, see Kitzinger, *I mosaici*, fasc. 1, figs. 211, 218, 225 and 237, which themselves also differ in important respects.

[223] Kitzinger, *I mosaici*, fasc. 1, fig. 83.

[224] Ibid., fig. 67.

[225] Ibid., figs. 9 and 10.

[226] Ibid., figs. 62 and 103, 106.

[227] On the relics of the chapel, see Mongitore, *Dell'istoria sagra*, 22ff.

[228] See above, pp. 38f.

older altars were removed and their identity carefully recorded by Buscemi.[229] The main altar of the chapel held relics of John the Baptist, Barnabas, Gervasius and Protasius; the south altar, Sebastian and Philip; the north, Stephen and Barnabas. The relics attributed to the main altar do not match the selection of saints represented in the mosaic—but this mosaic appears to have been disturbed. With the side altars, on the other hand, there is a perfect fit. The four standing saints correspond to the relics purported to have been in the altars below. Of course, it is possible that the relics followed the figures by some time, but not likely; it may be assumed that this correspondence was a twelfth-century one, and that in it, we have part of the original program for the sanctuary.[230]

It should be noted finally how well suited the various figures are in a compositional sense to the curved spaces of the side apses. The standing saints below are fitted neatly beside the areas where the windows were once contained, and are well proportioned in relation to the larger busts above them. These busts are fully frontal in their conchas, which are unusually tall, while in the case of Paul specifically, still in proportion to the Pantokrator at the top of the wall (fig. 64).[231] The same cannot be said of the main apse. Here the concha is much broader and flatter by contrast, with an unusually high lower border in the mosaic above the springing of the vault. Thus the Pantokrator is pitched at a steep angle, and seems to lay almost flat when seen from the front (fig. 38).[232] The figures beneath him are too tall by comparison, which makes them appear, in turn, to be the dominant elements of the composition.

Lack of fit is one indication that something is not quite right with the decoration of the main apse. Another is the later date of the few bits of authentic twelfth-century mosaic that survive. The point can be made most clearly with two heads: Peter and Christ. Enough of the twelfth-century mosaic survives of the figure of Peter—essentially the left three-quarters of the head, a large part of the beard and a small part of the hair—to demonstrate precisely which model the mosaicist used (fig. 87). It was not the model employed for Peter elsewhere in the sanctuary—with thinner face and lanker hair and beard—but in the aisles, as the Peter in the healing of the lame man at the Temple Gate, or the resuscitation of Tabitha (fig. 88).[233] Similarly, the

---

[229] Buscemi, *Notizie*, 26 n. 1.

[230] Kitzinger, *I mosaici*, fasc. 1, 15.

[231] The composition of figures within the high and narrow containers of the side apses, each with a bust above a window flanked by two standing figures has parallels in Byzantium; see, for instance, the apses of the prothesis and diaconicon in the twelfth-century church of St. Panteleemon in Nerezi (Gabriel Millet, *La peinture du moyen âge en Yougoslavie (Serbie, Macédoine et Monténégro)*, vol. 1, Paris, 1954, pl. 16.1); the thirteenth-century Church of the Holy Trinity, Sopoćani (Millet, *La peinture*, vol. 2, 1957, pl. 41); and the fourteenth-century church at Ljuboten (Millet, *La peinture*, vol. 4, 1969, pl. 2, figs. 5 and 6). See also Hagios Strategos Boularion, Boularioi (N. B. Drandakes, *Byzantinai toichographiai tes mesa Manes*, Athens, 1964, 2ff.,

pl. 16B and plan opp. p. 16), and Episkopi, Mezapos (Drandakes, *Byzantinai toichographiai*, 65ff., fig. 4). See also the remarks of Otto Demus, *The Mosaics of San Marco*, 2 vols., Chicago and London, 1984, 1:31ff. regarding the representation of patron saints and saints whose relics were preserved in the church.

[232] Borsook, *Messages in Mosaic*, fig. 18.

[233] For the sake of contrast, see the figure of Peter in the scene of the Pentecost in the south transept vault, with its more erect bearing, leaner profile and fuller hair; Kitzinger, *I mosaici*, fasc. 1, figs. 224, 236. For the figures of Peter in the north aisle, see Kitzinger, *I mosaici*, fasc. 2, fig. 125, 130, 132, 133. The same model for the head of Peter, which is extremely close to the one used for the head of Peter in the apse, in fact, seems to have been employed throughout the aisles.

Pantokrator relates most closely, not to the image of Christ in the main dome of the sanctuary, nor, in fact, to the one at Monreale, but to one in the apse of the Cathedral at Cefalù, which places the figure also in the ambient of the late 1140s (figs. 96 and 97).[234]

Both Demus and Kitzinger have suggested that the present mosaic belonged to a second decoration of the main apse of the chapel, with which these observations would agree.[235] This redecoration must have been contemporary with the making of the mosaics of the nave and aisles. But what did the later decoration replace? The architectural form of the apse supports Demus's proposal that it once contained the figure of a seated or standing Virgin. Such a figure can easily be imagined as having occupied the space beneath the steeply pitched vault and above the window, as it does in other apse programs like the one in Cefalù.[236] In this way the awkward vault would be explained: it would never have been meant to contain a bust-length figure at all. But however compelling, this proposal also has an implication that bears spelling out. If the figure of a Virgin had been so placed, would it then have been flanked by ancillary figures in the manner of accompanying saints? Generally speaking when an apse was divided vertically for figures the zones were kept separate; they were not staggered.[237] But here, given the size and disposition of the elements to be reconstructed (specifically the window and the Virgin above it), these figures would either have had to have been staggered with the Virgin, or made disproportionately small. If ancillary figures were lacking, what then would have happened to the chapel's titular saint? It is unthinkable that Peter would not have been represented in the chapel, and most likely in a place of honor in its central apse. It can only be assumed, therefore, that Peter was represented here, probably in the same position that he still occupies, to the left of center beside the then open window. The one other compositional possibility that bears mentioning would alleviate the spatial constraint, although it would probably have resulted in a rather strange image, namely, that the Virgin above the window was not a full figure, but only a bust.

One final point about the second state of the main apse: the figure to the left of Santi Cardini's Virgin is identified by an inscription, as well as its long hair and dress, as Mary Magdalen (fig. 38).[238] But the only portion of it that dates from the twelfth

[234] Kitzinger, *I mosaici*, fasc. 1, figs. 130, 131. Demus, *Norman Mosaics*, figs. 2 (Cefalù) and 61 (Monreale). Note especially the eyes of the figure, which do not pull to the nose and turn downward at the sides as they do in the figure of the Pantokrator in the concha of the apse at Monreale, but remain level, perpendicular to the axis of the nose, as in the Pantokrator in the concha of the apse at Cefalù, which gives the figure a less tumultuous, more alert look. See also the remarks of Roberto Salvini, *Mosaici medievali in Sicilia*, Florence, 1949, 51.

[235] Demus, *Norman Mosaics*, 54ff.; Kitzinger, "Cappella Palatina," 272 n. 18; idem, *I mosaici*, fasc. 1, 14.

[236] Demus, *Norman Mosaics*, figs. 1 and 3.

[237] Otto Demus and Max Hirmer, *Romanesque Mural Painting*, trans. Mary Whittall, New York, 1968, figs. 41 (Foro Claudio, Santa Maria della Libera, after 1200); 85 (Castel Appiano, castle chapel, c. 1200); 205 (Tahull, Santa Maria, ca. 1123).

[238] Kitzinger, *I mosaici*, fasc. 1, fig. 143. The possibility that the Magdalen was, in its twelfth-century manifestation, a male figure, such as John the Evangelist, whose features as they were often rendered in medieval images of the saint would appear to resemble the twelfth-century physiognomy preserved in the present mosaic, should not be excluded. Sts. John the Evangelist and John the Baptist were paired in the apse of the basilica at Monte Cassino; see *Chron. Cas.* III, 28, 397; Nicola Acocella, *La decorazione pittorico di Montecassino dalle didascalie di Alfano I (sec. XI)*, Salerno, 1966, 43ff.; Bloch, *Monte*

century is the figure's face and part of its neck, both of which are, at best, ambiguous. Demus's reconstruction of the figure as the Virgin is plausible. Not only is the head of the figure—a smooth oval tilted slightly to the right in a three-quarter view—much like the head of the Virgin in the Nativity or the Flight into Egypt, but the presence of the Magdalen without the Virgin in a twelfth-century apse is unthinkable.[239] With the closure of the window and the addition of Santi Cardini's figure on the main axis, however, a potential duplication was resolved by the transformation of the figure from the Virgin into Mary Magdalen.

A plausible reconstruction of the history of the three apses in the twelfth century is thus possible. When the sanctuary and transept arms of the chapel were first decorated beginning probably in the early 1140s, the three apses were also outfitted with mosaics: a figure of the standing or seated Virgin in the main apse accompanied by Peter and other saints (John the Baptist? Gervasius and Protasius? Barnabas?), Paul with Philip and Sebastian to the south, and Andrew with Barnabas and Stephen to the north (fig. 42). Little over a decade later, probably in the reign of William I when the nave and aisle mosaics for the chapel were being made, the program for the apses was changed. A figure of the Pantokrator was substituted for the Virgin as the main motif of the central apse, and with it four new standing saints were placed in a zone that was created flanking the window below.

## SOME CONCLUSIONS REGARDING DATES

It has been difficult at times to keep our discussion of chronology separate from the issues of form and content that I would like to take up in chapter 3. But in attempting to draw these rather diverse observations together I would like to limit myself to an account of the chapel in the most straightforward, chronological sense. Unfortunately dates alone are not enough to understand the Cappella Palatina. It is also necessary to come to terms with how the various parts, as they were developed, related to one another, which raises the problem of the functional rationale of the edifice. The following conclusions, therefore, must be considered preliminary in the sense that they have not sought to engage this problem.

Our investigation into the decorations and furnishings of the Cappella Palatina has indeed borne out the impression that the interior outfitting of the chapel was not executed at once in a single campaign, but over decades in the second half of the twelfth century. However, it is now possible to speak about the chronology with greater precision: the main phases of activity fall into three separate periods, each of which may be associated with one of the Norman kings. The chapel that Roger II built consisted of a domed sanctuary cast in the form of a Byzantine church, adjoining a nave that was covered by a muqarnas vault. Sanctuary and nave were separated from one another by a high chancel barrier. Both contained balconies on the north wall

*Cassino*, vol. 1, 53ff.; Serena Romano, "Affreschi da S. Maria del Monacato a Castrocielo (e un aggiunta da Roccasecca)," *Arte medievale* 3, 1989, 155ff.

[239] Kitzinger, *I mosaici*, fasc. 1, figs. 153, 165.

(fig. 62). The nave also had a low platform at its west end which was surmounted by a window. The sanctuary was decorated with a pictorial program in mosaic that terminated (or commenced) with the figures of the two angels on the west side of the sanctuary arch facing the nave.[240] What decorated the nave at this stage, apart from the ceiling paintings, is unknown, but there is every reason to believe that it was quite different from the mosaics later put in place. In terms of their overall appearance, therefore, the Rogerian sanctuary and nave were quite distinct from one another, and this distinction was reinforced by the placement of the balconies and the platform, and by the high sanctuary wall separating the two spaces.

In the late 1150s or early 1160s, under William I, the nave and aisles of the chapel were redecorated with a new mosaic program that embraced an Old Testament narrative in the nave, and stories from the lives of Peter and Paul in the aisles. At this time the marble wainscoting was added to the aisle walls.

Finally, under William II, probably in the 1180s when the work at Monreale was well under way, the chapel was provided with a pulpit, baptismal font (?) and paschal candelabrum, and the nave platform was aggrandized to bring it into line with what we see today: a monumental fastigium surmounted by an image of Christ flanked by Peter and Paul.

How then are we to imagine the relationship between these phases? It is commonly assumed that the outfitting of the chapel proceeded according to a master plan that was established under Roger II. But there are now three reasons to believe that this was not the case. First of all, with regard to all of the post-Rogerian interventions in the chapel, we have had the opportunity to see how poorly they fit the Rogerian setting. The most blatant case is the mosaic decorations in the nave and aisles, which are so awkwardly and (for the subject matter) uncharacteristically disposed, that it is impossible to believe that they were envisioned when the architecture of the chapel was planned. But the later twelfth-century furnishings of William II also involved significant architectural readjustments to the chapel, which resulted in an ungainly and inconsistent use of space. In order to accommodate the new throne superstructure, the entire west end of the chapel, including doors and window, had to be refashioned, which must have considerably diminished the status of the southwest entrance into the south aisle. Inserting the pulpit and paschal candelabrum into the east end of the south aisle also blocked the Nativity scene and the Pantokrator from view from the west end of the chapel, from which they were clearly meant to be seen.

Second, from the evidence at our disposal, it would seem that there were no Christian elements in the first, Rogerian decoration of the nave of the chapel—apart from the angels in mosaic on the eastern arch of the nave which belonged, properly speaking, to the sanctuary program—or at least nothing like the Christian furnishings that were later put in place. Without pulpit, baptismal font and paschal candelabrum, not to mention the mosaic decoration of the nave and aisles, one wonders how this space could have been originally intended to be used as the nave of a church. Conversely, one wonders whether the insertion of new Christian "content" into the nave in the

[240] See above, p. 56.

post-Rogerian period did not represent an attempt to bring this space into line, functionally speaking, with ecclesiastical usages that were not a part of the original Rogerian program.

Finally, there is a factor that will be better treated in the following chapter but must also be mentioned here. The Rogerian scheme for the chapel, in distinction to the main axis of the plan, placed a decided emphasis on a north-south direction of use. This is perhaps clearest in the sanctuary where the king's balcony to the north established a decisive sightline southward, around which much of the imagery of the sanctuary was then arranged. A similar point will be argued for the balcony in the nave, for which the original entranceway to the southwest is key. Given this situation, the Christian elements of the later twelfth century imposed a new order on the nave space, essentially symmetrical, balancing both aisles and nave and relating them more clearly and directly to the sanctuary than they had ever been before. In other words, the later phases of decoration and furnishing diluted a Rogerian pattern of use by bringing the chapel more into line with a functional framework implicit in the plan.

Thus there is good reason to speak of a Rogerian concept or plan for the Cappella Palatina, which was then changed in later years. In introducing a concept of change into the discussion of the chapel, however, we have not only conjured up a "hidden" Cappella Palatina, disguised under the layers of usage of later years, we have also altered our framework for an understanding of the function of the edifice in a fundamental way.

# 3

# Proposals Regarding the Functional Rationale of the Chapel

## THE CHAPEL UNDER ROGER II

What has emerged through the chronological studies of the previous chapter is a new picture of the chapel as it must have existed in the mid-twelfth century, in its original, Rogerian manifestation, and the question to which I would now like to turn is how this building might have functioned. In this regard we shall have to content ourselves with a certain level of imprecision: there are no liturgical texts or books of ceremonies that might have provided an answer for us. But there is the physical fabric of the building itself, and not only the architecture but also the decorations and furnishings, from which some important insights may be gained. For instance, one of the most striking aspects of King Roger's chapel, as opposed to the edifice that took shape in the later twelfth century, seems to have been a decided asymmetry with regard to the main axis of its plan. An important aspect of this asymmetry was the presence of two balconies on the north side of the chapel, in the northern transept arm and on the north wall of the nave, with which we may begin (fig. 62). What purpose did these balconies serve?

It has been argued, and indeed demonstrated beyond a reasonable doubt, that the balcony in the sanctuary on the north wall of the northern transept arm was reserved for the king (fig. 15). This was established by the close connection between the balcony and the north side of the palace, where the private living quarters of the king were situated, and by the nature of the sanctuary decoration, which assembles for the purview of the balcony occupant, an array of subjects and themes that have explicit royal connotations.[1] Within this framework, the function of the balcony is thus clear: to provide a place for the king to observe the liturgy. It was not, however, a good or even adequate place from which the king himself could be observed, except by the canons of the chapel and other celebrants in the sanctuary, since the viewing angle from the

---

[1] On the issue of the king's quarters, see the remarks attributed to Hugo Falcandus cited above, chapter 1, n. 58.

nave was too oblique. The sanctuary balcony, therefore, cannot be imagined as a "pre-sentational" structure (a "window of appearances" to cite Ćurčić's term), at least in this obvious sense. One may well wonder whether the celebration of the liturgy in the chapel originally was intended for the king alone.

A similar argument can be made for the balcony in the nave, that is to say that it too was meant for an observer or a group of observers; in this case, however, identifying the occupants, which is also bound up with the issue of sightlines, is a little more complicated. No matter how far the balcony extended into the nave (and it is difficult to imagine that it projected very far) it would never have been a good place to view the liturgical celebrations of the sanctuary, since the angle of sight for any of the balcony's occupants would have been too sharp (fig. 62). Nor would the balcony have been the best place to present oneself to an audience in the chapel, perhaps assembled in the nave, since the nave is so narrow. But if not to see the liturgy or to be seen, what purpose did it serve?

The argument here hinges on two contexts. One of them is the immediate context of the area above the north aisle (fig. 56). The nave balcony, like the sanctuary balcony to the east, must have been accessible from the north, where a small room is now located. It will be recalled that this room may have gone back to the twelfth century in a form similar to that it now has. It is mentioned in the nineteenth century as the "Cappella del Vicerè," as well as the location of the workshop that maintained the chapel mosaics. The walls of this room also bear traces of ancient (although not pre-cisely datable) use in the form of numerous cuts, repairs and fragments of old fres-coes. But the most telling feature is the wall that abuts the north wall of the nave with the balcony opening, that is to say, the west wall of the northern transept arm. This wall—actually just the arched upper portion of it beneath the barrel vault of the northern transept arm—contains, not a window like the corresponding piece of wall in the transept arm opposite (west wall of the southern transept arm) but three smaller openings that have been joined together, one slightly larger and rectangular, sur-mounting the other two, which are narrow slits (figs. 59, 60, and 61). That all of the perforations here are original cannot be doubted. They make sense as view-ing/listening apertures, that is, as openings that would have allowed someone to see below and listen but not to be seen, which is interesting because the area above the north aisle, directly behind these openings, contains the room that must have given access to the presumed balcony in the nave. As a matter of fact, these two walls, the wall with the slits and the wall with the balcony may well have come together in this very room in the twelfth century, as they do now, which, in turn, would have given access from one space to both positions (namely, views into the nave and into the transept from the nave balcony and the transept opening and slits). The only problem is that the slits are substantially higher on the wall, vis-à-vis the possible balcony open-ing, which would presume, if one were to hold the viewing/listening hypothesis, some sort of structure that would have made them accessible from a lower level. In fact, it may well have been a staircase, placed within the room against the wall with the slits, because there must have been access to an even higher level in this vicinity (the level of

the cupola of the choir), as yet another opening higher on the balcony wall (the north wall of the nave) near the cupola of the chapel suggests (fig. 137).[2]

Now the viewing/listening hypothesis is interesting since none of the other functional rationales that can be imagined, based on the evidence about such elevated positions from other contexts—such as churches, palaces and mosques, where they served as places for musicians, for instance, or guards—would fit the situation here very well. The location of the chapel structures, the presumed balcony and the slits, was simply too eccentric. But a viewing/listening purpose would have had a logic within the context of the chapel. It would have been from this point precisely that one would have had an optimal view of the king or would have been able to hear the activities taking place around him in both of his places: in the balcony in the northern transept arm as he beheld the liturgy, which was overlooked by the slits, and on the platform at the west end of the chapel, where he would have been seen in conjunction with the main entrance to the chapel, whose original location must now be spelled out (fig. 32).

As argued earlier, a change in the throne platform in the late twelfth century must also have involved a change in the entrance pattern of the chapel, with an emphasis now on the west and on symmetry—on what one must assume were parallel movements through the two doors of the narthex into the aisles alongside the throne. There is good reason to believe, however, that before the narthex was built, the original main entrance to the chapel was not to the west but to the southwest, at the far west end of the south aisle (fig. 32).[3] Not only is this even today the largest doorway into the chapel, it was probably the only door that would have been reached via a monumental public staircase, as the reconstruction of the architect Valenti suggests (fig. 16). And it was also probably the only door that was outfitted on its outward facing side with a monumental inscription (figs. 48 and 49). Bearing this interpretation in mind, the original approach to the Cappella Palatina is thus not difficult to envision: one presumably entered the palace itself from the south, where the public portion of the edifice is believed to have been, proceeded into a large court and then via the monumental stair, into the chapel through the southwest door ornamented with its monumental inscription. At this point, however, a difficulty arises, for in positing a southwest entrance, one must then also imagine the medieval visitor, upon passing through the chapel door, brought into an encounter with the great platform of the nave, minus of course the throne back, from the side (fig. 51). This would have been an odd juxtaposition by any account, and the question arises as to why it occurred. Part of the answer lay at one's feet, in the opus sectile pavement of the chapel.

As we have already had an opportunity to observe, the chapel pavement is laid out in the customary Byzantine manner in a series of square and rectangular compart-

---

[2] The opening is clearly indicated in the section from the Valenti archive referred to above, chapter 2, n. 87, and reproduced in fig. 58, with the notation, "Accesso antico al soffitto." Palermo, Biblioteca Comunale, 5 Qq E146, no. 50 (30 June 1939) refers to "Scrostamento dell'intonaco dal lato sud delle due stanzette di passaggio alla cupola, sulla navatina nord."

[3] See above, chapter 2, pp. 44ff.

ments with only one serious departure from the norm (fig. 22). This occurs in the first two bays to the west in the south aisle, at precisely the point where the original main entrance to the chapel is believed to have been. Here, instead of the usual curvilinear and rectilinear patterns in simple frames, there are two compartments divided between large central elements and narrower flanking bands (figs. 22 and 32). Now a design variation of this sort, involving only abstract patterns of ornaments and frames, would not necessarily be meaningful, but for two facts. Ancient and medieval pavements, especially in public and ceremonial spaces, were often constructed with patterns that served to describe or support the actual use of the space in terms of processions, rituals, movements and so on. A case in point is the group of ecclesiastical pavements from Rome and Monte Cassino from the later Middle Ages, which often show a processional route down the main axis of the nave of the church inscribed in a series of distinctively patterned panels; another comes from the tenth-century *De ceremoniis* of Constantine VII Porphyrogennetos, which makes frequent mention of the function of certain designs—involving in this case porphyry disks (ὀμφαλόι)—in the floors of various rooms in the Great Palace as physical indicators of important moments in the progress of court rituals.[4]

That design elements were used this way in the Cappella Palatina pavement is thus not implausible. But there is a more specific reason to ascribe meaning to the design change in the chapel. Pavements with panels divided in precisely this way, that is, into a central square or rectangle with narrower flanking bands, also occur with some frequency in both antiquity and the Middle Ages in the same kind of context that is posited here, namely, at the entrance to a room or corridor (fig. 138).[5] In fact this type of pavement is known as a threshold pavement, and it is in this sense, I believe, that the first two bays to the west of the south aisle should be understood. What these pavements indicate is that the first bay of the south aisle to the west was a threshold: in fact, it was the main threshold of the chapel. But they also tell us that the second bay too was a threshold, and the only space for which it could have thus served was the nave. Taken together, these patterns may be seen as inscribing a path of movement through the chapel, from a point of entry at the southwest, down the south aisle one bay and into the nave—in other words from the entrance into a direct, head-on and close encounter with the occupant of the platform, the king. One need only recall the reconstruction of the western end of the chapel under William II to realize how much at odds with the later arrangement the implied movement of the Rogerian design would be.

This Rogerian movement certainly seems like a ceremony of greeting, like the Byzantine custom of ritual bowing or *proskynesis*, and in it, in all likelihood, we have the subject that was viewed by the occupants of the presumed balcony on the north wall of the nave. But we also have a critical second pole, as it were, from which our picture of the chapel function might be hung. It almost goes without saying again that the sanc-

---

[4] On the function of porphyry disks in medieval pavements, see William Tronzo, "The Prestige of Saint Peter's: Observations on the Function of Monumental Narrative Cycles in Italy," *Studies in the His-* *tory of Art of the National Gallery of Art* 16, 1985, 101ff. with bibliography.

[5] Hiltrud Kier, *Der mittelalterliche Schmuckfussboden*, Düsseldorf, 1970, 29, fig. 337.

tuary of the chapel served for the performance of the liturgy, and that this performance, from all that we can tell, especially from the presence of the sanctuary balcony and from the degree of separation of sanctuary from nave, was reserved for all intents and purposes for the king. There may have been an audience in the nave for these services, but they would have seen precious little. What now seems to have taken place in the nave, however, was a greeting ceremony, or something along these lines, which obviously could not have occurred simultaneously with the liturgy because it too involved the king. Two separate ceremonies, in two separate and yet linked spaces, and two roles above all for the king. That these two spaces—the "Byzantinizing" sanctuary and the "Islamicizing" nave—would have been less interpenetrating in that they would have been much more distinct in their look in the Rogerian chapel than they are now, only further suggests one of the ways in which the original rationale of the chapel has begun to reassert itself.

Up to this point we have availed ourselves only of the mute facts of decorations and spatial relations. However there is one final piece of physical evidence that needs to be inserted into this picture, the aforementioned inscriptions adduced in the contexts of the southwest door frame, since they provide striking confirmation of our interpretation and lend to it, in addition, a new dimension (figs. 48 and 49). Let us recall the main lines of the earlier argument: that there were two fragmentary inscriptions found in the Cappella Palatina, one in 1892 in a storeroom of the chapel (no. 1) and the other in 1863 in the south aisle (no. 2); that the inscriptions, although both in Arabic and carved in the same intarsia technique in cipollino with porphyry and serpentine breccia, were rendered in different meters—the one in *kamil* (1892), and the other in *ramal* (1863)—and had different content; and that they may have come, no. 1, from the outer frame of the southwest entrance into the south aisle, and no. 2, from the stairway preceding the southwest entrance, possibly too from a door frame belonging to it. According to Johns, who has treated them most recently and authoritatively, they may be construed as follows: " . . . graciously//and you make haste to kiss and salute him. Roger has competed with . . . " (no. 1); ". . . (?) kiss its corner after having embraced it// and contemplate the beautiful things that it holds" (no. 2). So much is obviously missing here that it would be brash to attempt to reconstruct the text in either case, but even given their fragmentary state there are two aspects of the inscriptions that are significant. One is that they are both addressed to the viewer explicitly, and implore him to perform certain acts. The other is that they both speak of homage, first to the building itself (no. 2), and then to the king (no. 1), which in both cases are understood to be the recipient of kisses. In other words, as the mid-twelfth-century visitor encountered and then proceeded into the Cappella Palatina as it may now be reconstructed, ritual acts of homage were spelled out for him by the speaking building itself in a way that reinforced and supported the messages that were also communicated by the mute patterns of the decoration.

It is only when we move back to embrace a larger frame of reference, however, that the nave of the chapel and particularly the relationship that it must have borne to an Islamic context comes into sharper focus. As things stand now, and especially with the later twelfth-century mosaics, the nave itself is a rather mixed form. But in its original

appearance as it has been reconstructed here, with its muqarnas vault, its high, stilted arches, its low platform against the west wall, its balcony, its tapestries and its Kufic inscriptions, it would have been quite different, and one wonders whether it would not have looked, in the eyes of a contemporary viewer, more like a Fatimid *iwan* than anything else.[6] The problem is that we cannot define the Fatimid tradition with a great deal of precision for the twelfth century. But if we are content with the assumptions that have often been made in other contexts—that both earlier and later structures, objects and texts can elucidate this period—then the following connections are possible.[7]

It was precisely at this time, in fact, that we have the evidence of the great throne in the Fatimid Palace to which I alluded earlier.[8] The throne occurred in the Eastern Palace, the greater of the two Fatimid palaces in Cairo, composed, in the words of Nasir-i Khusrau, of

> twelve pavilions (qasr) touching each other, and all were square in shape. Every one I entered was more beautiful than the last; each covered 100 square cubits (aresh), except the last which covered 60 only. In the latter was *a throne occupying the whole width of the hall*; it was four guez high and wide. Three of its sides were of gold and had represented on them hunting scenes, with knights racing horses and other subjects. One also saw inscriptions rendered in beautiful characters.[9]

It is noteworthy that the throne platform in the Cappella Palatina spanned the width of the nave from column to column. Curtains or wall hangings were the customary outfitting of such ceremonial spaces and were also placed in conjunction with thrones, as witness the account of Nasir i Khusrau, as well as the report in the *Historia* of William of Tyre made by Geoffrey Fulcher and Hugh of Caesarea, of an audience in 1167 at the court of the last of the Fatimid rulers of Cairo, the caliph al-Adid, whose throne was covered with a heavy drape, and the description of Maqrizi, which differentiates between the brocade of winter and the linen of summer for palace walls.[10]

---

[6] For *iwan*, see *Encyclopedia of Islam*, ed. E. van Donzel et al., 2d ed., Leiden, 1978, 4:287ff.

[7] Richard Ettinghausen, "Painting of the Fatimid Period: A Reconstruction," *Ars Islamica* 9, 1942, 112ff.; Jonathan M. Bloom, "The Origins of Fatimid Art," *Muqarnas* 3, 1985, 20ff.

[8] On the Fatimid Palaces, Eastern and Western, about which only meager information is available, see Edmond Pauty, *Les Palais et les maisons d'époque musulmane au Caire*, Cairo, 1932, 31ff.; K.A.C. Creswell, *The Muslim Architecture of Egypt*, Oxford, 1952–59, 1:33ff.; Robert Hillenbrand, *Islamic Architecture: Form, Function and Meaning*, New York, 1994, 434ff.

[9] *Sefer Nameh, Relation du Voyage de Nassiri Khosrau*, ed. and trans. Charles Schefer, Paris, 1881, 54f., trans. 157f. as quoted in Creswell, *Muslim Architecture*, 1:33f. (italics mine). See also Laila ali Ibrahim, "Residential Architecture in Mamluk Cairo,"

*Muqarnas* 2, 1984, 52.

[10] William of Tyre, *Historia rerum in partibus transmarinis gestarum*, bk. 19, c. 19: *Recueil des historiens des croisades. Historiens occidentaux*, I, pt. 2, Paris, 1844, 912; Pauty, *Les palais et les maisons*, 34f.; Creswell, *Muslim Architecture*, 1:33. See also *Histoire d'Egypte de Mahrizi*, trans. E. Blochet, Paris, 1908, I, 386, 13. Maurice Canard, "Le cérémonial fatimite et le cérémonial byzantin: Essai de comparison," *Byzantion* 21, 1951, 360. On drapes, see Paula Sanders, *Ritual, Politics, and the City in Fatimid Cairo*, Albany, N.Y., 1994, 20, 32 and 84. See also *The History of the Mohammedan Dynasties in Spain, extracted from the Nafhu-t-tib min ghosni-l-andalusi-r-rattib was tarikh lisanu-d-din ibni-l-khattib by Ahmed ibn Mohammed al-Makkari*, trans. Pascual de Gayangos, London, 1843, vol. 2, 137f., 141: "the great hall of the palace was hung with the richest curtains and drapes."

There are also descriptions of viewing balconies in such contexts, which correspond to the appearance of the form in later structures, such as the qaʻa of Muhibb al-Din al-Muʻaqqa in Cairo, to such an extent that one cannot help but assert the validity of the connection.[11]

One might also cite here a rare collection of sculpted beams from eleventh-century Cairo (fig. 139).[12] These beams are actually now only *disiecta membra*, so their original placement and use is not certain. But they are believed to have come from the Western Fatimid Palace, and they show a set of figures enframed in a rinceau and engaged in a variety of activities—drinking, dancing and music-making—including images that must be construed as those of the ruler, that correspond to a remarkable degree to the imagery of the nave ceiling in the Cappella Palatina.[13] This imagery, moreover, appears in another, distantly related context of the twelfth-century Islamic world, in a set of tiles that decorated a kiosk of the royal palace at Konya (Ikonion) which was built by Kilidj Arslan II in 1173–74.[14]

We have purposefully considered evidence from both royal and aristocratic contexts and from a number of different times and places, and have dealt with this evidence cursorily, because the point here was only to render a sketch. There is as yet no study of the hall of state as such in the Islamic world, or indeed the halls for receptions and audiences, and it is precisely such a study by specialists in the field that would pursue such vexed questions of form as the origins and meaning of muqarnas that are so important to the Cappella Palatina.[15] The frequent references to Fatimid Palaces in

---

[11] The term *qaʻa* had a range of meanings, for which see S. D. Goitein, *A Mediterranean Society*, vol. 4, *Daily Life*, Berkeley, 1983, 69ff.; Ibrahim, "Residential Architecture," 47. In the south liwan of Qaʻa Dardir, the window in between the pendentives is filled in with mashrabiya screen; Creswell, *Muslim Architecture*, 1:261. For later examples, see Jacques Revault and Bernard Maury, *Palais et maisons du Caire du XIVe au XVIIIe siècle*, 4 vols., Cairo, 1975–83, 1:29 (Qayt-Bay), 35 (al-Razzaz), 67 (Radwan Bey), pls. XVII B, XXIX A; 2:1 (Beštak), 18 (Muhibb al-din al-Muʻaqqa), 79 (Al-Irsan), pls. X, XVIII, XXI B, LXIV A and B, LXVI A and B.

[12] Edmond Pauty, *Les bois sculptés jusqu'à l'époque ayyoubite: Catalogue général du Musée Arabe du Caire*, Cairo, 1931, 48ff., esp. 50, pls. XLVI–LVIII.

[13] Ibid.

[14] Friedrich Sarre, *Der Kiosk von Konia*, Berlin, 1936, passim, esp. pls. 5 and 7.

[15] A study in which the Sicilian material finds a place would be most useful; see, for example, the overview of Hillenbrand, *Islamic Architecture*, 377ff. on the medieval palace, and 441f. on palaces in Sicily; Hans-Rudolf Meier, *Die normannischen Königspaläste in Palermo: Studien zur hochmittelalterlichen Residenzbaukunst*, Worms, 1994, 24ff. One wonders about the significance of resemblances between Sicily and Egypt, especially with regard to the Cap-

pella Palatina and later Mamluk structures. A case in point is the palace of Beštak in Cairo with its exceptionally noble qaʻa, built in stone and embellished with highly stilted colonnades and galleries, and with vaults in muqarnas and with star-shaped patterns; see Pauty, *Les palais et les maisons*, 43, pl. XV; Alexandre Lézine, "Les Salles nobles des palais mamelouks," *Annales Islamologiques* 10, 1972, 63ff., 98ff., fig. 17, pls. XII–XV; Revault and Maury, *Palais et maisons*, 2:1ff., fig. 5, pl. X. The palace postdates the Cappella Palatina by a considerable stretch: it was constructed in the Bahri Mamluk period but it has been used by scholars to make inferences about the architectural state of affairs in Cairo in earlier times. Beštak has been related in particular to a rare surviving example of Fatimid or Ayyubid domestic architecture, the Qaʻa Dardir, with its stone qaʻa composed of a central space, the durqaʻa, and two adjoining bays, or liwans, vaulted in brick, one of which contained a screened-in viewing window; see Creswell, *Muslim Architecture*, 2:87 and 263; Revault and Maury, *Palais et maisons*, 1:1ff.; 2:pls. III–V. On the date of the structure now see also Ibrahim, "Residential Architecture," 53. The strength of the twelfth-century tradition in another respect was stressed by K.A.C. Creswell, "The Origin of the Cruciform Plan of the Cairene Madrasas," *Bulletin de l'Institut français de*

Cairo in the foregoing brief account, however, confirms in a sense what Johns has argued for the inscriptions and what Ettinghausen believes for the painting of the nave ceiling: that the model was Fatimid. The proposition also finds support in the one further observation about the ceiling that we have already made. Whatever the immediate source of these forms—Fatimid Egypt or North Africa—one thing is clear: that the craftsmen who executed them were trained in this tradition. They were Muslim artists who were fluent in these forms and images—in other words, foreigners, schooled in the very finest workshops of their craft and bearing with them the knowledge of the most contemporary developments, who came to Sicily at the request of Roger II, like the Byzantine mosaicists who began the decoration in the sanctuary of the chapel.

The convergence of sanctuary and nave in this regard suggests one further point. The sanctuary of the chapel has often been spoken of as a "Byzantine church," and the nave as a "Western basilica," but perhaps the situation is better characterized in the following terms. What the sanctuary and the nave of the Cappella Palatina represent are two parallel efforts, effected by two separate groups of foreign artists, of mise-en-scène, undertaken in the service of a joint function. That function was the liturgical juxtaposition of Christ and the king. But the parallel efforts defined it as unfolding in two separate and culturally distinct realms, Byzantine and Islamic, which is the truly remarkable fact. In the end it is the union and yet the stylistic separateness of these two realms that seems so profoundly new.

But before we explore this issue in earnest, let us return to the Kufic inscriptions. Directed as they are to the viewer and speaking explicitly of ritual acts, these inscriptions are supremely important pieces of evidence for our reconstruction of a functional picture of the Cappella Palatina. But how are they to be understood? Were the rituals of embracing, kissing and salutation that were stipulated in words actually performed by twelfth-century visitors to the chapel? If so, to what purpose and in what larger ceremonial context? To answer these questions it will now be necessary to go beyond the confines of the Cappella Palatina, indeed beyond Norman Sicily itself.

✛    ✛    ✛

Scholars have propounded essentially three views of the ceremonial life of the Cappella Palatina, or indeed of the Norman court to which it so intimately belonged, which now deserve our careful attention. Only two preliminary remarks. Obviously none of these accounts have had the benefit of the close scrutiny that we have been able to give the physical fabric of the edifice, against the background of which, however, they must now be judged. It is also the case that they make use of sources exterior to the chapel itself, from other Norman Sicilian contexts or places outside of Norman Sicily altogether, which is an unfortunate necessity as we have already ob-

*l'archéologie orientale du Caire* 21, 1922, 45ff. See also Alexandre Lézine, "Persistance de traditions pré-islamiques dans l'architecture domestique de l'Egypt musulmane," *Annales Islamologiques* 11, 1972, 1ff., and 16f., with an interesting use of the Sicilian material.

served. Norman rulers, unlike their counterparts elsewhere, such as the Byzantine emperors, did not keep accounts of their ceremonial activities, or at least none have come down to us today. Non-Norman sources, however, are important insofar as they provide us with what one might call "the parameters of the possible" in a twelfth-century context. These sources give us some sense of what court ceremonial was like in the twelfth century, in contexts of which the Norman rulers themselves may well have been aware. The main problem here, of course, is the possibility of false analogy: in entering this evidence into account—especially when it is so much richer than the surviving Norman material—we run the risk of imposing on the Normans a situation that never occurred. Let me offer as a countermeasure the following principles: that evidence from the outside will not be brought to bear on the Norman situation unless it fits the entire palatine context, not just one aspect of it; and this evidence must also find some corroboration in an explicit way in the Norman material. That other ceremonial traditions were influential on the Normans, however, is without doubt: it has already been proven in the study of the two Kufic inscriptions.

Jeremy Johns, following the great nineteenth-century Arabist of Norman Sicily, Michele Amari, has seen in the larger of the two inscriptions of the Cappella Palatina—the one regarding the building itself—an explicit reference to a ritual involving the kissing of the Ka'ba that was performed by the pilgrim during his visit to Mecca.[16] Not only are identical acts of homage called for in both contexts (embraces and kisses), but the very vocabulary that is employed to describe them is the same. The relationship is succinct and incontrovertible. Given this fact, Amari assumed that the Mecca pilgrimage was the direct source of the palatine inscription, which left him wondering about the impact that this impious borrowing might have had on the twelfth-century Muslim visitor to the Norman Palace. Johns, on the other hand, saw the connection as having been effected through the mediation of the Fatimid court.

The Fatimids were the great rivals of the Normans to the South, the North African dynasty that established itself in Cairo in the eleventh century. There they built a capital for themselves, where they propounded a philosophy that set them apart from the other ruling houses of Islam, a main tenet of which regarded the imam not merely as God's representative, but as "an emanation of the divine light."[17] The Fatimid rulers encouraged their subjects to worship them as gods, and in support of his interpretation Johns cited Fatimid panegyrics comparing the Fatimid palace to the Ka'ba. An anonymous verse concerning the Fatimid palace in al-Mahdiyya makes the point: "Thus as the pilgrim kisses the corner (of the Ka'ba), we have kissed the walls of your palace."[18] The Norman Arabic verses were concrete proof, to quote Johns, "that King Roger and his advisors modelled the Arabic aspect of the new Sicilian monarchy on the Fatimid caliphate of Cairo." Are we then to imagine that Fatimid ceremonial holds the key to the larger context in the Cappella Palatina to which the inscribed texts themselves belonged?

[16] Jeremy Johns, "I re normanni e i califfi fatimiti: Nuove prospettive su vecchi materiali," unpublished paper presented at the Fondazione Caetani in Rome, May 1993.

[17] Sanders, *Ritual, Politics, and the City*, 41.

[18] Johns, "I re normanni."

On both counts, in terms of the two principles that have been adduced, the answer must be negative. On the one hand, insofar as it has been possible to determine, there is no other Norman evidence of the textual sort that would support this hypothesis. Of course, such evidence may someday come to light, but it seems rather unlikely for the following reason. The work of Canard and Sanders—which has provided us with an important critical base for an understanding of Fatimid court ceremonial—has shown that nowhere is there evidence of a ceremony or a ceremonial structure that would have been appropriate to a space like that of the Cappella Palatina, and it is no accident.[19] In keeping with the new relationship between the ruling dynasty and the deity that the Fatimids propounded, there was no need for a separate "religious" establishment within the confines of the palace; the palace itself carried religious meaning. The greatest of all of the Fatimid palaces, that of Cairo, did not have a mosque attached to it, unlike the palaces of any of the other ruling houses of Islam.[20] But the Cappella Palatina was clearly constructed, not only in artistic terms, but also in terms of functional spaces, as a composite edifice, with a sanctuary and a nave adjoining one another and yet given over to liturgies and receptions separately. Such a joining together and yet a keeping apart must have been purposeful; indeed, it must have been the most important purpose of the Cappella Palatina, and any reconstruction of function must seek to account for it first. The kind of religious activity presumed by the presence of the sanctuary of the chapel would not have been possible for the Fatimids, which immediately establishes a important conceptual distance between the Cappella Palatina and Fatimid ceremonial. In other words, no matter how broadly or loosely interpreted, Fatimid ceremonial could not be argued to embrace the larger Norman palatine context.

No such distance, however, can be assumed for another text that speaks about ritual explicitly, an *ordo* of coronation that has been dated by Reinhard Elze to a period after 1135.[21] This text, which may or may not have been employed for Roger II, is especially interesting in this context precisely because of its Norman-Sicilian origins and its possible Rogerian associations, and for these reasons it has been brought to bear on the form of the Cappella Palatina by Beat Brenk. As Brenk himself recognized, the coronation ceremony of the Norman kings, with only one later and unusual exception, never occurred in the Cappella Palatina. It took place in the Cathedral of Palermo, beginning with Roger II in 1130, as reported in the chronicle of Alexander of Telese. But Brenk argued that this ceremony may have been influential for two reasons: that it too involved, and most significantly, a throne, and this throne was set some distance from the altar of the church. Brenk's implication is that the throne platform in the chapel was made in imitation of this coronation throne, as indicated by

[19] Canard, "Le cérémonial fatimite," 355ff. Sanders, *Ritual, Politics, and the City*, passim. See also the related studies of earlier and later periods: Dominique Sourdel, "Questions de cérémonial Abbaside," *Revue des Etudes Islamiques*, 1960, 121ff.; Karl Stowasser, "Manners and Customs at the Mamluk Court," *Muqarnas* 2, 1984, 13ff.

[20] Sanders, *Ritual, Politics, and the City*, 40ff.

[21] Reinhard Elze, "Tre ordines per l'incoronazione di un re e di una regina del regno normanno di Sicilia," *Atti del congresso internazionale di studi sulla Sicilia normanna (Palermo, 4–8 Dicembre 1972)*, Palermo, 1973, 438ff. Elze dismisses the reference to William in the Madrid manuscript: "non è un criterio di datazione da prendere troppo sul serio" (Elze, 442). See also below, pp. 126ff.

its placement at the far west end of the nave, and by what Brenk calls its "state-representational" character. Thus in Brenk's view the throne platform, as well as the nave and perhaps even the chapel itself had a royal commemorative function. In this sense it could be understood within the tradition of the "Festkrönung," or the crown wearings that punctuated the liturgical year and commemorated the king's coronation in certain royal courts of the North.[22]

However suggestive the connection between the king's initiation and the ritual heart of the king's own house, it would seem that it should not be made, or at least not made in these terms. For one thing, there is no good reason to posit a relationship between the two thrones. Although the *ordo* is silent about the form of the coronation throne, it could hardly have resembled the throne platform in the chapel; and as far as distance in the Cathedral from the altar is concerned, it could not have been substantial. The text speaks about a movement to a throne after the placing of a cross on the altar.[23] But this occurs before the mass is celebrated, and so it is from this throne that the king must have watched the liturgy. Obviously this could not have been the case in the Cappella Palatina. With regard to the palatine throne the important point in any event is this: that it was not a constant in the chapel throughout the twelfth century, as Brenk assumed, but underwent an important change, and a single moment like the coronation could hardly explain both phases and the reason for the change itself. Finally, there is the presence of the Arabic inscriptions, which would seem to constitute an incontrovertible contradiction, ritually speaking, to the German-inspired *ordo*.

The contradiction inherent in this last juxtaposition, however, only highlights a deeper problem with Brenk's method that we might express in the following terms: to what extent are we justified in seeking to assimilate the Rogerian Cappella Palatina to a Western model? Obviously the Normans themselves traced their roots to Normandy, and this lineage found expression in a variety of ways in Sicilian Norman culture and in the Norman state. Explicitly or at least demonstrably Western elements as such—for example, the images of Sts. Dionysius and Martin, who were particularly revered in France—are present even in the sanctuary of the Cappella Palatina, as is a Latin inscription which finds its closest affiliation in a verse attributed to Hildebert of Lavardin.[24] But the predominant impression of the chapel as it has been reconstructed here in its Rogerian phase derives from two main cultural traditions: Byzantine and Muslim. One may well ask about the functional arrangement of the chapel: if it befitted a purpose along the lines of a Western model, why is there no adumbration of it or parallel to it anywhere else? The fact is that the Cappella Palatina, with its balconies and platform, and separate yet adjoining spaces, resembles in its totality no other Western chapel or church.

For the sake of argument, however, let us take as an example one element of the functional arrangement of the chapel that would seem to come closest to a Western tradition, the throne platform in the nave. The practice with which the platform can

[22] Hans Walter Klewitz, "Die Festkrönungen der deutschen Kaiser," *Zeitschrift der Savigny-Stiftung für Rechtsgeschichte* 28, 1939, 48ff.; Carlrichard Brühl, "Frankischer Krönungsbrauch und das Problem der Festkrönung," *Historisches Zeitschrift* 194, 1962, 205ff.

[23] Elze, "Tre ordines," 454.

[24] See above, chapter 2, n. 100.

be compared may be defined in broadest terms as the monumentalization of the western end of the church building. This practice seems to have been an early medieval development in ecclesiastical architecture, and to have evolved most significantly not in the Mediterranean world, but in northern Europe, beginning in the kingdom of the Franks, with structures like the Palatine Chapel at Aachen and the abbey church of St. Riquier.[25] It took on a variety of forms that have been commonly subsumed under the term "Westwerk." I would also like to include in the discussion here the western king's throne (as at Aachen) and king's choir, though some scholars have insisted on maintaining a distinction between them.[26] The emphasis on the western end of the chapel or church, as a counterpoint to the main altar to the east, is perhaps the most important aspect of this practice that relates directly to the platform at the western end of the Cappella Palatina. Another point of resemblance, however, is the presence of the king. Although not all of these western structures were created for the use of the king, and the debate still continues about the purpose of many of them, a certain number clearly were, and these include both royal and non-royal foundations. Finally, it is rarely the case that the western premises so designated included fixed and permanent thrones in the manner of the throne of the Ottonian period now in the Palatine Chapel at Aachen (*solium*; fig. 140). More often the actual seat of the king must have been portable (*faldistorium*) and installed at the time of its intended use, in much the same way that one would imagine that the throne platform in the Cappella Palatina might have been outfitted in its post-Rogerian phase.[27]

On the other hand, none of these western structures encompassed a throne "receptacle" in the form of a throne platform quite like the one in the Cappella Palatina, whose proportions must have struck the viewer from a Western perspective as rather odd. The platform is extraordinarily wide, and with its (originally) low sides, it must have seemed more like a frame for the kind of couch on which the Muslim ruler typically reclined in state than for any known Western throne. Spanning the nave from colonnade to colonnade it also recalls the famous throne of the Fatimid Palace in Cairo, which extravagantly spanned the palace chamber in which it was housed from wall to wall, but of this point more later.

There are two other reasons for dissociating the chapel platform from Western

---

[25] From the extensive literature on the subject, mention may be made of the followings studies: Alois Fuchs, "Entstehung und Zweckbestimmung der Westwerke," *Westfälische Zeitschrift* 100, 1950, 227ff.; Percy Ernst Schramm, *Herrschaftszeichen und Staatssymbolik*, Stuttgart, 1954, 354ff.; idem, "Lo stato post-carolingio e i suoi simboli del potere," *I problemi comuni dell'europa post-carolingia* (=*Settimane di studio del centro italiano di studi sull'alto medioevo* 2, 1954), Spoleto, 1955, 149ff.; Adolf Schmidt, "Westwerke und Doppelchöre: Höfische und liturgische Einflüsse auf die Kirchenbauten des frühen Mittelalters," *Westfälische Zeitschrift* 106, 1956, 347ff.; Albrecht Mann, "Doppelchor und Stiftermemorie: Zum kunst- und kultgeschichtlichen Problem der

Westchore," *Westfälische Zeitschrift* 111, 1961, 149ff.; Hans Eberhardt and Paul Grimm, *Die Pfalz Tilleda am Kyffhäuser*, Tilleda, 1966; Friedrich Möbius, *Westwerkstudien*, Jena, 1968.

[26] Regarding the king's choir, see the discussion of Peter Metz, "Der Königschor im Mainzer Dom," *Universitas: Dienst an Wahrheit und Leben. Festschrift Dr. Albert Stohr*, Mainz, 1960, 290ff.

[27] On the portable throne, see Ole Wanscher, *Sella curulis: The Folding Stool, an Ancient Symbol of Dignity*, Copenhagen, 1980. The distinction figures in an interesting way in the discussion of Francesco Gandolfo, "Reimpiego di sculture antiche nei troni papali del XII secolo," *Rendiconti della pontificia accademia* 47, 1974–75 (1976), 203ff.

European practices—both interrelated and both having to do with function. More often than not when a ruler (or other important personage) was given a place at the western end of a chapel or church, this place was elevated, on the second story or gallery level (i.e., as at Aachen, Corvey, Goslar, Soest, Schwarzrheindorf).[28] As such it was also often constructed not for close contact with the king, but for longer sightlines: the king's view of the altar at which the liturgy was performed, and the view of the king from the participants in the liturgy standing on the floor of the nave. The arrangement at Aachen is a case in point, with the throne placed near the center of the westernmost bay, whose balustrade was detachable so as to leave the necessary views unimpeded (fig. 140). This seems much more like the situation of the king's balcony in the sanctuary of the Cappella Palatina, at least in spirit, than of the king's platform at the west end of the nave, which was clearly contrived to function in the context of the broad plateau of the nave floor surrounding it.[29]

Fatimid ceremonial and Western practice, therefore, present at best a partial and at worst a false analogy to the situation in the Cappella Palatina. There is another possibility, however, that emerges all the more clearly if one bears in mind the principles adduced earlier, beginning with the form of the chapel in its palatine context. The fact is that the spatial logic of the building—two separate yet adjoining spaces at the very heart of the royal palace, one for the performance of the liturgy with a balcony for the king, the other for reception ceremonies with a platform for the king—presumes some kind of activity that embraced both functional poles as it were, and that this activity or set of activities was a recurring event, since it was encoded in the very structure of the chapel itself. In fact, this functional disposition constituted the first structure of the Cappella Palatina, which brings us, finally, to the last of the interpretations to be considered. This is the view of Josef Deér whose remarks, short and sketchy, were recorded not in his monograph on the Norman porphyry tombs, but in an earlier work on Frederick II, and they concern the Norman court in general.[30] But they are of significance for two reasons: they indicate a larger context in which the chapel can be viewed, and they point to a rich source or set of sources concerning courtly ceremonial in the Mediterranean world, of which the Normans were well aware. The context was Byzantium, whose influence in Norman Sicily was indicated for Deér by such disparate phenomena as King Roger's use of the title of *basileus*, the red tint in the rotae of the royal documents of the Norman chancery and the use of porphyry in the Norman tombs. Deér speculated that Norman court ceremonial too derived from Byzantium, and although he offered no proof for his hypothesis, there is to commend it the very fabric of the Cappella Palatina.[31]

✢   ✢   ✢

[28] Schramm, *Herrschaftszeichen*, 1:361ff.

[29] Ibid., 1:362 n. 3.

[30] Josef Deér, *Der Kaiserornat Friedrichs II*, Bern, 1952.

[31] Deér, *Kaiserornat*, 11ff., esp. 14 n. 20. See also Léon-Robert Ménager, "L'institution monarchique dans les Etats normands d'Italie. Contributions à l'étude du pouvoir royal dans les principautés occidentales, aux XIe–XIIe siècles," *Cahiers de civilisation médiévale*, 2, 1959, 452ff.; Helene Wieruszowski, "Roger II of Sicily, *Rex-Tyrannus*, in Twelfth-Century Political Thought," *Speculum* 38, 1963, 50 n. 22.

Our picture of the ceremonial life of the Byzantine court in the later Middle Ages derives largely from two texts, the lengthy *De ceremoniis* composed in two books by the emperor Constantine VII Porphyrogennetos (945–59) and revised in the later tenth century, and the shorter *Treatise on the Dignities and Offices* written between 1347 and 1368 by an author of unknown identity whom modern scholarship has named Pseudo-Kodinos.[32] Both of these texts are complicated documents, compilations of diverse sources from different periods, put together for a variety of purposes. They are also mainly prescriptive rather than descriptive with regard to ceremonies, that is, they purport to set out verbal models for rituals rather than accounts of actual rituals that have occurred, and the question that has always remained is to what extent these models were followed at any given time. In the words of one recent study of the *De ceremoniis*, "we cannot tell how many of the rituals were actually carried out from year to year."[33] But there can be hardly any doubt as to the pervasiveness and importance of such ceremonies in Byzantium, as a substantial body of circumstantial evidence from the Middle Byzantine period as a whole would attest. First, there are descriptions of ceremonies that were actually performed, some of them quite extended and evocative, like the reception of ambassadors recorded in the report of a visit to the court of Nikephoros II Phokas by Liutprand of Cremona in 968, one of whose highlights was a demonstration of the emperor's infamous lion-flanked, rising throne in the audience chamber of the Magnaura. Then there are the references to ceremonies in chronicles and letters, which are more numerous, although they are often offered in passing and thus with considerably less descriptive detail. And finally there are the texts of recitations for such occasions, among the most famous of which from the twelfth century are those of Michael Italikos, Theodore Prodromos and the Manganeios Prodromos as he has been differentiated by Magdalino.[34] All of this evidence may be read with profit in the context of these prescriptive texts, and as has been pointed out by Cameron what it indicates is the development and change, as well as the continuity of ceremonial as a vital force in Byzantium. It also validates the spirit, if not the letter of the texts, which makes the following observations possible.

There are two characteristics of the ceremonies described by the texts, separated as they are by approximately four hundred years, that are so closely shared one may well assume that they were among the most deeply engrained and enduring qualities of

---

[32] Their critical importance notwithstanding, the two texts have been surprisingly little studied in conjunction; see J. B. Bury, "The Ceremonial Book of Constantine Porphyrogennetos," *English Historical Review* 22, 1907, 209ff., 417ff.; Otto Treitinger, *Die oströmische Kaiser- und Reichsidee nach ihrer Gestaltung im höfischen Zeremoniell vom oströmischen Staats- und Reichsgedanken*, Darmstadt, 1956; André Grabar, "Pseudo Codinos et les cérémonies de la cour byzantine au XIVe siècle," *Art et société à Byzance sous les Paléologues, Actes du colloque organisé par l'Association Internationale des Etudes Byzantines à Venise en Septembre 1968*, Venice, 1971, 195ff.; Averil Cameron, "The Construction of Court Ritual: The Byzantine Book of Ceremonies," *Rituals of Royalty:*

*Power and Ceremonial in Traditional Societies*, ed. David Cannadine and Simon Price, Cambridge, 1987, 106ff.; Michael McCormick, "Analyzing Imperial Ceremonies," *Jahrbuch der österreichisches Byzantinistik* 35, 1985, 1ff.

[33] Cameron, "Construction of Court Ritual," 112.

[34] *Theodoros Prodromos. Historische Gedichte*, ed. Wolfram Hörandner (=*Wiener byzantinische Studien* 11), Vienna, 1974. See also Alexander Kazhdan and Simon Franklin, *Studies on Byzantine Literature of the Eleventh and Twelfth Centuries*, Cambridge, 1984, 87ff.; Paul Magdalino, *The Empire of Manuel I Komnenos, 1143–1180*, Cambridge, 1993, 413ff., and 494ff. on the "Manganeios Prodromos."

Byzantine court ceremonial. One is the custom of celebrating the major feasts of the liturgical year with processions and receptions whose centerpiece was the emperor himself. These activities, which were held in elaborately contrived sequences involved not only movements from place to place within the emperor's palace and beyond, and acclamations to the emperor, or conventional declamations of praise and exhortations of good wishes recited by members of his court or by the factions, but also—and most significantly in the present context—acts of homage in the form of *proskynesis* to the emperor.[35]

In the *De ceremoniis* these aspects of the ceremonies are so elaborately detailed that they are set out in separate chapters of the text, of which the sequence of acclamations from the processional liturgy of the Nativity may be cited as an illustration (chap. 2): beginning at the Tribunal, where the emperor received the acclamations of the Domestikos ton Scholon and the Blue faction, he then moved on to the gate of the Holy Apostles, where he received the Domestikos ton Exkoubiton and the Green faction. Thence inside the Chalke Gate, he received the Blues again, and moved outside the Chalke, where he received the Blues and Whites. Next he proceeded to the Achilleus, where he received the Greens and Reds, to the Horologion of Hagia Sophia, where he received the Blues and Whites, and finally to the holy service, after which, he returned to the palace with five more stops in the processional route.[36] At each point the emperor was greeted by a litany of exhortations wishing him many more years of rule. Equally instructive for the later period, on the other hand, is the protocol recorded in the treatise of Pseudo-Kodinos of the order of precedence for imperial greetings at the Easter liturgy.[37]

These ceremonies clearly involved what have been termed both secular and religious events—the acclamations and *proskynesis* that took place at receptions and dinners, and the celebrations of the liturgy that occurred at the altar of a given chapel or church—interwoven to such an extent to assert the validity of the connection between them, which is the second point to make.[38] As Henry Maguire has recently stressed, the major feasts of the liturgical year in Byzantium served as an opportunity, indeed they were the prime opportunity, for the comparison between the heavenly and earthly rulers, Christ and the emperor, which Byzantine orators exploited richly.[39] Witness, for instance, the verses of Theodore Prodromos, cited by Maguire, which were composed for recitation by the demes on Christmas to the emperor John II Komnenos (1118–43):

> Once more [we celebrate] the birthday of Christ and the victory of the emperor. The birth of the one inspires awe, the victory of the other is irresistible. Again God has been seen [coming] out of Teman, bearing flesh, and the emperor has entered out of Teman, bear-

[35] On the image of *proskynesis* in Byzantium, see Iohannis Spatharakis, "The Proskynesis in Byzantine Art: A Study in Connection with a Nomisma of Andronicus II Palaeologue," *Bulletin Antieke Beschaving* 49, 1974, 190ff.; Anthony Cutler, *Transfigurations: Studies in the Dynamics of Byzantine Iconography*, University Park, Penna., 1975, 53ff.

[36] *De cer.*, 1:29ff.

[37] Pseudo-Kodinos, 234ff.

[38] Cameron, "Construction of Court Ritual," 112ff.

[39] Henry Maguire, "The Mosaics of the Nea Moni: An Imperial Reading," *Homo byzantinus: Papers in Honor of Alexander Kazhdan*, ed. Anthony Cutler and Simon Franklin (=*Dumbarton Oaks Papers* 46, 1992), 205ff.

ing victory. The star of God announces His Advent to the Magi, but the many stars of his trophies declare the emperor. One of them has three Persians doing obeisance to Him as He lies in His crib; the other has all of Persia bending in neck under his feet. . . . Both of them regenerate the whole creation . . . both defeat all the barbarians, destroy cities, increase the boundaries of New Rome, and become the saviors of the Christian clergy.[40]

But perhaps these sentiments were rendered more effectively in one of the succinct formulations from the Christmas receptions recorded in the *De ceremoniis*: "The same one who gives life, raises your power, O sovereigns, in the whole universe, that He constrains all nations to offer, like the Magi, gifts to your imperial power."[41] In this sense the liturgy was the opportunity to expound the very hierarchy of power that gave the Byzantine state meaning.

From even a glancing survey of these documents, the following conclusions are thus possible. The elaborate liturgical practices involving the emperor that were developed in Byzantium by the tenth century, what we may call the imperial liturgy—the "basilike leitourgia" in the terms of the *De ceremoniis*—were designed to make tangible a link between the emperor and Christ, the terrestrial and celestial rulers, through the vehicle of the major feasts of the liturgical year. This linkage, which found expression in acts of homage, was then repeated incessantly as one moved again through the cycle of these feasts. In other words, homage to the ruler was paid repeatedly on two levels, first to Christ by the emperor and then to the emperor by his court, which ratified and confirmed the chain of command that was the very basis of the Byzantine state.

That such a ceremonial structure provided a framework for the Cappella Palatina in Palermo is quite plausible given the arrangement of the chapel, with its two separate yet adjoining spaces, differently articulated in decorations, with different places for the king, and carrying the implication of different rituals that involved him. What lends this hypothesis weight, however, is precisely these receptions, and their ritual of *proskynesis*, which to my knowledge never existed in this form anywhere else. But there is another aspect of the chapel that may also be revealing in this regard. One of the most distinctive elements of the sanctuary mosaics is the cycle of scenes from the life of Christ, which may be attributed, in a sense, to two masters. One of them was Byzantium, which invented the form of church decoration of which this cycle was a part and from which it derived; in the Cappella Palatina, the cycle undoubtedly functioned in a Byzantine sense, that is, as an evocation of the major feasts of the liturgical year. But the cycle was also shaped by an idea about the position of the king, for whose view, in fact, many of the narrative scenes and other elements of the decoration were arranged.[42] Neither a Byzantine nor royal program seems to hold, at least in an obvious sense, in the scene of the Nativity, as we have already had an opportunity to observe (fig. 64).[43] This scene is set directly above the south apse of the chapel, and would have been essentially invisible to the king as he stood in his balcony in the northern transept arm. Nor is the position of the scene to be accounted for in reference to the

[40] Poem IX, ed. Horänder, 244f.; trans. Maguire, "Nea Moni," 211.

[41] *De cer.*, 1:33.

[42] See above, chapter 1, pp. 20ff.

[43] See above, chapter 2, p. 56.

conventions of Byzantine church decoration. These conventions did not govern the absolute placement of every element in the Byzantine program, but determined many of them, such as the figure of the Pantokrator, which was always placed in the main dome, or the scene of the Annunciation, which was often placed on the arch over the main apse of the church (as here). But in no other Byzantine church known was the Nativity so disposed.

On the other hand, the scene is quite large—in fact it occupies the largest area of wall of any of the christological scenes in the chapel, and even the width of the eastern face of the southern transept arm was not enough to accommodate it. The scene wraps around both the north and south walls of the southern transept arm, because it was so detailed. Not only was it rendered with the central and essential figures of the Virgin and child, but it also included the Journey and Adoration of the Magi, the Annunciation to the Shepherds, the First Bath of the Child, and Joseph's Doubt. The scene is also accompanied by a verse inscription in gold letters on a silver frame that forms its upper border ("Stella parit solem rosa florem forma decorem") at once referring to the star that so prominently illuminates the figure of Christ, one of whose epithets was the sun, and echoing as well the text held by the figure of the Pantokrator in the lunette on the east wall of the south transept above the Nativity: "ΕΓΩ ΕΙΜΙ ΤΟ ΦΩΣ. . . ."[44]

But perhaps the most telling aspect of the Nativity scene as it appears in the Cappella Palatina is in the nature of its derivation, or at least what may be inferred about it. The palatine version of the Nativity is unusually crowded with figures and incident, but in this respect it is not alone. As an iconographic construction it finds very close parallel in a painted version of the scene, also from the mid-twelfth century, in the Cathedral of the Transfiguration at Pskov (fig. 65).[45] The two scenes differ in details

[44] Compare the description by Nikolaos Mesarites of the Pantokrator in the Church of the Holy Apostles as "Sun of Justice" and "Lord of Light"; Glanville Downey, "Nikolaos Mesarites: Description of the Church of the Holy Apostles at Constantinople," *Transactions of the American Philosophical Society* 47/6, 1957, 901 (XIII,9), 902 (XV, 1). On rulership and metaphors of light, see Jaroslav Pelikan, *The Light of the World: A Basic Image in Early Christian Thought,* New York, 1962; Ernst Kantorowicz, "Oriens Augusti—Lever du Roi," *Dumbarton Oaks Papers* 17, 1963, 117ff.

[45] Ernst Kitzinger, *I mosaici di Santa Maria dell'Ammiraglio a Palermo,* Palermo, 1990, 175ff. For the decoration of the Monastery of the Transfiguration at Pskov and the scene of the Nativity, see Viktor N. Lazarev, *Old Russian Murals and Mosaics from the XIth to the XVIth Century,* trans. Boris Roniger, London, 1966, 99ff., 247ff.; M. N. Soboleva, "Stenopis Spaso-Preobraženskogo sobora Mirožskogo monastyra v Pskove," *Drevne-russkoe iskusstvo: chudožestvennaja kultura Pskova,* ed. V. N. Lazarev, Moscow, 1968, 7ff.; Hubert Faensen and Wladimir

Iwanow, *Altrussische Baukunst,* Vienna, 1972, 283f., and 283 plan, figs. 122–27. Closely resembling the Nativity in the Cappella Palatina are also the versions of the scene in the Panagia tou Arakou (1192) in Lagoudera (Andreas Stylianou and Judith A. Stylianou, *The Painted Churches of Cyprus: Treasures of Byzantine Art,* London, 1985, 157ff., esp. 164, fig. 89 (unfortunately only a partial view), and Göreme, Chapel 22 (Çarikli kilise, second half of the twelfth century) and Chapel 23 (Karanlik kilise, early thirteenth century), both which are particularly interesting in this context because the scenes turn around the corner of a wall (Marcell Restle, *Die byzantinische Wandmalerei in Kleinasien,* 3 vols., Recklinghausen, 1967, 2:figs. 193ff., esp. 200ff. (Chapel 22), and 218ff., esp. 227ff. (Chapel 23). See also Charles Diehl, *L'art byzantin dans l'Italie méridionale,* Paris, 1894, 60, fig. 67 (Grotto of San Biagio in Brindisi, twelfth century). The twelfth-century description by John Phocas of the scene of the Nativity in the Grotto of the Nativity in Bethlehem by is also interesting in this regard; see *PG* 133, 957.

such as the position of the Adoration of the Magi and the bearing of the shepherds (one shown in the chapel most unusually milking a ewe), but they are otherwise so similar, even down to the landscape as it is subdivided into gently rounded hills, that they could only refer to a common model.[46]

The Nativity was among the first of the narrative episodes from the New Testament to be visualized in art and so by the Middle Ages had a rich pictorial tradition, full of variations and idiosyncrasies.[47] One development that is relevant here, however, seems to have taken place in the eleventh century, when what must be regarded as the first true ancestors of the versions of the scene in the Cappella Palatina and Pskov are attested. This occurred when the traditionally separate events of the Nativity proper, with its ancillary episodes of the Annunciation to the Shepherds, the Washing of the Child and Joseph's Doubt, and the Journey/Adoration of the Magi were joined together to form a single pictorial unit.[48] The precise moment of the creation of this iconography is difficult to pinpoint, and is it impossible to say why it occurred, beyond the speculation that is prompted by the following facts. The Magi were identified as kings already in the third century, and to bring them directly into the Nativity scene was to inject into the feast picture for Christmas an element that had at least the potential to convey messages of majesty and obeisance that would have befitted the emperor as well as Christ, as the passage adduced from the *De ceremoniis* has already made clear.[49]

In this light, it is interesting to observe that one of the earliest cases of the new iconography is to be found in a Gospel Lectionary now in the Skeuophylakion of the Lavra Monastery on Mt. Athos, the so-called Phokas Lectionary, a liturgical text that Kurt Weitzmann once argued was an imperial gift of the early eleventh century (fig. 66).[50] That Weitzmann later revised his dating, suggesting the late eleventh or even twelfth century for the manuscript, does not alter the fact that its painting is of a quality that would have befitted the highest level of patronage.[51] It should also be said

[46] It is also interesting to observe that the figure of the prophet Isaiah also occurs in proximity to both scenes; Kitzinger, *I mosaici*, fasc. 1, fig. 148; Soboleva, "Stenopis Spaso-Preobraženskogo," 12f.

[47] Gabriel Millet, *Recherches sur l'iconographie de l'évangile aux XIVe, XVe et XVIe siècles*, Paris, 1916, 93ff.; J. H. Cornell, *The Iconography of the Nativity of Christ*, Uppsala, 1924; Kon. D. Kalokyris, *Η ΓΕΝ-ΝΗΣΙΣ ΤΟΥ ΧΡΙΣΤΟΥ ΕΙΣ ΤΗΝ ΒΥΖΑΝΤΙΝΗΝ ΤΕΧΝΗΝ ΤΗΣ ΕΛΛΑΔΟΣ*, Athens, 1956; Jacqueline Lafontaine-Dosogne, "Iconography of the Cycle of the Infancy of Christ," *The Kariye Djami*, vol. 4, *Studies in the Art of the Kariye Djami and its Intellectual Background*, ed. Paul Underwood, London, 1975, 208ff.; idem, "Les representations de la nativité du Christ dans l'art de l'orient chrétien," *Miscellanea codicologica F. Masai dicata MCMLXXIX*, Ghent, 1979, vol. 1, 11ff.; André Grabar, "Récit, panégyrique, acte liturgique: Les trois interprétations possibles d'un meme sujet dans l'iconographie byzantine," *Rayonnement Grec. Hommages à Charles Delvoye*, ed. Lydie Hadermann-Misguich and George Raep-

saet, Brussels, 1982, 431ff.; Gunter Ristow, "Zur spätantiken Ikonographie der Geburt Christi," *Spätantike und frühes Christentum*, Frankfurt am Main, 1983, 347ff.

[48] Millet, *L'iconographie*, 136ff.; Lafontaine-Dosogne, "Représentations," 16ff.

[49] Hugo Kehrer, *Die heiligen drei Könige in Literatur und Kunst*, Leipzig, 1908. See also the discussion of the royal significance of the star in F. W. Deichmann, "Zur Erscheinung des Sternes von Bethlehem," *Vivarium: Festschrift Theodor Klauser zum 90. Geburtstag, Jahrbuch für Antike und Christentum*, Ergänzungsheft 11, 1984, 98ff., esp. 99; Bellarmino Bagatti, "La 'luce' nell'iconografia della Natività di Gesu," *Studium Biblicum Franciscanum, Liber Annuus* 30, 1980, 233ff.

[50] Kurt Weitzmann, "Das Evangelion im Skevophylakion zu Lawra," *Seminarium Kondakovianum* 8, 1936, 83ff.

[51] Regarding Weitzmann's revised chronology, see Kurt Weitzmann, *Byzantine Liturgical Psalters and Gospels*, London, 1980, no. XI, 97n.: "The dating to

that the same kind of iconographic relationship to another work of art (Pskov), with all of its attendant implications, is not discernible for any of the other christological narratives in the Cappella Palatina, or at least not to the same degree, which suggests that the Nativity was more than just another element in a larger sequence.

In her monograph on the Norman mosaics Eve Borsook argued that the Nativity in the Cappella Palatina served as a reminder that Roger II was first crowned on Christmas day, 1130.[52] But the interpretation has so little to commend it in the chapel itself that it seems tenuous: one wonders in particular why the references to the event that Borsook deduces are so oblique, especially given that a coronation of Roger's was depicted explicitly in the nearby establishment of George of Antioch, the monastery church of St. Mary's of the Admiral. Yet the two elements here could hardly be unrelated: how could the scene of the Nativity, especially when it was rendered in the royal chapel with such elaborateness and prominence, and within the context of a cycle of feast scenes, not have called to mind that fateful day when the first of the Sicilian Normans was crowned king. A solution arrives quite naturally, however, when we reverse the equation.

It is most unfortunate that none of the places where the imperial liturgy was celebrated in Constantinople have survived, with the exception of Hagia Sophia, and the great church has come down to us only in a sadly mutilated state. But we do have the prescriptive texts of Constantine VII and Pseudo-Kodinos, and in them we can detect a distinct emphasis placed on the feast of the Nativity.[53] To begin with, in both texts, the description of the Christmas protocols opens the section of the ceremonial account, which could only mean that, from the point of view of the yearly cycle of the imperial liturgy, the Birth of Christ was understood as the beginning. This is in counterdistinction to normal liturgical practice in Byzantium, which regarded the feast of the Annunciation, a fixed feast celebrated on March 25, as the opening of the liturgical year, and the reason for the difference is not hard to seek. Imperial power, whose source was spelled out in images like the ones carved in the ivory reliefs now in Berlin and Moscow, may be said to have originated with the birth of the God-made-man who conferred on the emperor his crown (fig. 146).[54] In the words of the acclamations of

the early eleventh century based on an inclination to save the Phocas-Athanasios tradition is no longer defended by the author, who would not even exclude a date as late as the twelfth century." Unfortunately the text of the manuscript has never been published. I would like to thank Mary-Lyon Dolezal for this reference and for discussing the problem of the chronology of the manuscript with me.

[52] Eve Borsook, *Messages in Mosaic: The Royal Programmes of Norman Sicily 1130–1187*, Oxford, 1990, 17ff. Roger's coronation on December 25, 1130, may have intentionally echoed in its choice of date that of Charlemagne by Pope Leo III on December 25, 800, as well as that of Charlemagne's grandson Charles the Bald by Pope John VIII on December 25, 875. See also Chalandon, *La domination normande*, 2:9 n. 1; Antonio Marongiu, "Concezione

dell sovranità di Ruggero II," *Atti del convegno internazionale di Studi Ruggeriani (21–25 aprile 1954)*, 2 vols., Palermo, 1955, 1:213ff., esp. 226f.; Ménager, "L'institution," 447 n. 230.

[53] For the Christmas liturgy in St. Sophia, see *Le Typicon de la Grande Eglise, Ms. Sainte-Croix no. 40, Xe siècle*, ed. Juan Mateos, 2 vols., Rome, 1962, 1:149ff.

[54] That the birth of Christ signaled a new chapter in the history of earthly rule was a point made by Christian writers from late antiquity on; Theodor E. Mommsen, "Aponius and Orosius on the Significance of the Epiphany," *Late Classical and Medieval Studies in Honor of Albert Mathias Friend, Jr.*, Princeton, 1955, 99ff., esp. 103ff.; Anselm Strittmatter, "Christmas and Epiphany, Origins and Antecedents," *Thought* 17, 1942, 600ff. The theme appears in the twelfth century in the Chronicle of

the *De ceremoniis*, "The heavens have sent the star to direct the Magi to the Nativity; the earth prepares the cave to receive the Author of all things; so that He Himself, having taken on flesh from the Virgin, may guard in the purple your imperial power crowned by God." The sentiment was put more succinctly in the acclamation that occurs at an important moment in the ceremony recorded in the *Treatise* of Pseudo-Kodinos: "Christ is born who has crowned you emperor!"[55]

One might draw attention, too, to what must have been a rather spectacular moment in the larger ritual of the imperial celebration of the Nativity that is also recorded in the *Treatise* of Pseudo-Kodinos.[56] After a series of receptions and acclamations strongly reminiscent of the *De ceremoniis*, the emperor was bidden to mount a tribune (or *prokypsis*, which has given its name to the ritual in the literature), which was a raised platform or stand probably built as an independent and temporary structure for the occasion, around which members of the court assembled in a carefully demarcated order. The emperor then stood behind closed curtains on the raised platform while he was prepared with his crown, cross, and purse, and lights in the form of candelabra were brought and set beside him. At a certain moment, the curtains were then parted to reveal the ruler, brilliantly illuminated in all of his regalia, to the sound of acclamations (as quoted above) and musical accompaniment. In the words of the poet Manuel Holobolos, "Christ is encircled by the tiny cave of his birth and the emperor by the narrowness of the prokypsis which on Christmas symbolized the hollow of Bethlehem filled with the light of the rising Sun of Justice."[57] In the *Treatise*, only one other occasion is described at which the ritual was to be performed, on the feast of the Epiphany, with which the feast of Christmas was closely linked.[58]

This was certainly a moment of high drama in the imperial liturgy, with music, chants and above all shining lights, in which, one might surmise, the imperial presence may even have eclipsed the image of Christ himself, for whom the feast was created. In fact, some scholars, such as Andreyeva and Kantorowicz, have seen the roots of this ritual going back as far as late antiquity in the imperial celebrations of the hippodrome, in which the emperor in the kathisma, or the raised imperial box, was ritually acclaimed by the factions; such ancient rites may have been the distant ancestors of this celebration.[59] Because of its extraordinary and profoundly meaningful use of

Otto of Freising; *The Two Cities: A Chronicle of Universal History to the Year 1146 A.D. by Otto, Bishop of Freising*, ed. Austin P. Evans and Charles Knapp, New York, 1928, 222ff. See also the discussion of Kantorowicz, "Oriens Augusti," 135ff.

[55] Pseudo-Kodinos, 204.

[56] Pseudo-Kodinos, 189ff. See also Niketas Choniates, *Nicetae Choniatae Historia*, ed. J. L. van Dieten (=*Corpus Fontium Historiae Byzantinae*, XI/1), Berlin, 1975, 477f., and Manuel Holobolos, *Anecdota Graeca*, ed. Jean Francois Boissande, 5 vols., Hildesheim, 1962 (repr. of Paris, 1833), 5:159–82.

[57] *Anecdota Graeca*, 5:161 and 163. H. P. L'Orange, *Studies on the Iconography of Cosmic Kingship in the Ancient World*, Cambridge Mass., 1953, 89 n. 1.

[58] Pseudo-Kodinos, 221f.

[59] M. A. Andreyeva, "O Ceremonii 'Prokipsis'," *Seminarium Kondakovianum* 1, 1927, 157ff.; Ernst Kantorowicz, "Oriens Augusti," 119ff. See also August Heisenberg, *Aus der Geschichte und Literatur der Palaiologenzeit*, Munich, 1920, 82ff.; Otto Treitinger, *Die oströmische Kaiser- und Reichsidee nach ihrer Gestaltung im höfischen Zeremoniell vom oströmischen Staats- und Reichsgedanken*, Darmstadt, 1956, 85ff.; Iohannis Spatharakis, *The Portrait in Byzantine Illuminated Manuscripts*, Leiden, 1979, 214ff.; Michael Jeffreys, "The vernacular εἰσιτήριοι for Agnes of France," *Proceedings of the First Australian Byzantine Studies Conference, Canberra, 17–18 May 1978*, ed. Elizabeth and Michael Jeffreys and Ann Moffat, Canberra, 1981, 11, pl. 13.

light, the ritual has also been related by Kantorowicz to the "sun-kingship" of the Byzantine emperors, whose roots too lay in the distant past of the hellenistic-Roman tradition, as Kantorowicz has argued.[60] The fact that the *prokypsis* event as such is not attested for Christmas before the fourteenth century, however, may suggest that, whatever its historical background and antecedents, it was only a late addition to the imperial liturgy.

On the other hand, one can detect distinct traces of themes that were critical to the *prokypsis* event in earlier sources. The theme of illumination, for instance, which played such an important role in the *prokypsis* ceremony in a physical sense is adumbrated in the Christmas acclamations of the *De ceremoniis*, in astral and solar metaphors that were repeated frequently throughout the service: "The star advances and shines on the grotto to indicate to the Magi the Mother of the Sun," and "The star announces the Sun." It appears again in a most interesting set of texts composed by the court poet Theodore Prodromos for the feasts of Christmas and the Epiphany, which in the later *Treatise*, it must be recalled, were the only two liturgical celebrations at which the *prokypsis* ritual was performed.[61] We have already had an opportunity to quote a relevant passage from one of the three Christmas hymns; another passage from one of the two hymns for the Epiphany, addressed to the same emperor, John II, reads as follows:

> Light up, Rhomaean City! And once more: Light up!
> Bask in the doubled beams of your Two Suns.
> You have the Sun of Justice, here, the Father's
> Bright-mirrored splendour, naked in the Jordan.
> And, there, you have the Sun of Monarchy,
> The Father's vicar, shining in the palace.[62]

These texts, for Christmas and the Epiphany, in fact, have been used to argue for the existence of the imperial-liturgical *prokypsis* in Komnenian times.[63]

It is the twelfth century that is most relevant to us here, and even if we cannot agree on the precise place and function of Prodromos's hymns, one thing is clear: they embody a theme that had a connection both backward into the tenth-century world of the *De ceremoniis*, and forward into the fourteenth-century world of the *Treatise*, and perhaps this is the most cogent way, at present, to read them. Prodromos's hymns fal! on a mid-point of the trajectory that may be traced between the tenth and fourteenth centuries, between practices at the courts of the Macedonian emperors and the Palaiologoi, in the evolution of the Christmas ritual, in which the imperial liturgy was reformulated in order to make explicit first in dramatic words and then in dramatic

[60] Kantorowicz, "Oriens Augusti," 193 n. 251 (Eugenius of Palermo's panegyric for William II).

[61] Poems IX, X, XXI–XXIII, ed. Horändner, 244ff., 363ff.

[62] Poem X, ed. Horändner, 250; trans. Kantorowicz, "Oriens Augusti," 151.

[63] Andreyeva, "O Cerimonii," 166ff.; Heisenberg, "Aus der Geschichte," 84; Treitinger, *Kaiser- und Reichsidee*, 92ff.; Kantorowicz, "Oriens Au-

gusti," 159; Paul Magdalino and Robert Nelson, "The Emperor in Byzantine Art of the Twelfth Century," *Byzantinische Forschungen* 8, 1982, 166 n. 113; Paul Magdalino, "The Bath of Leo the Wise and the 'Macedonian Renaissance' Revisited: Topography, Iconography, Ceremonial, Ideology," *Dumbarton Oaks Papers* 42, 1988, 111 n. 101; idem, *Manuel I*, 246f.

actions, the relationship between Christ and the emperor, the birth of God-made-man and the source of imperial power, the heavenly and earthly lights. This trajectory provides us with a context for understanding the imperial significance of the feast of the Nativity in the twelfth century, which may, in turn, also shed some new light on other activities and interests of the Komnenoi, such as the program of the refurbishment of the Church of the Nativity at Bethlehem which was undertaken by Manuel I (1143–80).[64]

We arrive at the point at which we can articulate the notion of reversal to which we alluded earlier. Roger's choice of Christmas as the day of his first coronation was clearly meaningful, but its meaning was not in an intended evocation of the earlier coronation of Charlemagne, or at least not simply and directly as has been claimed. Roger chose Christmas for the same reason that he later chose to be represented in the garb of the Byzantine emperor crowned by Christ in the narthex of George of Antioch's church of St. Mary's of the Admiral: to lay claim to the sovereignty of the emperor as king in his own land. The claim was later formulated in the phrase of John of Salisbury, "Rex imperator in regno suo," as Reinhard Elze has argued in a study that, perhaps more than others, has elucidated these assertions. But in so doing Roger also sought to establish a relationship that no Byzantine ruler would have ever attempted. Although the Byzantine emperor was often shown crowned by Christ, in none of these depictions was the ruler ever made to look like Christ, as Roger, in his facial features, was so constructed in St. Mary's of the Admiral.[65] Nor was the emperor ever crowned on Christmas day, the feast of the God-made man from whom his office derived, as was Roger. In so doing, Roger laid claim to a special relationship between himself and Christ, between the earthly and heavenly rulers: an absolute and perfect symmetry.

It is in this context that the Nativity scene in the Cappella Palatina should be viewed. In taking up an exceptionally elaborate Byzantine model, which was followed to an extraordinary degree in its particulars, the designers of Roger's chapel have proclaimed the supreme importance of the feast of the Nativity. This significance is spelled out for the viewer, in turn, by the inscription ("Stella parit solem rosa florem forma decorum") and the figure of the Pantokrator above, which may be construed as a kind of gloss on the Nativity scene, characterizing it above all as the appearance of the divine light on earth. The inscription finds its closest parallel in a verse attributed to Hildebert of Lavardin (ca. 1055–1133), archbishop and poet employed by Roger II on another project.[66] But these words rendered a sentiment that *opened* the acclamations to the emperor in the Christmas liturgy recorded in the *De ceremoniis*, "*The star*

[64] Hughes Vincent and F.-M. Abel, *Bethléem: Le sanctuaire de la Nativité*, Paris, 1914, 157ff.; William Harvey, *Structural Survey of the Church of the Nativity Bethlehem*, London, 1935, x; Bellarmino Bagatti, *Gli antichi edifici sacri di Betlemme*, Jerusalem, 1952, 60f.; G. Kühnel, "Das Ausschmuckungsprogramm der Geburtsbasilika in Bethlehem: Byzanz und Abendland in Königreich Jerusalem," *Boreas: Mün-*

*stersche Beiträge zur Archäologie* 10, 1987, 133ff.; Lucy Ann Hunt, "Art and Colonialism: The Mosaics of the Church of the Nativity in Bethlehem (1169) and the Problem of 'Crusader' Art," *Dumbarton Oaks Papers* 45, 1991, 69ff., and esp. 73.

[65] See below, pp. 140ff.

[66] See above, chapter 2, 56 n. 100.

*announces the Sun*, Christ arising in Bethlehem from the breast of a Virgin," and thus may be understood as a free translation or reworking of them.

But it was the viewer who was also important in this case, and that viewer, as we have already had the occasion to observe, could hardly have been the king. The scene of the Nativity, and the inscription and the Pantokrator above it, formed a coherent set of images that faced westward, in fact, they were visually the most striking elements of the sanctuary decoration that were turned in this direction, and in order to be so positioned, in a sense, they had to deny the conventions that shaped the models from which they were derived.[67] Narrative scenes were not traditionally put on the portion of wall above the small apses in the Byzantine church, nor was this area ever the location for the image of the Pantokrator, whose primary position, in any case, was in the main dome. These elements were constructed as a unity in order to address a viewer, and with the removal of the pulpit and paschal candelabrum, which were not part of the original Rogerian program, the position of this viewer becomes clear: in the south aisle primarily, and only very secondarily in the nave. These elements, in fact, must have been designed with the entrance into the chapel in mind, and particularly with the turn implied by the floor design into the south aisle. As the visitor would have made this turn, after having breached the chapel, he would have seen on the eastern surface of the south aisle facing him, a column of images and words that spoke to him about the essential meaning of the experience on which he was about to embark: of the most important, indeed, from a royal point of view, of the first of the liturgical feasts, of the birth of the God-made-man who, as Pantokrator, or heavenly ruler, conferred on the earthly ruler, Roger II, the ruler now present in this very place and to whom the visitor had come to pay his respects, his office as sovereign king. There is no pendant to the Nativity-Pantokrator group of the southern transept arm with regard to the main axis of the plan of the chapel, and so this arrangement too must be thought of as an asymmetry, which in a sense completes the asymmetry of the floor design by providing the implied movement with a focus, or view.

Given the hypothetical nature of the reconstruction of the function of the Cappella Palatina up to this point it is most unfortunate that we do not have the kinds of texts that we possess from Byzantium that set out the ceremonial life of the court in detail. But perhaps one testimony has been here for us all along in a form that we were not capable of recognizing until now. It need only be recalled that Theodore Prodromos provided one link in a chain of evidence regarding the feast of the Nativity, and indeed an important one since the author was a contemporary of the events in Sicily with which we are concerned.[68] The man himself is also of interest in the following sense. He was a poet at the court of Irene Doukaina and John II who undertook a much larger project of imperial panegyric that included, among other subjects, hymns of praise of the emperor's victories, and of imperial events such as coronations and marriages. In the authoritative edition of Prodromos's hymns, the view of the imperial

---

[67] That the Pantokrator also functioned in the context of the scene of the Pentecost situated in the vault of the southern transept arm is argued by Ernst Kitzinger, "The Mosaics of the Cappella Pal-atina in Palermo: An Essay on the Choice and Arrangement of Subjects," *Art Bulletin* 31, 1949, 277.

[68] On Theodore's career in court, see Hörand-ner, 21ff.

office purveyed by the poet's work has been characterized as traditional, if not cliché-ridden, and the poet himself as a kind of courtier-hack.

But this view has recently been challenged by Alexander Kazhdan who has argued that Prodromos, far from unoriginal, gave a genuinely new and specifically twelfth-century inflection to the "Kaiseridee" in his hymns.[69] It now appears that Prodromos invested old imperial themes with new meanings; he also pushed old metaphors and images to new levels of explicitness. One of these was the comparison of the emperor and Christ, a venerable theme in imperial panegyric, but one that achieved in Prodromos's hymns an expression that was, to quote Kazhdan, "indeed extreme."[70] Kazhdan cites the case of the hymn on the birth of Alexios, son of the sebastokratorissa Irene, on Easter, in which the newborn is described as "resurrected together with Christ; dead for nine months, as Christ was dead for three days, (Alexios) rose from his tomb into the world." But there are other examples from which to chose. In the Epiphany hymn from which we have already quoted, for instance, the water of Christ's bath, by which he overcame the devil, is compared to the emperor's sweat, by which he overcomes barbarians; the dove of the holy spirit, to the dove of imperial victory; and the voice of God at the Baptism of Christ, to a voice from heaven announcing, "This is my emperor, in whom I am well pleased."[71] These sentiments, linking the christological narrative and the imperial persona in such a direct and palpable way, must have lain at the heart of the political self-identity of the dynasty of John II, whose son, Manuel I, assumed the name of Christ himself (he is called "Christ-named," christonymos, by certain twelfth-century writers).[72]

Roger's court also had a figure who wrote in these terms, in fact the author of the sermon we have employed in analyzing the individual features of the Cappella Palatina: Philagathos of Cerami. Philagathos was a monk of the Cathedral of Rossano, born probably in Cerami in the late eleventh century, but these facts, meager as they are, hardly do the man justice. His writings betray a familiarity with the life of the royal court in Palermo, a knowledge of classical literature, and a rather high degree of stylistic refinement.[73] In contrast to Theodore, Philagathos's main writings were not in the form of hymns, but sermons, which have come down to us in an apparent miscellany. Some of them were for major feasts, others for rather minor liturgical celebrations; indeed some of the subjects one would expect to find in such a collection are missing, such as Christmas, and yet there are multiples for other feasts, like Palm Sunday.[74] Like Prodromos's hymns, on the other hand, two of Philagathos's sermons contain prefaces that were clearly constructed as royal panegyrics, making the kind of comparison between Christ and the king with which Prodromos himself would have

[69] Kazhdan and Franklin, *Studies on Byzantine Literature*, 87ff., esp. 104ff.

[70] See also below, chapter 4, pp. 148ff.

[71] Poem X, ed. Horändner, 248ff.

[72] Kazhdan and Franklin, *Studies on Byzantine Literature*, 100.

[73] Bruno Lavagnini, "Filippo-Filagato promotore degli studi di greco in Calabria," *Bollettino della Badia Greca di Grottaferrata*, n.s. 28, 1974, 3ff.; idem, *Profilo di Filagato da Cerami con traduzione della Omelia XXVII pronunziata dal pulpito della Cappella Palatina in Palermo*, Palermo, 1992.

[74] Stefano Caruso, "Le tre omelie inedite 'Per la Domenica delle Palme' di Filagato da Cerami (LI, LII, LIII Rossi Taibbi)," *Epeteris Heteiraias Byzantinon Spoudon* 41, 1974, 109–27.

been familiar. Let me quote from them both, beginning with the proemium to a sermon for Palm Sunday (Rossi Taibbi, 50):

> Cheerful and bright is the assembly of the present day, shining is the gathering of the festival, for it includes among its ornaments the progress of the king. We see him now preside glorious and radiant from his deeds rather than from his diadem, or more precisely deriving his strength not so much from his deeds as from his faith in God. The present celebration, illuminated by a double splendor, is both a divine and a royal feast.[75]

The second text is "Sermon 27" from which we have already amply quoted, and it begins:

> I rejoice with you, O city, and with you, sacred temple of the palace, because people of all ages have poured into you today, all of the illustrious citizens and many priests who adorn with their presence the present-day feast. The first cause of all of these things is God, from whom all good things for men flow, and in second place, the pious king, savior and benevolent ruler when he casts his gaze on his people, because his anger is reserved for his enemies. He, after having procured many and great benefits, and after having surpassed his contemporaries and his predecessors in piety and in greatness of spirit, as the rays of the sun eclipse the splendor of the stars, has added another proof of his spirit, truly great and regal, in this most commodious temple of the Holy Apostles, a temple that he built in his palace from the foundations and bulwarks, and most large and beautiful, it is distinguished by a new beauty, resplendent with light, shining with gold, lustrous with mosaics and enlivened with images, so that even after having seen it many times, when one sees it again one admires it and remains stupefied as if one were seeing it for the first time, turning here and there to look.[76]

Given the fact that Philagathos makes use of the same kinds of images and metaphors of the sun and light that were so prevalent in the work of Theodore Prodromos and with the same degree of explicitness, and the fact that the two were near contemporaries operating in courts that were well aware of each other's existence, it is difficult to believe that they were not related.[77] But how? Surely the weight of evidence is not sufficient to argue for a direct influence involving specific borrowings or a concrete knowledge of one another's works. Rather it must be expressed in more general terms, and here the chronological precedence of Prodromos's work assumes importance. What Philagathos, and particularly the author in these two prefaces, must represent is a response on the part of the recently created royal court at Palermo to the new image of the ruler that was being purveyed in Byzantium in works of imperial propaganda, such as Prodromos's hymns, under the direct sponsorship of the em-

---

[75] *PG*, 132, 542.

[76] Philagathos, "Sermon 27," 174.

[77] Note the conclusion of Kantorowicz, "Oriens Augusti," 163: "It is not an exaggeration to say that in the West, so far as solar imagery during the earlier Middle Ages survived at all in the language of courtly veneration of rulers secular or spiritual, it was not interlocked with, or the counterpart of, the liturgical solar imagery due to Christ as the Oriens or Sol Iustitiae. Such bipolarization was Byzantine, but it was not western in the early Middle Ages."

perors of the Komnenian house, in which the imagery of light and the christological narrative were employed to characterize the ruler in a striking, not to say extreme way.

But the value of Philagathos's work also lies in the connection that it implies in the other direction. It is a passage from the latter text of Philagathos that immediately calls to mind one of the predominant images of the Cappella Palatina in its Rogerian phase, the wooden ceiling of the nave with its pattern of stars. This passage compares the king to the sun whose rays eclipse the splendor of the stars—a metaphor familiar from Prodromos's hymns—and it is difficult to believe that anyone, having heard Philagathos's words pronounced in the chapel in the presence of the king, could have missed the point: the king was truly the sun-ruler on earth whose proper and indeed only frame of reference in a worldly sense was an entire heaven of stars, as witness the decoration of the very edifice in which he had his place. In other words, Philagathos's texts bear witness to a conduit through which the contemporary political imagery of Byzantium was transmitted to Sicily, absorbed, employed, and eventually located in the Cappella Palatina itself.[78] And it is in a Byzantine sense that the functional arrangement of the Cappella Palatina finds its most cogent explanation.

<p style="text-align:center">✛  ✛  ✛</p>

One of the ways in which the chapel was originally designed to function may be described as follows. The king heard the liturgy recited from his balcony in the sanctuary, literally closer to God than any other mortal man in a universe that was imbued with his own royal themes and preoccupations. But it was above all God's realm, the realm of the king in heaven (figs. 10 and 15). He then descended to the realm of the king on earth, Roger's own realm, the terrestrial realm, or the nave of the chapel where he stood on his platform, only slightly elevated above his court to be greeted by them and to receive them, beneath a canopy of stars on which were projected images of the perfect earthly kingdom (figs. 8 and 101).[79] Visitors entered from the southwest where they saw the king first in profile. They then turned to walk down the south aisle where the grandest narrative image of the entire chapel, the Nativity, confronted them on the east wall of the southern transept arm above the south apse: the eternal moment of beginning of the temporally unfolding link between Christ and the king in the liturgical year, and the point of departure for an imperial-royal feast cycle that then wrapped around the entire sanctuary (figs. 64 and 111). The visitor then turned to enter the nave and to confront the king full face in all of his glory.

One might imagine that these ceremonies were watched from above by the women of the court, who, as often the case with their Muslim and Byzantine counterparts,

[78] Panegyric of Eugenius of Palermo for William II: L. Sternbach, "Eugenios of Palermo," *Byzantinische Zeitschrift* 11, 1902, 406ff., 449ff., no. 24, esp. vv. 8–11.

[79] The possibility that the king was seated on a throne on the platform cannot be excluded. Although no throne for King Roger has ever come to light, Deér believed that he could identify one in the two fragmentary heads of lions in porphyry now in the Byzantine Collection at Dumbarton Oaks, Washington, D.C.; see Deér, *Porphyry Tombs*, 116, figs. 162ff. The Byzantine emperor participated in court receptions both standing and seated; see Treitinger, *Kaiser- und Reichsidee*, 52ff.

were probably not given a place on the main floor of the edifice.[80] It could also have been the case that the order of events was changed from feast to feast, and the content as well, particularly with regard to receptions and acclamations. And given the presence of stairs at the end of the south aisle, visits to the cryptlike substructure of the chapel may have been incorporated into these ceremonies at times, or this may have been a point at which visitors exited the main chapel space. In any case, the asymmetry noted with regard to the stairs, and the emphasis on the south aisle, only supports a picture of the Rogerian edifice as having had an asymmetrical (north-south) use.[81] Variations notwithstanding, the essential point of the Rogerian ceremonies must have been the same: to bring the building to life in an insistent repetition of the linkage between the heavenly and the earthly realms, following the liturgical year, like the cycle of scenes in the sanctuary or Philagathos's sermons, in what was ultimately a

[80] It is interesting to observe that the three figures depicted in mosaic directly beneath the slits on the west wall of the northern transept arm are female saints; see Kitzinger, *I mosaici*, fasc. 1, 37, fig. 92. The only one now bearing a legible inscription is Agatha (left); Demus, *Norman Mosaics*, 42. The central figure, crowned, has been compared to a queen or princess flanked by her ladies in waiting; Pasca, *Descrizione*, 31; Kitzinger, "Cappella Palatina," 285. The letters of an inscription accompanying the central figure, "EKAT," were still visible to Buscemi (*Notizie*, 37ff.), and as Demus has observed, the costume is the "traditional dress of St. Catherine"; Demus, *Norman Mosaics*, 42 n. 141. The third figure, right, has been indentified as St. Lucy of Syracuse by Buscemi, *Notizie*, 50, and Benedetto Rocco, "I mosaici delle chiese normanne in Sicilia: Sguardo teologica, biblico, liturgico II/III. La Cappella Palatina, I/II," *Ho Theologos* 3, 1976, 166. Venera or Paraskevi, the saint who appears in the mosaics of Monreale together with Agatha and Catherine in approximately the same location in the church, has also been suggested; Demus, *Norman Mosaics*, 42 n. 142. Buscemi connected these images to the function of the balcony in the northern transept arm already in the nineteenth century; see *Notizie*, 50: "è curioso poi il vedere davanti il palco regio i santi, che ebbero fama in guerra, per essere sempre sugli occhi di un re guerriero: ed alla destra dello stesso palco rappresentarsi in mezzo a due vergini, una santa di sangue reale, onde rendersi soggetto della imitazione delle regine."

One of the few references to the habits and customs of Norman women in twelfth-century Palermo occurs in the account of Ibn Jubayr:

The Christian women of this city follow the fashion of Muslim women, are fluent of speech, wrap their cloaks about them, and are veiled. The go forth on this Feast Day (Christmas Day) dressed in robes of gold-embroidered silk,

wrapped in elegant cloaks, concealed by colored veils and shod with gilt slippers. Thus they parade to their churches or rather their dens (a play on the word *kana'is*, "churches", and *kunus*, "dens"), bearing all the adornments of Muslim women, including jewelry, henna on the fingers, and perfumes. We called to mind—in the way of literary witticism—the words of the poet: "Going into the church one day, he came upon the antelope and gazelle" (Ibn Jubayr, *Travels*, 349f).

Images on the ceiling of the nave of the Cappella Palatina also show women peering out from what appears to be the balcony of a palace or church (?); Monneret de Villard, *Soffitto*, figs. 205, 228, 230. In the scene of the Dormition of the Virgin in church of St. Mary's of the Admiral two women are depicted observering the event on a balcony to the right; Kitzinger, *I mosaici di Santa Maria*, fig. 160.

On the placement of women in the Byzantine church, see *The Correspondence of Athanasius I Patriarch of Constantinople*, ed. and trans. Alice-Mary Maffry Talbot (*Corpus Fontium Historiae Byzantinae* VII), Washington, D.C., 1975, 94f.; George P. Majeska, *Russian Travellers to Constantinople in the Fourteenth and Fifteenth Centuries*, Washington, D.C., 1984, 104, 420f. Regarding the placement of women in Byzantine court ceremonies, see Pamela G. Sayre, "The Mistress of Robes—Who Was She?" *Byzantine Studies* 13/2, 1986, 229ff. One wonders whether illustrations like that to Psalm 50, vv. 1–3, in the Theodore Psalter, showing David enthroned, speaking to Nathan, and overlooked by Bathsheba from an opening above, echoed, if only distantly, some actual architectural situation in the Byzantine palace; see Sirarpie Der Nersessian, *L'illustration des psautiers grecs du Moyen Age II, Londres Add. 19.352*, Paris, 1970, pl. 34, fig. 102.

[81] See above, chapter 1, p. 22.

Byzantine-derived function. But the edifice itself was not derivative in the sense of being unoriginal.

The Rogerian version of the Cappella Palatina was unusual, I would daresay bold and unique, in two main ways. The first was in its function. If it is true that the Byzantines invented the functional format that provided a model for the kind of ceremonies that took place in the Cappella Palatina, they never, at least insofar as it is now possible to determine, had an architectural form that served the function in precisely the same way, and for one reason. What the first phase of the chapel as I have reconstructed it implies is not only a paragone between the heavenly and earthly kingdom, but the link between them, as a matter of fact, the sole link between them: the king. It was the king alone who had the privilege of occupying a position in both realms, who moved between them as the hinge that held them together. In his physical place—on a balcony and on the ground—and in his physical movement, he gave the world its very structure. In Byzantium, on the other hand, although the emperor was the head, he was not the sole hinge between the here and the beyond.[82] The possibility of access, unmediated and direct, to the higher power was something that was always open to all. Thus the liturgies and receptions that are described in the books of ceremonies were either accommodated in structures that were separate from one another, or if joined, done so in a way that implied the priority of one over the other. Two of the examples cited by Ćurčić, the Kainourgion, built by Basil I (876–86) and the Mouchroutas, built probably in the later twelfth century, fall into the first category. They are purely aulic structures without any place for the celebration of the liturgy. In the Chrysotriklinos or Great Throne Room of the Byzantine emperors built by Justin II (565–78), on the other hand, there was an oratory dedicated to St. Theodore, though it was only in an ancillary niche closed off from the main space by a curtain. The fact that it was an oratory suggests that it was not a fully functioning liturgical arena, and its raison d'être may have been in the dedication itself. Theodore was one of the most important military saints and his presence in the throne room may have had a protective as well as commemorative connotation.

A second point of the Cappella Palatina's originality has to do with style. There is a great deal of evidence from throughout the Middle Ages of the preference of one culture for the art and architecture of another, but nowhere else gave rise to a structure that combined the arts in such a clear and purposeful way: Byzantine art was used for the sanctuary of the Cappella Palatina because it alone had a format capable of depicting the universal order of the Pantokrator, who was the only ruler above the king; Islamic art, on the other hand, was the true terrestrial realm for the Normans, citizens of Sicily, an Arab land, and especially of Palermo, an Arab capital of three hundred mosques which became the Norman capital, in which a Christian king spoke Arabic and in which Arabic architecture defined the place of the king. But these propositions, which only hint at the significance of the style of the chapel, cannot properly

---

[82] Nor, it might be added, was this the case in the medieval West, and the architectural tradition was shaped accordingly; see, for example, Peter Metz, "Der Königschor im Mainzer Dom," *Universitas: Dienst an Wahrheit und Leben. Festschrift Dr. Albert Stohr*, vol. 2, Mainz, 1960, 299ff.

be offered as conclusions; they deserve a fuller treatment, which will be the subject of chapter 4.

## LATER TWELFTH-CENTURY DEVELOPMENTS

As argued in the individual analyses of chapter 2, the decorations and furnishings of the Rogerian chapel were augmented and fundamentally changed in the later twelfth century in two major campaigns of activity. The first occurred in the reign of William I (1154–66), and consisted of the addition of mosaics depicting scenes from the Old Testament and from the lives of Peter and Paul to the nave and aisles of the chapel. Under William II (1166–89), the space in front of the chapel to the west was enclosed to form a narthex, the western doorways into the aisles were refurbished with new bronze doors, new furnishings were provided for the chapel in the form of a new superstructure for the throne platform, a pulpit, paschal candelabrum and baptismal font, and new mosaics were added to the central apse. Since we have already had an opportunity to discuss these additions from the perspective of the Rogerian edifice, it would be useful to begin here by turning the matter around and looking at it from the opposite point of view: how did the two campaigns themselves relate to one another? Were the added and changed items simply a miscellaneous collection, or did they represent the working out of a coherent plan?

In attempting to answer this question we are hampered again by the lack of textual sources. We cannot say with certainty whether there was a master plan for the chapel in the second half of the twelfth century. On the other hand, the later additions and changes clearly worked together in two ways that have already been pointed out: first of all they served to "christianize" the nave space which before had very little christian about it in appearance, and secondly, they reoriented that space, making it symmetrical and relating it more directly to the sanctuary of the chapel. Thus one might say that these efforts, while not necessarily envisioned as a whole, spoke to the same or similar functions, about which three points may now be made:

1. Under William I there was an increase in the number of regular liturgical services held in the chapel, or at least this is one of the inferences that may be drawn from the increase in the number of canons reported in the Chronicle of Romuald of Salerno: "Cappellam sancti Petri, que erat in palatio, mirabilis musidii fecit pictura dipingi, et eius parietes preciosi marmoris varietate vestivit et eam ornamentis aureis et argenteis et vestimentis pretiosis ditavit plurimum et ornavit. *Clericos in ea multos et prebendas instituit, et divinum in illa officium decenter et tractatim et cum Dei reverentia et timore celebrari disposuit.*"[83] There is no indication that the number of canons was either augmented or reduced under William II.

2. After King Roger's death the Cappella Palatina was also the site of at least two important royal events. One of them was the funeral of William I, which took place in

[83] Romuald of Salerno, 254 (1166). See also Garofalo, *Tabularium*, 78, and the discussion of    Pasca, *Descrizione*, 48ff.

the chapel in May 1166.[84] According to the *Liber de regno Sicilie*, the king's body had been hidden in the palace after his death (which occurred on either May 7 according to Romuald of Salerno or May 15 according to the *Necrologio Cassinese*) for several days prior to the funeral in order to effect a transition of power to his son without alarming the citizens of the city. The body was then transferred to the chapel, where "per totum autem hoc triduum mulieres nobilesque matrone, maxime sarracene, quibus ex morte regis dolor non fictus obvenerat, saccis operte, passis crinibus et die noctuque turmatim incedentes ancillarum preeunte multitudine, totam civitatem ululatu complebant ad pulsata tympana cantu flebili respondentes."[85] The affair must have been quite striking, both to the eye and to the ear, although it is difficult to tell from the text exactly what occurred in the chapel itself. The other occasion was the wedding of William II.

On 13 February 1177, William II was married in the chapel to Joan of England who was also crowned queen on this day.[86] William II was crowned king too for a second time at the ceremony; his first coronation took place on 17 May 1166. Kantorowicz, following Schramm, identified what he believed were the ordines for this ceremony (of 1177) in two Norman texts published by Schwalm from a Beneventan manuscript of the twelfth century.[87] The ordines were for the coronation of a king and a queen, and give as the name of the king, Wilielmus. The only problem is that the ordines were written, not for the palace chapel, but for the Cathedral, and it is partly on the basis of this discrepancy that Elze then rejected Kantorowicz's interpretation, dating the ordines to the reign of Roger II (Elze's ordines B and C).[88]

But perhaps Elze's reasoning was too rigid. An ordo is the prescription for a ceremony written so that it can repeated, and in the case of the event of 1177, this fact alone would have presented a problem. The Norman kings had always been crowned in the Cathedral of Palermo, and there is every reason to believe that the same had been intended in 1177 for William II and Joan of England—but for the fact that the Cathedral itself was then under construction.[89] The Cappella Palatina was chosen as a venue of necessity not custom, and it could hardly have been expected that such a choice would have been repeated. On the other hand, it is possible that ordines of coronation written for the Cathedral were adapted on an ad hoc basis for the unusual staging of the event.

One further piece of evidence would appear to support the latter interpretation,

[84] On the date of William's death, see *La Historia o Liber de regno sicilie e la Epistola ad petrum panormitane ecclesie thesaurium di Ugo Falcando*, ed. G. B. Siragusa, Rome, 1897, 88 n. 1.

[85] *La Historia o Liber de regno sicilie*, 88f. See also Romuald of Salerno, 435.

[86] *Ex gestis Henrici II. et Ricardi I.*, ed. F. Liebermann and R. Pauli (=*MGH, SS*, 27), Leipzig, 1925, 93; Chalandon, *La domination normande*, 337f.

[87] Ernst Kantorowicz, *Laudes Regiae: A Study in Liturgical Acclamations and Mediaeval Ruler Worship*, Berkeley, 1946, 166, esp. n. 44: "The Order can hardly refer to any other South Italian coronation

than that of William II and Joan of England." See Jakob Schwalm, "Reiseberichte 1894–1896," *Neues Archiv der Gesellschaft für altere deutsche Geschichtskunde* 23, 1898, 17ff.; Reinhard Elze, "Tre ordines per l'incoronazione di un re e di una regina del regno normanno di Sicilia," *Atti del congresso internazionale di studi sulla sicilia normanna (Palermo, 4–8 Dicembre 1972)*, Palermo, 1973, 438ff.

[88] Elze, "Tre ordines," 438ff., esp. 442f.

[89] See Pietro Gramignani, "La Cappella dell'Incoronazione in Palermo," *Archivio Storico Siciliano* 54, 1934, 227f.

although its implications will not become clear until a later point. The ordo for the king's coronation makes mention of acclamations to the king sung in both Latin and Greek after the reading of the epistle—"lecta epistola cantentur laudes regis, latine prius, postea greca."[90] This phrase is the first concrete evidence that we have of the performance, in a Norman royal context, of the chant of the *laudes regiae*—the "famous and most impressive liturgical acclamation of rulership" in the words of Kantorowicz—which was so widely diffused in the West, as Kantorowicz has amply demonstrated. These chants were typically cast in the form of a litany, of which we have an actual surviving text from southern Italy and probably from the Norman period. The text is preserved in a fifteenth-century manuscript in the Cathedral of Palermo, and although it names as titular ruler "Frederick" (possibly one of the Aragonese kings), Kantorowicz has argued that the acclamations were Norman in origin. That the text went back to the time of Roger II, as Kantorowicz has also suggested, however, is more doubtful.

One of the other chronological indicators in the text are the names of saints, two of which, Mary Magdalen and Christina, were particularly revered in the post-Rogerian period. William II built a chapel dedicated to Mary Magdalen in the Cathedral of Palermo; he also finished a chapel begun by his father dedicated to Christina, whose remains were transferred from Tyre to Palermo in 1160.[91] The evidence for the performance of the *laudes* under Roger otherwise is circumstantial and thus of an entirely different nature. Kantorowicz, for instance, implies that the legend, "Christus vincit, Christus regnat, Christus imperat," on the coins of Roger II may have derived from the *laudes*, whose acclamations opened with the phrase.[92] But such a legend was widely used on coins in the later Middle Ages where, presumably, the *laudes* were not always to be held in account. Nor does the fact that the *laudes* were performed for Richard of Aversa by the monks of Monte Cassino in 1058—which Kantorowicz cites as a precedent—necessarily imply anything about the practices of Roger II.

It is also interesting to observe that the other Norman coronation ordo of which we have knowledge, dated by Elze also to the period of Roger II, does not make mention of the *laudes regiae*.[93] It may well have been the case, therefore, that the Palermitan text belonged to the period of the coronation ordo that Kantorowicz dated to the time of William II.[94] Given our last observation about the lack of explicit reference to the practice one might wonder in addition whether the *laudes* themselves did not undergo some change in Sicily from earlier to later twelfth century to become a more prominent and consciously stressed part of the liturgy.

3. Finally, the decoration of two large rooms in the Norman palace, the so-called Sala di Ruggero, or the Norman Stanza, and the main hall of the Torre Pisana, should be introduced in the discussion (fig. 5, nos. 7 and 8; fig. 141).[95] There is a certain

---

[90] Elze, "Tre ordines," 455; Schwalm, 21.
[91] Kantorowicz, *Laudes Regiae*, 161 nn. 18 and 19.
[92] Kantorowicz, *Laudes Regiae*, 165 n. 41.
[93] Elze, "Tre ordines," 440ff., 445ff.
[94] See also Kantorowicz's related study, "A Norman Finale of the Exultet and the Rite of Sarum,"

*Harvard Theological Review* 34, 1941, 129ff.
[95] Demus, *Norman Mosaics*, 180ff.; Kitzinger, "The Mosaic Fragments in the Torre Pisana of the Royal Palace in Palermo: A Preliminary Study," *Mosaïque: Recueil d'hommages à Henri Stern*, Paris, 1983, 239ff.

parallelism in the history of the two spaces. Both occur in structures that are believed to have been built by Roger II, although they are first mentioned in the sources in the context of William I, with whom the decorations of the two rooms have been associated.[96] The Norman Stanza occupies the piano nobile of the wing of the palace called the Joharia, which lies to the north of the Cappella Palatina and south of the Torre Pisana. Both rooms are rather large, formal spaces, although the Torre Pisana is the larger. In both cases, the decoration consists of an elaborate mosaic program covering the upper reaches of the walls, including, for the Norman Stanza, also the vault, but neither have their original pavements or the original coverings of their lower walls. The main difference lies in the subjects that are depicted: the Norman Stanza is decorated with the imagery of the garden and of the hunt, with facing lions, hunters and centaurs in the lunettes of the walls, and lions, griffins and an eagle on the vault; in the hall in the Torre Pisana, on the other hand, the main theme seems to have been a military one, with several registers of battle scenes.

What functions did these rooms serve? One indication, and indeed the only direct indication we have from any source, is given with regard to King William II in the letter attributed to Hugo Falcandus: "medium vero locum pars illa palatii que Ioharia nuncupatur, plurimum habens decoris, illustrat, quam multiformis ornatus gloria prefulgentem, rex ubi otio quietique indulgere voluerit, familiarius frequentare consuevit."[97] The latter of course, were the members of the king's household—his court—and of the activities specified here, relaxation ("otio quietique") and the reception of members of the court, it was probably more for the latter function that the two rooms served; there are other smaller spaces in the Joharia and the Torre Pisana that would have been better adapted to the former purpose. This inference is supported by the shape of the rooms, and especially by their imagery, which partakes of what must have been in the twelfth century a distinct genre of decoration for the ceremonial spaces of palaces. It is interesting to observe that both of the themes that were depicted here, hunting and warfare, are mentioned in a passage of John Kinnamos's *Epitome* describing the customs of palace decoration of his time:

> When, some time later, he [Alexios Axouch, one of the generals of Manuel I] returned to Byzantium [from Cilicia] and determined to decorate with painting one of his suburban houses, he did not include among the subjects any ancient deeds of the Hellenes, nor did he represent, as is the custom among men in authority, the emperor's achievements *both in war and in the slaying of wild beasts*; for, indeed, the emperor had fought more wild beasts of different kinds than any other man we have heard of.[98]

96 See the remarks of Kitzinger, "Mosaic Fragments in the Torre Pisana," 243.

97 *La Historia o Liber de regno sicilie*, 177f.

98 John Kinnamos, *Ioannis Cinnami Epitome rerum ab ioanne et alexio comnenis gestarum*, ed. Augustus Meineke, Bonn, 1836, VI, 6, 266f.; trans. Cyril Mango, *The Art of the Byzantine Empire 312–1453: Sources and Documents*, Englewood Cliffs, N.J., 1972, 225 (italics mine). Paul Magdalino, "Manuel Komnenos and the Great Palace," *Byzantine and Modern Greek Studies* 4, 1978, 101ff.; idem and Robert Nelson, "The Emperor in Byzantine Art," 123ff.; Lucy Ann Hunt, "Comnenian Aristocratic Palace Decorations: Descriptions and Islamic Connections," *The Byzantine Aristocracy, IXth to XIIth Centuries*, ed. M. Angold, Oxford, 1984, 138ff. See also the frescoes in the "princely passageway" in the southwest tower of St. Sophia in Kiev, with scenes from hunts in the arena, also dating to the twelfth century; André Grabar, "Les Fresques des escaliers à Sainte-Sophie

To return now to the problem of the later changes in the chapel, we might say that these three considerations contribute to our picture of the rationale for them in the following sense. Let us begin with the performance of the *laudes regiae*. The *laudes* were typically performed for the king not just at the moment of his coronation, or indeed his second coronation as was probably the case with William II, but also during the ritual crown wearings or *Festkrönungen* that punctuated the royal liturgical year.[99] These rituals constituted in a sense a parallel to the Byzantine imperial liturgy with its imperial acclamations, with the single noteworthy distinction that they did not also embrace receptions and greetings with ritual bowing or *proskynesis*. The fact that the *laudes* exist in a version that may go back to the time of William I or William II, as witness the Palermitan manuscript, suggests that such crown wearings may have been a part of the court ritual under these two Norman kings.

It was a greeting ceremony with *proskynesis* that served to explain the unusual design of the Cappella Palatina pavement, particularly the asymmetry of its plan. If the royal liturgy as it evolved under Roger II then persisted into later times, but with a Western rather than Byzantine model, and with the *laudes* rather than *proskynesis*, the need for this asymmetry would have diminished. Although I know of no medieval account of how the *laudes* were performed, one might easily imagine them as having been staged in a symmetrical composition around the king, and symmetry was one of the characteristics of the later changes wrought in the chapel. It is quite possible, therefore, that the renovated throne platform gave focus to a performance of this nature around the figure of the king.[100]

But a change of this sort in the chapel could only have had an effect elsewhere, and it is here that the significance of the rooms in the Joharia and the Torre Pisana may be revealed. These rooms may have existed already under Roger, but they were only first decorated under William I, which suggests that they had begun to play a new role at that time. Could that role have been to accommodate the kinds of courtly receptions that had been displaced from the Cappella Palatina? At least the words attributed to Hugo Falcandus would seem to suggest so. That such a displacement might have occurred is also supported by the increase in the number of canons, with the implica-

---

de Kiev et l'iconographie impériale byzantine," *Seminarium Kondakovium* 7, 1935, 103ff.; idem, *L'Empereur dans l'art byzantin*, Paris, 1936, 62ff.; Lazarev, *Old Russian Murals*, 53ff.

[99] Reinhard Elze, "Die Herrscherlaudes im Mittelalter," in idem, *Päpste-Kaiser-Könige und die mittelalterliche Herrschaftssymbolik*, London, 1982, no. X (201–23).

[100] The throne platform continued to function in official ceremonies in the Cappella Palatina; see an eighteenth-century description in a unpublished text in the Biblioteca Comunale, Palermo, Qq H96, entitled "Mescolanze di cose siciliane," attributed to Carafa (?), fol. 671r–672r:

Nella Cappella Palatina Palermitana nei tempi nostri, li Vicerè di Sicilia con tutto il Consiglio,

Senato Palermitano, Titoli del Regno, in certe Feste intervengono per le Funzioni Ecclesiastiche principalmente nelle Domeniche dell'Avvento, e tempo di Quaresima per sentire le prediche, sedono nelli gradini del solio li Giudici della Gran Corte Civile, e Criminale, il Protonotajo, l'Auditore Generale, nel scalino più sotto sedono li Nazionali del Tribunale del Real Patrimonio, e Secretarij del Regno, tra lo Spazio dell'altare, ed il soglio sedono nelle sedie a forbice li Presidenti, e Capi de Tribunali cioè della Gran Corte Civile, e Criminale, Tribunale del Real Patrimonio, del Consistorio, ed il Consultore del Sig. Vicerè, siegue in un banco il Tribunale del Real Patrimonio, ed il Maestro Portolano, siegue il Senato col Pretore, ed il Capitano . . .

tion of the increase in the number of liturgical services held in the chapel, and the implantation of pulpit, paschal candelabrum and baptismal font(?) to accommodate them.

That these changes involved not only a displacement of activities, but also the displacement of an entire cultural model for the chapel is suggested by the physical forms and images themselves, which belong by and large to a Western, specifically Italian tradition not much in evidence in the chapel before this point. The paschal candelabrum and pulpit, for instance, find their closest parallels in Rome and Salerno, and the mosaics of the nave, in the Italian tradition of the great narrative cycles of early Christian Rome and Southern Italy. In all three cases the mediator of tradition and the direct source of inspiration may have been the monastery of Monte Cassino itself.

With the throne superstructure, however, the situation is more complex. The proportions of the ensemble, especially with the fastigium, which is wide and low, are without parallel, and in all likelihood to be explained in terms of the unique physical constraints (derived from the earlier throne platform) with which the designer of the later wall was confronted. The fastigium, of course, was an honorific symbol deeply embedded in the visual tradition of rulership in the West, not only in the design of thrones but also of tombs and of portraits.[101] In this case in particular one of the themes that may have given the form a more specific inflection was Biblical, the Throne of Solomon (1 Kings 10:19), to which the throne platform in the Cappella Palatina may have been assimilated with regard to the lions of the pediment zone and, as Ćurčić has pointed out, the steps (five extant and one implied).[102] There is also the echo, in the large facing figure of Christ, of an image more commonly found on the west wall of Italian churches, the Deesis of the Last Judgement, but it is hardly more than a distant reverberation here.

There are two traditions that have often been adduced in discussions of the scene of Christ flanked by Peter and Paul, namely the Byzantine and the Roman, although neither seems to provide an entirely satisfactory frame of reference. The emperor's throne in the throne room of the Great Palace of Constantinople, the Chrysotriklinos, was surmounted by an image of Christ described in the ninth century: "For behold once again the image of Christ shines above the imperial throne and confounds the murky heresies."[103] But there is no proof that the Chrysotriklinos was still in use in the twelfth century since the palace itself was inhabited by the then-ruling dynasty of the Komnenoi only sporadically; concerning the appearance of the emperor's throne

---

[101] Deér, *Porphyry Tombs*, 37f.

[102] Slobodan Ćurčić, "Some Palatine Aspects of the Cappella Palatina in Palermo," *Dumbarton Oaks Papers* 41, 1987, 142; potentially relevant here too are 1 Kings 7:7, Prov. 20:8, Is. 6:1, Is. 66:1, Matt. 19:28, and Heb. 4:16. The larger context for this association is sketched in part by Francis Wormald, "The Throne of Solomon and St. Edward's Chair," *De artibus opuscula XL: Essays in Honor of Erwin Pan-*

ofsky, ed. Millard Meiss, New York, 1961, 1:532ff., 2:175ff.

[103] *Anthologia graeca epigrammatum palatina cum planudea*, ed. Hugo Stadtmüller, Leipzig, 1904, 1:106, 28f.; trans. Mango, *Art of the Byzantine Empire*, 184, and n. 7 on the date, which Mango places between 856 and 866. On the Chrysotriklinos, see Jean Ebersolt, *Le grand palais de Constantinople et le livre de cérémonies*, Paris, 1910, 75ff.

room in the other dwellings in Constantinople there is unfortunately no indication.[104] Similarly, although the group of Christ flanked by Peter and Paul occurs in a number of Roman apse decorations and other pictorial works (an eleventh-century wall painting in the church of S. Urbano alla Caffarella), the Roman images overwhelmingly, though not exclusively, show the composition in the reverse of what occurs in the Cappella Palatina, with Peter to the (viewer's) right and Paul to the left, not to mention that the accompanying angels, Michael and Gabriel, are never identified in Rome as they are here.[105]

Yet it is precisely these discrepancies that may provide us with an important clue. I am struck above all by the similarity in the disposition of Peter and Paul in the Cappella Palatina and in certain works of imperial German patronage such as the Bamberg Apocalypse (Bamberg Staatsbibliothek, Bibl. 140, fol. 59v.) and the Pericopes of Henry II (Munich, Bayer. Staatsbibliothek Clm 4452, fol. 2r; fig. 142).[106] Peter and Paul appear left to right flanking Christ in the case of the latter, and the emperor himself in the case of the former. The disposition more prevalent in Rome, with Peter and Paul in reverse, must have been due to the derivation of the iconography from the early Christian scene of the *Traditio legis*, where Christ is shown blessing with his right hand, and giving the law to the first among equals, Peter, with his left. In the German miniatures, on the other hand, Peter has pride of place at the emperor's or Christ's right, especially when, in the case of the latter, he presents to Christ the em-

---

[104] See below, chapter 4, pp. 150f.

[105] Stephan Waetzoldt, *Die Kopien des 17. Jahrhunderts nach Mosaiken und Wandmalereien in Rom*, Vienna, 1964, 78f., fig. 561 (cat. no. 1091); Kitzinger, *I mosaici*, fasc. 2, 13. Peter also occupies a position to Christ's right in the mosaic on the triumphal arch of S. Lorenzo flm (Antonio Muñoz, *La Basilica di S. Lorenzo fuori le mura*, Rome, 1944, pl. LXXXIII), in the wall painting in the Oratory of Pope Formosus (S. Lorenzo super S. Clementem?) (Waetzoldt, *Kopien*, 54f., fig. 316 [cat. no. 316]) and on the lid of the reliquary of Paschal I (Beat Brenk, "Zur Bedeutung des Mosaiks an der Westwand der Cappella Palatina in Palermo," in *Studien zur byzantinischen Kunstgeschichte. Festschrift für Horst Hallensleben zum 65. Geburtstag*, ed. Birgitt Borkopp et al., Amsterdam, 1995, 189ff., fig 5). See also the decoration of the north wall of the Cappella Pellegrino, Bominaco; Jérôme Bashet, *Lieu sacré, lieu d'images: Les fresques de Bominaco (Abruzzes, 1263). Thèmes, parcours, fonctions*, Paris and Rome, 1991, fig. 6. On the development of the iconography, see Tilmann Buddensieg, "Le coffret en ivoire de Pola," *Cahiers Archéolgiques* 10, 1959, 157ff.; Caecilia Davis-Weyer, "Das Traditio-Legis-Bild und seine Nachfolge," *Münchner Jahrbuch der bildenden Kunst* 12, 1961, 7ff.; Gerhart B. Ladner, *Die Papstbildnisse des Altertums und des Mittelalters*, vol. 2, Vatican City, 1970, 56ff.;

Peter Hoegger, *Die Fresken in der Ehemaligen Abteikirchen S. Elia bei Nepi: Ein Beitrag zur romanischen Wandmalerei Roms und seiner Umgebung*, Stuttgart, 1975; Hanspeter Lanz, *Die romanischen Wandmalereien von San Silvestro in Tivoli: Ein römisches Apsisprogramm der Zeit Innocenz III*, Bern, 1983; Richard Krautheimer, "A Note on the Inscription in the Apse of Old St. Peter's," *Dumbarton Oaks Papers* 41, 1987, 317ff. In this context it is interesting to note the account of Alexander of Telese of a dream in which Peter and Paul figure as the king's guides and protectors; M. Reichemiller, "Bisher unbekannte Traumerzählungen Alexander von Telese," *Deutsches Archiv für Erforschung des Mittelalters* 19, 1963, 343ff.

[106] Percy Ernst Schramm, "Das Herrscherbild in der Kunst des frühen Mittelalters," *Vorträge der Bibliothek Warburg* 2, 1922–1923, 145ff., 206ff., fig. 16 (Bamberg Apocalypse), fig. 17 (Pericopes of Henry II); idem and Florentine Mütherich, *Denkmale der deutschen Könige und Kaiser: Ein Beitrag zur Herrschergeschichte von Karl dem Grossen bis Friedrich II. 768–1250*, Munich, 1962, 208, fig. 112 (Bamberg Apocalypse); 215, fig. 122 (Pericopes of Henry II). Percy Ernst Schramm, *Die deutscher Kaiser und Könige in Bildern ihrer Zeit 751–1150*, ed. F. Mütherich, Munich, 1983, 89 and 208, pl. 112 (Bamberg Apocalypse), 94, 215, pl. 122 (Pericopes of Henry II).

peror himself.[107] It should be noted that the two miniatures also include personifications of provinces bearing gifts, which they raise to offer to the emperor and Christ. Implicit in these presentations is acclamation, which returns us finally to the image in the Cappella Palatina.

This image, abstract and timeless though it seems, was supremely the creation of the ritual of royal acclamations, for which it served as the perfect backdrop. It presented to the viewer an epitome of the hierarchy of which he sang, above the king himself, and most important, boldly textualized with the figures' names. This hierarchy was then completed in the images of the saints, also inscribed with names, that lined the walls and soffits of the nave.[108] Although there is no proof that the very text from the fifteenth-century Palermitan manuscript was recited in the Cappella Palatina, it is instructive to quote it here (figures represented in the mosaic of the west wall are marked with "*"; figures in the mosaics of the nave, with "+"; and figures in the presbytery, with "#"):

| | | | | |
|---|---|---|---|---|
| * | # | Christus vincit, Christus regnat, Christus imperat. | | |
| | | | R/ | Exaudi Christe |
| | | *Domino nostro regi Friderico, magnifico et triumphatori* | | |
| | | *ac invictissimo, vita perpetua!* | | Exaudi Christe |
| * | # | Salvator mundi | | tu illum adiuva |
| * | # | Redemptor mundi | | tu illum adiuva |
| | | S. Trinitas | | tu illum adiuva |
| # | | S. Maria | | tu illum adiuva |
| * | # | S. Michael | | tu illum adiuva |
| * | # | S. Gabriel | | tu illum adiuva |
| # | | S. Raphael | | tu illum adiuva |
| # | | S. Johanne Baptista | | tu illum adiuva |
| | | *Regi nostro Friderico glorioso et triumphatori* | | |
| | | *pax sempiterna!* | | Exaudi Christe. |
| * | # | S. Petre | | tu illum adiuva |
| * | # | S. Paule | | tu illum adiuva |
| # | | S. Stephane | | tu illum adiuva |
| # | | S. Laurentii | | tu illum adiuva |
| | | *Pacifico rectori et piissimo gubernatori regi nostro* | | |
| | | *Friderico lux indeficiens et pax eterna!* | | Exaudi Christe |

[107] Peter also appears to the right of Christ (the viewer's left), en buste, in the concha of the right apse in the monastery church at Müstair (with St. Paul to Christ's left); see Linus Birchler, "Zur karolingischen Architektur und Malerei in Münster-Müstair," *Akten zum III. Internationalen Kongress für Frühmittelalterforschung*, Lausanne, 1954, 167ff., esp. 217 and fig. 97. See also the decoration of the apse vault in Hedensted (Norlund and Lind, *Danmarks Rom. Kalkmal.*, 1944, fig. 24), and the west wall of the choir of Cologne Cathedral (Paul Clemen, *Der Dom Köln* [=*Die Kunstdenkmäler der Rheinprovinz*, 6, pt. III], Düsseldorf, 1937, fig. 126.

[108] The choice of saints depicted in the chapel matches in no small part the relics recorded as having been in the possession of the Cappella Palatina in the eighteenth century; see Rocco Pirri, *Notitia Regiae ac Imperialis Capellae sacri et regii Palatii Panormitani, cum additionibus D. Antonini Mongitore, canonici Panormitani* (=Pirri, *Sicilia Sacra*, vol. II), Palermo, 1733, 378f.

| # | S. Sylvestre | tu illum adiuva |
|---|---|---|
| # | S. Maria Magdalena | tu illum adiuva |
| + | S. Christina | tu illum adiuva |
| # | S. Agatha | tu illum adiuva |
| *   # | Christus vincit, Christus regnat, Christus imperat. | Exaudi Christe. |

*Ipsi soli honor et gloria, virtus et victoria per infinita*
*secula seculorum. Amen.*

All of which brings me to my final point. The image on the west wall of the Cappella Palatina speaks, if not in these exact words, at least in these terms. But it was not unique. It was in the later years of the twelfth century, between 1189 and 1200, that the apse of the east choir in the Cathedral of Mainz, which then became the king's choir, was decorated with an image of Christ in majesty flanked by Mary and Peter and accompanied by John the Baptist, Stephen, Boniface, Martin, Albanus and Lawrence, busts of five angels, and the following inscription: "O quam felices sunt et sine fine beati, qui Patris ad regnum sunt Christi voce vocati."[109] It was here that the king's *festkrönung* took place, and the image has been construed in relationship to the ritual, as a model of the heavenly empire and hierarchy of which the earthly one was a reflection.[110] The Palatine Chapel at Aachen was also redecorated under the Hohenstaufen, which embraced, among other things, a monumental image of Christ in the dome, with figures of the twenty-four elders.[111] In this case, the image had a narrative rationale. It depicted a moment in the Last Judgement. But it was a moment when the heavenly ruler was acclaimed and it can only be surmised that this image too played a role in the ritual of acclamations that took place in the chapel.

What these images have in common therefore cannot be circumscribed in narrowly iconographical terms. The "content" of these images in terms of specific figures or indeed of narrative events varied from place to place. What ties them together is their function as the heavenly model of an earthly kingdom, whose true meaning must have become apparent only when image and ritual were combined in the moment of homage and acclamation. In each case the images were inserted into an existing structure with overwhelmingly rich royal associations, and themselves overwhelmed these structures—taking over apse, dome, and in the case of the Cappella Palatina, the largest uninterrupted stretch of wall in the edifice—as much physically as in the new role of royal liturgy that they embodied.

[109] Metz, "Königschor" (above, n. 82), 305ff.; Friedrich Schneider, *Der Dom zu Mainz*, Berlin, 1886, 27.

[110] Metz, "Königschor," 318.

[111] Hermann Schnitzler, *Der Dom zu Aachen*, Düsseldorf, 1950, pl. 16; Walter Maas, *Der Aachener Dom*, Cologne, 1984, 19f.

# 4

# On the Self-Sufficiency of the Image
# in King Roger's Sicily

There has been considerable interest among scholars in recent years in the problem of artistic interchange in the Mediterranean world of the later Middle Ages.[1] The problem itself is not new. Late medieval Mediterranean art—from Moissac, Cairo, Jerusalem or Rome—has long been analyzed in terms of "influences" and "borrowings" from foreign lands by scholars who have taken it upon themselves to distinguish "sources" even when the sources would seem to have been inextricably bound together in the object itself. What has changed is the framework in which the problem is now put: artistic interchange is no longer argued exclusively in terms of iconographic motifs and drapery folds, but rather in terms of "form as property of meaning," of systems of meaning manifest visually in both the production and consumption of works of art. Thus in this context it has become more accurate to speak of "visual cultures" than of "artistic traditions" as the subject of analysis. At the same time, there has also been a tendency to see these visual cultures, especially as they revealed themselves in the princely courts—in Constantinople, Cairo, Palermo and Cordoba—as having been constituted along similar lines, with similar tastes, and an interest in the same kinds of luxurious and intricate works.[2] On the face of it would seem a rather

[1] The following collections of papers, several of which have derived from scholarly seminars or conferences, illustrate the point: Christine Verzar Bornstein and Priscilla P. Soucek, *The Meeting of Two Worlds: The Crusades and the Mediterranean Context*, Ann Arbor, 1981; *The Meeting of Two Worlds: Cultural Exchange Between East and West During the Period of the Crusades* (=*Studies in Medieval Culture*, 21), ed. Vladimir P. Gross and Christine Verzar Bornstein, Kalamazoo, Mich., 1986; *The Medieval Mediterranean: Cross-Cultural Contacts*, ed. Marilyn J. Chiat and Kathryn L. Reyerson (=*Medieval Studies at Minnesota* 3), St. Cloud, Minn., 1988; *The Legacy of Muslim Spain*, ed. Salma Khadra Jayyusi, Leiden, 1992. Individual studies include Robert S. Nelson, "An Icon at Mt. Sinai and Christian Painting in Muslim Egypt during the Thirteenth and Fourteenth Century," *Art Bulletin* 65, 1983, 201ff.; Eva Baer, *Ayyubid Metalwork with Christian Images*, Leiden, 1989; Antonio Cadei, "Architettura federiciana: La questione delle componenti islamiche," *Nel segno di Federico II: Unità politica e pluralità culturale del mezzogiorno: Atti del IV convegno internazionale di studi della Fondazione Napoli Novantanove, Napoli 30 settembre-1 ottobre 1988*, Naples, 1989, 143ff.

[2] Similarities between the Byzantine and Muslim courts were stressed in the Spring Symposium on "Byzantine Court Culture" held at Dumbarton Oaks in April 1994, particularly in the introductory remarks of Henry Maguire and in the presentation of Oleg Grabar, "The Shared Culture of the Objects at Court." Grabar's argument took up an ear-

odd turn of argument—to gainsay difference when the subjects of analysis have been defined as "cultural" and "systematic"—which brings me to the issue with which I would like to conclude.

What has always been most striking about the Cappella Palatina is the degree to which it incorporates art forms and styles (Byzantine mosaic; Islamic muqarnas) with different cultural roots and affiliations. These forms in the past have seemed rather oddly combined, which has fostered the impression of the chapel as miscellaneous and circumstantial, an eclectic, even disorderly mixture. But it has now become apparent that one of the reasons for this impression is, in a word, "overlay": the Cappella Palatina as we now see it is an overlay of plans. There were essentially two of them, different both conceptually and functionally, that were superimposed in the twelfth century. Differentiating them, in turn, has enabled us to see more clearly the stylistic logic of the building as it was originally conceived. Byzantine- and Islamic-derived forms were not quite so interpenetrating; rather they were disposed between sanctuary and nave in an arrangement that approached the systematic.

Is there a historical context in which such a use may be viewed? The two aspects of the problem, or more accurately, the two frames of reference that I have chosen—the Byzantine use of Islamic art and the nature of the sanctuary program—are based on the interrelated convictions that an answer lies in an analysis of visual data, but because of the very nature of this evidence, it can only be presented in the form of a rough sketch—not a finished picture—in which sharp contrasts alone will define the theme.

One further point by way of introduction. Implicit in this view of the Cappella Palatina is an image of the culturally diversified court that it served, as it has been sketched by historians such as Ménager and Von Falkenhausen.[3] As Von Falkenhausen points out, this diversity was as meaningful to the first of the Norman kings as it is apparent to us today from the vantage of the documentary sources. Who could doubt that Roger II, when he spoke of the "varietas populorum nostro regno subiectorum" in the Assizes of Ariano, also had in mind his own court, where titles such as "emir" (Muslim), "logothete" (Byzantine), and "camerlengus" (Norman) vividly identified offices of diverse provenances.[4] Multiple languages, often in direct juxtaposition, served

---

lier theme that he treated in an unpublished paper presented at Dumbarton Oaks in 1981, "Islamic Elements in the Art of Norman Sicily," a brief summary of which appeared in *Dumbarton Oaks Papers* 37, 1983, 169, and in an essay he co-authored with André Grabar, "L'Essor des arts inspirés par les cours princières à la fin du premier millénaire; princes musulmanes et princes chrétiens," *L'Occidente e l'Islam nel'alto medioevo, Settimane di studio del centro italiano di studi sull'alto medioevo, 2–8 aprile 1964,* Spoleto, 1965, vol. 2, 845ff.

[3] Léon-Robert Ménager, "Pesanteur et étiologie de la colonisation normande de l'Italie," *Roberto il Guiscardo e il suo tempo (=Relazioni e communicazioni nelle prime giornate normanno-sveve, Bari, maggio*

*1973*), Rome, 1975, 204; idem, "Inventaire des familles normandes et franques emigrées en Italie méridionale et en Sicile (XIe–XIIe siècles)," *Robero il Guiscardo e il suo tempo (=Relazioni e communicazioni nelle Prime Giornate normanno-sveve, Bari maggio 1973*), Rome, 1975, 261ff. Vera von Falkenhausen, "I gruppi etnici nel regno di Ruggero e la loro partecipazione al potere," *Società, potere e popolo nell'età di Ruggero II, Atti delle terze giornate normanno-sveve, Bari 23–25 maggio, 1977,* Bari, 1979, 133ff.

[4] Francesco Brandileone, *Il diritto romano nelle leggi normanne e sveve del Regno di Sicilia,* Rome/Turin/Florence, 1884, 96; Von Falkenhausen, "I gruppi etnici," 137, 141.

for court documents and monumental inscriptions, both public and private.[5] Arabs, Greeks and Latins coexisted in peaceful toleration (at least until nearly the end of Roger's reign) as scribes and notaries, poets and scientists, churchmen and homilists, and political advisors and military commanders in the royal court.[6] Christian baptism was a necessity for a courtly career, but it could also be treated superficially, and by no means implied the subsequent cursus of practices that made up a Christian life.[7] In other words, Muslim courtiers could continue to practice their religion if they kept it to themselves. To judge from the albeit late, but nonetheless visual source of the illustrations to the poem by Petrus de Ebulo on Henry VI, the personal habits and dress of courtiers were also strikingly differentiated; in aggregate these differences must have created a brilliant effect. Would it be too crude to describe King Roger's ethnic/cultural policy in this regard as "separate but equal"? Probably. But it is interesting to observe, as a number of scholars have done, that a process of latinization is detectable in the court as well as the society at large in the period after Roger's death.[8] "Separate but equal" comes as close to describing the Cappella Palatina in Roger's time, as "latinized" does in the period of his successors. But such analogies in the end are inadequate to the task of historical explanation in the visual arts; the argument must be cast in different terms.[9]

<center>✝   ✝   ✝</center>

Let me begin by taking the case of another culture where Islamic art played an important role and to which Norman Sicily has often been compared, that of Byzantium, even if the evidence here is mostly of a secondary nature, that is to say, that it consists of descriptions in written sources rather than actual objects, especially in the case of the monumental arts of the court. One example that has been adduced in the context of the Cappella Palatina is that of the Mouchroutas, the infamous hall of the Great Palace of Constantinople which figured in the revolt of John the Fat. Needless to say the edifice itself has not survived, but it is preserved for us in a description of Nikolaos Mesarites:

> The Mouchroutas is an enormous building adjacent to the Chrysotriklinos, lying as it does on the west side of the latter. The steps leading up to it are made of baked brick, lime and marble; the staircase, which is serrated (?) on either side and turns in a circle, is colored blue, deep red, green and purple by means of a medley of cut, painted tiles of cruciform shape. This building is the work not of a Roman, nor a Sicilian, nor a Celt-Iberian, nor a Sybaritic, nor a Cypriot, nor a Cilician hand, but of a Persian hand, by virtue of which it contains images of Persians in their different costumes. The canopy of the roof, consisting of hemispheres joined to the heaven-like ceiling, offers a variegated spectacle; closely packed angles project inward and outward; the beauty of the carving is extraordinary, and wonderful is the appearance of the cavities which, overlaid with gold, produce the effect of a rainbow more colorful than the one in the clouds. There is insatiable enjoyment here—

---

[5] See above, chapter 2, n. 16, and below, n. 53.
[6] For the literature on this issue, see below, n. 33.
[7] Von Falkenhausen, "I gruppi etnici," 147ff.

[8] Von Falkenhausen, "I gruppi etnici," 152ff.
[9] See above, chapter 1, pp. 13ff.

not hidden, but on the surface. Not only those who direct their gaze to these things for the first time, but those who have often done so are struck with wonder and astonishment. Indeed, this Persian building is more delightful than the Laconian ones of Menelaus.[10]

The Mouchroutas has been cited in the context of the Cappella Palatina for two main reasons: because of its date, being in all likelihood a product of the late twelfth century, but perhaps more important because of the nature of its ceiling.[11] The ceiling of the Mouchroutas, with its "closely packed angles" projecting "inward and outward," "overlaid with gold," and with "images of Persians in their different costumes" resembles nothing less than a decorated muqarnas ceiling, which is also supported by Mesarites' claim that the work was of a "Persian hand." Among twelfth-century muqarnas ceilings no example more closely approximates Mesarites' description than the one found in the nave of the Norman chapel. In fact Mesarites' text has been used to argue that the Cappella Palatina as a whole—in both its Byzantine and Islamic aspects—was inspired by the architectural practices and fashions of the Byzantine court.[12]

Mesarites' text is admittedly a brief description, and one can only assume that there were aspects of the building that the author himself chose not to communicate to the reader or perhaps even himself take in. But it is interesting to observe that nowhere in his description is there a mention of texts. Nowhere do we find reference to the kinds of inscriptions, on doors and ceilings, walls and furnishings, that were a part of the architectural mise-en-scène in the Islamic world, and that must have been a familiar feature of buildings to the artists and craftsmen "of a Persian hand" who constructed and decorated the edifice.[13] Could these inscriptions have been entirely overlooked by Mesarites, who appears to have been a close observer in other respects? Although it can only be an argument *ex silentio*, one wonders whether the Byzantine exemplar was not distinguished from its Islamic prototype precisely in its lack of explanatory texts. Such texts, however, abounded in the Cappella Palatina. Let us review briefly the evidence for them: the epithets on the ceiling, ringing the central stars in a profuse and repetitive litany; the fragmentary inscriptions in opus sectile that may well have adorned the chapel's portals; the inscription around the door knocker in the southern transept arm; and the inscription that most likely filled the cavetto molding around the ceiling of the nave, to mention only the relevant texts in Kufic that pertain directly to an Islamic style.[14] These inscriptions were more than merely incidental decoration, and herein I would argue may well have lain an essential difference between Byzantium and Norman Sicily. Given the absence of an actual structure comparable to the Mouchroutas, let me explain the point by making recourse to another type of evidence.

[10] A. Heisenberg, ed., *Die Palastrevolution des Johannes Komnenos*, Würzburg, 1907, 44f.; trans. Cyril Mango, *The Art of the Byzantine Empire 312–1453: Sources and Documents*, Englewood Cliffs, N.J., 1972, 228f.

[11] Slobodan Ćurčić, "Some Palatine Aspects of the Cappella Palatina in Palermo," *Dumbarton Oaks Papers* 41, 1987, 141f.

[12] Ćurčić, "Some Palatine Aspects," esp. 140ff.

[13] With regard to monumental inscriptions in a Muslim context, see most recently the discussion of Oleg Grabar, *The Mediation of Ornament*, Princeton, 1992, 47ff.

[14] See above, pp. 44ff., 57ff.

Direct witness to contemporary Byzantine perceptions of Islamic objects is most rare, but there are two accounts that seem to be of significant interest in this context. The first comes from a letter of Constantine VII Porphyrogennetos to his friend Theodore, Metropolitan of Kyzikos, around the year 940, in which the emperor speaks of a cup he had just received as a gift:

> When I had received the mountain vegetables and found these more tasty than honey in (the) honeycomb, I was thankful to the sender. I marveled at the Arabic cup, its variegated [beauty], its smoothness, its delicate work—both while eating and while going to bed; and, having thought of pouring myself some wine into it, I also (felt) a great pleasure, greater than if the famous nectar were abundantly poured over my lips . . . [15]

Over three hundred years later, as narrated in the chronicle of George Pachymeres, another Muslim vessel, also prized for its beauty, was dramatically withdrawn from an imperial ceremony when the "Egyptian letters" with which it was decorated were discovered to exalt the name of Mohammed:

> [The vessel] was decorated with Egyptian letters, which was the custom among the Egyptians: to use letters instead of other kinds of ornament on textiles, lamps, and all sorts of objects. But as it turned out, the letters exalted the name of Mahomet the Accursed—that is, Mohammed; this text, written in a circle around the plate, did not go unnoticed by its accusers. . . . Not only could this vessel not take part in the benediction because of the impure character of its inscription, but it also had the capacity of infecting others with the worst of impurities. Informed of these things and wishing to verify the inscription, the emperor sent straightaway for the Parakoimenos of the Chamber, Basil Basilikos, who knew how to read the writing of the Haggarites; he read the inscription and testified that what the accusers had said was true. The vessel, therefore, was not presented to the emperor for moral reasons. [16]

In other words, "Egyptian letters" could be appreciated in their aesthetic dimension when they served as the decoration of a vessel, but when it became apparent that they also had meaning, and indeed verbally conveyed the meaning of the vessel, they were unacceptable. Admittedly Pachymeres' story concerns a liturgical context and what was in effect a piece of spolia, but in a way, it only confirms the impression so strongly communicated over three centuries earlier by Constantine VII: how else could it be imagined that a vessel of foreign manufacture would find its way to the most sacred locus in Byzantium, except for the preciousness of its material and the fact of aesthetic appreciation. It was considered beautiful and thus appropriate for use in this most important place.

That the Byzantines cultivated non-indigenous art forms and styles imported from

[15] J. Darrouzès, "Épistoliers byzantins du Xe siècle," *Archives de l'orient chretien* 6, 1960, 329, as cited in Ioli Kalavrezou-Maxeiner, "The Cup of San Marco and the 'Classical' in Byzantium," *Studien zur mittelalterlichen Kunst 800–1250, Festschrift für Florentine Mütherich*, Munich, 1985, 173.

[16] George Pachymeres, *Relations historiques II: Livres IV-VI*, ed. Albert Failler and trans. Vitalien Laurent (=*Corpus Fontium Historiae Byzantinae*, XXIV/2), Paris, 1984, 572–75 (VI.12).

the Islamic world, and not only in the case of the Mouchroutas, is well beyond doubt. From the Bryas Palace of Theophilos to the Mouchroutas and beyond, there is ample evidence of the Byzantine recognition of and appreciation for Islamic art, and one can only assume that their motives throughout this period and in these different contexts were diverse.[17] But I do not know of a single case where the Byzantines invested the Islamic forms or motifs that they had appropriated with the burden of meaning that they were granted in the Cappella Palatina. Even allowing for the enormous gaps in our knowledge, I would characterize the Byzantine reception of the visual culture of their eastern and southern neighbors as contingent, based more on a love of luxury and ornament and on the aesthetic appeal of the object than on its "content" or programmatic meaning, which, in turn, is confirmed by an equally strange phenomenon in artistic practice arising in the Middle Byzantine period.

We do not need Pachymeres' text to tell us that the Byzantines had an appreciation for "Egyptian letters." The evidence is nearly everywhere. It occurs on the borders of vessels and textiles, in the frames of paintings and along the edges of capitals, columns and moldings.[18] Many examples, in fact, the great preponderance of them are in churches. A case in point is the Church of the Theotokos at Hosios Lukas in Phocis with its numerous decorative motifs based on the Kufic alphabet (fig. 143); but these motifs are found on the facades of a number of churches of the tenth to twelfth century in Attica, Boeotia and the Argolid, executed in cut brick.[19] The famous cup of the "Macedonian Renaissance" now in the treasury of San Marco, with its classicizing

[17] André Grabar, "Le Succès des arts orientaux à la cour byzantine sous les macédoniens," *Münchner Jahrbuch der bildenden Kunst* 2, 1951, 32ff. See also David Talbot Rice, "Iranian Elements in Byzantine Art," *Memoirs of the International Congress of Iranian Art and Archaeology, Leningrad, 1935*, St. Petersburg, 1939, 203ff.; Gerard Brett, "The Automata in the Byzantine 'Throne of Solomon'," *Speculum* 29, 1954, 477ff.; Elizabeth S. Ettinghausen, "Byzantine Tiles from the Basilica in the Topkapi Sarayi and St. John of the Studios," *Cahiers archéologiques* 7, 1954, 79ff.; Oleg Grabar, "Islamic Art and Byzantium," *Dumbarton Oaks Papers* 18, 1964, 69ff.; David Talbot Rice, "Late Byzantine Pottery at Dumbarton Oaks," *Dumbarton Oaks Papers* 20, 1966, 207ff.; Oleg Grabar, "Trade With the East and the Influence of Islamic Art on the 'Luxury Arts' in the West," *Il medio oriente e l'occidente nell'arte del XIII secolo* (=*Atti del XXIV congresso internazionale di storia dell'arte*), Bologna, 1979, vol. 2, 27ff.; Robert S. Nelson, "Palaeologan Illuminated Ornament and the Arabesque," *Wiener Jahrbuch für Kunstgeschichte* 41, 1988, 7ff. For the Bryas Palace, see Semavi Eyice, "Contributions à l'histoire de l'art byzantin: Quatre édifices inédits ou mal connus," *Cahiers Archéologiques* 10, 1959, 245ff.; Cyril Mango, *Byzantine Architecture*, New York, 1976, 194. See also Steven Runciman, "The Country and Suburban Palaces of the Emperors,"

*Charanis Studies: Esays in Honor of Peter Charanis*, ed. Angeliki E. Laiou-Thomadakis, New Brunswick, N.J., 1980, 219ff.; Lucy Ann Hunt, "Comnenian Aristocratic Palace Decorations: Descriptions and Islamic Connections," *The Byzantine Aristocracy*, ed. M. Angold, Oxford, 1984, 140f.

[18] S.D.T. Spittle, "Cufic Lettering in Christian Art," *Archaeological Journal* 111, 1955, 138ff.; George C. Miles, "Byzantium and the Arabs: Relations in Crete and the Aegean Arena," *Dumbarton Oaks Papers* 18, 1964, 20ff.; *The Church of Hagia Sophia at Trebizond*, David Talbot Rice, ed., Edinburgh, 1968, 55ff.

[19] George C. Miles, "Material for a Corpus of Architectural Ornament of Islamic Derivation in Byzantine Greece," *Yearbook of the American Philosophical Society*, 1959, 486ff.; idem, "Classification of Islamic Elements in Byzantine Architectural Ornament in Greece," *Actes du XIIe congrès international d'études byzantines*, Belgrad, 1964, vol. 3, 281ff.; André Grabar, "La décoration architecturale de l'église de la Vièrge à Saint-Luc en Phocide et le début des influences islamiques sur l'art byzantin en Grèce," *Comptes-rendus des séances de l'Académie des Inscriptions et Belles Lettres*, 1971, 15ff.; Richard Ettinghausen, "Kufesque in Greece, the Latin West and the Muslim World," *A Colloquium in Memory of George Carpenter Miles (1904–1975)*, New York, 1976, 28ff.; Mango, *Byzantine Architecture*, 215.

vignettes, also bears a simulated Kufic inscription on its inner rim (fig. 144).[20] What all of these examples have in common is the fact that the Kufic alphabet has been transformed into nonsense writing, a purely decorative script—pseudo-Kufic—that mimics the visual pleasure of the original without bearing any of its meaning; thus the "alphabet" has been made fully the equivalent of any other decorative motif that would have been appropriate for a border or frame: interlace, vine scroll, scale pattern, etc. The phenomenon was by no means limited to Byzantium; several cases of pseudo-Kufic have been attested in Western European contexts as well.[21] But it was in Byzantium that this type of ornament had its greatest appeal, and in the Middle Byzantine period that it spread to its farthest extent.

What occurs in the Cappella Palatina is profoundly different. The Kufic inscriptions were not simply an aesthetic choice. They addressed the viewer, explaining to him what to see and think and do, and not in and of themselves, but in the persona of the building—the building that spoke above all to an Arabic audience. They were part of the "program" of the edifice, not just window-dressing—a component of meaning whose absence would have altered in a profound way the balance of the whole. As a matter of fact, in overlooking them as an aggregate we have never fully been able to appreciate this balance: the Kufic inscriptions communicated to the viewer the nature and significance of the *royal function* of the Cappella Palatina, staged primarily in the nave, as the Greek and Latin inscriptions of the sanctuary spoke to the *liturgical function* at the altar. In an important sense these texts were fully equal, and they complemented and reinforced the visual messages of the decorations; in fact, the force of these decorations would have been diluted without them. Thus we return to a notion of stylistic juxtaposition, but perhaps with a deeper understanding of its substance, for which there was one important parallel in the Norman situation: in portrayals of the king.

The most famous image of Roger II is the mosaic portrait in the monastery church of St. Mary's of the Admiral, built in the 1140s by one of Roger's trusted advisors, George of Antioch (fig. 145). The mosaic dates to this period—the 1140s—and although it is not in its original place, it must be near it since it was probably intended to adorn the twelfth-century narthex of the church, which was later enlarged into the nave in which the mosaic now stands.[22] Within the frame of a single panel stand two figures—King Roger, to the viewer's left, and Christ, to his right. Christ is shown placing the king's crown on Roger's head, who in return lifts his hands in homage to

[20] Kalavrezou-Maxeiner, "Cup of San Marco," 173, fig. 8. See also Anthony Cutler, "The Mythological Bowl in the Treasury of San Marco at Venice," *Near Eastern Numismatics, Iconography, Epigraphy and History: Studies in Honor of George C. Miles,* ed. D. K. Koumijian, Beirut, 1974, 235ff. It is my understanding, however, that the inscription on the cup has never been examined by an Arabist.

[21] Kurt Erdmann, "Arabische Schriftzeichen als Ornamente in den abendlandischen Kunst des Mittelalters," *Abhandlungen der geistes- und sozialwissenschaftlichen Klasse, Akademie der Wissenschaft und der*

*Literatur in Mainz,* 1953, 467ff. Katherine Watson, "The Kufic Inscription in the Romanesque Cloister of Moissac in Quercy: Links with Le Puy, Toledo and Catalan Woodworkers," *Arte medievale* 3, 1989, 7ff.

[22] Ernst Kitzinger, "On the Portrait of Roger II in the Martorana in Palermo," *Proporzioni* 3, 1950, 30ff. (repr. in *The Art of Byzantium and the Medieval West, Selected Studies,* ed. W. Eugene Kleinbauer, Bloomington, Ind., 1976, 320ff.), and idem, *I mosaici di Santa Maria dell'Ammiraglio a Palermo,* Palermo, 1990, 191ff.

Christ. What is particularly interesting is the extent to which the image depends on Byzantine prototype, even to the details of Roger's garb, which is modeled to an amazingly precise degree on the Byzantine emperor's court costume (fig. 146). In fact, it is this aspect of the mosaic that has been commented on by scholars, who have seen embodied in it *the* political ideology of the Norman court. One line of thinking—and the most persuasive one—has seen the image as a statement about sovereignty.[23] The king has assumed the garb of the emperor because, in the medieval scheme of things, the emperor was a sovereign ruler. He was at the top of the pyramid of the medieval hierarchy of rule, and in assimilating himself to the emperor the king proclaimed himself a sovereign ruler in his own land—in the phrase of John of Salisbury (1168), "rex imperator in regno suo," or "the king is an emperor in his own land."[24]

Less persuasive, on the other hand, has been the concomitant attempt to construe the image as the claim of the king to the territories of the Byzantine state, which is too narrow, or even to suggest that Roger himself owned the Byzantine court costume or wore it in the royal ceremonies of Palermo. This latter point overlooks an aspect of the mosaic that Ernst Kitzinger has recently argued, namely, that Roger's costume here does not reflect contemporary Byzantine practice of the 1140s but an earlier court style, out of date then by several generations. Kitzinger's conclusion, which is plausible, is that the mosaic was a purely pictorial construction, based on a pictorial prototype and not reflective of any actual practice of the Norman king whatsoever.[25]

Turning now to the other image that I would like to consider, and indeed the only other type of image of Roger II distinct from the Byzantine one produced in the king's own lifetime, we find ourselves in a somewhat different situation.[26] That this image even represents the king has not been obvious, and has to be argued to begin with, but it is also something about which there can be little doubt as we have already had an opportunity to observe. The image occurs not once but seven times in the same context, in seven separate panels of the nave ceiling of the Cappella Palatina (fig. 72). Each of the seven panels bears essentially the same figure: a seated ruler, cross-legged on a low platform in the Islamic style, dressed in a caftan and wearing a three-pointed crown.[27] The fact that this figure is repeated is not disturbing; it is in keeping with

[23] Reinhard Elze, "Zum Königtum Rogers II. von Sizilien," in *Festschrift Percy Ernst Schramm*, Wiesbaden, 1964, esp. 110ff.

[24] Elze, "Zum Königtum," 113ff. John Dickinson, "The Mediaeval Conception of Kingship and Some of Its Implications, as Developed in the *Policraticus* of John of Salisbury," *Speculum* 1, 1926, 308ff.; Walter Ullmann, "The Development of the Medieval Idea of Sovereignty," *English Historical Review* 64, 1949, 1ff.; Ernst Kantorowicz, "*Pro patria mori* in Medieval Political Thought," *American Historical Review* 56, 1951, 472ff.; Gaines Post, "Two Notes on Nationalism in the Middle Ages," *Traditio* 9, 1953, 296ff.; Michael Wilks, *The Problem of Sovereignty in the Later Middle Ages*, Cambridge, 1963.

[25] Kitzinger, *I mosaici di Santa Maria*, 192ff.

[26] The portrait of Roger II on his coins conformed to the Byzantine type; see Rodolfo Spahr, *Le monete siciliane dai bizantini a Carlo I d'Angio (582–1282)*, Zurich/Graz, 1976, 145ff. The plaque in Bari showing the king dressed in Byzantine garb with St. Nicholas cannot be ascribed with certainty to the period of Roger's reign; see Emile Bertaux, "L'Émail de saint Nicolas de Bari," *Fondation Eugène Piot: Monuments et mémoires* 6, 1889, 61ff., pl. 6; Sigfrid H. Steinberg, "I ritratti dei re normanni di Sicilia," *La Bibliofilia* 39, 1937, 29ff., fig. 4; *I normanni, popolo d'Europa 1030–1200* (exh. cat.), ed. Mario D'Onofrio, Venice, 1994, 398f., no. 65.

[27] Monneret de Villard, *Soffitto*, figs. 189 and 190.

repetitive, non-narrative structure of the ceiling as a whole, an almost infinitely faceted surface decorated with single figures or small groups (drinkers, dancers, musicians) representing, as argued, the perfect earthly kingdom (Roger's kingdom) with its bounty and pleasures, and peace, which the king samples and over which he presides. What supports, indeed proves, that the king is Roger is one detail: his face, with what Jeremy Johns was the first to recognize as its distinctively Western physiognomy, hairstyle and beard (compare figs. 72 and 73).[28]

As in the first image of the king, the figure's dress is the most interesting element of this second type . This costume may be described as generically Islamic—a cloak and caftan. For the sake of parallelism with the mosaic, I have searched to discover whether the costume was a current or past style, and where in the Islamic world. Although these searches, including consultations with experts in the field, have been inconclusive, they may be rendered redundant by one fact. Roger himself possessed a cloak that, for all intents and purposes, can be described only as Islamic (fig. 147; plate X).[29] I say for all intents and purposes because it is quite clear that the cloak is not Islamic in its shape; it is a half circle, meant to be worn symmetrically over the shoulders as was common in the medieval West.[30] The decoration—two huge, symmetrically disposed pairs of lions attacking camels on either side of a large, stylized palm tree—however, is rendered in a driving, exuberant style that finds its closest analogies in Islamic art (fig. 148), and in this case it can only be imagined that the decoration would have conveyed overwhelmingly the essential message of the garment.[31] In wearing the cloak the ruler, Roger II,

[28] Jeremy Johns, "I re normanni e i califfi fatimiti: nuove prospettive su vecchi materiale," unpublished paper presented at the Fondazione Caetani, Rome, May 1993.

[29] Erwin Margulies, "Le Manteau impérial du Trésor de Vienne et sa doublure," *Gazette des Beaux Arts*, ser. 6, 9, 1933, 36off.; Ugo Monneret de Villard, "Le tessitura palermitana sotto i normanni e i suoi rapporti con l'arte bizantina," *Miscellanea Giovanni Mercati*, vol. 3, *Letteratura e storia bizantina*, Vatican City, 1946, 464ff.; Hermann Fillitz, *Die Insignien und Kleinodien des Heiligen Römischen Reiches*, Vienna, 1954, 23ff., 57f.; Filippo Pottino, "Le vesti regali normanne dette dell'incoronazione," *Atti del convegno internazionale di studi ruggeriani, 21–25 aprile 1954*, Palermo, 1955, vol. 1, 291ff.; Deér, *Porphyry Tombs*, 40ff.; F. Al Samman, "Arabische Inschriften auf den Krönungsgewändern des Heiligen Römischen Reiches," *Jahrbuch der kunsthistorischen Sammlungen in Wien* 78, 1982, 7ff.; David Jacoby, "Silk in Western Byzantium Before the Fourth Crusade," *Byzantinische Zeitschrift* 84/85, 1991/92, 464ff.; Rotraud Bauer, "Il manto di Ruggero II," *I normanni, popolo d'Europa 1030–1200* (exh. cat.), ed. Mario D'Onofrio, Venice, 1994, 279ff.

[30] A correct impression of the garment in use is conveyed by Dürer's drawing of Charlemagne wearing the mantle; see Hermann Fillitz, *Die Schatzkammer in Wien*, Vienna, 1964, fig. 6. For comparable

material in the medieval West, see J. Braun, *Die liturgische Gewandung*, Freiburg, 1907; E. Eichmann, "Von der Kaisergewandung im Mittelalter," *Historisches Jahrbuch* 58, 1938, 268ff.; *Sakrale Gewänder des Mittelalters*, exh. cat., Bayerischen Nationalmuseum, Munich, 1955; *Die Zeit der Staufer: Geschichte-Kunst-Kultur*, exh. cat., Württembergisches Landesmuseum, ed. Reiner Haussherr et al., 5 vols., Stuttgart, 1977, 1:607ff., 2:fig. 586ff.; 5:389ff.; Percy Ernst Schramm and Florentine Mütherich, *Denkmale der deutschen Könige und Kaiser: Ein Beitrag zur Herrschergeschichte von Karl dem Grossen bis Friedrich II. 768–1250*, Munich, 1962, 163ff.

[31] Deér, *Porphyry Tombs*, 52ff. See, for example, the eleventh-/twelfth-century luster ware bowl from Cairo with similar ornamental scroll-work within the figure; Janine Sourdel-Thomine and Bertold Spuler, *Die Kunst des Islam* (=*Propyläen Kunstgeschichte* 4), Berlin, 1973, 265, figs. 198 and 199. With regard to the meaning of the subject matter, see Deér, *Porphyry Tombs*, 66ff. Philagathos cites Ps. 91:13 ("The just shall flourish like the palm tree; he shall grow up like the cedar of Libanus"), and Cant. 5:11 ("His head is as the finest gold, his locks as branches of palm trees, black as a raven") in his Palm Sunday sermon, both of which may be brought to bear on the image of the palm on the mantle. See also the follaro (follis) with the head of a lion and a palm tree, attributed to both Roger II and William II; Philip Grier-

would have been enveloped in an imagery and style that contemporary viewers would have undoubtedly associated with the Muslim world. The cloak, furthermore, carries a lengthy inscription in Kufic that gives its date of manufacture, 1133–34, and its place of origin, the royal Tiraz ("Khizana al-malikiya"), or the *regium ergasterium* in the royal palace in Palermo; the institution, devoted to making textiles, was a royal prerogative in the Muslim world taken over by Roger II for his court.[32] The inscribed words in Arabic and the technique would have supported the impression that I have just described.

Let me now attempt to relate these observations to the Cappella Palatina as it was originally conceived under Roger II, in two parts, in two sharply contrasting styles. The eastern portion of the chapel, the sanctuary, was imagined as a Byzantine church, replete with dome and mosaics, and including an image of the Pantokrator and scenes from the life of Christ. The nave, on the other hand, was imagined as an Islamic-style reception hall, with tapestry-lined walls, a colonnade carried on high, stilted arches, and a bold muqarnas vault. Both parts too had a place for the king: in the sanctuary, the king stood on a balcony to the north to watch the liturgy at the altar below; in the nave, he occupied a low platform to the west, like an Islamic ruler's low, wide throne, to receive and greet, and in turn be greeted by, the members of his court. These two places, in the king's own chapel, defined the role of the king, or perhaps it would be more accurate to say the two roles of the king *and* their relationship to one another.

I would like to suggest that Roger's mode of presentation, or his style, if you will, as we have understood in the portraits helped to characterize his roles. Whenever Roger was shown in conjunction with Christ or the Pantokrator, not only in his mosaic portrait, but also on his coins, he assumed the garb of the Byzantine emperor—the sovereign ruler in the realm of the Pantokrator, both images and concepts evolved in Byzantium. When he confronted his people, however, he wore the garb of his own land, Sicily, an Arabic-speaking kingdom with a culture that belonged to the world of Islam. These two roles constituted Roger's image of his place for himself in the heavenly and earthly realms,

son, "Guglielmo II o Ruggero II? Un attribuzione errata," *Rivista italiana di numismatica e scienze affini* 91, 1989, 195ff.; Lucia Travaini, "Le prime monete argentee dei normanni in Sicilia: un ripostiglio di Kharrube e i modelli antichi delle monete normanne," *Numismatic Chronicle*, 92, 1990, 186; idem, "Aspects of the Sicilian Norman Copper Coinage in the Twelfth Century," *Numismatic Chronicle*, 151, 1991, 159ff., esp. 166ff. For a contemporary twelfth-century view of the palm, see John of Salisbury, *The Statesman's Book*, trans. L. Dickinson, New York, 1927, 89, who writes that the tree was a symbol of "unconquerable justice which knows not how to descend but only to rise to even higher things." For further discussion of the symbolism of the palm, see Penelope C. Mayo, "The Crusaders Under the Palm: Allegorical Plants and Cosmic Kingship in the *Liber Floridus*," *Dumbarton Oaks Papers* 27, 1973, 29ff. The metaphorical function of imagery on the ruler's robes in the twelfth century is explained by an anonymous ekphracist with regard to a garment

of Manuel I Komnenos decorated with winged griffins, which in his words "*hinted* that the emperor is high and elevated, and thundering, as it were, from heaven, he performs great and wonderful deeds"; see Henry Maguire, "The Heavenly Court," *Dumbarton Oaks Papers*, forthcoming.

[32] Otto von Falke, *Kunstgeschichte der Seidenweberei*, Berlin, 1913, vol. 1, 119ff.; Nancy Pence Britton, "Pre-Mameluke Tiraz in the Newberry Collection," *Ars Islamica* 9, 1942, 158ff.; R. B. Serjeant, "Material for a History of Islamic Textiles up to the Mongol Conquest," *Ars Islamica* 9, 1942, 54ff.; R. Pfister, "Toiles à inscriptions abbasides et fatimides," *Bulletin d'études orientales de l'Institut français de Damas* 11, 1945–46, 47ff.; Ernest Kühnel and L. Bellinger, *Catalogue of Dated Tiraz Fabrics: Umayyad, Abbasid, Fatimid*, Washington, D.C., 1952; Maurice Lombard, *Les Textiles dans le monde musulman du VIIe au XIIe siècle* (=*Etudes d'économie médiévale* III), New York, 1978, 53f.

the one directed upward and the other downward, and they seem to have been further characterized by the level of reality that they occupied in the mind of the viewer: distant, pictorial/present, real.

It is interesting to observe in Roger's architecture generally that the place of the Pantokrator is defined in precisely these terms, as a Byzantine space, with Byzantine mosaics and images, and these spaces were also pictorial in the sense that they were meant *not* to be entered, but simply to be viewed. The one exception, of course, was the king who always had a place in these otherwise otherworldly situations. Conversely, the spaces which were conceived of as belonging to this world, and which were the king's own—his palaces and villas such as the Torre Pisana, the Favara or Maredolce, the Uscibene or Menani, not to mention the constructions of Roger's successors in the Zisa, the Cuba and the Cubula—in which his courtiers also played a role, in which they met him and interacted with him, were Islamic in their appearance, with muqarnas vaults, Kufic inscriptions and step fountains.[33] The royal palace in Palermo, and in the Cappella Palatina, was one of the places where these two roles were seen most clearly in conjunction.

<div align="center">✢  ✢  ✢</div>

There are a number of parallels to the sanctuary program in the Byzantine sphere we have not had the opportunity to discuss, one of which is the decoration in the Church

---

[33] For the Torre Pisana, see above, chapter 1, nn. 12 and 58, chapter 2, n. 150; Valenti, "Palazzo Reale," 517ff.; Monneret de Villard, *Soffitto*, 20.

For the Favara, see Adolph Goldschmidt, "Die Favara des Könige Roger von Sizilien," *Jahrbuch der königlich preussischen Kunstsammlungen* 16, 1895, 199ff.; Vincenzo Di Giovanni, "Il castello e la chiesa della Favara di S. Filippo a Mare Dolce in Palermo," *Archivio Storico Siciliano*, n.s. 22, 1898, 301ff.; Adolph Goldschmidt, "Die normannischen Königspaläste in Palermo," *Zeitschrift für Bauwesen* 48, 1898, 553ff.; Silvana Braida Santamaura, "Il castello di Favara: Studi di restauro," *Architetti di Sicilia* 1, 1965, no. 5/6, 21ff.; Guido Di Stefano, *Monumenti della Sicilia normanna*, Palermo, 1979, 70ff; Hans-Rudolf Meier, *Die normannischen Königspaläste in Palermo: Studien zur hochmittelalterlichen Residenzbaukunst*, Worms, 1994, 54ff.

For the Menani or Scibene, see Goldschmidt, "Königspaläste," 563ff.; Silvana Braida Santamaura, "Il 'Sollazzo' dell'Uscibene," *Architetti di Sicilia* 1, 1965, no. 1, 31ff.; Di Stefano, *Monumenti*, 101ff; Meier, *Die normannischen Königspaläste*, 65ff.

For Altofonte, see Letitia Anastasi, *L'arte nel parco reale normanno di Palermo*, Palermo, 1935; Silvana Braida Santamaura, "Il palazzo ruggeriano di Altofonte," *Palladio* 23, 1973, 185ff; Meier, *Die normannischen Königspaläste*, 62ff.

For the Zisa, see above, Chapter 2, n. 49; Goldschmidt, "Königspaläste," 569ff.; G. Bellafiore, *La Zisa di Palermo*, Palermo, 1978; Di Stefano, *Monumenti*, 103ff.; Giuseppe Caronia, *La Zisa di Palermo: Storia e restauro*, Rome, 1982; Ursula Staacke, *Un palazzo normanno a Palermo: La Zisa. La cultura musulmana negli edifici dei Re*, Palermo, 1991; Meier, *Die normannischen Königspaläste*, 68ff.

For the Cuba and Cuba Soprana, see Goldschmidt, "Königspaläste," 579ff.; Pietro Lojacono, "L'organismo costruttivo della Cuba alla luce degli ultimi scavi," *Palladio*, n.s. 3, 5/6, 1953, 1ff.; Di Stefano, *Monumenti*, 108ff.; Giuseppe Bellafiore, *La cuba di Palermo*, Palermo, 1984; Giuseppe Caronia and V. Noto, *La cuba di Palermo (arabi e normanni nel XII secolo)*, Palermo, 1988; Meier, *Die normannischen Königspaläste*, 79ff.

For the Cubula, see Di Stefano, *Monumenti*, 110f.; Meier, *Die normannischen Königspaläste*, 87ff.

See also Wolfgang Krönig, "Il complesso di Caronia nel quadro dell'architettura siculo-normanna," *Römische Forschungen der Bibliotheca Hertziana* 22, 1977, 99ff.

Historians have often spoken of King Roger's tolerance with regard to race and culture, and it is important to bear in mind the larger context in which these building were constructed; see Michele Amari, *Storia dei musulmani di Sicilia*, 3 vols., Catania, 1933–39, 3:351ff., esp. 3:448ff.; Antonio de Stefano, *La cultura in Sicilia nel periodo normanno*, Palermo, 1938, 9ff.; R. Herval, "Ecléctisme intellectuel à la cour de Roger II de Sicile," *Atti del convegno*

of the Holy Cross at Aght'amar.[34] The church was the project of Gagik Arcuni, the Armenian king of Vaspurakan in the early tenth century (d. 936), who commissioned an extraordinary set of sculpted reliefs to ornament its exterior. The interior of the church was decorated as well with wall paintings, and although the question has been raised as to whether these belonged to the same phase of activity, the precise chronology is not a pressing concern here. Suffice to say that the relevant portion of the decoration forms a unified whole. It consists of a series of scenes from the life of Christ, over two dozen in fact, making a rather lengthy cycle, treating Christ's life from beginning to end, which is the first point of resemblance that it bears to the decoration of the sanctuary of the chapel. The church once had a royal balcony or viewing platform in the south cross arm of the nave, across from which, on the north wall of the north cross arm, was located the scene of the Transfiguration of Christ, which is similar to the situation in the chapel as well (fig. 149). But the Cappella Palatina also differs from the Armenian arrangement in two important respects. First, the scene of the Transfiguration is not positioned on the same level as the royal box, as it probably was in the Cappella Palatina, but above it, so that the figure of Christ in the center of the scene would not have been on level with the figure of the ruler on the balcony, but above him. And second, the christological scenes, though they cover a substantial part of three of the cross arms of the church, do not adjoin the royal balcony. In the Cappella Palatina, however, they seem to have done so very closely indeed.

It is important to recall that the king's balcony in the chapel, though demonstrated beyond any reasonable doubt by archeology and documents, no longer exists, nor does the original surface of the wall that must have immediately surrounded it.[35] This surface is covered with modern mosaics showing John the Baptist preaching and a landscape (fig. 14).[36] But how would it have been decorated in the twelfth century? The most plausible explanation is Kitzinger's. Kitzinger observed that the sanctuary

*internazionale di studi ruggeriani (21–25 aprile 1954)*, Palermo, 1955, vol. 1, 73ff.; Gianvito Resta, "La cultura siciliana dell'età normanna," *Atti del congresso internazionale di studi sulla Sicilia normanna (Palermo 4–8 dicembre 1972)*, Palermo, 1973, 263ff.; Umberto Rizzitano, *Storia e cultura nella Sicilia saracena*, Palermo, 1975, 267ff.; Giuseppe Galasso, "Social and Political Developments in the Eleventh and Twelfth Centuries," *The Normans in Sicily and Southern Italy*, Oxford, 1977, 47f.; *Palerme 1070–1492. Mosaïque de peuples, nation rebelle: la naissance violente de l'identité sicilienne*, ed. Henri Bresc and Geneviève Bresc-Bautier, Paris, 1993, 33ff. According to Ibn al-Atir, King Roger preferred the conversation of learned Muslims to that of Christian monks; Michele Amari, *Biblioteca arabo-sicula*, Ital. ed., 2 vols., Turin and Rome, 1880–89, 1:118.

[34] Sirarpie der Nersessian, *Aght'Amar: Church of the Holy Cross*, Cambridge, Mass., 1965, 7ff., figs. 63ff.; idem and Hermann Vahramian, *Aght'Amar*,

Venice, 1974, figs. 55 and 56 with general views of the interior; J. G. Davies, *Medieval Armenian Art and Architecture: The Church of the Holy Cross Aght'Amar*, London, 1991, 154ff., fig. 14 (diagram of narrative scenes). The twelfth-century Episcopal Chapel at Schwarzrheindorf has also been compared to the Cappella Palatina in this regard; see Albert Verbeek, *Die Doppelkirche und ihre Wandgemälde*, Düsseldorf, 1953, xxxxv, lxv, fig. 38; Wolfgang Krönig, "Zur Transfiguration der Cappella Palatina in Palermo," *Zeitschrift für Kunstgeschichte* 19, 1956, 162ff., fig. 4; Anne Derbes, "The Frescoes of Schwarzrheindorf, Arnold of Wied and the Second Crusade," *The Second Crusade and the Cistercians*, ed. Michael Gervers, New York, 1992, 141ff.

[35] See above, chapter 1, pp. 20ff.

[36] Demus, *Norman Mosaics*, 36; Ernst Kitzinger, "The Mosaics of the Cappella Palatina in Palermo: An Essay on the Choice and Arrangement of Subjects," *Art Bulletin* 31, 1949, 276 n. 38.

program, like that of the classical Middle Byzantine system as a whole, possessed a true christological cycle, that is complete, with a beginning, a middle and an end, and with all of the major events—or feasts—of Christ's life depicted, save two: the Crucifixion and the Anastasis, the feast scenes for Good Friday and Easter Sunday respectively.[37] Especially in twelfth-century Byzantium or the Byzantine-influenced world, such a cycle is unthinkable without these important subjects.[38] That there was space enough for the two scenes on the two pieces of wall flanking the balcony we know almost as a fact. The same text that mentions the balcony also records its width—that is, 11 palmi or 2.46 m ("largo 11 palmi alto 10")—which would have left ample space vacant on either side of the structure for the two scenes (see fig. 15).[39] Placing them there—which would seem to be the only viable solution to the problem of the original decoration of the sanctuary—however, does more than simply complete the cycle: it creates a pairing around the balcony of the king which had a distinct resonance in the Byzantine tradition.

One finds such a pairing, for instance, in the narthex of Hosios Lukas. There, scenes of the Crucifixion and the Anastasis are significantly singled out for placement in the two large lunettes over the side doors leading into the nave (fig. 150).[40] These scenes flank a figure of the Pantokrator, who holds an open book proclaiming the Gospel of John, chapter 8, verse 12: "I am the light of the world. He that follows me will not walk in darkness but will have the light of life." Similarly, in the monastery church of Daphni, the Crucifixion and the Anastasis are also pendants, on the eastern faces of the north and south cross arms of the nave, although in this case what they flank may be construed in two terms: as the Pantokrator in the central dome on the one hand, or as the altar below, which is another kind of image of Christ, being tomb and table where he is materially present, on the other.[41] Kartsonis, who has studied these pairings, has concluded that they were intensely meaningful. She has called them an "incantation for salvation," that is, an "expression of . . . a sacramental, liturgical, theological and historical *synopsis* of Christ and his church as the means and ends of redemption."[42] It should also be mentioned that although both of these examples predate the Cappella Palatina, there are later cases, and the practice that they indicate seems to have been more widely known.[43]

[37] Kitzinger, "Cappella Palatina," 275f.

[38] See the discussion of Ernst Kitzinger, "Reflections on the Feast Cycle in Byzantine Art," *Cahiers archéologiques* 36, 1988, 51ff., and esp. 53 n. 27 concerning the Cappella Palatina.

[39] Pasca, *Descrizione*, 29ff., 100. Pasca, of course, is describing what he took (and what I believe) to have been the original opening to the balcony, and not the balcony itself, which could have been wider. One possible constraint on the width of the structure, however, may have been the two windows, now walled up, in the north wall, regarding which, see above, chapter 1, n. 59.

[40] Ernst Diez and Otto Demus, *Byzantine Mosaics of Greece*, Cambridge, Mass., 1931, 67ff., 119 (plan of church), fig. 12 (Pantokrator), pl. XIII (Crucifixion), pl. XIV (Anastasis); Anna D. Kartsonis, *Anastasis: The Making of an Image*, Princeton, 1986, 217f., figs. 83 (Anastasis) and 84 (plan of church).

[41] Diez and Demus, *Byzantine Mosaics*, 67ff., 121 (plan of church), frontispiece (Pantokrator in dome), fig. 99 (Crucifixion), fig. 100 (Anastasis); Kartsonis, *Anastasis*, 219ff., figs. 85 (Anastasis) and 86 (plan).

[42] Kartsonis, *Anastasis*, 219 and 221.

[43] See, for instance, the decoration in the Church of Christos in Veroia by Kalliergis (1315): Stylianos Pelekanides, Καλλιέργης. Ὅλης Θετταλίας ἄριστος ζωγράφος, Athens, 1973, 14, pls. 5, 8f.; Kartsonis, *Anastasis*, 220f., figs. 87 (Anastasis) and 88 (layout). In this context it is also interesting to observe that the twelfth-century Typikon for the Pantokrator Monastery in Constantinople specifies that lights be

These cases appear to have certain elements in common, which, in the present context, may be counted as three. First, the two scenes, although clearly paired, also form a critical part of the christological cycle as a whole, they are not independent units. Second, although the scenes flank fields in several different formats—a lunette, a dome, and an altar—all of these fields may be understood in terms of an image of the Lord. And third, these scenes are also situated in relationship to an opening, a door, which may be construed as a passage *into* the ruler's realm, either from the narthex into the nave of the church, or from the nave into the bema. In a certain sense, therefore, the pair of scenes, together with their centerpiece, may be thought of as a building block—individual and coherent, albeit one of many of which the classical Middle Byzantine system of church decoration was composed; but one too that was capable of inflection, by siting and form, that lent it a great deal of flexibility, and expanded opportunities for its use. All of these conditions may also be fulfilled in the Cappella Palatina: if present, the scenes of the Crucifixion and the Anastasis would clearly have formed part of the christological cycle, which was constructed around the chapel in essentially the same zone; they would also have clearly flanked an opening, the king's balcony, which was also nothing less than the passage into the ruler's space.[44] The question is, could the designer of the sanctuary program have intentionally varied the composition, to embrace, instead of the image of the Byzantine Pantokrator, the real presence of the Norman king? To the best of my knowledge, such a variation involving the emperor had never been attempted in the monumental arts of Byzantium, and to imagine it here, in the Cappella Palatina would be to posit a bold move.[45]

Such a move may find an analogy, and a rationale, in the famous image of King Roger to which we may now return: the mosaic panel made for the church of St. Mary's of the Admiral in Palermo. As we have already seen, the Norman mosaic must have copied a Byzantine image of the emperor down to the details of Roger's garb, which are taken directly from the emperor's costume (figs. 145 and 146). But in this relationship the Norman image also seems to embody a kind of paradox, in the following sense. Although close to the Byzantine visual prototype, the Norman mosaic also differs from it, markedly, in one important respect, namely, in the degree to which

placed in front of the scenes of the Crucifixion and Anastasis (among a limited number of other scenes); see Paul Gautier, "Le Typikon du Christ Sauveur Pantocrator," *Revue des Etudes Byzantines* 32, 1974, 37.

[44] Regarding the rebuilding of the wall immediately behind the north transept, see above, chapter 2, pp. 50ff.; Francesco Valenti, "L'arte nell'era normanna," in *Il Regno normanno*, Messina/Milan, 1932, 220; Trizzino, "*La Palatina*", passim, esp. 21ff.

[45] Carmen Laura Dumitrescu points out what may in fact be a related phenomenon: the distinct echo, in the portrait of the Emperor Michael VII Doukas in Coislin 79, fol. 2, of the composition of the Deesis, in which the emperor himself appears

as the center of a group of three (between the St. John Chrysostom [left] and the Archangel Michael "Chonaiates" [right]), as if he had been substituted for and in turn was meant to evoke in the memory of the viewer the figure of Christ; Dumitrescu, "Remarques en marge du Coislin 79: Les trois eunuques et le problème du donateur," *Byzantion* 57, 1987, 32ff., esp. 40f., fig. 4. I would like to thank Henry Maguire for this reference. See also the portrait of the Emperor Basil I in the Homelies of Gregory of Nazianzus (Paris B.N. gr. 510), in which the emperor appears in between the prophet Elijah [left] and the Archangel Gabriel [right]; Iohannis Spatharakis, *The Portrait in Byzantine Illuminated Manuscripts*, Leiden, 1979, 96ff., fig. 62.

the face of the king has been assimilated to that of Christ. As has been pointed out, Roger, with his long hair and beard and idealized features, looks very much like Christ—something the Byzantines seem never to have attempted.[46] When the emperor was depicted in the presence of the Pantokrator in Byzantium, there was always a physiognomic distinction between the two, as witness Constantine VII or any of the relevant images from the twelfth century.[47] On the other hand, Byzantine rhetoric, especially as it developed in the twelfth century, came increasingly to stress this important similarity.[48] Suffice to quote a short passage from an encomium of Manuel I (1143–80) by Michael Italikos, composed sometime after August or November 1143, in which the emperor is compared to his father, John, and God:

> You dwell here below as a living and moving statue of the king who made you king, O Emperor, and I don't know of anyone else on earth more like him. For bearing his name is an indication of your strong resemblance to him. For think: Emanuel is the theological name from above; Manuel is the name acclaimed here below. . . . If God is expressed in both names, he is the first and heavenly God, while you are the second and earthly one.[49]

The paradox is that the Norman image expresses the extremity of the christomimetic theme especially as it developed in Byzantium in the twelfth century *better* than any work of art that we know from Byzantium, and the question is why?

A critical consideration may be in the function of these words—as in the passage just quoted. Clearly they did not set out simply to repeat what the images around them must have already shown.[50] They provided an alternate set of information that complemented, elaborated or focused on selected aspects of these images, and this must have been the heart of the relationship between images and words in the Byzantine court. Images and words existed symbiotically. They explained one another, without merely repeating the explanation. They amplified and elaborated one another, thus conspiring to fill the most important sensory dimensions through which a Byzantine courtier could construct a world-view. In the context of the Byzantine court of

---

[46] Kitzinger, "On the Portrait of Roger II," 30ff.

[47] See, for example, the portrait of Alexios I in the *Panoplia Dogmatica* of Euthymius Zygabenus, Vat. gr. 666 (early twelfth century); Spatharakis, *The Portrait*, 122ff., fig. 80. Robin Cormack's argument, apropos of the mosaic of Christ with Constantine IX Monomachos and Zoe in the south gallery of Hagia Sophia, that the head of Christ was changed when the head of the emperor was changed, because the head of Christ was originally made to resemble the first emperor represented in the mosaic (Zoe's first husband Romanos III) is unconvincing; see Cormack, "Interpreting the Mosaics of S. Sophia at Istanbul," *Art History* 4, 1981, 131ff., esp. 141f., fig. 6.

[48] Paul Magdalino, *The Empire of Manuel I Komnenos, 1143–1180*, Cambridge, 1993, 413ff., and his earlier study with Robert Nelson, "The Emperor in Byzantine Art of the Twelfth Century," *Byzan-*

*tinische Forschungen* 8, 1982, 123ff. See also Alexander Kazhdan and Simon Franklin, *Studies on Byzantine Literature of the Eleventh and Twelfth Centuries*, Cambridge, 1984, 110f.

[49] Michael Italikos, in Paul Gautier, ed., *Michel Italikos, lettres et discours* (=*Archives de l'orient chrétien* 14), Paris, 1972, 294; Paul Magdalino, trans., *The Empire of Manuel I Komnenos*, 437. See also Kazhdan and Franklin, *Studies on Byzantine Literature*, 111, and the discussion of Henry Maguire, "Style and Ideology in Byzantine Imperial Art," *Gesta* 28, 1989, 229, in which the phrase "audacity of the comparison," is employed to characterize a passage from a poem of Theodore Prodromos on the Emperor John II and Christ. Paul Magdalino, "The Phenomenon of Manuel I Komnenos," *Byzantinische Forschungen* 13, 1988, 178f., esp. n. 24.

[50] See the discussion of Henry Maguire, *Art and Eloquence in Byzantium*, Princeton, 1981, with bibli-

the twelfth century, with its dramatic revival of the rhetorical arts, this relationship reached a new peak.[51]

Such a tradition, however, did not pass to Sicily. The Italo-Greek homiliary, with its sermons scattered somewhat enigmatically throughout the liturgical year and only very rarely attested by its author, Philagathos, as having been recited in the presence of the king, is no substitute for the works of Michael Italikos, Theodore Prodromos, and the "Manganeios Prodromos" as he has been differentiated by Magdalino.[52] But such a project could hardly have succeeded in any case. With its multiple languages, and insistence on maintaining these differences, the Norman court could hardly have sought to follow a single path in the rhetorical arts.[53] What the Normans had to create was an image that could stand on its own, that was not embedded in or dependent on a single rhetorical tradition for explanation, that did not need or benefit excessively from verbal commentary—that was, in a word, visually self-sufficient. This, I would argue, is what they created in their portrait of Christ and the King: an image that explained the derivation of Roger's power (not from pope or emperor, but from God alone) and at the same time, demonstrated the fact of his "similitudo" (his essential christomimetic nature) *in purely visual terms*. Such an image could thus be understood by anyone, Arab, Norman, Greek or Latin.[54]

Returning now to the sanctuary of the Cappella Palatina, I would argue that a similar point was being made here also: that the Norman king was intended to have a place in this Byzantine-derived triadic scheme, as the divinely appointed ruler on earth, whose nature was essentially christomimetic. This interpretation is supported by two other features of the chapel's east end. The first is the balcony itself. This structure defined the place of the king in God's realm, the sanctuary, as above that of other mortal men. But perhaps more important in this most hierarchical scheme, it placed the king on the level with and integrated into Christ's life, which he, in an important sense, completed. In the downward and outward progression from the

ography; Liz James and Ruth Webb, " 'To Understand Ultimate Things and Enter Secret Places': Ekphrasis and Art in Byzantium," *Art History* 14, 1991, 1ff.

[51] Magdalino, *Manuel I*, 413ff.

[52] For the sermons of Philagathos, see *PG*, 132; Filagato de Cerami, *Omelie per i vangeli domenicali e le feste di tutto l'anno*, ed. Giuseppe Rossi Taibbi, Palermo, 1969. In addition, Stefano Caruso, "Le tre omelie inedite 'Per la Domenica delle Palme' di Filagato da Cerami (LI, LII, LIII Rossi-Taibbi)," *Epeteris Heteiraias Byzantinon Spoudon* 41, 1974, 109ff.; Bruno Lavagnini, "Filippo-Filagato promotore degli studi di greco in Calabria," *Bollettino della Badia greca di Grottaferrata*, n.s., 28, 1974, 3ff.; idem, *Profilo di Filagato da Cerami con traduzione della Omelia XXVII pronunziata dal pulpito della Cappella Palatina in Palermo*, Palermo, 1992.

[53] A case in point is the inscription in three languages that formed part of a water clock erected by Roger II in the Norman Palace; see Michele Amari, *Le epigrafi arabiche in Sicilia trascritte, tradotte e illustrate*, ed. Francesco Gabrieli, Palermo, 1971, 29ff., pl. I, fig. 3. Of interest in this context is also the quadrilingual epitaph (Greek, Latin, Arabic and Hebrew) of Anna, mother of the priest Crisandus (Grisandus); Amari, *Le epigrafi arabiche*, 201ff., pl. IX, fig. 2. On the relationship of ethnic groups, linguistic and otherwise, see Von Falkenhausen, "I gruppi etnici," 133ff.; also Vincenzo Di Giovanni, "Divisione etnografica della popolazione di Palermo nei secoli XI, XII, XIII," *Archivio Storico Siciliano* n.s. 13, 1888, 1ff.; De Stefano, *La cultura in Sicilia*; Galasso, "Social and Political Developments," 47ff.

[54] It is interesting to observe that the church of St. Mary's was not off-limits to non-Christians, who could apparently visit it freely; see *The Travels of Ibn Jubayr*, trans. R.J.C. Broadhurst, London, 1952, 349, concerning the author's Christmas visit to the church.

image of the Pantokrator in the sanctuary of the Cappella Palatina, the king took up his place in the stratum of Christ's life, where another portrait of the Pantokrator might have been expected to have been placed.[55]

The other point concerns the south wall. It has been noted that on his balcony the king must have stood directly across from the scene of the Transfiguration, although I believe that this relationship has been understood primarily in terms of the king's view: that he was here meant to be the direct witness of the glorification of Christ (fig. 151).[56] But the configuration changes if we imagine that the relationship was also appreciated from a different point of view—that of those standing below, in choir, nave, or aisles, who would have understand the two images, the king and Christ, as pendants, parallel glories of divine and divinely appointed rulers, and in them, the necessary balance of the composition. The two angels facing the nave on the spandrels of the triumphal arch, which belong to the Rogerian program, lack a subject on the arch itself to whom they so clearly bend in homage (fig. 67). Nor is this subject evident in the decoration of the eastern wall of the chapel, especially as it has been reconstructed in its first phase. In fact, it could only be imagined as the figure of the Pantokrator in the dome, who was here presented not in isolation, but in relationship to King Roger, toward whom the angels too would seem to bow.

<center>✛   ✛   ✛</center>

It is interesting to observe that the ruler's balcony at Aght'Amar was located on the south side of the church. In this respect it seems to have followed a Byzantine custom as embodied, for instance, at Hagia Sophia, where the emperor's loge (metatorion) from which he witnessed the liturgy was also located to the south, in the southeast exedra of the church.[57] The situation in the Cappella Palatina was decidedly different. There the celebration of the liturgy was intended to be viewed by the king from the opposite side, from a balcony on the north wall of the northern transept arm of the chapel; in this respect the palatine scheme seems to have followed a specifically Norman practice. In the three other cases from Norman Sicily where the king's place was given an architectural definition in an ecclesiastical context—in the Cathedrals of Cefalù, Monreale and Palermo—this place is to be found the north side of the

[55] The fact that the image of the Pantokrator was present in the chapel in the dome of the choir and thus manifest "above" the king should also be stressed. Two other images of the Pantokrator occur in the eastern portion of the chapel: one is located in the lunette at the top of the eastern wall above the southern apse (see Kitzinger, *I mosaici*, fasc. 1, fig. 253); the other is located in the vault of the main apse (see Kitzinger, *I mosaici*, fasc. 1, fig. 130).

[56] Krönig, "Zur Transfiguration," 162ff.; Ćurčić, "Some Palatine Aspects," 127ff.

[57] George P. Majeska, *Russian Travellers to Constantinople in the Fourteenth and Fifteenth Centuries*, Washington, D.C., 1984, 228, 432f., correcting the inter-

pretation of Thomas Mathews, *The Early Churches of Constantinople, Architecture and Liturgy*, University Park, Penna., 1971, 96, 132 and 134. The ruler also sat south of the altar in the Sainte-Chapelle in Paris; see the fifteenth-century miniature with the representation of Philip the Good in L.M.J. Delaissé, *Mittelalterliche Miniaturen*, Cologne, 1959, 172ff., no. 40. The situation seems to have been different in other churches, as for example Sts. Sergius and Bacchus and the Blachernae, which the emeperor visited on certain feasts; see *De cer.*, 1: 79f.; Jean Ebersolt, *Le grand palais de Constantinople et le livre de cérémonies*, Paris, 1910, 49, 101 n. 1.; idem, *Sanctuaires de Byzance*, Paris, 1921, 44ff.; idem, *Sainte-Sophie de Constantinople*, Paris, 1910, 25 n. 7.

church.[58] Now such practices may have been purely circumstantial in origin and reflexively habitual, but in the context of Norman Sicily a plausible case has been made: that the Normans located the place of the king characteristically to the north because the north was the right hand of the Pantokrator (imagined, that is, as a figure facing forward from the apse or dome), and it was the king who stood at God's right hand.[59] A motto from Ps. 117: 16, "Dextera domini fecit virtutem, dextera domini exaltavit me, dextera Domini fecit virtutem," in fact, frequently appears on King Roger's diplomas and coins.[60] But such an interpretation would also have made more meaningful the overall arrangement of the Norman palace.

The Cappella Palatina was not only the receptacle of the king's balcony for purposes of viewing the liturgy, it was also the site of the platform where he stood to receive his courtiers—in other words, it functioned not only in terms of itself, internally as a church, but also externally, in terms of its palatine context. The basic form of this palace, it should also be recalled, was an oval with sections developed to the north and south of the Cappella Palatina in an arrangement that must have resembled, if only distantly, the present plan (fig. 5). And it should be recalled, finally, that there were three aspects of the chapel that proved unusual when viewed in this context, all of which may now have some clarification.

By raising the chapel up on a lower story, by placing it in the center of the complex, and by providing it with a public entrance to the south as a pendant to the king's access from the north, the intention must have been to express its enhanced role: as the nexus of the heavenly and earthly rulers, the realms of the Panto-krator (inscription at the top of the dome) and the Skeptro-krator (inscription at the base of the dome), and the graphic demonstration of the relationship between them.[61] That these themes would have been encapsulated in the edifice that formed the heart of the ruler's residence, which in turn was at the very center of the kingdom, only underscores the clarity of the conception. And so too, by contrast, may the later changes to the chapel: one might well wonder whether it was not the shift to Christian imagery in the nave (and concommitant displacement of function?) that gave rise to a need for a new reception hall in the palace in the Norman Stanza, which was decorated under William I. In the end, it is the clarity of the Rogerian order in the Cappella Palatina, both

[58] For Cefalù Cathedral, see Mark J. Johnson, "The Episcopal and Royal Views at Cefalù," *Gesta* 33, 1994, 118ff. Francesco Gandolfo, "Le tombe e gli arredi liturgici medioevali," *La cattedrale di Palermo: Studi per l'ottavo centenario dalla fondazione*, ed. Leonardo Urbani, Palermo, 1993, 238 and n. 22 (with bibliography), figs. 34 and 35, argues that the two thrones in Cefalù were post-Norman inventions, but this could not have been the case. They have twelfth-century foundations, even if, as Gandolfo points out, they were otherwise much changed in post-medieval times. For the Cathedral of Monreale, see Wolfgang Krönig, *Il Duomo di Monreale e l'architettura normanna in Sicilia*, Palermo, 1965, 47f.; Gandolfo, "Le tombe," 238ff., fig. 33. For the Cathedral of Palermo, see Giuseppe Bel-

lafiore, *La cattedrale di Palermo*, Palermo, 1976, 239ff., fig. 168, pl. XIX, with a discussion of the restorations of the throne, and Gandolfo, "Le tombe," 246ff., fig. 42.

[59] Eve Borsook, *Messages in Mosaic: The Royal Programmes of Norman Sicily 1130–1187*, Oxford, 1990, 11, but requiring correction on her chronology; see below, n. 60.

[60] Karl Andreas Kehr, *Die Urkunden der normannisch-sizilischen Könige*, Innsbruck, 1902, 171f.; Deér, *Porphyry Tombs*, 157; *I documenti originali dei re normanni di Sicilia*, ed. Antonino de Stefano and Franco Bartolini, Rome/Palermo, 1954, fasc.1, 1 (1132), n. 25 (1134), 5 (1156).

[61] For the two inscriptions, see Kitzinger, *I mosaici*, fasc. 1, 11 and 25.

inside and out, that seems such a striking stylistic characteristic. Roger's choice of roles for himself was not unique—relating upward to the divinity and downward to his people were the alternatives that confronted any medieval ruler—but his choice of styles to define these roles was. It cannot be attested anywhere else, and it must have reflected a conception of kingship that was his alone, having arisen from his own creative response to the problem of forging a kingdom in a Greek, Arabic and Latin land, Sicily, where none had existed before.[62]

Given the history of medieval Sicily, it would seem logical to expect to find an artistic tradition in both a Byzantine and an Islamic mode that would help to explain the extraordinary efflorescence of these arts under Roger. But the fact is that none exists. We can only assume that both craftsmen and designs were sought out from the indigenous cultures in which they were produced and imported into Sicily by the king for the express purpose of creating something new, which was nothing less than the visual culture of his kingdom, which itself was something new. One wonders, in the end, how Roger's expenditures in this regard (building and decoration) compared to those of other rulers—the Byzantine or the Fatimid, for instance.[63] It is difficult to gauge. But one suspects that these expenditures represented a truly extraordinary effort, and that Roger's interests more than usually ran to the visual, to which it is important now to return. In the *Regnum* of Sicily in which many languages were yoked in various degrees of mediation, only one primary medium, the visual, provided a single basis for all to understand. It must have been the singular genius of the first of the Sicilian kings to have recognized this fact, and to have exploited it, both in imagery and in style, for the purposes of forging his kingdom. But it might also be said that it was the singular urgency of the visual in mid-twelfth century Sicily that gave the art produced there its extraordinary clarity of program-in-form.

As a coda to this interpretation, let me simply evoke the Cathedral of Monreale, the great project of Roger's grandson, William II, with its Byzantine, Western and Islamic motifs, now distilled, refined and blended so that they cannot be separated, to stand as a image of how much Sicilian art—and by implication the conditions in which it was produced—had changed since the time of Roger's death in mid-century, with the completion of the of the first phase of the Cappella Palatina (fig. 152).[64]

[62] One is reminded of as-Safadi's report of the scientific interests of Roger II as quoted in Amari, *Biblioteca Arabo-Sicula*, 2:290.

[63] Art patronage in the Middle Ages has yet to be the subject of an economic study; however see the incisive remarks of Richard Goldthwaite, *Wealth and the Demand for Art in Italy 1300–1600*, Baltimore, 1993, esp. 150ff. A survey of the Norman economy is provided by David Abulafia, "The Crown and the Economy under Roger II and His Successors," *Dumbarton Oaks Papers* 37, 1983, 1ff.

[64] See Krönig, *Il Duomo di Monreale*, for a discussion of the architecture; for the sculpture, see Roberto Salvini, *Il chiostro di Monreale e la scultura romanica in Sicilia*, Palermo, 1962. A more recent survey is provided by Wolfgang Krönig et al., eds., *L'anno di Guglielmo 1189–1989: Monreale, percorsi tra arte e cultura*, Palermo, 1989.

# Selected Bibliography

Abulafia, David. "The Crown and the Economy under Roger II and His Successors," *Dumbarton Oaks Papers* 37, 1983, 1–14.

Aceto, Francesco. "I pulpiti di Salerno e la scultura romanica della costiera di Amalfi," *Napoli Nobilissima* 18, 1979, 169–94.

Acocella, Nicola. *La decorazione pittorico di Montecassino dalle didascalie di Alfano I (sec. XI).* Salerno, 1966.

Adriani, Götz. *Der mittelalterliche Predigort und seine Ausgestaltung.* Stuttgart, 1966.

Alexander of Telese. *De Rebus Gestis Rogerii Siciliae Regis Libri IV*, ed. Giuseppe del Re, *Cronisti e scrittori sincroni napolitani editi e inediti*, vol. 1, *Normanni*, Aalen, 1975 (repr. of Naples, 1845).

Al Samman, F. "Arabische Inschriften auf den Krönungsgewändern des Heiligen Römischen Reiches," *Jahrbuch der kunsthistorischen Sammlungen in Wien* 78, 1982, 7–34.

Amari, Michele. *Biblioteca arabo-sicula.* Leipzig, 1857 (ital. trans. 3 vols. Turin/Rome, 1880–89).

_____. *Le epigrafi arabiche in Sicilia trascritte, tradotte e illustrate*, ed. Francesco Gabrieli. Palermo, 1971.

_____. *Storia dei musulmani di Sicilia.* 3 vols. Catania, 1933–39.

Amato, G. M. *De principe templo panormitano.* Palermo, 1728.

Anastasi, Letizia. *L'arte nel parco reale normanno di Palermo.* Palermo, 1935.

Atil, Esin. *Freer Gallery of Art Fiftieth Anniversary Exhibition III: Ceramics from the World of Islam.* Washington, D.C., 1973.

Baer, Eva. *Ayyubid Metalwork with Christian Images.* Leiden, 1989.

_____. *Metalwork in Medieval Islamic Art.* Albany, 1983.

Bak, J. M. "Medieval Symbology of the State: Percy E. Schramm's Contribution," *Viator* 4, 1973, 33–63.

Bassan, Enrico. "Il candelabro di S. Paolo fuori le mura: note sulla scultura a Roma tra XII e XIII secolo," *Storia dell'arte* 45, 1982, 117–31.

Beck, Ingamaj. "The First Mosaics of the Cappella Palatina in Palermo," *Byzantion* 40, 1970, 119–64.

Bellafiore, Giuseppe. *Architettura in Sicilia nelle età islamica e normanna (827–1194).* Palermo, 1990.

_____. *La cattedrale di Palermo.* Palermo, 1976.

_____. "Edifici dell'età islamica e normanna presso le cattedrale di Palermo," *Bollettino d'arte* 52, 1967, 178–95.

_____. *La Zisa di Palermo.* Palermo, 1978.

Benjamin ben Jonah, of Tudela. *The Itinerary of Benjamin of Tudela*, intro. Michael A. Signer, Marcus Nathan Adler, and A. Asher. Malibu, Calif., 1983.

Benson, Robert L., and Giles Constable, eds. *Renaissance and Renewal in the Twelfth Century.* Cambridge, Mass., 1982.

Bertaux, Emile. *L'art dans l'Italie méridionale.* Paris, 1903.

_____. "L'Émail de saint Nicolas de Bari," *Fondation Eugène Piot: Monuments et mémoires* 6, 1889, 61–99.

Bertelli, Carlo, ed. *La Pittura in Italia: L'alto-medioevo.* Milan, 1994.

Bloch, Herbert. *Monte Cassino in the Middle Ages.* 3 vols. Cambridge, Mass., 1986.

Bloom, Jonathan M. "The Introduction of the Muqarnas into Egypt," *Muqarnas* 5, 1988, 21–28.

_____. "The Origins of Fatimid Art," *Muqarnas* 3, 1985, 20–38.

Boglino, Luigi. *Storia della Real Cappella di S. Pietro della Reggia di Palermo.* Palermo, 1894.

Borenius, Tancred. "The Cycle of Images in the Palaces and Castles of Henry III," *Journal of the Warburg and Courtauld Institutes* 6, 1943, 40–50.

Borg, A. "The Development of Chevron Ornament," *Journal of the British Archaeological Association* 120, 1967, 122–40.

Bornstein, Christine Verzar, and Priscilla P. Soucek. *The Meeting of Two Worlds: The Crusades and the Mediterranean Context.* Ann Arbor, Mich., 1981.

Borsook, Eve. *Messages in Mosaic: The Royal*

*Programmes of Norman Sicily 1130–1187.* Oxford, 1990.

————. "Messaggi in mosaico nella Cappella Palatina di Palermo," *Arte medievale*, ser. 2, 5, 1991, 31–47.

Brandileone, Francesco. *Il diritto romano nelle leggi normanne e sveve del Regno di Sicilia.* Rome/Turin/Florence, 1884.

Braun, J. *Die liturgische Gewandung.* Freiburg, 1907.

Brenk, Beat. "Il concetto progettuale degli edifici reali in epoca normanna in Sicilia," *Quaderni dell'Accademia delle Arti del Disegno* 2, 1990, 5–21.

————. "La parete occidentale della Cappella Palatina a Palermo," *Art medievale*, ser. 2, 4, 1990, 135–50.

————. "Zur Bedetung des Mosaiks an der Westwand der Cappella Palatina in Palermo." *Studien zur byzantinischen Kunstgeschichte. Festschrift für Horst Hallensleben zum 65. Geburtstag,* ed. Birgitt Borkopp, Barbara Schellewald, and Lioba Theis, Amsterdam, 1995, 185–94.

Bresc, Henri, and Geneviève Bresc-Bautier, eds. *Palerme 1070–1492. Mosaïque de peuples, nation rebelle: la naissance violente de l'identité sicilienne.* Paris, 1993.

Brett, Gerard. "The Automata in the Byzantine 'Throne of Solomon'," *Speculum* 29, 1954, 477–87.

Britton, Nancy Pence. "Pre-Mameluke Tiraz in the Newberry Collection," *Ars Islamica* 9, 1942, 158–66.

Brühl, Carlrichard. "Frankischer Krönungsbrauch und das Problem der Festkrönung," *Historisches Zeitschrift* 194, 1962, 205–326.

————. "Remarques sur les notions de 'capitale' et de 'résidence' pendant le haut moyen age," *Journal des Savants*, Oct.–Dec. 1967, 193–215.

————. *Rogerii II: Regis diplomata Latina* (=*Codex diplomaticus Regni Siciliae,* ser. 1, 2/1, ed. C. Brühl), Cologne/Vienna, 1987.

————. *Urkunden und Kanzlei König Rogers II. von Sizilien* (=*Studien zur normannisch-staufischen Herrscherurkunden Siziliens* 2). Cologne-Vienna, 1978.

Buchthal, Hugo. "The Beginnings of Manuscript Illumination in Norman Sicily," *Papers of the British School in Rome* 24, 1956, 78–85.

Bury, J. B. "The Ceremonial Book of Constantine Porphyrogennetos," *English Historical Review* 22, 1907, 209–27.

Buscemi, Nicola. *Notizie della Basilica di San Pietro detta la Cappella Regia.* Palermo, 1840.

Cadei, Antonio. "*Exegi monumentum aere perennius:* Porte bronzee di età normanna in Italia meridionale e Sicilia," *Unità politica e differenze regionale nel regno di Sicilia: Atti del convegno internazionale di studio in occasione dell'VII centenario della morte di Guglielmo II, re di Sicilia (Lecce-Potenza, 19–22 aprile 1989),* ed. Cosimo Damiano Fonseca, Hubert Houben and Benedetto Vettere, Galatina, 1992, 135–49.

————. "La prima committenza normanna," *Le porte di bronzo dall'antichità al secolo XIII,* ed. Salvatore Salomi, Rome, 1990, 357–72.

Calandra, Roberto, Alessandro La Manna et al. *Palazzo dei Normanni.* Palermo, 1991.

Cameron, Averil. "The Construction of Court Ritual: The Byzantine Book of Ceremonies," *Rituals of Royalty: Power and Ceremonial in Traditional Societies,* ed. David Cannadine and Simon Price, Cambridge, 1987, 106–136.

Canale, Cleofe Giovanni. "Spazio interno nell'architettura religiosa del periodo normanno: mosaici e sculture," *Storia della Sicilia,* vol. 5, Naples, 1981, 125–38.

Canard, Maurice. "Le cérémonial fatimite et le cérémonial byzantin: Essai de comparison," *Byzantion* 21, 1951, 355–420.

Cantarella, Glauco Maria. *La Sicilia e i normanni: Le fonti del mito.* Bologna, 1989.

Carafa, Giuseppe Maria. *De Capella regis utriusque Siciliae et aliorum principum.* Rome, 1749.

Caronia, Giuseppe. *La Zisa di Palermo: Storia e restauro.* Rome, 1982.

Caronia, Giuseppe, and V. Noto. *La cuba di Palermo (arabi e normanni nel XII secolo).* Palermo, 1988.

Carucci, Arturo. *I mosaici salernitani nella storia e nell'arte.* Cava dei Tirreni, 1983.

Caruso, Stefano. "Le tre omilie inedite 'Per la Domenica della Palme' di Filagato da Cerami (LI, LII, LIII Rossi Taibbi)," *Epeteris Heteiraias Byzantinon Spoudon* 41, 1974, 109–27.

Caspar, Erich. *Roger II: (1101–1154) und die Gründung der normannisch-sizilischen Monarchie.* Innsbruck, 1904.

Cavallo, Guglielmo. *Rotoli di Exultet dell'Italia meridionale*. Bari, 1973.

Chalandon, Ferdinand. *Histoire de la domination normande en Italie et en Sicile*. 2 vols. Paris, 1907.

Chiat, Marilyn J., and Kathryn L. Reyerson, eds. *The Medieval Mediterranean. Cross-Cultural Contacts* (=*Medieval Studies at Minnesota* 3). St. Cloud, Minn., 1988.

Claussen, Peter Cornelius. *Magistri Doctissimi Romani: Die römischen Marmorkunstler des Mittelalters*. Stuttgart, 1987.

Cochetti Pratesi, Lorenza. "Il candelabro della Cappella Palatina," *Scritti di storia dell'arte in onore di Mario Salmi*, Rome, 1961, vol. 1, 291–304.

———. "In margine ad alcuni recenti studi sulla scultura medievale nell'Italia meridionale: II. Sui rapporti tra la scultura campana e quella siciliana, I/II/III," *Commentari* 18, 1967, 126–50; 19, 1968, 165–96; 21, 1970, 255–90.

Colvin, Howard Montagu, ed. *The History of the King's Works: The Middle Ages*. 2 vols. text; 1 vol. pls. London, 1963.

Constantine VII Porphyrogennetos. *Le livre des cérémonies*, ed. Albert Vogt. 2 vols. Paris, 1935.

Cott, Perry Blythe. *Siculo-Arabic Ivories*. Princeton, 1939.

Creswell, K.A.C. *The Muslim Architecture of Egypt*. 2 vols. Oxford, 1952–59.

———. "The Origin of the Cruciform Plan of the Cairene Madrasas," *Bulletin de l'Institut français de l'archéologie orientale du Caire* 21, 1922, 1–54.

Ćurčić, Slobodan. "Some Palatine Aspects of the Cappella Palatina in Palermo," *Dumbarton Oaks Papers* 41, 1987, 125–44.

Cutler, Anthony. "The Mythological Bowl in the Treasury of San Marco at Venice," *Near Eastern Numismatics, Iconography, Epigraphy and History: Studies in Honor of George C. Miles*, ed. D. K. Koumijian, Beirut, 1974, 235–54.

Cutrera, Antonio. "Il palazzo degli emiri di Sicilia in Palermo," *Bollettino d'arte* 25, 1931, 198–205.

Daneu Lattanzi, Angela. *Lineamenti di storia della miniatura in Sicilia*. Florence, 1966.

———. *I manoscritti miniati della Sicilia*. 2 vols. Rome, 1965–84.

Davi, Giulia. "Il Castello di Giuliana e il Palazzo Reale di Palermo," *Federico II e l'arte del duecento italiano*, ed. Angiola Maria Romanini (=*Atti della terza settimana di studi di storia dell'arte medievale dell'Università di Rome, 15–20 Maggio 1978*), Rome, 1980, 147–52.

Davies, J. G. *Medieval Armenian Art and Architecture: The Church of the Holy Cross at Aght'Amar*. London, 1991.

Deér, Josef. "Der Anspruch der Herrscher des 12. Jahrhunderts auf die apostolische Legation," *Archivium Historiae Pontificiae* 2, 1964, 117–86.

———. "Die basler Löwenkamee und der süditalienische Gemmenschnitt des 12. und 13. Jahrhunderts: ein Beitrag zur Geschichte der abendländlischen Proto-renaissance," *Zeitschrift für schweizerische Archäologie und Kunstgeschichte* 14, 1953, 129–58.

———. *The Dynastic Porphyry Tombs of the Norman Period in Sicily*. Cambridge, Mass., 1959.

———. *Der Kaiserornat Friedrichs II*. Bern, 1952.

———. *Papsttum und Normannen. Untersuchungen zu ihren lehnsrechtlichen und kirchenpolitischen Beziehungen*. Cologne/Vienna, 1972.

Delogu, Paolo. *I Normanni in Italia: Cronache della conquista e del regno*. Naples, 1984.

Delogu, Raffaello, and Vincenzo Scuderi. *La Reggia dei normanni e la Cappella Palatina*. Florence, 1969.

Demus, Otto. *Byzantine Art and the West*. New York, 1970.

———. *The Mosaics of Norman Sicily*. New York, 1950.

———. *The Mosaics of San Marco*. 2 vols. Chicago and London, 1984.

Demus, Otto, and Max Hirmer. *Romanesque Mural Painting*, trans. Mary Whittall. New York, 1968.

Derbes, Anne. "The Frescoes of Schwarzrheindorf, Arnold of Wied and the Second Crusade," *The Second Crusade and the Cistercians*, ed. Michael Gervers, New York, 1992, 141–54.

Der Nersessian, Sirarpie. *Aght'Amar: Church of the Holy Cross*. Cambridge, Mass., 1965.

De Seta, Cesare, and Leonardo Di Mauro. *Palermo*. Bari, 1981.

De Stefano, Antonio. *La cultura in Sicilia nel periodo normanno*. Palermo, 1938.

De Wald, Ernest Theodore. *The Illustrations of the Utrecht Psalter*. Princeton, 1932.

Dickinson, John. "The Mediaeval Conception of Kingship and Some of Its Limitations, as Developed in the *Policraticus* of John of Salisbury," *Speculum* 1, 1926, 308–37.

Di Giovanni, Vincenzo. "Il castello e la chiesa della Favara di S. Filippo a Mare Dolce in Palermo," *Archivio Storico Siciliano*, n.s. 22, 1898, 301–74.

———. "Divisione etnografica della popolazione di Palermo nei secoli XI, XII, XIII," *Archivio Storico Siciliano*, n.s. 13, 1888, 1–72.

Di Marzo, Gioacchino. *Delle belle arti in Sicilia dai normanni fino alla fine del secolo XIV*. 4 vols. Palermo, 1858–70.

Di Stefano, Guido. *Monumenti della Sicilia normanna*. 2d ed., annotated by Wolfgang Krönig. Palermo, 1979.

D'Onofrio, Mario, ed. *I normanni. Popolo d'Europa 1030–1200*. Exhibition catalogue. Venice, 1994.

Dupré-Theseider, Eugenio. "Lo stanziamento dei normanni nel mezzogiorno," *L'art dans l'Italie méridionale: Aggiornamento dell'opera di Emile Bertaux sotto la direzione di Adriano Prandi*, Rome, 1978, vol. 4, 67–131.

Ebersolt, Jean. *Le grand palais de Constantinople et le livre de cérémonies*. Paris, 1910.

———. *Sanctuaires de Byzance*. Paris, 1921.

Eichmann, E. "Von der Kaisergewandung im Mittelalter," *Historisches Jahrbuch* 58, 1938, 268–304.

Elze, Reinhard. *Päpste-Kaiser-Könige und die mittelalterliche Herrschaftssymbolik*. London, 1982.

Erdmann, Kurt. "Arabische Schriftzeichen als Ornamente in den abendlandischen Kunst des Mittelalters," *Abhandlungen der geistes- und sozialwissenschaftlichen Klasse, Akademie der Wissenschaft und der Literatur in Mainz*, 1953, 467–513.

Esin, Emel. "Oldrug-Turug: The Hierarchy of Sedent Postures in Turkish Iconography," *Kunst des Orients* 7, 1970–71, 3–29.

*L'età normanna e sveva in Sicilia: Mostra storico-documentaria e bibliografica*. Palazzo dei Normanni, Palermo, 1994.

Ettinghausen, Richard. *Arab Painting*. Lausanne, 1962.

———. *From Byzantium to Sassanian Iran and the Islamic World. Three Modes of Artistic Influence*. Leiden, 1972.

———. "Kufesque in Greece, the Latin West and the Muslim World," *A Colloquium in Memory of George Carpenter Miles (1904–1975)*, New York, 1976, 28–47.

———. "Painting of the Fatimid Period: A Reconsideration," *Ars Islamica* 9, 1942, 112–24.

Ettinghausen, Richard, and Oleg Grabar. *The Art and Architecture of Islam 650–1250*. New York, 1987.

Eyice, Semavi. "Contributions à l'histoire de l'art byzantin: Quartre édifices inédits ou mal connus," *Cahiers Archéologiques* 10, 1959, 245–58.

———. "Two Mosaic Pavements from Bithynia," *Dumbarton Oaks Papers* 17, 1963, 373–83.

Falkenhausen, Vera von. "I gruppi etnici nel regno di Ruggero II e la loro participazione al potere," *Società, potere e popolo nell'età di Ruggero II, Atti delle terze giornate normanno-sveve, Bari, 23–25 maggio 1977*, Bari, 1979, 133–56.

Falkenstein, Ludwig. *Der 'Lateran' der karolingischen Pfalz zu Aachen (=Kölner historische Abhandlungen, 13)*. Cologne, 1966.

Fazello, Tommaso. *De rebus siculis Decades duae*. Palermo, 1560.

Fichtenau, Heinrich. "Byzanz und die Pfalz zu Aachen," *Mitteilungen des Instituts für österreichische Geschichtsforschung* 59, 1951, 1–54.

Fillitz, Hermann. *Die Insignien und Kleinodien des Heiligen Römischen Reiches*. Vienna, 1954.

———. *Die Schatzkammer in Wien*. Vienna, 1964.

Franz, Heinrich Gerhard. *Von Baghdad bis Cordoba: Ausbreitung und Entfaltung der islamischen Kunst, 850–1050*. Graz, 1984.

Fuchs, Alois. "Entstehung und Zweckbestimmung der Westwerke," *Westfälische Zeitschrift* 100, 1950, 227–91.

Fuiano, Michele. "La fondazione del *Regnum Siciliae* nella versione di Alessandro di Telese," *Papers of the British School at Rome* 24, 1956, 65–77.

Gabrieli, Francesco, and Umberto Scerrato. *Gli arabi in Italia*. Milan, 1985.

Galasso, Giuseppe. "Social and Political Devel-

opments in the Eleventh and Twelfth Centuries," *The Normans in Sicily and Southern Italy*, Oxford, 1977, 47–63.

Gandolfo, Francesco. "Reimpiego di sculture antiche nei troni papali del XII secolo," *Rendiconti della pontificia accademia di archeologia* 47, 1974–75 (1976), 203–18.

Gardelles, Jacques. "Le palais dans l'Europe occidentale chrétienne du Xe au XIIe siècle," *Cahiers de la civilisation médiévale* 19, 1976, 115–34.

Garofalo, Aloysius. *Tabularium Regiae ac Imperialis Capellae Collegiatae Divi Petri in Regio Panormitano Palatio*. Palermo, 1835.

Gautier, Paul. "Le Typikon du Christ Sauveur Pantocrator," *Revue des Etudes Byzantines* 32, 1974, 1–145.

Gelfer-Jørgensen, Mirjam. *Medieval Islamic Symbolism and the Paintings in the Cefalù Cathedral*. Leiden, 1986.

Genuardi, Luigi. *Palermo*. Rome, 1929.

Glass, Dorothy. *Studies on Cosmatesque Pavements* (=*British Archaeological Reports, International Series* 82). Oxford, 1980.

Goitein, S. D. *A Mediterranean Society: The Jewish Communities of the Arab World as Portrayed in the Documents of the Cairo Geniza*. 6 vols. Berkeley, 1967–93.

Goldschmidt, Adolph. "Die Favara des Könige Roger von Sizilien," *Jahrbuch der königlich preussischen Kunstsammlungen* 16, 1895, 199–215.

———. "Die normannischen Königspäläste in Palermo," *Zeitschrift für Bauwesen* 48, 1898, 541–90.

Golvin, Lucien. *Recherches archéologiques à la Qal'a des Banu Hammad*. Paris, 1965.

Grabar, André. "La Décoration architecturale de l'église de la Vièrge à Saint-Luc en Phocide et le début des influences islamiques sur l'art byzantin en Grèce," *Comptes-rendus des séances de l'Academie des Inscriptions et Belles Lettres*, 1971, 15–37.

———. *L'Empereur dans l'art byzantin*. Paris, 1936.

———. "Les Fresques des escaliers à Sainte-Sophie de Kiev et l'iconographie impériale byzantine," *Seminarium Kondakovium* 7, 1935, 103–17.

———. "Image d'une église chrétienne parmi les peintures musulmanes de la Chapelle Palatine à Palerme," *Aus der Welt der islamischen Kunst: Festschrift für Ernst Kühnel zum 75. Geburtstag am 26.10.1957*, Berlin, 1959, 226–33.

———. "Pseudo Codinos et les cérémonies de la cour byzantine au XIVe siècle," *Art et société à Byzance sous les Paléologues, Actes du colloque organisé par l'Association International des Etudes Byzantines à Venise en Septembre 1968*, Venice, 1971, 193–221.

———. "Récit, panégyrique, acte liturgique: Les trois interprétations possibles d'un même sujet dans l'iconographie byzantine," *Rayonnement Grec. Hommages à Charles Delvoye*, ed. Lydie Hadermann-Misguisch and George Paepsaet, Brussels, 1982, 431–36.

———. "Le Succès des arts orientaux à la cour byzantine sous les macédoniens," *Münchner Jahrbuch der bildenden Kunst* 2, 1951, 32–60.

Grabar, André, and Oleg Grabar. "L'Essor des arts inspirés par les cours princières à la fin du premier millénaire; princes musulmanes et princes chrétiens," *L'Occidente e l'Islam nel'alto medioevo. Settimane di studio del centro italiano di studi sull'alto medioevo, 2–8 aprile 1964*, Spoleto, 1965, vol. 2, 845–92 (with discussion).

Grabar, Oleg. "Imperial and Urban Art in Islam: The Subject Matter of Fatimid Art," *Colloque international sur l'histoire du Caire, 27 mars-5 avril, 1969*, Cairo, 1972, 173–89.

———. "Islamic Art and Byzantium," *Dumbarton Oaks Papers* 18, 1964, 69–88.

———. *The Mediation of Ornament*. Princeton, 1992.

———. *Studies in Medieval Islamic Art*. London, 1976.

———. "Trade with the East and the Influence of Islamic Art on the 'Luxury Arts' in the West," *Il medio oriente e l'occidente nell'arte del XIII secolo* (=*Atti del XXIV congresso internazionale di storia dell'arte*), Bologna, 1979, vol. 2, 27–34.

Gramignani, Pietro. "La Cappella dell'Incornazione in Palermo," *Archivio Storico Siciliano* 54, 1934, 227–58.

Gramit, David. "The Music Paintings of the Cappella Palatina in Palermo," *Imago Musicae: International Yearbook of Musical Iconography* 2, 1985, 9–49.

Grierson, Philip. "Guglielmo II o Ruggero II?

Un attribuzione errata," *Rivista italiana di numismatica e scienze affini* 91, 1989, 195–204.

Guiotto, Mario, ed. *Palazzo ex reale di Palermo. Recenti restauri e ritrovamenti.* Palermo, 1947.

Hacker-Sück, Inge. "La Sainte-Chapelle de Paris et les chapelles palatines du moyen âge en France," *Cahiers Archéologiques* 13, 1962, 217–57.

Haskins, Charles Homer. "England and Sicily in the Twelfth Century," *English Historical Review* 103, 1911, 433–47.

———. *The Normans in European History.* New York, 1915.

———. *The Renaissance of the Twelfth Century.* Cambridge, Mass., 1927.

Haussherr, Rainer et al., eds. *Die Zeit der Staufer. Geschichte, Kunst, Kultur (Württembergisches Landesmuseum, Stuttgart).* 5 vols. Stuttgart, 1977.

Heisenberg, A., ed. *Die Palastrevolution des Johannes Komnenos.* Würzburg, 1907.

Herval, R. "Ecléctisme intellectuel à la cour de Roger II de Sicile," *Atti del convegno internazionale di studi ruggeriani (21–25 aprile 1954),* Palermo, 1955, vol. 1, 73–104.

Herzfeld, Ernst E. *Die Malereien von Samarra.* Berlin, 1927.

Hill, Derek, and Lucien Golvin. *Islamic Architecture in North Africa: A Photographic Survey.* London, 1976.

Hill, Derek, and Oleg Grabar. *Islamic Architecture and Its Decoration.* London, 1964.

Hillenbrand, Robert. *Islamic Architecture: Form, Function and Meaning.* New York, 1994.

Hinkle, William M. "The Iconography of the Apsidal Fresco at Montmorillon," *Münchner Jahrbuch der bildenden Kunst* 23, 1972, 37–62.

*La Historia o Liber de regno sicilie e la Epistola ad petrum panormitane ecclesie thesaurium di Ugo Falcando,* ed. G. B. Siragusa. Rome, 1897.

Hoag, John D. *Islamic Architecture.* New York, 1977.

Hunt, Lucy Ann. "Art and Colonialism: The Mosaics of the Church of the Nativity in Bethlehem (1169) and the Problem of 'Crusader' Art," *Dumbarton Oaks Papers* 45, 1991, 69–85.

———. "Comnenian Aristocratic Palace Decorations: Descriptions and Islamic Connections," *The Byzantine Aristocracy, IXth to XIIth Centuries,* ed. Michael Angold, Oxford, 1984, 138–57.

Ibn Jubayr, Muhammed Ibn Ahmad. *The Travels of Ibn Jubayr,* trans. R.J.C. Broadhurst. London, 1952.

Ibrahim, Laila ali. "Residential Architecture in Mamluk Cairo," *Muqarnas,* 2, 1984, 47–59.

Idrisi. *Il libro di Ruggero,* trans. Umberto Rizzitano. Palermo, 1994.

Jacoby, David. "Silk in Western Byzantium Before the Fourth Crusade," *Byzantinische Zeitschrift* 84/85, 1991/92, 452–500.

James, Liz, and Ruth Webb. "'To Understand Ultimate Things and Enter Secret Places': Ekphrasis and Art in Byzantium," *Art History* 14, 1991, 1–17.

Jamison, Evelyn. "The Sicilian Norman Kingdom in the Mind of Anglo-Norman Contemporaries," *Proceedings of the British Academy* 24, 1938, 237–85.

Janc, Zagorka. *Ornaments in the Serbian and Macedonian Frescoes from the XII to the Middle of the XV Century, Exhibition September-October 1961, Museum of Applied Art, Belgrad.* Belgrad, 1961.

Jayyusi, Salma Khandra, ed. *The Legacy of Muslim Spain.* Leiden, 1992.

Johns, Jeremy. "I re normanni e i califfi fatimiti: nuove prospettive su vecchi materiali," unpublished paper presented at Fondazione Caetani, Rome, in May 1993.

Johnson, Mark J. "The Episcopal and Royal Views at Cefalù," *Gesta* 33, 1994, 118–31.

Jones, Dalu. "The Cappella Palatina, Problems of Attribution," *Art and Archaeology Research Papers* 2, 1972, 41–57.

Kalavrezou-Maxeiner, Ioli. "The Cup of San Marco and the 'Classical' in Byzantium," *Studien zur mittelalterlichen Kunst 800–1250, Festschrift für Florentine Mütherich zum 70. Geburtstag,* ed. Katharina Bierbrauer, Peter S. Klein, and Willibald Sauerländer, Munich, 1985, 167–74.

Kantorowicz, Ernst. *The King's Two Bodies: A Study in Medieval Political Theology.* Princeton, 1957.

———. *Laudes Regiae: A Study in Liturgical Acclamations and Mediaeval Ruler Worship.* Berkeley, 1946.

————. "A Norman Finale of the Exultet and the Rite of Sarum," *Harvard Theological Review* 34, 1941, 129–43.

————. "Oriens Augusti—Lever du Roi," *Dumbarton Oaks Papers* 17, 1963, 117–77.

————. "*Pro patria mori* in Medieval Political Thought," *American Historical Review* 56, 1951, 472–92.

*Karl der Grosse: Werk und Wirkung (Aachen, 26 Juni bis zum 19. September 1965)*. Aachen, 1965.

Kartsonis, Anna D. *Anastasis: Making of an Image*. Princeton, 1986.

Kazhdan, Alexander, and Simon Franklin. *Studies on Byzantine Literature of the Eleventh and Twelfth Centuries*. Cambridge, 1984.

Kehr, Karl Andreas. *Die Urkunden der normannisch-sizilischen Könige*. Innsbruck, 1902.

Kerscher, Gottfried. "Privatraum und Zeremoniell im spätmittelalterlichen Papst- und Königspalast. Zu den Montefiascone-darstellungen von Carlo Fontana und einem Grundriss des Papstpalastes von Avignon," *Römisches Jahrbuch der Bibliotheca Hertziana* 26, 1990, 87–134.

Kier, Hiltrud. *Der mittelalterliche Schmuckfussboden*. Düsseldorf, 1970.

Kitzinger, Ernst. "Art in Norman Sicily. Report on the Dumbarton Oaks Symposium of 1981," *Dumbarton Oaks Papers* 37, 1983, 167–70.

————. "The Date of Philagathos' Homily for the Feast of Sts. Peter and Paul," *Byzantino-Sicula II: Miscellanea di scritti in memoria di Giuseppe Rossi Taibbi*, Palermo, 1975, 301–6.

————. "The Descent of the Dove: Observations on the Mosaic of the Annunciation in the Cappella Palatina in Palermo," *Byzanz und der Westen: Studien zur Kunst des europäischen Mittelalters*, ed. Irmgard Hutter, Vienna, 1984, 99–115.

————. "Mosaic Decoration in Sicily under Roger II and the Classical Byzantine System of Church Decoration," *Italian Church Decoration of the Middle Ages and Early Renaissance. Functions, Forms and Regional Traditions. Ten Contributions to a Colloquium Held at the Villa Spelman, Florence*, ed. William Tronzo, Bologna, 1989, 147–65.

————. "The Mosaic Fragments in the Torre Pisana of the Royal Palace in Palermo: A Preliminary Study," *Mosaïque: Recueil d'hommages à Henri Stern*, Paris, 1983, 239–43.

————. *I mosaici del periodo normanno in Sicilia*, fasc. 1–3. Palermo, 1992–94.

————. *I mosaici di Santa Maria dell'Ammiraglio a Palermo*. Palermo, 1990.

————. *The Mosaics of Monreale*. Palermo, 1960.

————. "The Mosaics of the Cappella Palatina in Palermo: An Essay on the Choice and Arrangement of Subjects," *Art Bulletin* 31, 1949, 269–92.

————. "On the Portrait of Roger II in the Martorana in Palermo," *Proporzioni* 3, 1950, 30–35.

————. "The Portraits of the Evangelists in the Cappella Palatina in Palermo," *Studien zur mittelalterlichen Kunst 800–1250. Festschrift für Florentine Mütherich zum 70. Geburtstag*, ed. Katharina Bierbrauer, Peter K. Klein and Willibald Sauerländer, Munich, 1985, 181–192.

————. "Reflections on the Feast Cycle in Byzantine Art," *Cahiers Archéologiques* 36, 1988, 51–73.

————. "The Son of David: A Note on a Mosaic in the Cappella Palatina in Palermo," *ΕΥΦΡΟΣΥΝΟΝ. ΑΦΙΕΡΩΜΑ ΤΟΝ ΜΑΝΟΛΗ ΧΑΤΖΗΔΑΚΗ*, Athens, 1991, 239–42.

————. "Two Mosaic Ateliers in Palermo in the 1140s," *Artistes, artisans et production artistique au moyen age: Colloque international, Centre National de la Recherche Scientifique, Université de Rennes II, Haute-Bretagne, 2–6 Mai 1983*, ed. Xavier Barral i Altet, vol. 1, *Les hommes*, Paris, 1986, 277–94.

————. Review of Otto Demus, *Mosaics of Norman Sicily*, in *Speculum* 38, 1953, 143–50.

Krautheimer, Richard. *Corpus basilicarum christianarum Romae*. 5 vols. Vatican City, 1937–77.

Kreutz, Barbara M. *Before the Normans: Southern Italy in the Ninth and Tenth Centuries*. Philadelphia, 1991.

Krönig, Wolfgang. *Il castello di Caronia in Sicilia. Un complesso normanno del XII secolo (=Römische Forschungen der Bibliotheca Hertziana, 22)*. Rome, 1977.

————. "Considerazioni sulla Cappella Palatina di Palermo," *Atti del convegno inter-

*nazionale di studi ruggeriani (21–25 aprile 1954)*, Palermo, 1955, 247–68.

——. *Il duomo di Monreale e l'architettura normanna in Sicilia.* Palermo, 1965.

——. "Il palazzo reale normanno della Zisa a Palermo: Nuove osservazioni," *Commentari* 26, 1975, 229–47.

——. "Vecchie e nuove prospettive sull'arte della Sicilia normanna," *Atti del congresso internazionale di studi sulla Sicilia normanna (Palermo, 1972)*, Palermo, 1973, 132–45.

——. "Zur Transfiguration der Cappella Palatina in Palermo," *Zeitschrift für Kunstgeschichte* 19, 1956, 162–79.

—— et al., eds. *L'anno di Guglielmo 1189–1989: Monreale, percorsi tra arte e cultura.* Palermo, 1989.

Kühnel, Ernest. *Die islamischen Elfenbeinskulpturen VIII-XIII. Jahrhundert.* Berlin, 1971.

Kühnel, Ernest, and L. Bellinger. *Catalogue of Dated Tiraz Fabrics: Umayyad, Abbasid, Fatimid.* Washington, D.C., 1952.

Kutschmann, Theodor. *Meisterwerke saracenisch-normannischer Kunst in Sicilien und Unteritalien.* Berlin, 1900.

La Duca, Rosario. *La città perduta: Cronache palermitane di ieri e di oggi.* 2 vols. Naples, 1976–77.

Lagumina, B. "Iscrizione araba del re Ruggiero scoperta alla Cappella Palatina in Palermo," *Rendiconti della Reale Accademia dei Lincei, Classe di scienze morali, storiche e filologiche*, ser. 5, 2, 1893, 231–34.

Lauer, Philippe. *Les enluminures romanes des manuscrits de la Bibliothèque Nationale.* Paris, 1927.

——. *Le palais de Latran. Étude historique et archéologique.* Paris, 1911.

Lavagnini, Bruno. "Filippo-Filagato promotore degli studi di greco in Calabria," *Bollettino della Badia Greca di Grottaferrata*, n.s., 28, 1974, 3–12.

——. *Profilo di Filagato da Cerami con traduzione della Omelia XXVII pronunziata dal pulpito della Cappella Palatina in Palermo.* Palermo, 1992.

Lazarev, Viktor N. *Old Russian Murals and Mosaics from the XIth to the XIVth Century*, trans. Boris Roniger. London, 1966.

Lehmann, Karl. "The Dome of Heaven," *Art Bulletin* 27, 1945, 1–27.

Lehmann-Brockhaus, Otto. "Die Kanzeln der Abruzzen im 12. und 13. Jahrhundert," *Römisches Jahrbuch für Kunstgeschichte*, 6, 1942–44, 257–428.

Leroquais, Victor. *Les psautiers, manuscrits latins des bibliothèques publiques de France.* 3 vols. Mâcon, 1940–41.

Lézine, Alexandre. "Persistance de traditions pré-islamiques dans l'architecture domestique de l'Egypt musulmane," *Annales Islamologiques* 11, 1972, 1–22.

——. "Les Salles nobles des palais mamelouks," *Annales Islamologiques* 10, 1972, 63–148.

Lojacono, Pietro. "L'organismo costruttivo della Cuba alla luce degli ultimi scavi," *Palladio*, n.s. 3, 5/6, 1953, 1–6.

Lombard, Maurice. *Les Textiles dans le monde musulman du VIIe au XIIe siècle (=Etude d'économie médiévale III).* New York, 1978.

Lopez, Robert S. "The Norman Conquest of Sicily," in *A History of the Crusades*, ed. Kenneth M. Setton, vol. 1, *The First Hundred Years*, Philadelphia, 1955, 54–67.

Macridy, Theodore, with contributions by Arthur H. S. Megaw, Cyril Mango, and Ernest J. W. Hawkins. "The Monastery of Lips (Fenari Isa Camii) at Istanbul (translated by Cyril Mango)," *Dumbarton Oaks Papers* 18, 1964, 249–315.

Magdalino, Paul. *The Empire of Manuel I Komnenos, 1143–1180.* Cambridge, 1993.

——. "Manuel Komnenos and the Great Palace," *Byzantine and Modern Greek Studies* 4, 1978, 101–14.

——. "The Phenomenon of Manuel I Komnenos," *Byzantinische Forschungen* 13, 1988, 171–99.

Magdalino, Paul, and Robert Nelson. "The Emperor in Byzantine Art of the Twelfth Century," *Byzantinische Forschungen* 8, 1982, 123–83.

Maguire, Henry. *Art and Eloquence in Byzantium.* Princeton, 1981.

——. "The Mosaics of the Nea Moni: An Imperial Reading," *Dumbarton Oaks Papers* 46, 1992, 205–14.

——. "Style and Ideology in Byzantine Imperial Art," *Gesta* 28, 1989, 217–31.

Mango, Cyril. *The Brazen House: A Study of the Vestibule of the Imperial Palace of Constantinople.* Copenhagen, 1959.

Mann, Albrecht. "Dopplechor und Stifter-

memorie: Zum kunst- und kultgeschicht-lichen Problem der Westchöre," *Westfälische Zeitschrift* 111, 1961, 149–262.

Marçais, George. *Coupole et plafonds de la grande mosquée de Kairouan*. Paris, 1925.

Margulies, Erwin. "Le Manteau impérial du Trésor de Vienne et sa doublure," *Gazette des Beaux Arts*, ser. 6, 9, 1933, 360–68.

Marongiu, Antonio. "A Model State in the Middle Ages: The Norman and Swabian Kingdom of Sicily," *Comparative Studies in Society and History* 6, 1964, 307–20.

Maurici, Ferdinando. *Castelli medievali in Sicilia dai bizantini ai normanni*. Palermo, 1992.

Mayo, Penelope C. "The Crusaders Under the Palm: Allegorical Plants and Cosmic Kingship in the *Liber Floridus*," *Dumbarton Oaks Papers* 27, 1973, 29–67.

McCormick, Michael. "Analyzing Imperial Ceremonies," *Jahrbuch der österreichisches Byzantinistik* 35, 1985, 1–20.

Megaw, Arthur H. S. "Recent Work of the Byzantine Institute in Istanbul," *Dumbarton Oaks Papers* 17, 1963, 333–71.

Meier, Hans-Rudolf. *Die normannischen Königspaläste in Palermo: Studien zur hochmittelalterlichen Residenzbaukunst*. Worms, 1994.

Meinecke, Michael. *Die mamlukische Architektur in Agypten und Syrien*. 2 vols. Glückstadt, 1992.

Ménager, Léon-Robert. *Hommes et institutions de l'Italie normande*. London, 1981.

Mende, Ursula. *Die Bronzetüren des Mittelalters 800–1200*. Munich, 1983.

Metz, Wolfgang. "Betrachtungen zur Pfalzenforschung," *Historisches Jahrbuch* 87, 1967, 91–102.

Michael Italikos. *Michel Italikos, lettres et discours (=Archives de l'orient chrétien* 14), ed. Paul Gautier. Paris, 1972.

Miiatev, Krustiu. *Die Keramik von Preslav*. Sofia, 1936.

Miles, George C. "Byzantium and the Arabs: Relations in Crete and the Aegean Area," *Dumbarton Oaks Papers* 18, 1964, 1–32.

———. "Classification of Islamic Elements in Byzantine Architectural Ornament in Greece," *Actes du XIIe congrès international d'études byzantines*, Belgrad, 1964, vol. 3, 281–87.

———. "Material for a Corpus of Architectural Ornament of Islamic Derivation in Byzantine Greece," *Yearbook of the American Philosophical Society*, 1959, 486–90.

Millet, Gabriel. *La peinture du moyen âge en Yougoslavie (Serbie, Macédoine et Monténégro)*. 4 vols. Paris, 1954–69.

———. *Recherches sur l'iconographie de l'évangile aux XIVe, XVe et XVIe siècles*. Paris, 1916.

Möbius, Helga. *Passion und Auferstehung in Kultur und Kunst des Mittelalters*. Vienna, 1979.

Mongitore, Antonino. "Dell'istoria sacra di tutte le chiese, conventi, monasteri . . . ," Palermo, Biblioteca Comunale, Qq E4.

Monneret de Villard, Ugo. *Le Pitture musulmane al soffitto della Cappella Palatina in Palermo*. Rome, 1950.

———. "Le tessitura palermitana sotto i normanni e i suoi rapporti con l'arte bizantina," *Miscellanea Giovanni Mercati*, vol.3, *Letteratura e storia bizantina*, Vatican City, 1946, 464–89.

*I mosaici di Monreale: restauri e scoperte (1965–1982) (=Quaderno n. 4 del Bollettino "B.C.A." Sicilia)*, Palermo, 1986.

Nelson, Robert S. "Palaeologan Illuminated Ornament and the Arabesque," *Wiener Jahrbuch für Kunstgeschichte* 41, 1988, 7–22.

Nercessian, Nora. "The Cappella Palatina of Roger II: The Relationship of Its Imagery to Its Political Function," Ph.D. diss., UCLA, 1981, University Microfilms International, Ann Arbor, Michigan.

Noehles, Karl. "Die Kunst der Cosmaten und die Idee der Renovatio Romae," *Festschrift Werner Hager*, Recklinghausen, 1966, 17–37.

Nordström, Folke. *Medieval Baptismal Fonts: An Iconographical Study*. Stockholm, 1984.

Orsi, Paolo. *Le chiese basiliane della Calabria*. Florence, 1929.

Pace, Valentino. "Quarant'anni di studi sull'arte medievale nell'Italia meridionale. Un consuntivo e prospettive di ricerca," *Il Mezzogiorno medievale nella storiografia del secondo dopoguerra: risultati e prospettive, Atti del IV convegno nazionale sell'Associazione dei medioevalisti italiani, Cosenza, 1982*, Cosenza, 1985, 123–75.

Pantoni, Angelo. *Le vicende della basilica di Montecassino attraverso la documentazione archeologica*. Montecassino, 1973.

Paolini, Maria Grazia. "Considerazioni su edi-

fici civili di età normanna a Palermo," *Atti dell'Accademia di Scienze, Lettere e Arti di Palermo* 33, 1973–74, 299–346.

Pasca, Cesare. *Descrizione della Imperiale e Regale Cappella Palatina di Palermo.* Palermo, 1841.

———. "Intorno alla sagra liturgia della Cappella Palatina," Palermo, Biblioteca Nazionale, XIII.F.11.

———. "Miscellanea," Palermo, Biblioteca Nazionale, XII.G.2.

Patera, Benedetto. *L'arte della Sicilia normanna nelle fonti medievali.* Palermo, 1980.

Pauty, Edmond. *Bois sculptés d'églises coptes (époque fatimide).* Cairo, 1930.

———. *Les bois sculptés jusqu'à l'époque ayyoubite: Catalogue général du Musée du Caire.* Cairo, 1931.

———. *Les palais et les maisons d'époque musulmane, au Caire.* Cairo, 1932.

Pavlovskij, Alexis A. "Décoration des plafonds de la Chapelle Palatine," *Byzantinische Zeitschrift* 2, 1893, 361–412.

———. "Iconographie de la Chapelle Palatine," *Revue Archéologique,* ser. 3, 25, 1894, 305–44.

———. *Zhivopis' Palatinskoï Kapelly v Palermo.* St. Petersburg, 1890.

Petrassi, Mario. "L'artistico candelabro di San Paolo," *Capitolium* 46, 1971, 4–12.

Petrus de Ebulo. *Petri Ansolini de Ebulo, De Rebus siculis carmen,* ed. Ettore Rota. Città di Castello, 1904.

———. *Liber ad honorem augusti sive de rebus siculus, Codex 120 II der Burgerbibliothek Bern. Eine Bilderchronik der Stauferzeit,* ed. Gereon Becht-Joerdens, Theo Koelzer, and Marlis Staehli. Sigmaringen, 1994.

Pfister, R. "Toiles à inscriptions abbasides et fatimides," *Bulletin d'études orientales de l'Institut français de Damas* 11, 1945–46, 47–90.

Philagathos of Cerami. *Omelie per i vangeli domenicali e le feste di tutto l'anno,* vol. 1, ed. Giuseppe Rossi Taibbi. Palermo, 1969.

Philon, Helen. *Early Islamic Ceramics, Ninth to Late Twelfth Centuries.* Westerham, Kent, 1980.

Pinder-Wilson, R. H., and C.H.L. Brooke. "The Reliquary of St. Petroc and the Ivories of Norman Sicily," *Archaeologia* 104, 1973, 261–305.

Pirri, Rocco. *Sicilia sacra disquisitionibus et notitiis illustrata.* 2 vols. Palermo, 1733.

Pottino, Filippo. *La Cappella Palatina di Palermo.* Palermo, 1976.

———. *La cripta della Cappella Palatina di Palermo: Storia e leggende, arte e culto.* Palermo, 1966.

———. *Il tesoro della Cappella Palatina di Palermo in mostra permanente.* Palermo, n.d.

———. "Le vesti regali normanne dette dell'incoronazione," *Atti del convegno internazionale di studi ruggeriani (21–25 aprile 1954),* Palermo, 1955, vol. 1, 277–94.

*Il Regno Normanno: Conferenze tenute in Palermo, per l'VIII Centenario dell'incoronazione di Ruggero a Re di Sicilia.* Messina/Milan, 1932.

Reichemiller, M. "Bisher unbekannte Traumerzählungen Alexander von Telese," *Deutsches Archiv für Erforschung des Mittelalters* 19, 1963, 339–52.

Resta, Gianvito. "La cultura siciliana dell'età normanna," *Atti del congresso internazionale di studi sulla Sicilia normanna (Palermo 4–8 dicembre 1972),* Palermo, 1973, 263–78.

Restle, Marcell. *Die byzantinische Wandmalerei in Kleinasien.* 3 vols. Recklinghausen, 1967.

Revault, Jacques, and Bernard Maury. *Palais et maisons du Cairo du XIVe au XVIIIe siècle.* 4 vols. Cairo, 1975–83.

Rice, David Talbot. "Iranian Elements in Byzantine Art," *IIIe Congrès international d'art et d'archéologie Iraniens, Mémoires, Leningrad, Septembre, 1935,* Leningrad, 1939, 203–7.

———. "Late Byzantine Pottery at Dumbarton Oaks," *Dumbarton Oaks Papers* 20, 1966, 207–19.

———. ed. *The Church of Hagia Sophia at Trebizond.* Edinburgh, 1968.

Riolo, Gaetano. *Notizie dei restauratori delle pitture a musaico della R. Cappella Palatina.* Palermo, 1870.

Rizzitano, Umberto. *Storia e cultura nella sicilia saracena.* Palermo, 1975.

Roberts, Eileen Lucille. "The Paschal Candelabrum in the Cappella Palatina at Palermo: Studies in the Art, Liturgy and Patronage of Sicily, Campania, and Rome during the Twelfth and Thirteenth Centuries," Ph.D. diss., State University of New York at Binghamton, 1984, University Microfilms International, Ann Arbor, Michigan.

———. "Replicas of Italian Medieval Sculpture at Cranbrook: A Chapter in the History of American Taste," *Source* 9, 1990, 23–29.

Rocco, Benedetto. "La Cappella Palatina di Palermo: Lettura teologica (parte prima/parte seconda)," *B.C.A. Bollettino d'informazione trimestrale per la divulgazione dell'attività degli organi dell'Amministrazione per i Beni culturali e ambientali della Regione Siciliana*, IV, 1983, 21–74; V, 1984, 31–100.

———. "Il candelabro pasquale nella Cappella Palatina di Palermo," *B.C.A. Bollettino d'informazione trimestrale per la divulgazione dell'attività degli organi dell'Amministrazione per i Beni culturali e ambientali della Regione Siciliana*, VI-VIII, 1985–87, 33–54.

———. "I mosaici delle chiese normanne in Sicilia: Sguardo teologico, biblico, liturgico, II/III. La Cappella Palatina, I/II," *Ho Theologos* 3, 1976, 121–74; 5, 1978, 9–70.

———. "Il tabulario della Cappella Palatina di Palermo e il martirologio di epoca ruggeriana," *Ho Theologos* 14, 1977, 131–44.

Romano, Serena. "Affreschi da S. Maria del Monacato a Castrocido (e un aggiunta da Roccasecca)," *Arte medievale* 3, 1989, 155–66.

Romuald of Salerno. *Chronicon*, ed. C. A. Garufi (=*Rerum Italicarum Scriptores*, VII, pt. 1). Città di Castello, 1928.

Rossi Taibbi, Giuseppe. *Sulla tradizione manoscritta dell'omiliario di Filagato da Cerami*. Palermo, 1965.

Runciman, Steven. "The Country and Suburban Palaces of the Emperors," *Charanis Studies: Essays in Honor of Peter Charanis*, ed. Angeliki E. Laiou-Thomadakis, New Brunswick, N.J., 1980, 219–28.

Salvini, Roberto. *Il chiostro di Monreale e la scultura romanica in Sicilia*. Palermo, 1962.

———. *Mosaici medievali in Sicilia*. Florence, 1949.

Sanders, Paula. *Ritual, Politics, and the City in Fatimid Cairo*. Albany, N.Y., 1994.

Santamaura, Silvana Braida. "Il castello di Favara: Studi di restauro," *Architetti di Sicilia* 1, 1965, n. 5/6, 21ff.

———. "Il palazzo ruggeriano di Altofonte," *Palladio* 23, 1973, 185–97.

———. "Il 'Sollazzo' dell'Uscibene," *Architetti di Sicilia* 1, 1965, no. 1, 31ff.

Santoro, Rodo. *Spazio liturgico bizantino nell'architettura panormita*. Palermo, 1978.

Sarre, Friedrich. *Der Kiosk von Konia*. Berlin, 1936.

Schäfer-Schuchardt, Horst. *Die Kanzeln des 11. bis 13. Jahrhunderts in Apulien*. Würzburg, 1972.

Schapiro, Meyer. "Two Romanesque Drawings in Auxerre and Some Iconographic Problems," *Studies in Art and Literature for Belle da Costa Greene*, ed. Dorothy Miner, Princeton, 1954, 331–49.

Schiavo, Armando. *Monumenti della costa di Amalfi*. Milan/Rome, 1941.

Schmidt, Adolf. "Westwerke und Doppelchöre: Höfische und liturgische Einflüsse auf die Kirchenbauten des frühen Mittelalters," *Westfälische Zeitschrift* 106, 1956, 347–438.

Schneider-Flagmeyer, Michael. *Der mittelalterliche Osterleuchter in Süditalien: Ein Beitrag zur Bildgeschichte des Auferstehungsglaubens*. Frankfurt aM, 1986.

Schöne, Wolfgang. "Die kunstlerische und liturgische Gestalt der Pfalzkapelle Karls des Grossen in Aachen," *Zeitschrift für Kunstwissenschaft* 15, 1961, 97–148.

Schönewolf, Otto. *Die Darstellung der Auferstehung Christi: ihre Enstehung und ihre ältesten Denkmäler*. Leipzig, 1909.

Schramm, Percy Ernst. *Herrschaftszeichen und Staatssymbolik: Beiträge zu ihrer Geschichte vom dritten bis zum sechzehnten Jahrhundert*. 3 vols. Stuttgart, 1954–56.

———. *Kaiser, Könige und Päpste: Gesammelte Aufsätze zur Geschichte des Mittelalters*. 4 vols. Stuttgart, 1968–71.

Schramm, Percy Ernst, and Florentine Mütherich. *Denkmale der deutschen Könige und Kaiser: Ein Beitrag zur Herrschergeschichte von Karl dem Grossen bis Friedrich II. 768–1250*. Munich, 1962.

Schürer, O. "Romanische Doppelkapellen Eine typengeschichtliche Untersuchung," *Marburger Jahrbuch für Kunstwissenschaft* 5, 1929, 99–192.

Schwarz, Heinrich M. "Die Baukunst Kalabriens und Siziliens im Zeitalter der Normannen," *Römisches Jahrbuch für Kunstgeschichte*, 6, 1942/44, 1–132.

Serjeant, R. B. "Material for a History of Islamic Textiles up to the Mongol Conquest,"

*Ars Islamica* 9, 1942, 54–92; 10, 1943, 71–90; 11/12, 1946, 98–145; 13/14, 1948, 75–117; 15/16, 1951, 29–85.

Serradifalco, Domenico lo Faso Pietrasanta, duca di. *Del duomo di Monreale e di altre chiese siculo normanne ragionamenti tre.* Palermo, 1838.

Seymour, Charles Jr. *Notre Dame of Noyon in the Twelfth Century. A Study in the Early Development of Gothic Architecture.* New Haven, Conn., 1939.

Shepherd, Dorothy G. "Banquet and Hunt in Medieval Islamic Iconography," *Gatherings in Honor of Dorothy E. Miner*, ed. Ursula E. McCracken, Lillian M. C. Randall, and Richard H. Randall, Jr., Baltimore, 1973, 79–92.

Simon Cahn, Annabelle. "Some Cosmological Imagery in the Decoration of the Ceiling of the Palatine Chapel in Palermo," Ph.D. diss., Columbia University, 1978.

Sinding-Larsen, Staale. "*Plura ordinantur ad unum*: Some Perspectives regarding the 'Arab-Islamic' ceiling of the Cappella Palatina at Palermo (1132–1143)," *Acta ad archaeologiam et artium historiam pertinentia* 7, 1989, 55–96.

Smith, Earl Baldwin. *Architectural Symbolism of Imperial Rome and the Middle Ages.* Princeton, 1956.

Sourdel, Dominique. "Questions de cérémonial Abbaside," *Revue des Etudes Islamiques*, 1960, 121–48.

Sourdel, Dominique, and Janine Sourdel. *La Civilisation de l'Islam classique.* Paris, 1968.

Sourdel-Thomine, Janine. "Le style des inscriptions arabo-siciliennes à l'époque des rois normands," *Etudes d'orientalisme dédiées à la mémoire de Levi-Provençal*, vol. 1, Paris, 1962, 307–15.

Sourdel-Thomine, Janine, and Bertold Spuler. *Die Kunst des Islam* (=*Propyläen Kunstgeschichte* 4), Berlin, 1973.

Spahr, Rodolfo. *Le monete siciliane dai bizantini a Carlo I d'Angio (582–1282).* Zurich/Graz, 1976.

Spatharakis, Iohannis. *The Portrait in Byzantine Illuminated Manuscripts.* Leiden, 1979.

———. "The Proskynesis in Byzantine Art: A Study in Connection with a Nomisma of Andronicus II Palaeologue," *Bulletin Antieke Beschaving* 49, 1974, 190–205.

Spittle, S.D.T. "Cufic Lettering in Christian Art," *Archaeological Journal* 111, 1955, 138–52.

Staacke, Ursula. *Un palazzo normanno a Palermo: La Zisa. La cultura musulmana negli edifici dei Re.* Palermo, 1991.

Starn, Randolph, and Loren Partridge. *Arts of Power. Three Halls of State in Italy, 1300–1600.* Berkeley, 1992.

Steinberg, Sigfrid H. "I ritratti dei re normanni di Sicilia," *La Bibliofilia* 39, 1937, 29–57.

Stowasser, Karl. "Manners and Customs at the Mamluk Court," *Muqarnas* 2, 1984, 13–20.

Stylianou, Andreas, and Judith A. Stylianou. *The Painted Churches of Cyprus: Treasures of Byzantine Art.* London, 1985.

Swoboda, Karl M. "The Problem of the Iconography of Late Antique and Early Medieval Palaces," *Journal of the Society of Architectural Historians* 20, 1961, 78–89.

Tabbaa, Yasser. "The Muqarnas Dome: Its Origin and Meaning," *Muqarnas* 3, 1985, 61–74.

Terrasse, Henri. *La mosquée al-Qaraouiyin à Fès.* Paris, 1968.

Terzi, Andrea. *La Cappella di S. Pietro nella Reggia di Palermo.* 2 vols. Palermo, 1889 (repr. Palermo, 1987).

Tomaselli, Franco. *Il ritorno dei Normanni.* Rome, 1994.

Tomasi, Gioacchino Lanza. *Il Palazzo dei Normanni.* Turin, 1966.

Torp, Hjalmar. "*Monumentum resurrectionis*: Studio sulla forma e sul significato del candelabro per il cero pasquale in S. Maria della Pietà in Cori," *Acta ad archaeologiam et artium historiam pertinentia, Institutum Romanum Norvegiae* 1, 1962, 79–112.

Toubert, Hélène. *Un art dirigé: Réforme grégorienne et iconographie.* Paris, 1990.

Travaini, Lucia. "Aspects of the Sicilian Norman Copper Coinage in the Twelfth Century," *Numismatic Chronicle* 151, 1991, 159–74.

———. "Le prime monete argentee dei normanni in Sicilia: un ripostiglio di Kharrube e i modelli antichi delle monete normanne," *Numismatic Chronicle* 92, 1990, 171–98.

Treitinger, Otto. *Die oströmische Kaiser- und Reichsidee nach ihrer Gestaltung im höfischen Zeremoniell vom oströmischen Staats- und Reichsgedanken.* Darmstadt, 1956.

Trizzino, Lucio. *"La Palatina" di Palermo: Dalle opere funzionali al restauro, dal ripristino alla tutela.* Palermo, 1983.

Tronzo, William. "The Medieval Object-Enigma and the Problem of the Cappella Palatina in Palermo," *Word & Image* 9, 1973, 197–228.

———. "The Prestige of St. Peter's: Observations on the Function of Monumental Narrative Cycles in Italy," *Studies in the History of Art of the National Gallery of Art* 16, 1985, 93–112.

Tyrrell-Green, E. *Baptismal Fonts Classified and Illustrated.* London, 1928.

Ullmann, Walter. "The Development of the Medieval Idea of Sovereignty," *The English Historical Review* 64, 1949, 1–33.

Urbani, Leonardo, ed. *La cattedrale di Palermo: Studi per l'ottavo centenario dalla fondazione.* Palermo, 1993.

Valenti, Francesco. "L'arte arabo-normanna," *Ospitalità Italiana,* Palermo, 1934, 19–24.

———. "L'arte nell'era normanna," *Il regno normanno: Conferenze tenute in Palermo, per l'VIII centenario dell'incoronazione di Ruggero a Re di Sicilia,* Messina/Milan, 1932, 195–251.

———. "Il Palazzo Reale di Palermo," *Bollettino d'Arte* 11, 1925, 512–28.

Valguarnera, Mariano. *Discorso dell'origine ed antichità di Palermo.* Palermo, 1614.

Verzone, Paolo. "La distruzione dei palazzi imperiali di Roma e di Ravenna e la ristrutturazione del Palazzo Lateranense nel IX secolo nei rapporti con quello di Constantinopoli," *Roma e l'età carolingia,* Rome, 1976, 39–54.

Waetzoldt, Stephan. *Die Kopien des 17. Jahrhunderts nach Mosaiken und Wandmalereien in Rom.* Vienna, 1964.

Wanscher, Ole. *Sella curulis: The Folding Stool, an Ancient Symbol of Dignity.* Copenhagen, 1980.

Ward-Perkins, Bryan. *From Classical Antiquity to the Middle Ages: Urban Public Building in Northern and Central Italy, AD 300–850.* Oxford, 1984.

Watson, Katherine. "The Kufic Inscription in the Romanesque Cloister of Moissac in Quercy: Links with Le Puy, Toledo and Catalan Woodworkers," *Arte medievale* 3, 1989, 7–27.

White, Lynn, Jr. *Latin Monasticism in Norman Sicily.* Cambridge, Mass., 1938.

Wieruszowski, Helene. "Roger II of Sicily, Rex-Tyrannus, in Twelfth-Century Political Thought," *Speculum* 38, 1963, 46–78.

Wilkinson, Charles K. *Nishapur: Some Early Islamic Buildings and Their Decorations.* New York, 1986.

Wilks, Michael. *The Problem of Sovereignty in the Later Middle Ages.* Cambridge, 1963.

Wormald, Francis. "The Throne of Solomon and St. Edward's Chair," *De artibus opuscula XL: Essays in Honor of Erwin Panofsky,* ed. Millard Meiss, New York, 1961, vol. 1, 532–39.

Zimmermann, Max. *Sizilien.* 2 vols. Leipzig, 1905.

Zinzi, Emilia. "La conca del Patirion (1137): Un recupero e alcune considerazioni sulla cultura figurativa dei monasteri italo-greci del sud in età normanna," *Rivista storia calabrese,* n.s. 6, 1985, 431–9.

Zorić, Vladimir. "Il cantiere della cattedrale di Cefalù ed i suoi costruttori," *La Basilica Cattedrale di Cefalù. Materiali per la conoscenza storica e il restauro,* vol. 1, Palermo, 1989, 99–340.

# Index

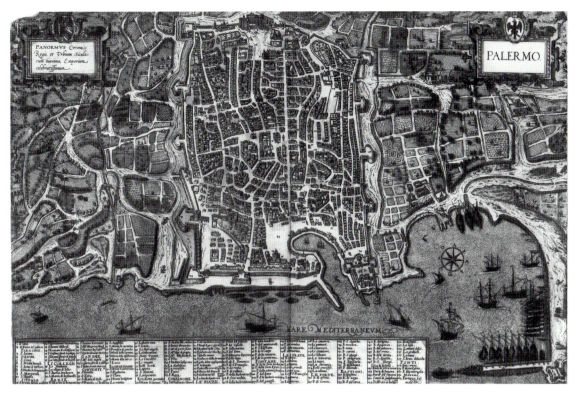

1. View of Palermo in the sixteenth century, from topographical atlas of Georg Braun and Franz Hogenberg, *Civitates orbis terrarum*, IV, pl. 59 (photo: Library of Congress)

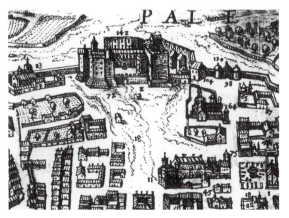

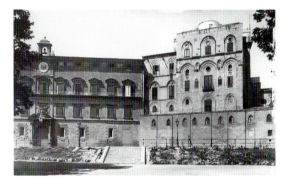

3. Palermo, Norman Palace, east facade (photo: Ministero per i beni culturali e ambientali, Istituto centrale per il catalogo e la documentazione)

2. View of the Norman Palace (detail of fig. 1) (photo: Library of Congress)

4. Palermo, Norman Palace, Cortile Maqueda looking toward the south flank of the Cappella Palatina (photo: Ministero per i beni culturali e ambientali, Istituto centrale per il catalogo e la documentazione)

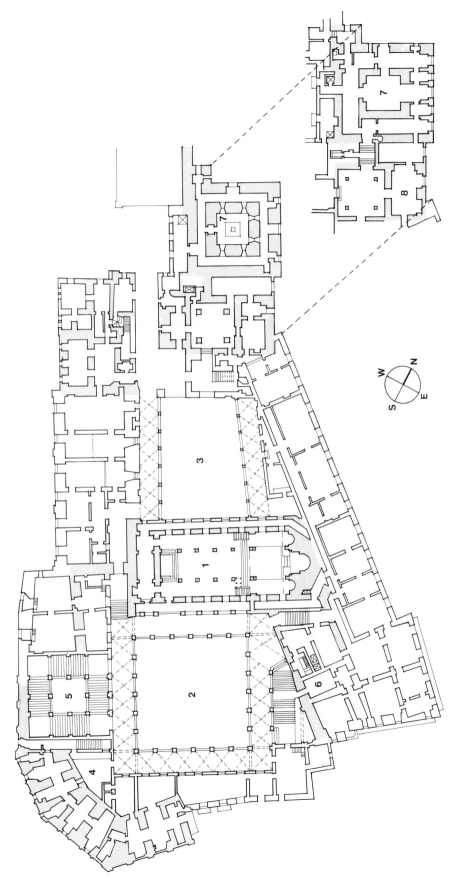

5. Palermo, Norman Palace, plan: no. 1, Cappella Palatina; no. 2, Cortile Maqueda; no. 3, Cortile della Fontana; no. 4, "Prigioni politiche"; no. 5, eighteenth-century staircase; no. 6, Torre Greca; no. 7, Torre Pisana; no. 8, Norman Stanza (drawing: Ju Tan, based on *Palazzo dei Normanni*, pls. II and III)

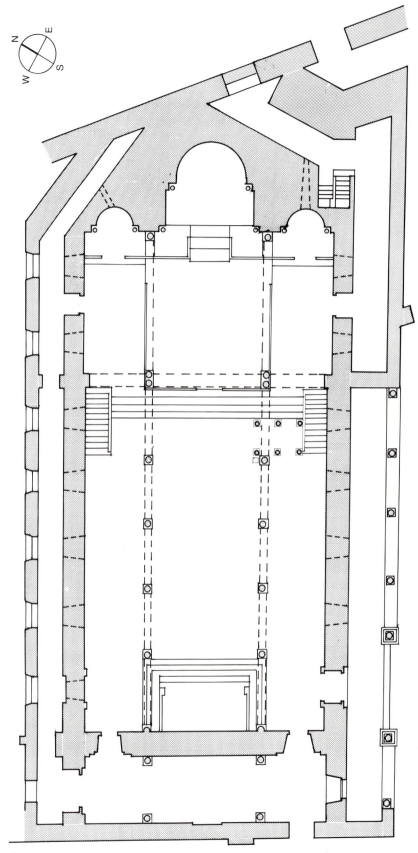

6. Palermo, Cappella Palatina, plan (drawing: Ju Tan)

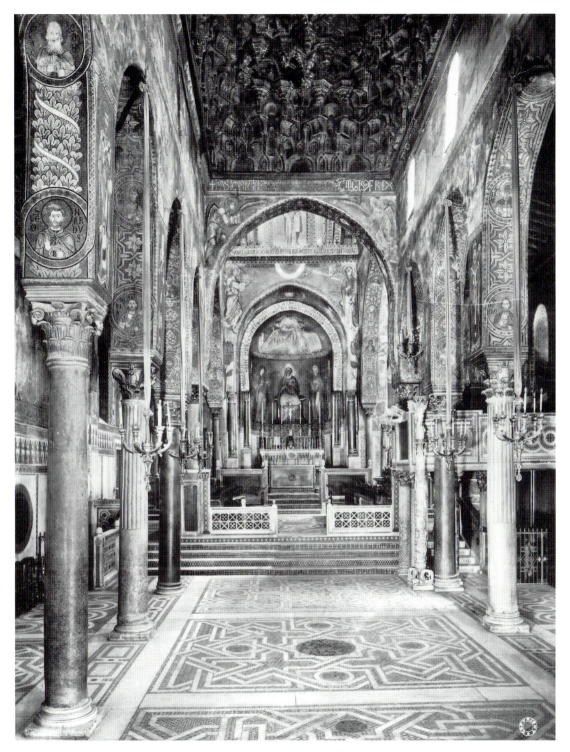

7. Palermo, Cappella Palatina, interior, view to east (photo: Fratelli Alinari/Art Resource, New York)

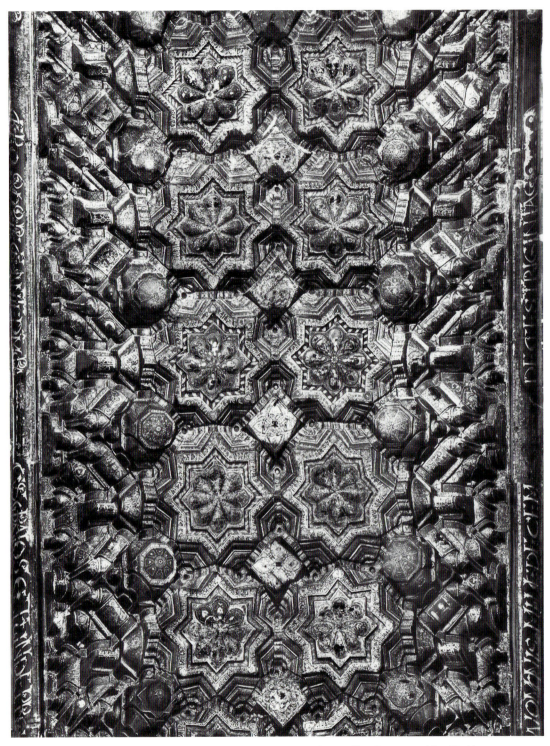

8. Palermo, Cappella Palatina, ceiling of nave (photo: Fratelli Alinari/Art Resource, New York)

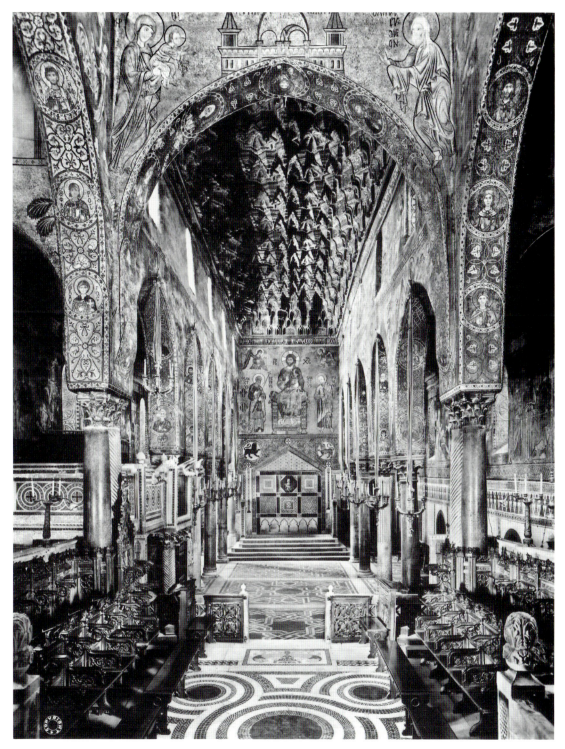

9. Palermo, Cappella Palatina, interior, view to west (photo: Fratelli Alinari)

10. Palermo, Cappella Palatina, mosaics of dome and central square of choir (photo: Chester Brummel)

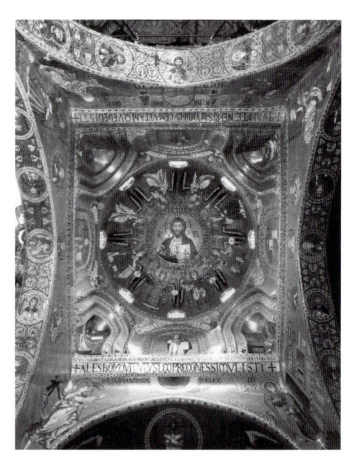

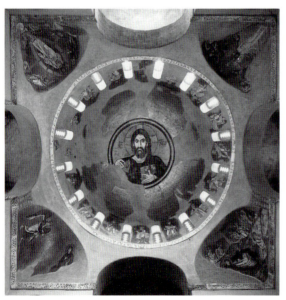

11. Daphni, Monastery church, mosaics of dome and central square (photo: Josephine Powell)

12. Palermo, Cappella Palatina, mosaic of north wall of north aisle, Aragonese coat of arms (Dumbarton Oaks, Trustees for Harvard University, Washington, D.C.)

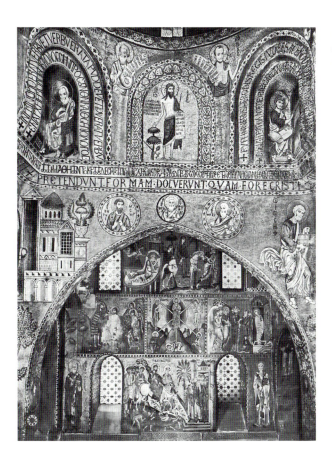

13. Palermo, Cappella Palatina, mosaics of south wall of southern transept arm (photo: Fratelli Alinari)

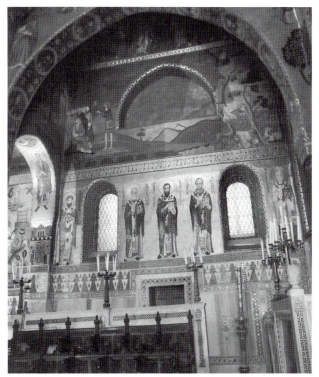

14. Palermo, Cappella Palatina, mosaics of north wall of northern transept arm (photo: Chester Brummel)

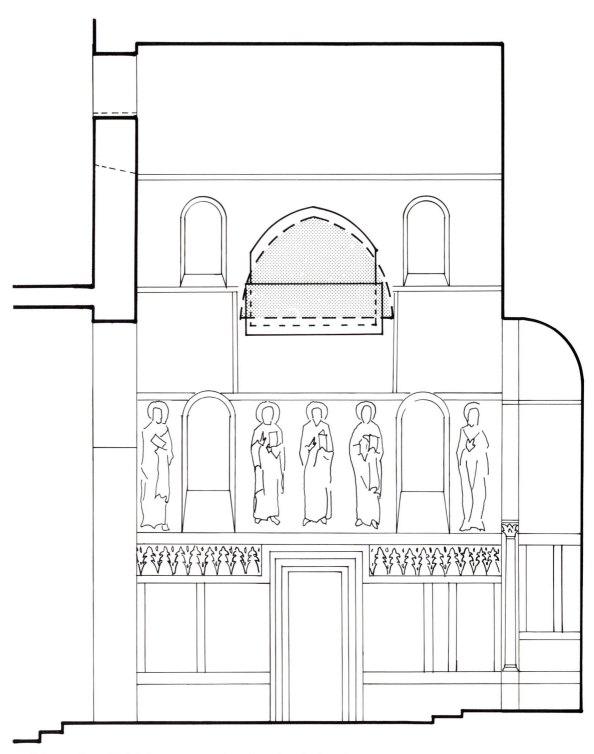

15. Palermo, Cappella Palatina, reconstruction of north wall of northern transept arm in period of Roger II, showing windows of upper story and opening to balcony of Norman king (present opening in this area is shaded) (drawing: Ju Tan)

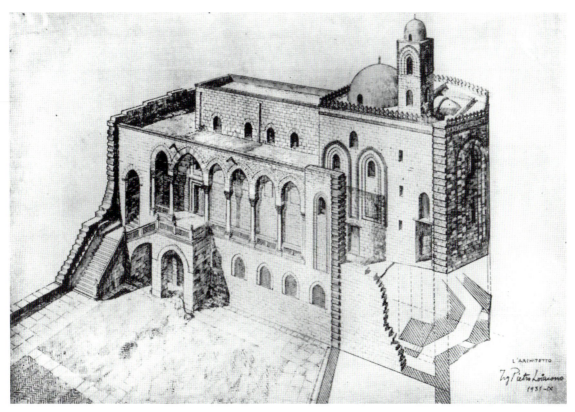

16. Palermo, Norman Palace, reconstruction of entrance into Cappella Palatina in period of Roger II (photo: after Di Stefano, *Monumenti*, pl. 52, fig. 86)

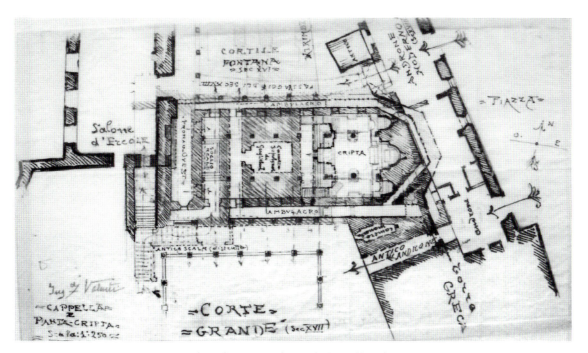

17. Palermo, Biblioteca Comunale, plan of structures beneath Cappella Palatina from archive of Francesco Valenti (photo: author)

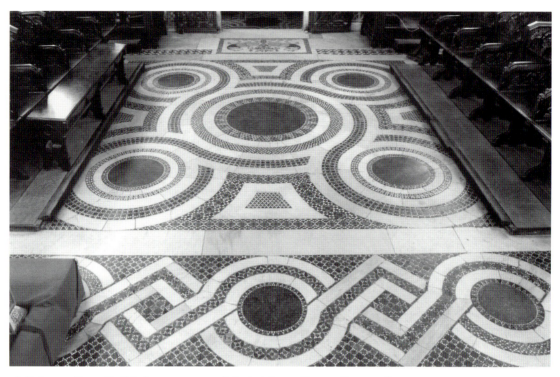

18. Palermo, Cappella Palatina, pavement of choir (photo: Chester Brummel)

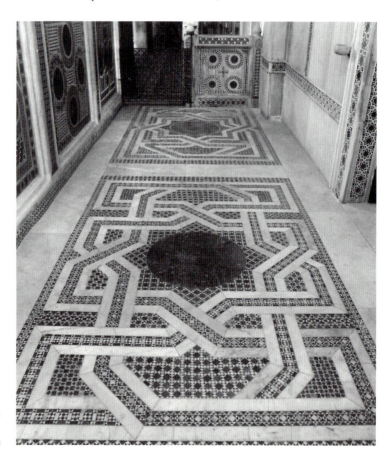

19. Palermo, Cappella Palatina,
pavement of northern transept
arm (photo: Chester Brummel)

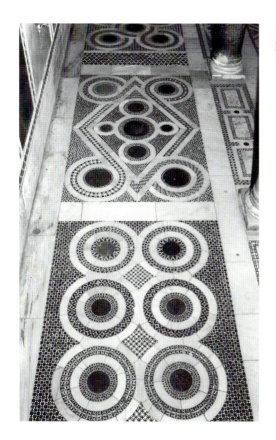

20. Palermo, Cappella Palatina,
pavement of south aisle
(photo: Chester Brummel)

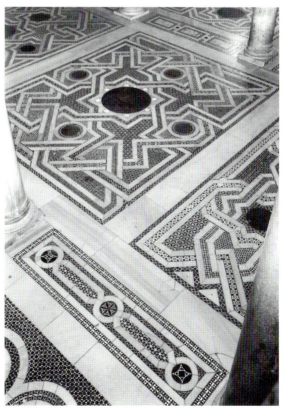

21. Palermo, Cappella Palatina,
pavement of nave (photo:
Chester Brummel)

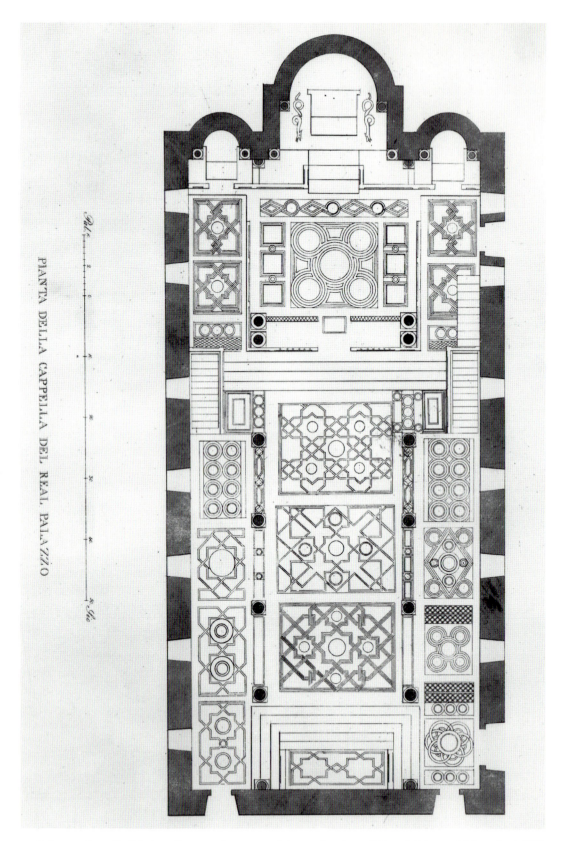

PIANTA DELLA CAPPELLA DEL REAL PALAZZO

22. Palermo, Cappella Palatina, diagram of pavement (photo: after Serradifalco, *Del duomo di Monreale*, pl. XV)

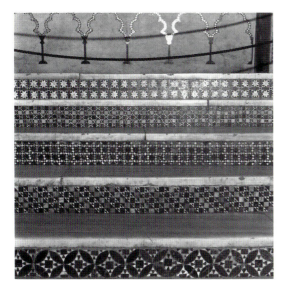

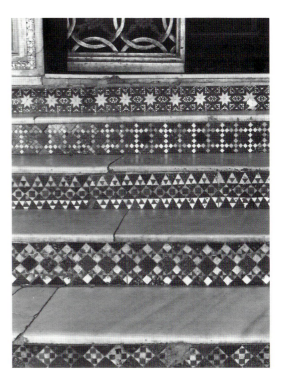

23. Palermo, Cappella Palatina, stairs of nave platform (photo: Chester Brummel)

24. Palermo, Cappella Palatina, stairs of nave to choir (photo: Chester Brummel)

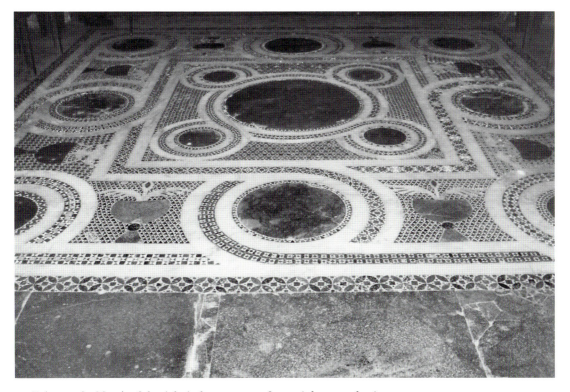

25. Palermo, St. Mary's of the Admiral, pavement of nave (photo: author)

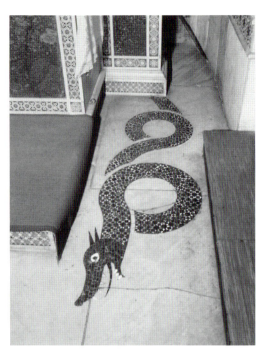

26. Palermo, Cappella Palatina, pavement beside main altar, snake (photo: Chester Brummel)

27. Palermo, Cappella Palatina, pavement at entrance to choir, lions (photo: Chester Brummel)

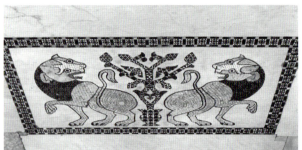

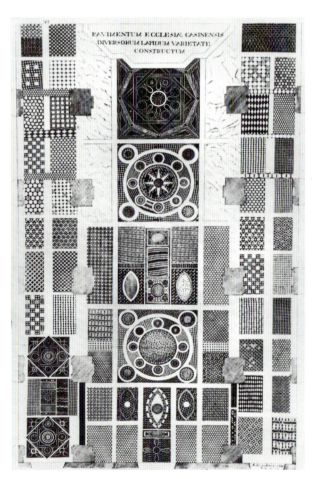

28. Monte Cassino, Basilica of Desiderius, diagram of pavement (photo: after Bloch, *Monte Cassino*, III, fig. 4)

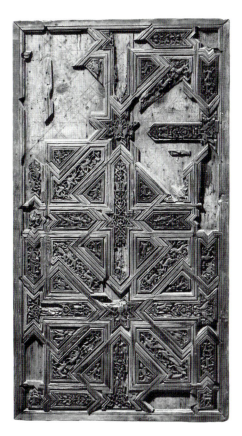

29. Palermo, Palazzo Abatellis,
wooden panel of twelfth century
(photo: Galleria Regionale della
Sicilia, Palazzo Abatellis, Palermo)

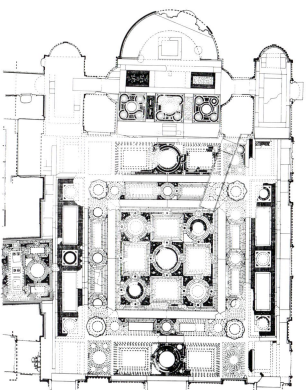

30. Istanbul, Pantokrator Monastery,
diagram of pavement (photo: after Eyice,
"Two Mosaic Pavements," fig. A)

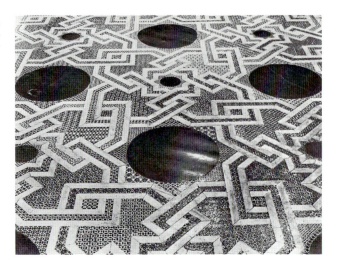

31. Monreale, Cathedral,
pavement of presbytery
(photo: Fratelli Alinari/
Art Resource, New York)

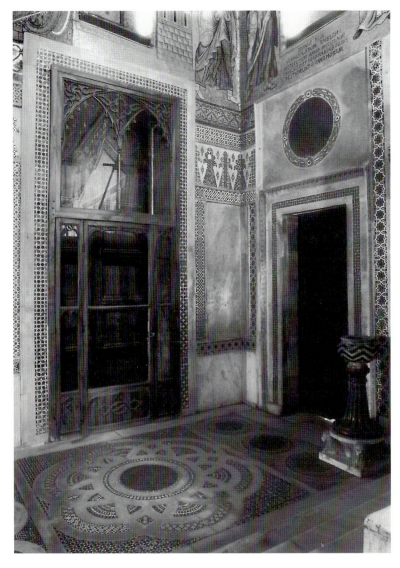

32. Palermo, Cappella
Palatina, western corner
of south aisle (photo:
Chester Brummel)

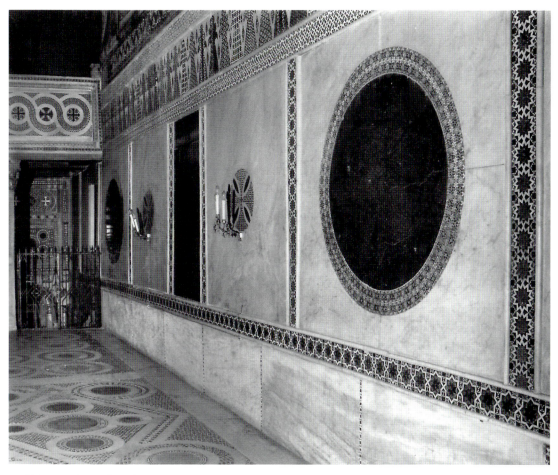

33. Palermo, Cappella Palatina, wainscoting of south aisle (photo: Chester Brummel)

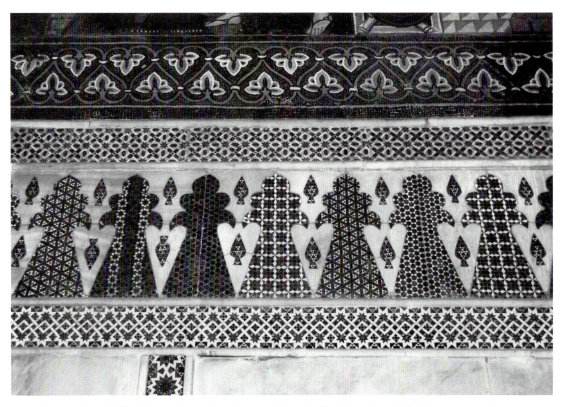

34. Palermo, Cappella Palatina, wainscoting of south aisle, detail of lotus lancéolé (photo: author)

35. Preslav, drawing of ceramic tile with ornamental pattern (photo: after Miiatev, fig. 40)

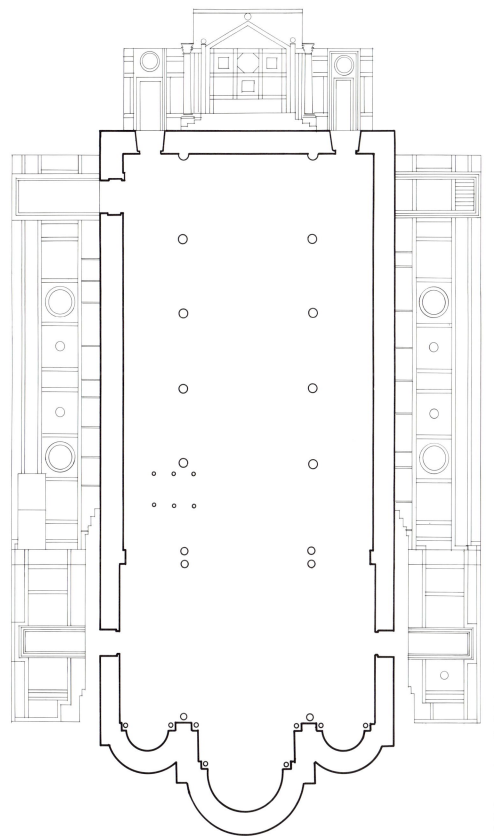

36. Palermo, Cappella Palatina, diagram of wainscoting in transept arms, aisles and nave (drawing: Ju Tan)

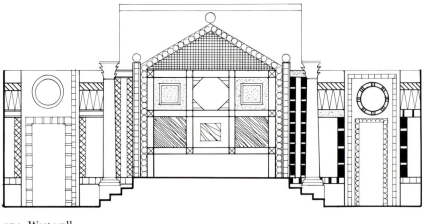

37A. West wall

37B. Key for ornamental patterns

37. Palermo, Cappella Palatina, diagram of wainscoting (drawing: Ju Tan)

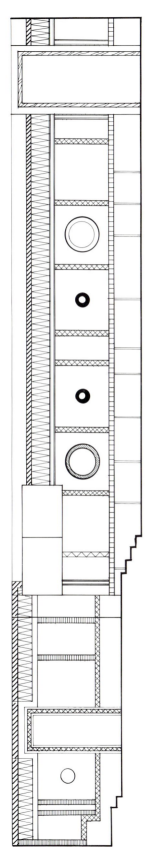

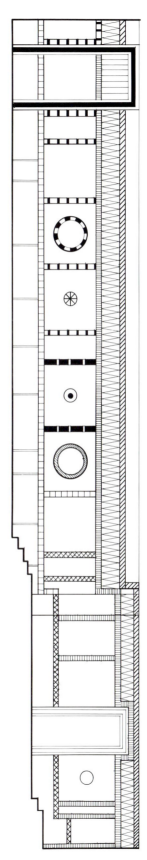

37A. North wall

37A. South wall

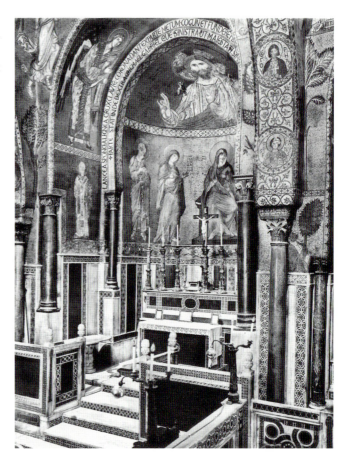

38. Palermo, Cappella Palatina, parapet wall, wainscoting and mosaics of main apse (photo: Fratelli Alinari/Art Resource, New York)

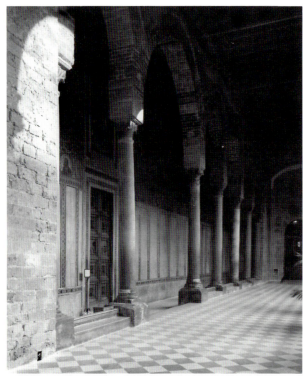

39. Palermo, Cappella Palatina, south facade of chapel (photo: Chester Brummel)

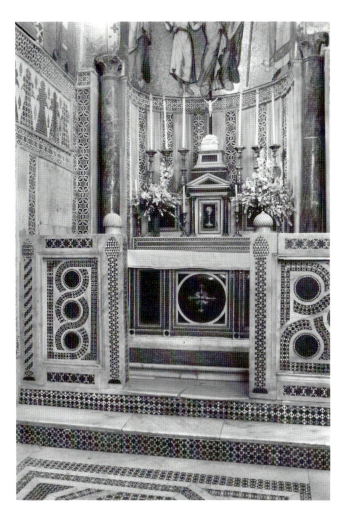

40. Palermo, Cappella Palatina, nineteenth-century altar and parapet wall in north apse, with wainscoting of altar wall (photo: Chester Brummel)

41. Palermo, Cappella Palatina, wainscoting of south facade of chapel, detail (photo: author)

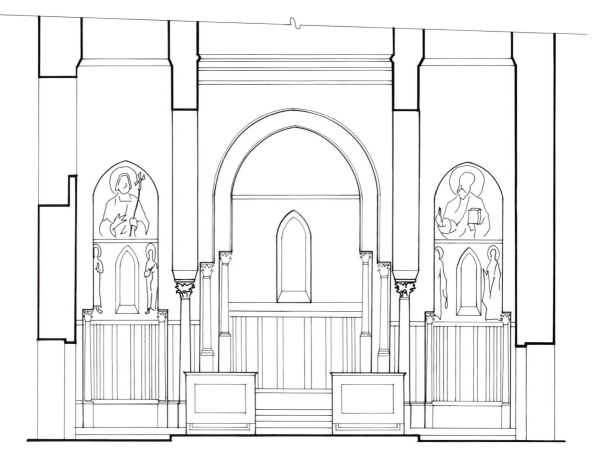

42. Palermo, Cappella Palatina, diagram of wainscoting in area of altars, and reconstruction of three apses under Roger II (drawing: Ju Tan)

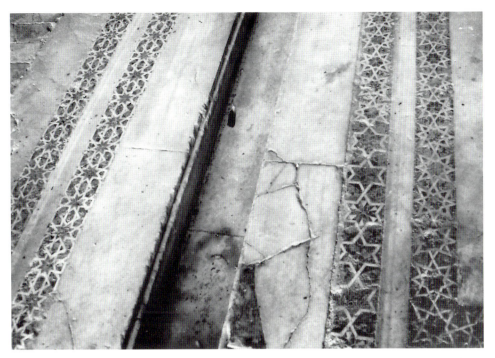

43. Palermo, Zisa, water channel in center of fountain room on ground floor, asymmetrical disposition of ornamental patterns (photo: author)

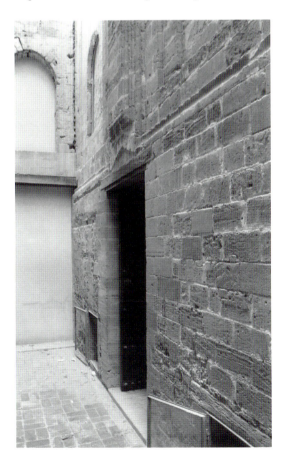

44. Palermo, Cappella Palatina, exterior, south wall of southern transept arm (photo: Chester Brummel)

45. Palermo, Cappella Palatina, interior, door in south wall of southern transept arm, door panels of twelfth century with bosses and door pull (photo: Chester Brummel)

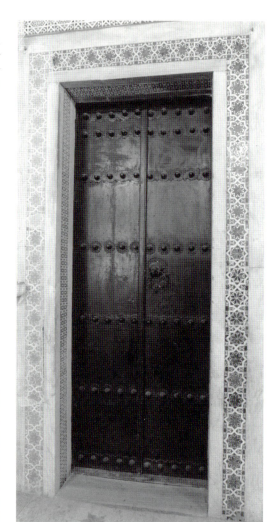

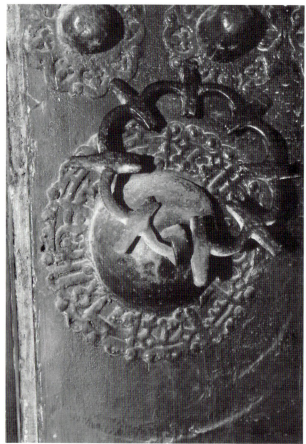

46. Palermo, Cappella Palatina, door pull in door of southern transept arm (photo: Chester Brummel)

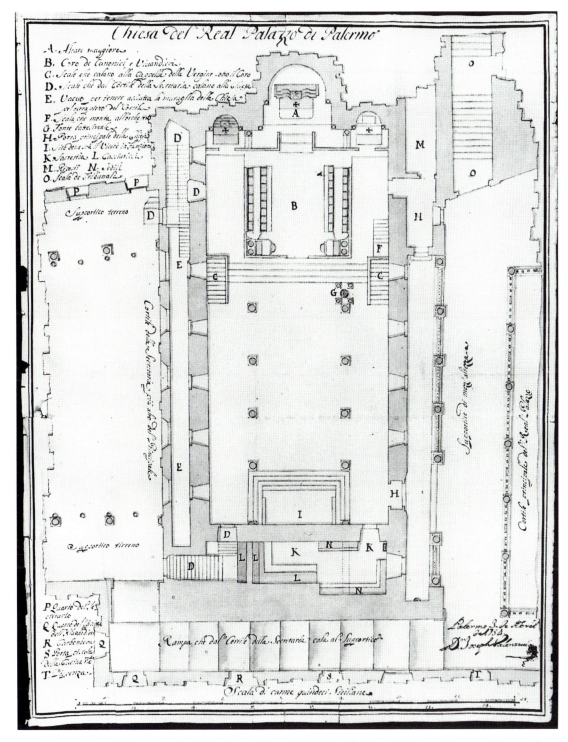

47. Palermo, Cappella Palatina, Archivio, plan of Cappella Palatina by Joseph Valenzuela, 1754 (photo: after *L'età normanna*, fig. 9L)

48. Palermo, Palazzo Abatellis, Kufic inscription (photo: Galleria Regionale della Sicilia, Palazzo Abatellis, Palermo)

49. Palermo, Palazzo Abatellis, Kufic inscription (photo: Galleria Regionale della Sicilia, Palazzo Abatellis, Palermo)

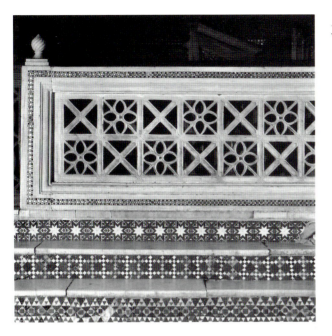

50. Palermo, Cappella Palatina, low wall on west side of chancel barrier (photo: Chester Brummel)

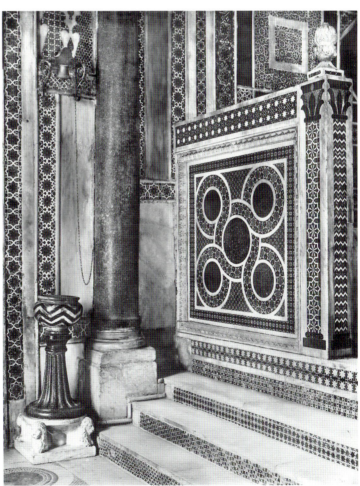

51. Palermo, Cappella Palatina, south side of throne platform of nave (photo: Fratelli Alinari/ Art Resource, New York)

52. Palermo, Cappella Palatina,
side of upright of high wall of
chancel barrier at southwest corner
(photo: author)

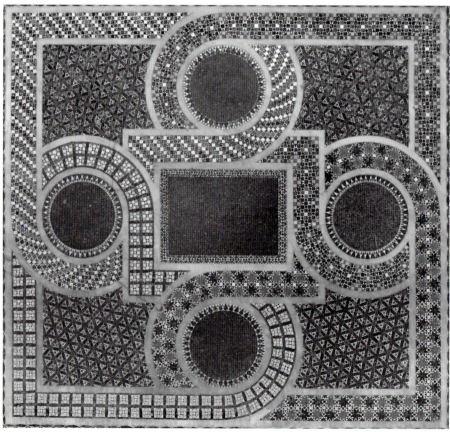

53. Palermo, Cappella Palatina, panel of high wall of chancel barrier on south side (photo: Chester Brummel)

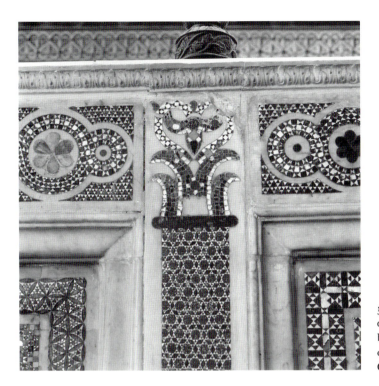

54. Palermo, Cappella Palatina,
detail of high wall of chancel
barrier on south side, with terra
cotta and stone inlay (photo:
Chester Brummel)

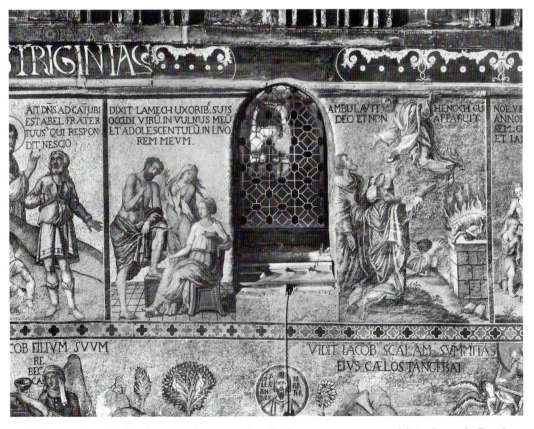

55. Palermo, Cappella Palatina, mosaics on north wall of nave to east, scenes of Cain, Lamech, Enoch,
and part of Noah dating to the eighteenth century (photo: Fratelli Alinari/Art Resource, New York)

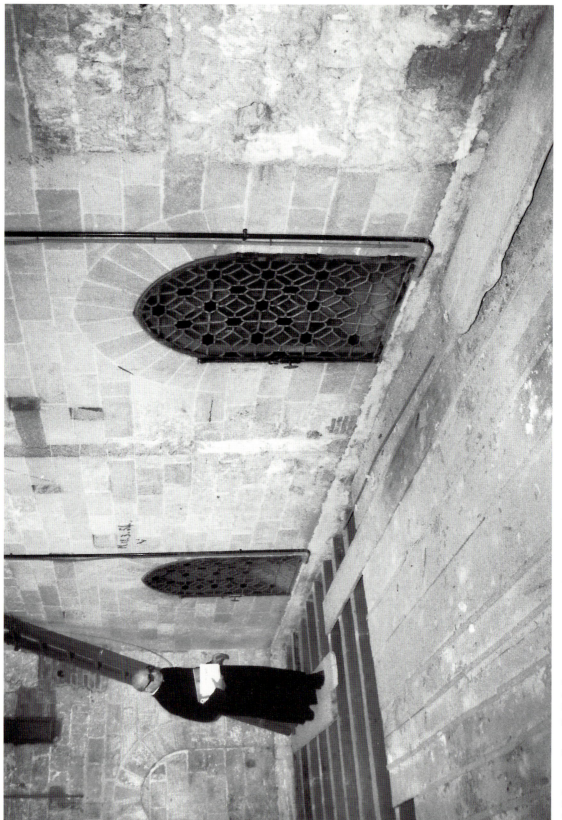

56. Palermo, Cappella Palatina, room over north aisle in 1989 (photo: author)

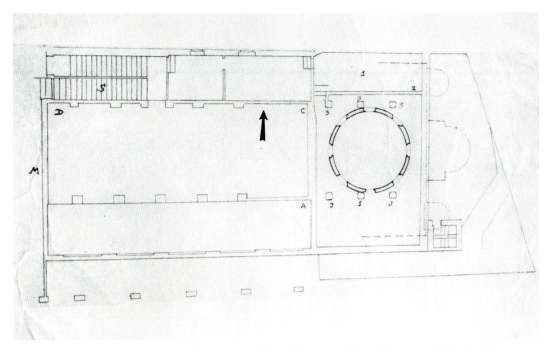

57. Palermo, Biblioteca Comunale, plan of Cappella Palatina in archive of Francesco Valenti, with arrow indicating room over north aisle (photo: author)

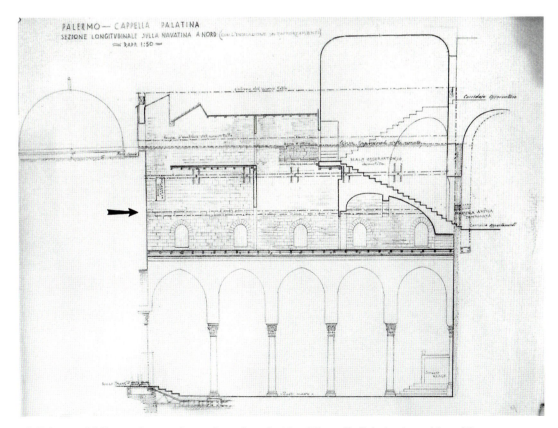

58. Palermo, Biblioteca Comunale, section of north side of Cappella Palatina in archive of Francesco Valenti, with arrow indicating room over north aisle (photo: author)

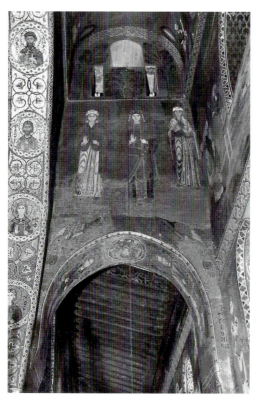

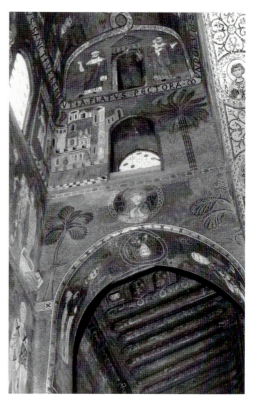

59. Palermo, Cappella Palatina, west wall of northern transept arm (photo: Chester Brummel)

60. Palermo, Cappella Palatina, west wall of southern transept arm (photo: Chester Brummel)

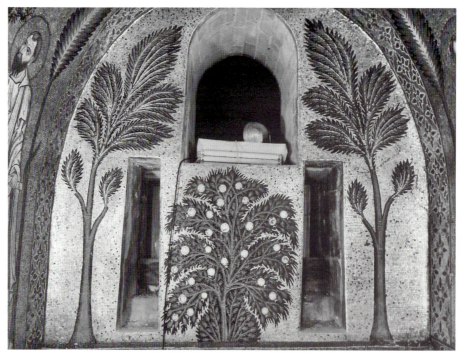

61. Palermo, Cappella Palatina, west wall of northern transept arm, detail of upper section of wall (photo: Dumbarton Oaks, Trustees for Harvard University, Washington, D.C.)

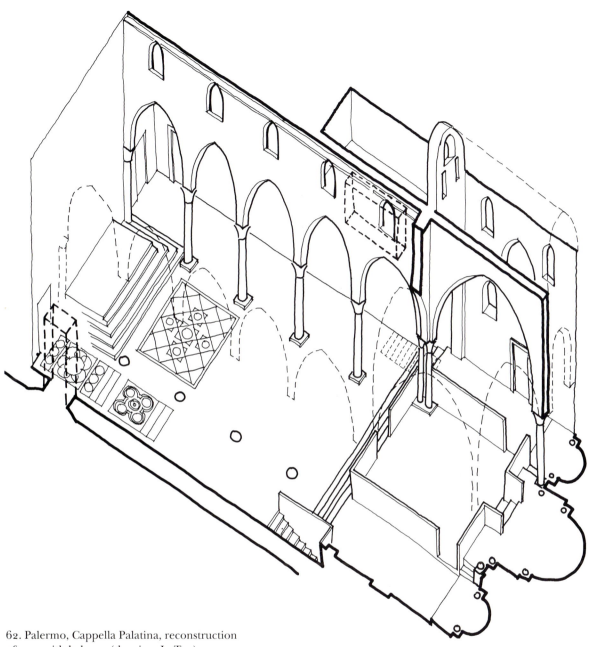

62. Palermo, Cappella Palatina, reconstruction
of nave with balcony (drawing: Ju Tan)

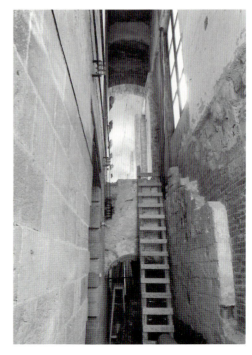

63. Palermo, Cappella Palatina, exterior, corridor along northern flank of Cappella Palatina looking west (photo: Chester Brummel)

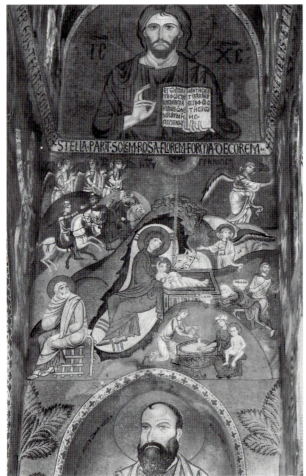

64. Palermo, Cappella Palatina, mosaics of east wall of southern transept arm: St. Paul, Nativity and Pantokrator (photo: Chester Brummel)

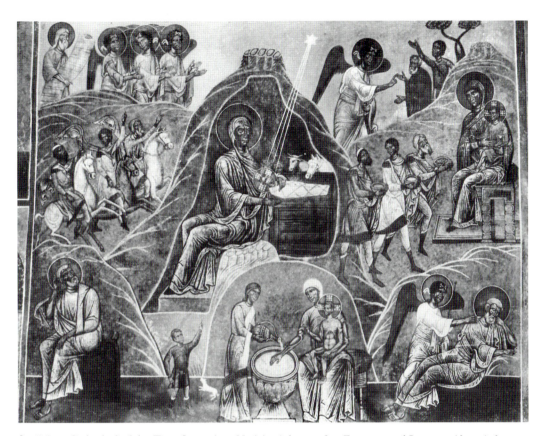

65. Pskov, Cathedral of the Transfiguration, Nativity (photo: after Faensen and Iwanow, *Altrussisches Baukunst*, pl. 124)

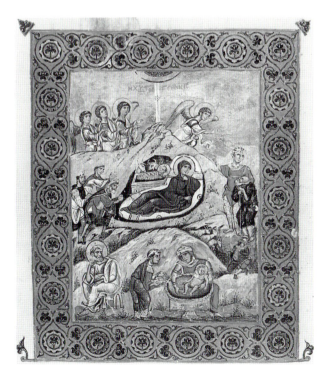

66. Mount Athos, Monastery of Lavra, "Phokas Lectionary," fol. 114v, Nativity (photo: after *Treasures of Mount Athos*, III, fig. 7)

67. Palermo, Cappella Palatina, mosaic on western arch of choir from nave, bowing angel (photo: Ministero per i beni culturali e ambientali, Istituto centrale per il catalogo e la documentazione)

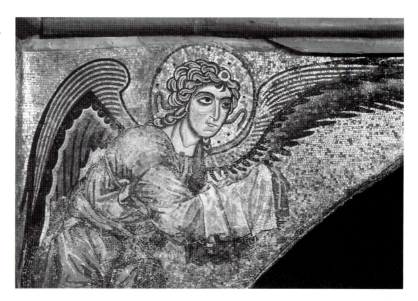

68. Palermo, Cappella Palatina, nave ceiling (photo: Ministero per i beni culturali e ambientali, Istituto centrale per il catalogo e la documentazione)

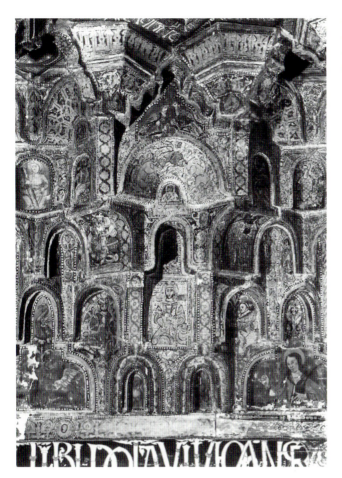

69. Palermo, Cappella Palatina, nave ceiling (photo: Ministero per i beni culturali e ambientali, Istituto centrale per il catalogo e la documentazione)

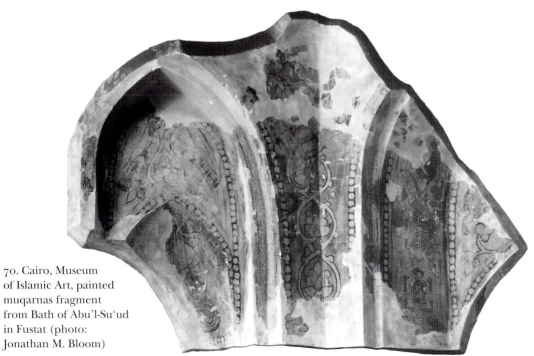

70. Cairo, Museum of Islamic Art, painted muqarnas fragment from Bath of Abu'l-Su'ud in Fustat (photo: Jonathan M. Bloom)

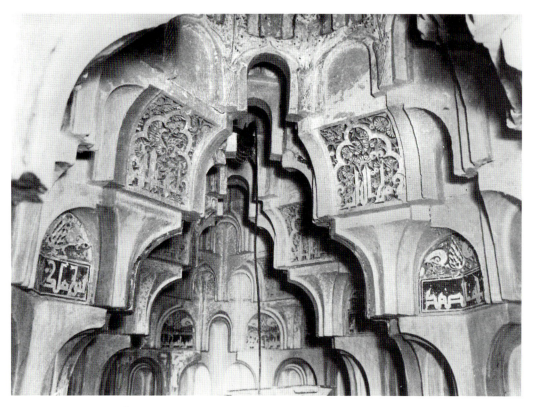

71. Fez, Mosque of al Qarawiyyan, detail of muqarnas in double bay vault in nave (photo: after Terrasse, *Mosquée*, pl. 29)

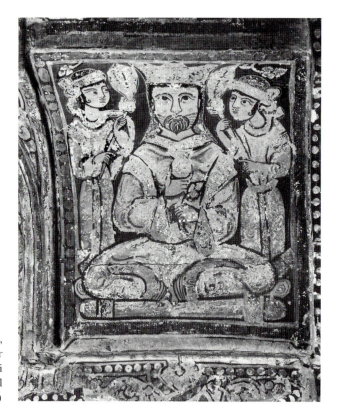

72. Palermo, Cappella Palatina, nave ceiling, figure of ruler (photo: Ministero per i beni culturali e ambientali, Istituto centrale per il catalogo e la documentazione)

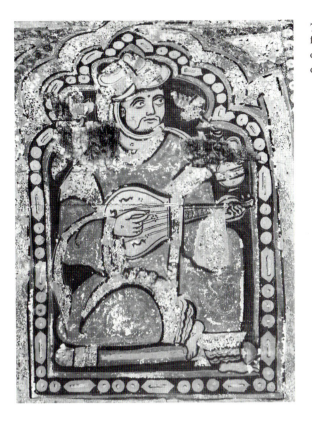

73. Palermo, Cappella Palatina, nave ceiling, figure of musician (photo: Ministero per i beni culturali e ambientali, Istituto centrale per il catalogo e la documentazione)

74. Athens, Benaki Museum, fragmentary plate with luster decoration from Cairo (photo: after Philon, *Early Islamic Ceramics*, pl. XXIIB)

75. Cefalù Cathedral, detail of painted beam of nave ceiling (photo: after Gelfer-Jørgensen, *Medieval Islamic Symbolism*, pl. 39)

76. Palermo, Cappella Palatina, ceiling of aisle (photo: Ministero per i beni culturali e ambientali, Istituto centrale per il catalogo e la documentazione)

77. Palermo, Cappella Palatina, mosaic of south wall of nave, Lot in Sodom, with restorations (photo: Dumbarton Oaks, Trustees for Harvard University, Washington, D.C.)

78. Palermo, Cappella Palatina, mosaic of south aisle, Baptism of Paul, head of Ananias (photo: Dumbarton Oaks, Trustees for Harvard University, Washington, D.C.)

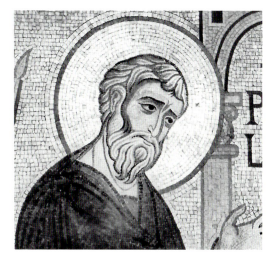

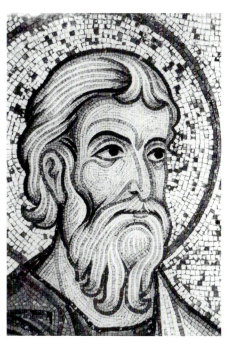

79. Cefalù Cathedral, mosaic of north wall of presbytery, head of Hosea (photo: Dumbarton Oaks, Trustees for Harvard University, Washington, D.C.)

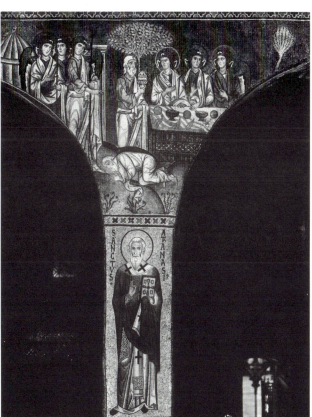

80. Palermo, Cappella Palatina, mosaic of south wall of nave, Hospitality of Abraham (photo: Fratelli Alinari/Art Resource, New York)

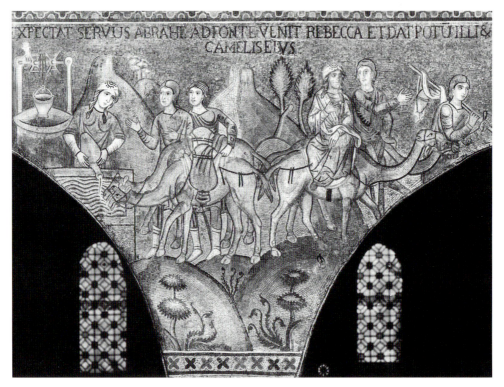

81. Palermo, Cappella Palatina, mosaic of north wall of nave, Rebecca at the Well (photo: Fratelli Alinari/Art Resource, New York)

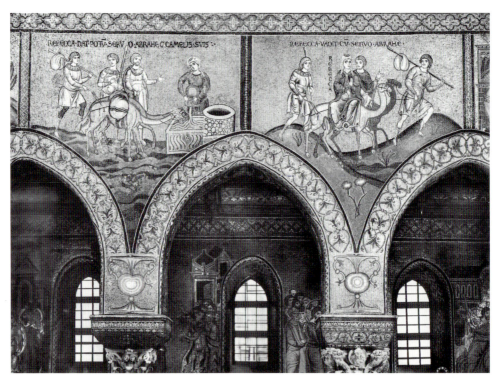

82. Monreale Cathedral, mosaic of north wall of nave, Rebecca at the Well, and Rebecca and Abraham (photo: Fratelli Alinari/Art Resource, New York)

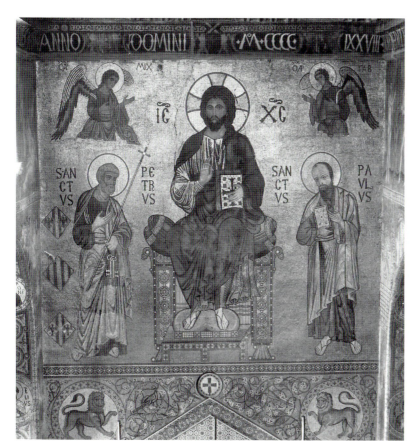

83. Palermo, Cappella Palatina, mosaic of west wall of nave, Christ flanked by Peter and Paul (photo: Dumbarton Oaks, Trustees for Harvard University, Washington, D.C.)

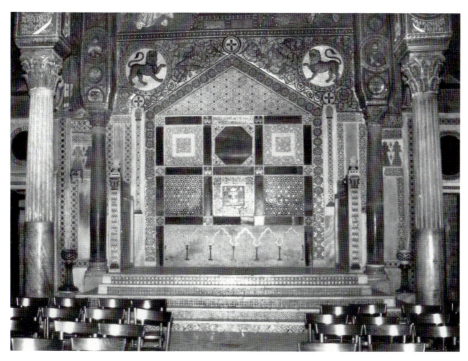

84. Palermo, Cappella Palatina, fastigium and throne platform at west wall of nave (photo: author)

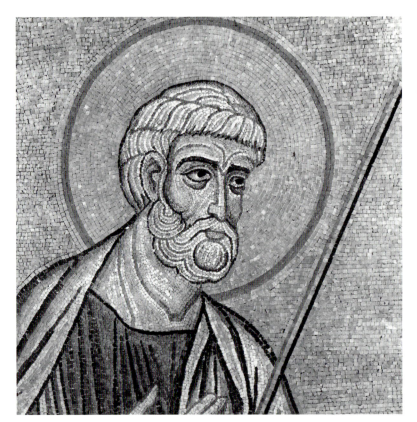

85. Palermo, Cappella
Palatina, detail of fig. 83,
head of Peter (photo:
Dumbarton Oaks, Trustees
for Harvard University,
Washington, D.C.)

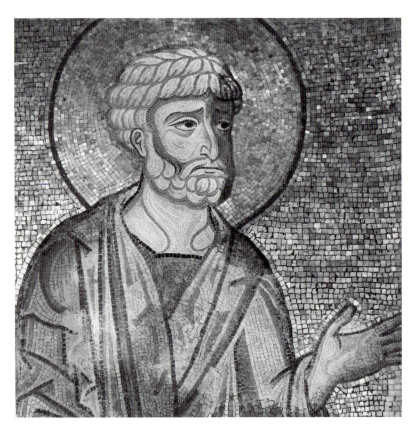

86. Palermo, Cappella
Palatina, mosaic of south
aisle, head of Peter (photo:
Dumbarton Oaks, Trustees
for Harvard University,
Washington, D.C.)

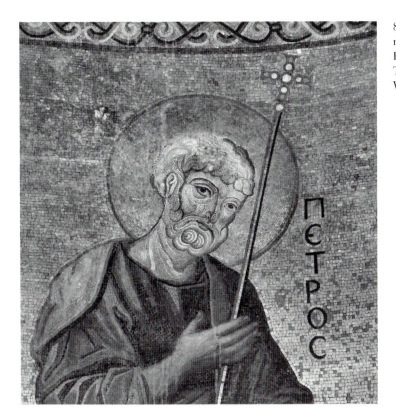

87. Palermo, Cappella Palatina, mosaic of main apse, head of Peter (photo: Dumbarton Oaks, Trustees for Harvard University, Washington, D.C.)

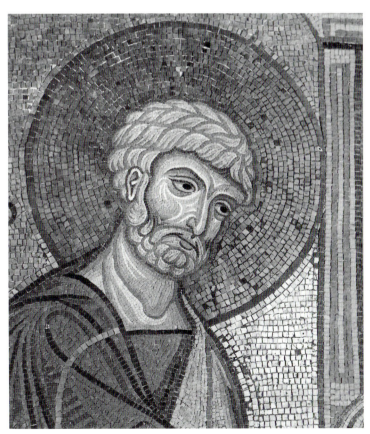

88. Palermo, Cappella Palatina, mosaic of north aisle, head of Peter (photo: Dumbarton Oaks, Trustees for Harvard University, Washington, D.C.)

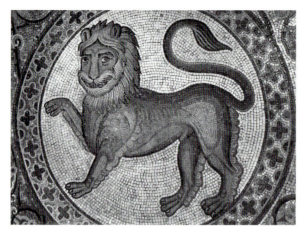

89. Palermo, Cappella Palatina, mosaic of west wall of nave, lion (photo: Dumbarton Oaks, Trustees for Harvard University, Washington, D.C.)

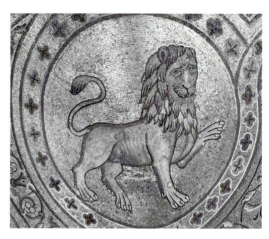

90. Palermo, Norman Palace, mosaic on vault of Norman Stanza, lion (photo: Dumbarton Oaks, Trustees for Harvard University, Washington, D.C.)

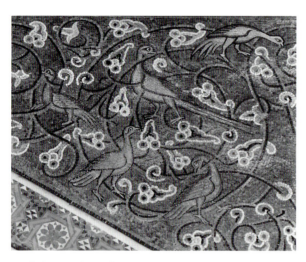

91. Palermo, Cappella Palatina, mosaic of west wall of nave, rinceaux with birds (photo: Dumbarton Oaks, Trustees for Harvard University, Washington, D.C.)

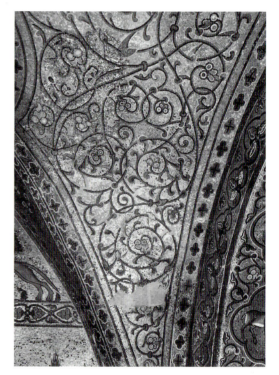

92. Palermo, Norman Palace, mosaic on vault of Norman Stanza, rinceaux (photo: Dumbarton Oaks, Trustees for Harvard University, Washington, D.C.)

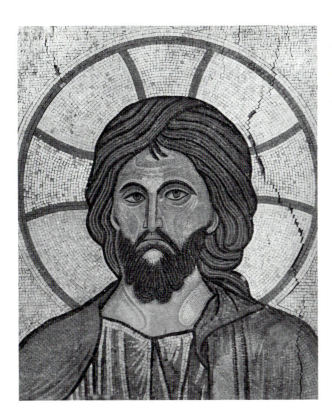

93. Palermo, Cappella Palatina, mosaic of west wall of nave, head of Christ (photo: Dumbarton Oaks, Trustees for Harvard University, Washington, D.C.)

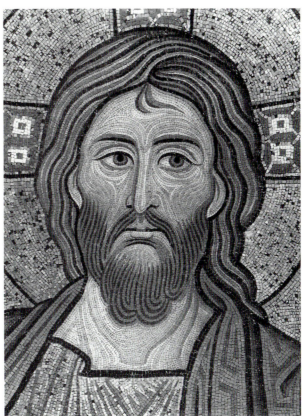

94. Palermo, Cappella Palatina, mosaic of dome, head of Christ (photo: Dumbarton Oaks, Trustees for Harvard University, Washington, D.C.)

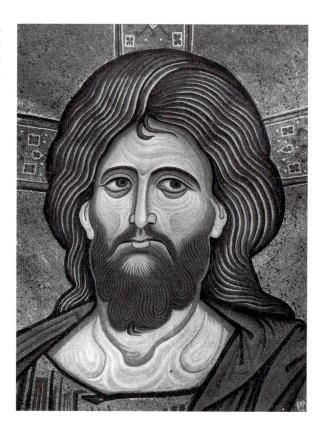

95. Monreale Cathedral, mosaic of main apse, head of Christ (photo: Dumbarton Oaks, Trustees for Harvard University, Washington, D.C.)

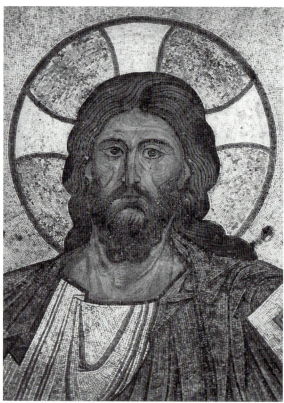

96. Palermo, Cappella Palatina, mosaic of main apse, head of Christ (photo: Dumbarton Oaks, Trustees for Harvard University, Washington, D.C.)

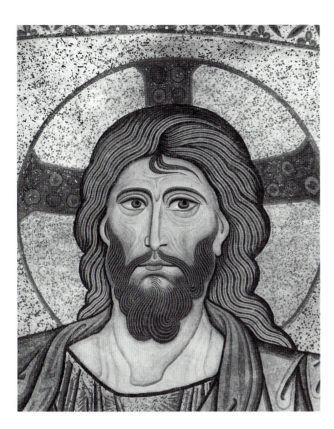

97. Cefalù Cathedral, mosaic of main apse, head of Christ (photo: Dumbarton Oaks, Trustees for Harvard University, Washington, D.C.)

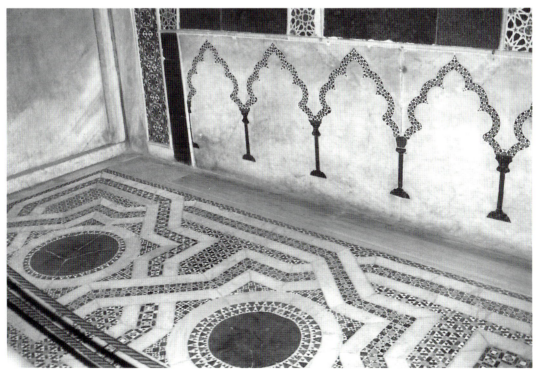

98. Palermo, Cappella Palatina, throne platform at west wall of nave, pavement and miniature colonnade (photo: author)

99. Palermo, Cappella Palatina, narthex with arrow showing location of closed window in west wall of nave (photo: Chester Brummel)

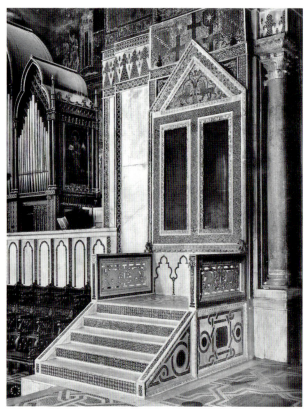

100. Monreale Cathedral, royal throne platform on north side of choir (photo: Fratelli Alinari/Art Resource, New York)

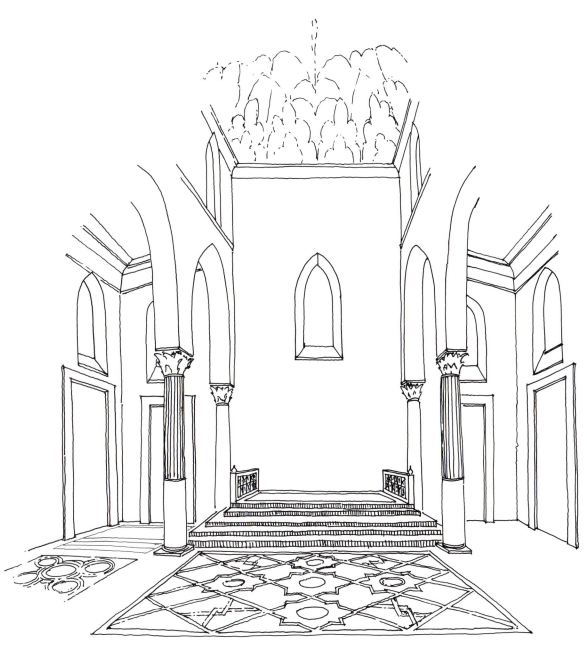

101. Palermo, Cappella Palatina, reconstruction of first phase of platform and west wall of nave (drawing: Ju Tan)

102. Palermo, Cappella Palatina, door from narthex into south aisle, viewed from south aisle (photo: Chester Brummel)

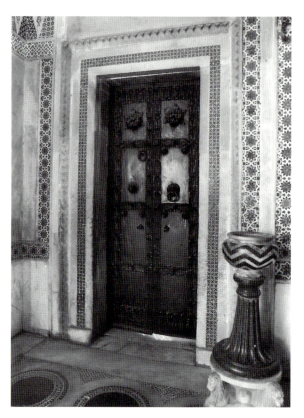

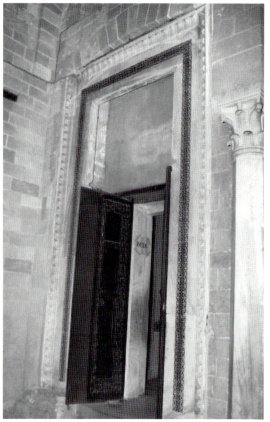

103. Palermo, Cappella Palatina, door from narthex into north aisle, viewed from narthex (photo: Chester Brummel)

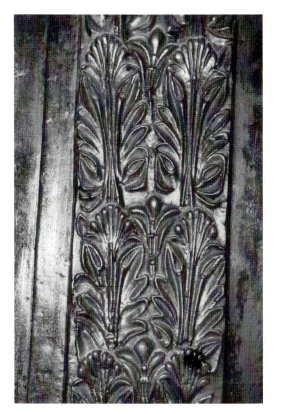

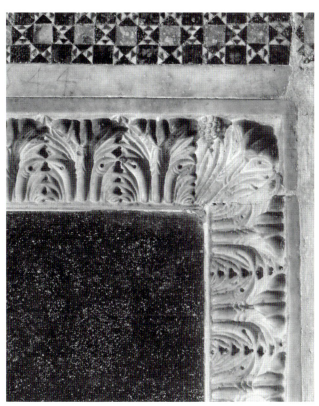

104. Palermo, Cappella Palatina, bronze panel of door from narthex into north aisle, detail of acanthus frame (photo: author)

105. Palermo, Cappella Palatina, frame of porphyry panel on parapet wall at main altar, detail of acanthus (photo: Chester Brummel)

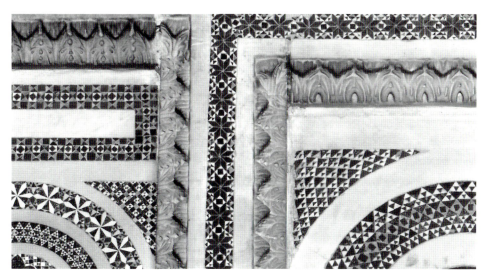

106. Palermo, Cappella Palatina, frame of opus sectile panel on west side of pulpit, detail of acanthus (photo: Chester Brummel)

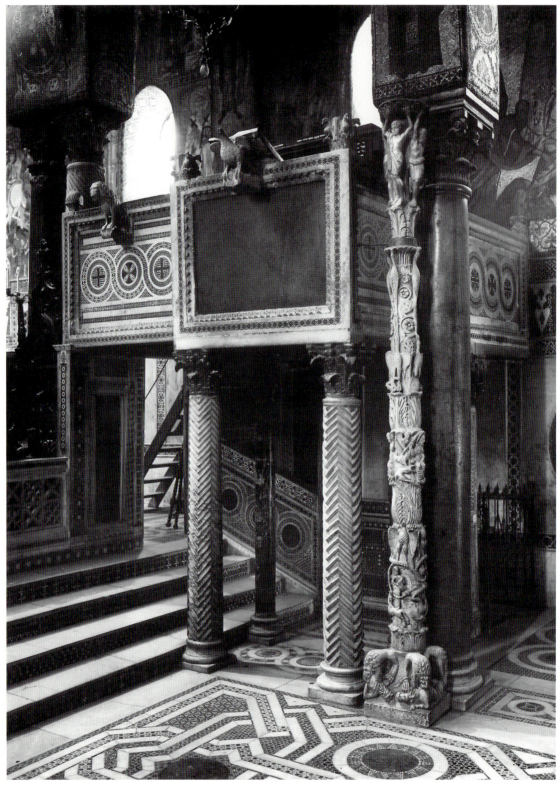

107. Palermo, Cappella Palatina, pulpit and paschal candelabrum (photo: Ministero per i beni culturali e ambientali, Istituto centrale per il catalogo e la documentazione)

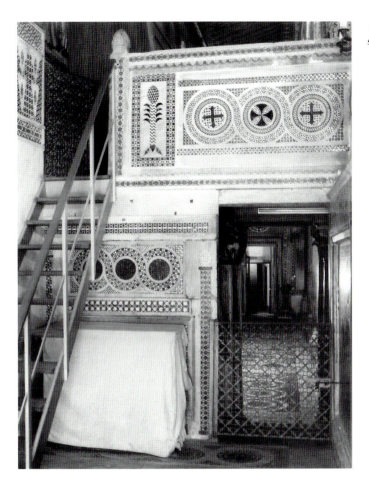

108. Palermo, Cappella Palatina, east side of pulpit (photo: Chester Brummel)

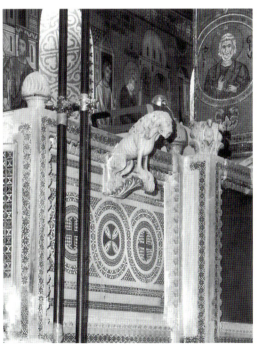

109. Palermo, Cappella Palatina, northeast corner of pulpit (photo: Chester Brummel)

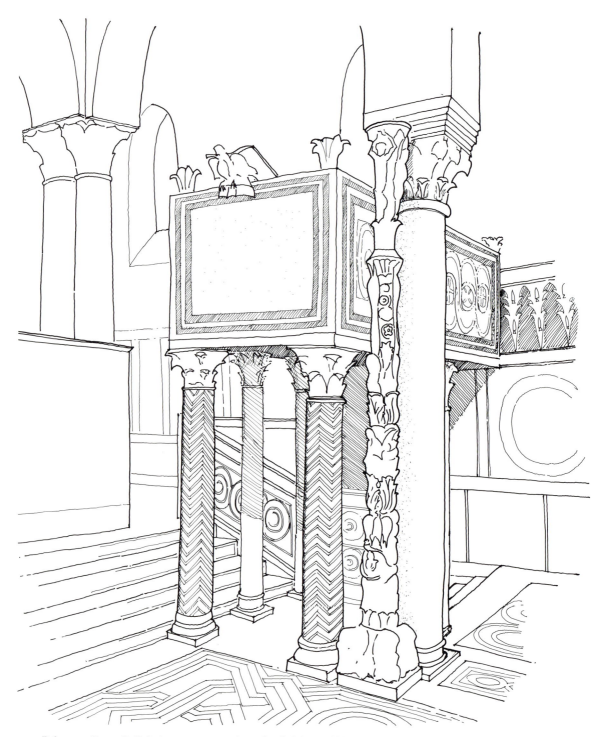

110. Palermo, Cappella Palatina, reconstruction of pulpit in twelfth century (drawing: Ju Tan)

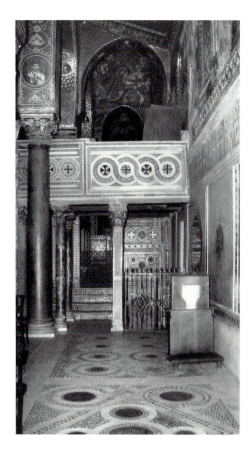

111. Palermo, Cappella Palatina, view of pulpit and wall above south apse from south aisle (photo: author)

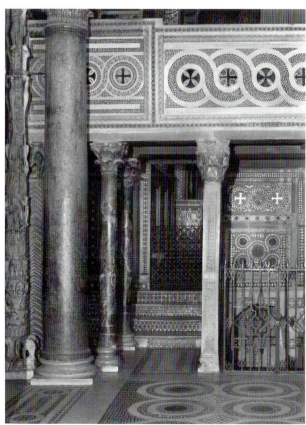

112. Palermo, Cappella Palatina, west side of pulpit (photo: Chester Brummel)

113. Monreale Cathedral, slab with opus sectile on south side of choir (photo: Bianca Maria Alfieri, *Il duomo di Monreale*, fig. p. 39)

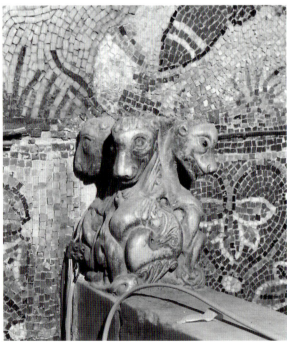

114. Palermo, Cappella Palatina, finial at southwest corner of pulpit integral with upright (photo: Chester Brummel)

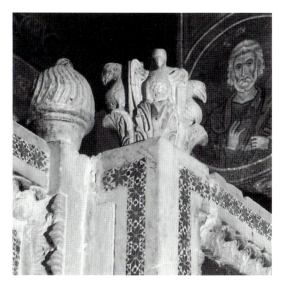

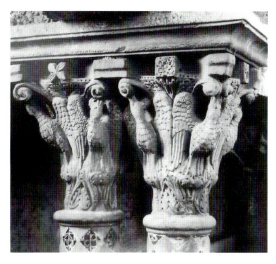

115. Palermo, Cappella Palatina, finial on north side of pulpit integral with upright (photo: Chester Brummel)

116. Monreale Cathedral, cloister, capital on west side, no. 18, south face (photo: Fratelli Alinari)

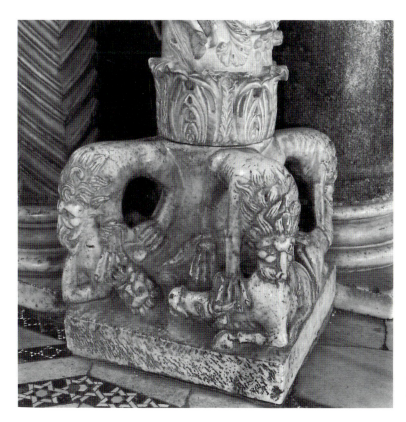

117. Palermo, Cappella Palatina, paschal candelabrum, base (photo: Chester Brummel)

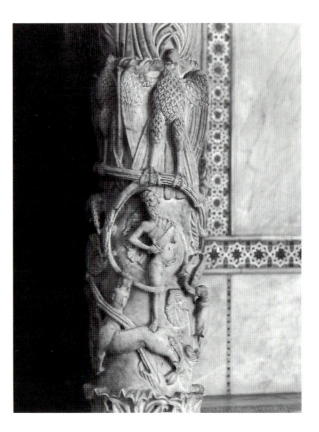

118. Palermo, Cappella Palatina, paschal candelabrum, shaft (photo: Chester Brummel)

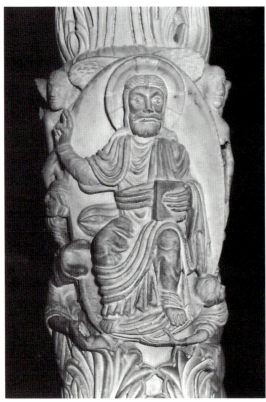

119. Palermo, Cappella Palatina, paschal candelabrum, shaft, Pantokrator (photo: Chester Brummel)

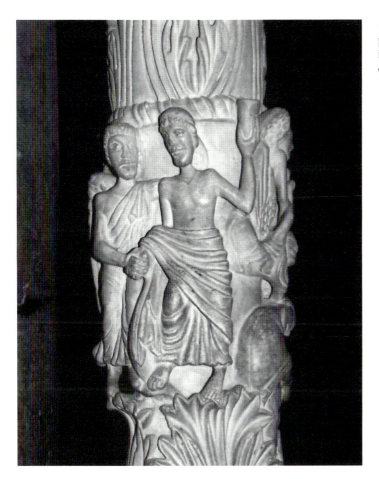

120. Palermo, Cappella Palatina, paschal candelabrum, shaft, scene identified here as the Resurrection of Christ (photo: author)

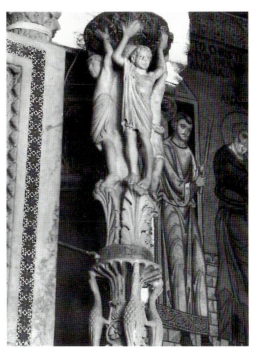

121. Palermo, Cappella Palatina, paschal candelabrum, top (photo: Chester Brummel)

122. Rome, S. Paolo fuori le mura,
paschal candelabrum (photo: Fratelli
Alinari/Art Resource, New York)

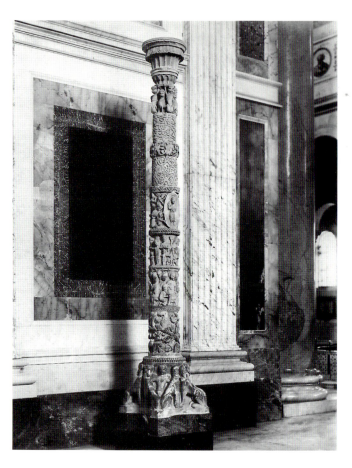

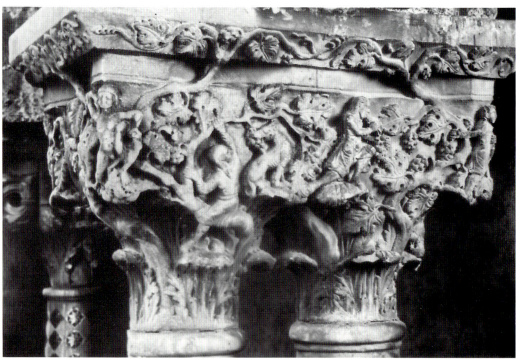

123. Monreale Cathedral, cloister, capital on south side, no. 11, west face (photo: Fratelli Alinari)

124. Rome, S. Paolo fuori le mura, paschal candelabrum, Resurrection of Christ after Ciampini, *Vetera Monumenta*, pl. XIV (photo: Bibliotheca Hertziana)

125. Hildesheim, Domschatz, ms. no. 37, "Ratmann-Sacramentary/Missal," fol. 75r, Resurrection of Christ (photo: after *Die Handschriften im Domschatz zu Hildesheim*, pl. 134)

126. Paris, Bibliothèque Nationale, Ms 4509 nouv. acq. du fond français, Joinville's Credo, Resurrection of Christ (photo: after Friedman, *Joinville's Credo*, 39)

127. Utrecht, Library of the University, ms. no. 484, Utrecht Psalter, fol. 10v, detail of illustration to Psalm XVIII (19), Resurrection of Christ (photo: after DeWald, *Utrecht Psalter*, pl. XVI)

128. Palermo, Cappella Palatina, paschal candelabrum, cleric kneeling at feet of Pantokrator (photo: author)

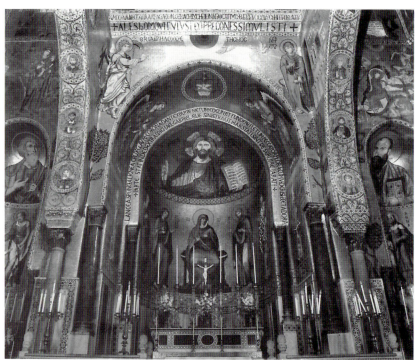

129. Palermo, Cappella Palatina, view of three apses (photo: Chester Brummel)

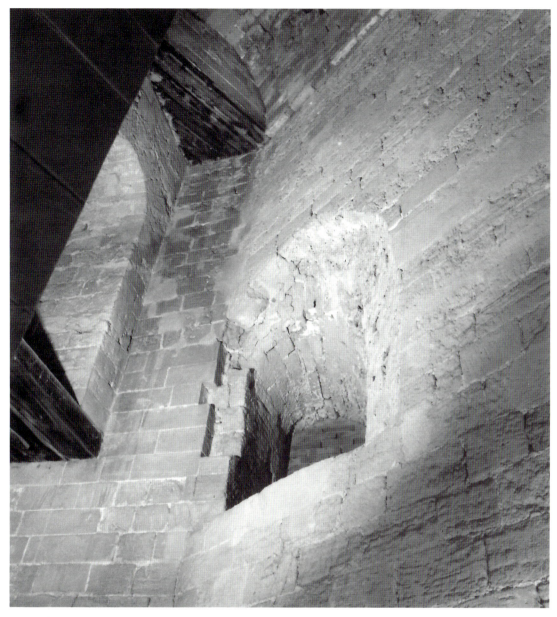

130. Palermo, Cappella Palatina, exterior of south apse with closed window (photo: Chester Brummel)

131. Palermo, Cappella Palatina, mosaic
of south apse, Paul (photo: Dumbarton
Oaks, Trustees for Harvard University,
Washington, D.C.)

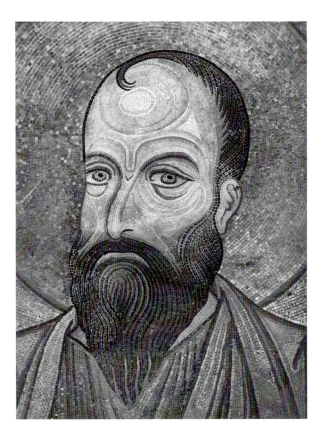

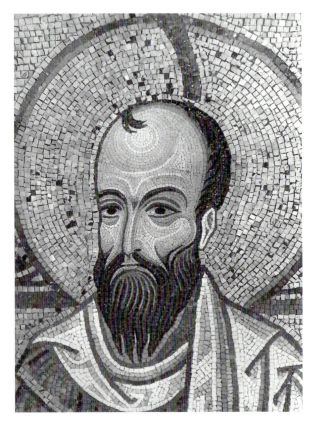

132. Palermo, Cappella Palatina,
mosaic of vault of southern transept
arm, Pentecost, bust of Paul (photo:
Dumbarton Oaks, Trustees for
Harvard University, Washington, D.C.)

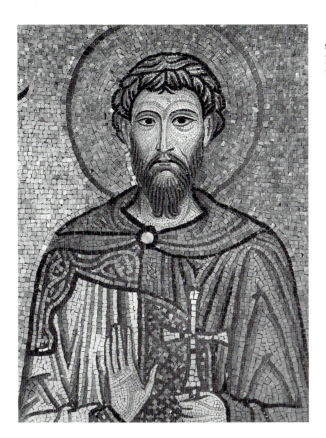

133. Palermo, Cappella Palatina, mosaic of south apse, head of Sebastian (photo: Dumbarton Oaks, Trustees for Harvard University, Washington, D.C.)

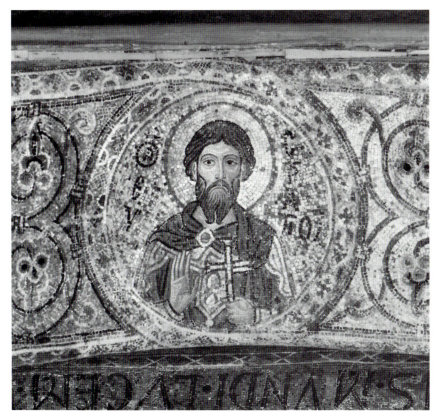

134. Palermo, Cappella Palatina, mosaic of soffit of western arch of choir, Eustratios (photo: Dumbarton Oaks, Trustees for Harvard University, Washington, D.C.)

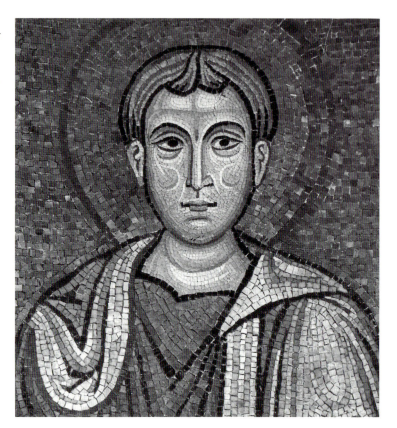

135. Palermo, Cappella Palatina, mosaic of south apse, head of Philip (photo: Dumbarton Oaks, Trustees for Harvard University, Washington, D.C.)

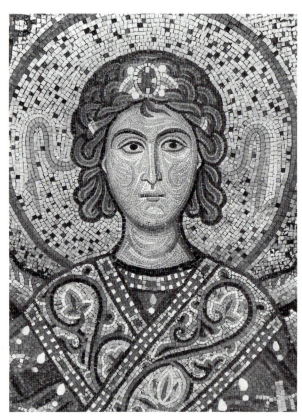

136. Palermo, Cappella Palatina, mosaic of dome, head of angel (photo: Dumbarton Oaks, Trustees for Harvard University, Washington, D.C.)

137. Palermo, Cappella Palatina, reconstruction of room over north aisle in twelfth century (drawing: Ju Tan)

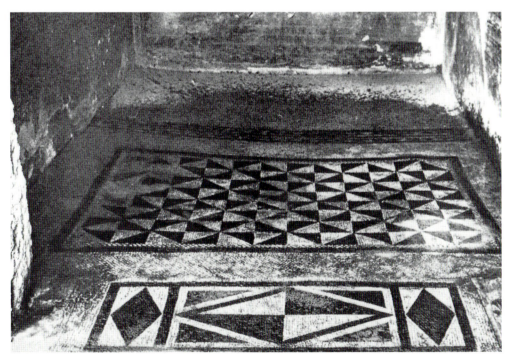

138. Pompeii, floor mosaic with threshold pattern (photo: after Kier, *Schmuckfussboden*, fig. 270)

139. Cairo, Museum of Islamic Art,
sections of carved wooden beam
(photo: after Pauty, *Les bois
sculptées*, pl. LIII)

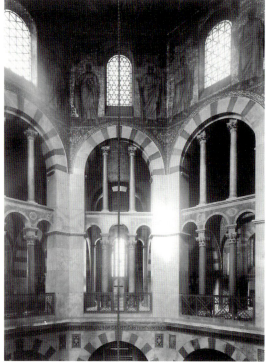

140. Aachen, Palatine Chapel, view to
west with throne in gallery (photo: Foto
Marburg/Art Resource, New York)

141. Palermo, Norman Palace, Norman Stanza (photo: Fratelli Alinari/Art Resource, New York)

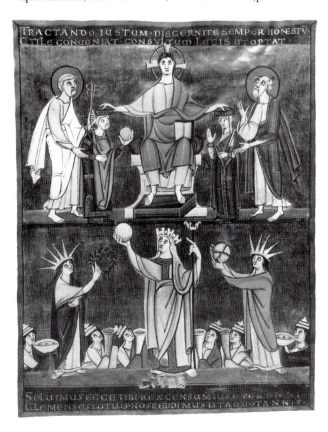

142. Munich, Bayerische Staatsbibliothek Clm 4452, Pericopes of Henry II, fol. 2r, Sts. Peter and Paul presenting Henry and Kunigund to Christ (photo: Foto Marburg/Art Resource, New York)

143. Phocis, Hosios Lukas, crypt, detail of wall painting with pseudo-Kufic ornament (photo: Carolyn L. Connor)

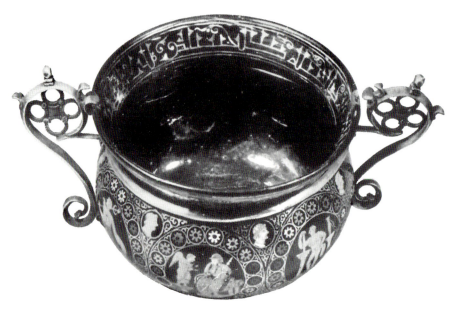

144. Venice, San Marco, Treasury, Byzantine cup with inscription (photo: after Kalavrezou Maxeiner, "Cup of San Marco," fig. 8)

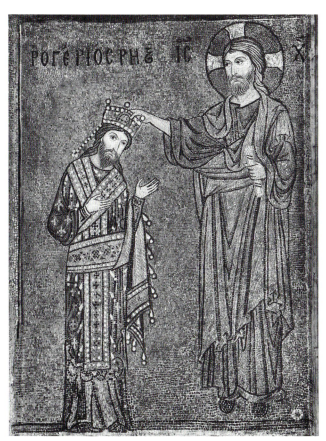

145. Palermo, St. Mary's of the Admiral, mosaic of Roger II crowned by Christ (photo: Fratelli Alinari/Art Resource, New York)

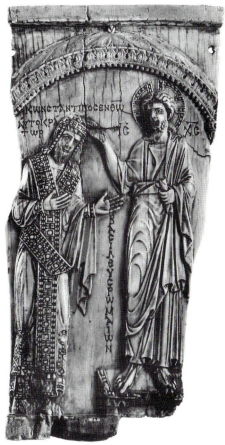

146. Moscow, Pushkin Museum of Fine Arts, ivory plaque of Christ crowning the emperor Constantine VII (photo: after Bank, *Byzantine Art in the Collections of Soviet Museums*, pl. 122)

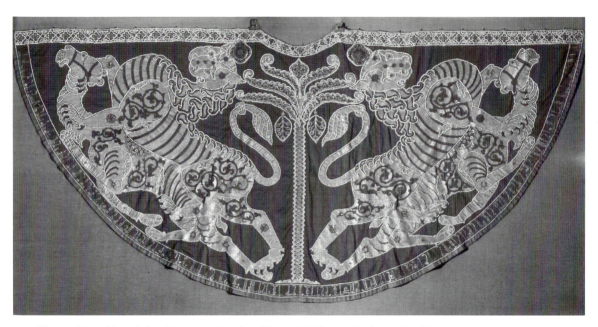

147. Vienna, Kunsthistorisches Museum, Mantle of Roger II (photo: Erich Lessing/Art Resource, New York)

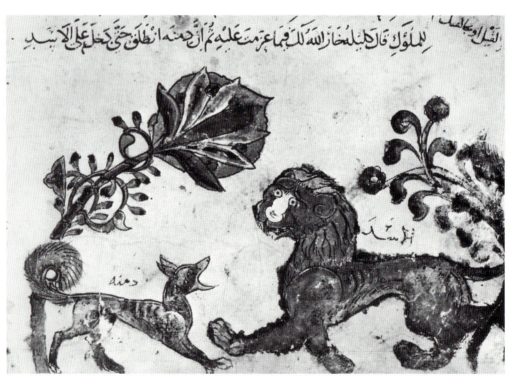

148. Paris, Bibliothèque National, ms. Ar. 3465, fol. 49v, Dimna and the lion (photo: after Ettinghausen and Grabar, *The Art and Architecture of Islam: 650–1250*, fig. 397)

149. Aght'Amar, Church of the Holy Cross, north exedra with christological scenes, including Transfiguration in center (photo: after Der Nersessian, *Aght'Amar*, fig. 67)

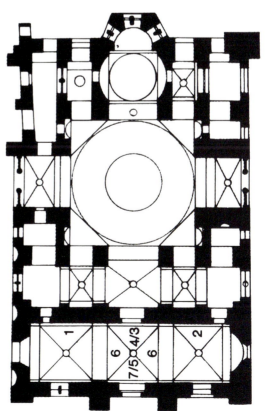

150. Phocis, Hosios Lukas, plan showing location of Crucifixion (no. 1), Pantokrator (no. 3), and Anastasis (no. 2) (photo: after Kartsonis, *Anastasis*, fig. 84)

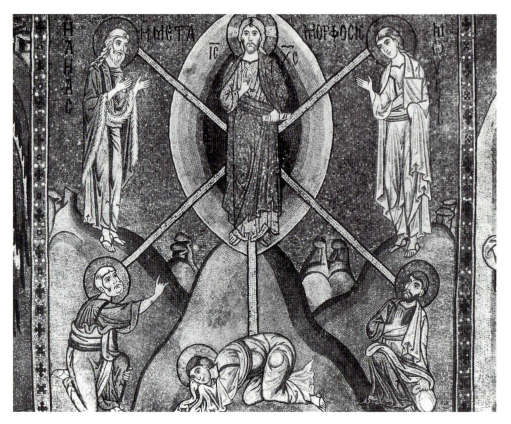

151. Palermo, Cappella Palatina, mosaic of south wall of southern transept arm, Transfiguration
(photo: Fratelli Alinari)

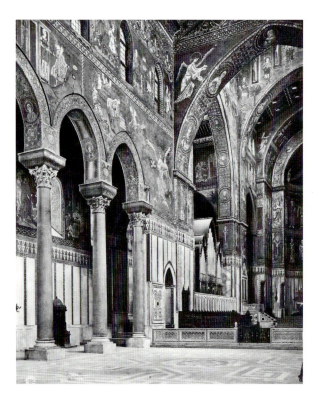

152. Monreale Cathedral, view
(photo: Fratelli Alinari/Art
Resource, New York)